The Promise of Photography

The Promise of Photography

The DG BANK Collection

Texts by

Carl Aigner
Jean-Christophe Ammann
Dieter Bartetzko
Hubert Beck
Bettina Becker
Christian Caujolle
A. D. Coleman
Iris Cramer
Günter Engelhard
Beate Ermacora
Monika Faber
Zdenek Felix
Jeannine Fiedler
Hans Günter Golinski
Boris Groys
Andreas Hapkemeyer
Barbara M. Henke
Martin Hentschel
Wulf Herzogenrath
Klaus Honnef
Petra Kirchberg
Mario Kramer
Rosalind E. Krauss
Heinz Liesbrock
Reinhold Mißelbeck
Gislind Nabakowski
Ulrich Pohlmann
Ursula Prinz
Peter-Cornell Richter
Luminita Sabau
Jutta Schütt
Paul Sztulman
Paul Virilio
Thomas Wagner
Peter Weiermair
Martina Weinhart
Thomas Wulffen
Armin Zweite

Edited by **Luminita Sabau**
with
Iris Cramer and
Petra Kirchberg

Essays by **Boris Groys**
Rosalind E. Krauss
and **Paul Virilio**

Prestel

Munich · London · New York

Foreword

When banks appear publicly as art sponsors, they arouse suspicions that they are acting purely to further their own interests. From what we hear, the conjectures raised assume one of two forms which are mutually exclusive. Nevertheless, if taken together, they round off the picture the public has of the motives underlying banks' art-sponsoring activities. First, banks as sponsors are assumed to view their commitment, in this case the acquisition and collection of art objects, as a form of diversification of assets and as capital investments. Second, from seeming committed to the public interest, banks are thought to profit from the good publicity thus achieved, which today is obligatory in any commercial dealings with the general public.

Fortunately, we can claim that both reservations about banks' sponsoring art are unjustified in the general sense. Considered from a more sophisticated standpoint, however, they are founded in fact. The collection of contemporary photography which we have been putting together since 1993 has, of course, appreciated in value since then. In fact, it has yielded much higher interest than would have been possible for even those capital investments made on the advice of leading investment experts on the financial markets. Viewed in this way, our commitment to art has paid off handsomely, even though the total value of what has grown to be a collection comprising 3,000 objects is rather modest compared to our balance achieved in conventional assets.

Our commitment to art both inside and outside the framework of banking has also definitely paid substantial symbolic dividends. Domestic success has been achieved because our acquisitions policy has, from the beginning, been twofold. On the one hand, there has been the architectural aspect of giving aesthetic form to our headquarters. On the other, we have consistently consulted our employees in the aesthetic process. This dual approach has, in turn, entailed promoting their affinity with art in a hands-on school of seeing which, in the broader sense, affects the way they view the world at large. To this end, projects have been realized with artists of international standing, and the objects which have emerged from this collaboration in all respects bear comparison with their best known work.

At the same time, we are well aware of how important the image we project to the public is. We are indeed fortunate in the response to our undertaking we have had from art historians and curators. Consequently, our collection has been much in demand with experts on the cutting edge of exhibition policy. Further, we are delighted that the accessibility of the exhibits in our headquarters has meant that the interest evinced by visitors, both business associates and art lovers, has grown by leaps and bounds. And we are overjoyed at the increasing number of visitors to all the exhibitions we have sponsored. Whether or not the exhibits in them are drawn primarily from our collection, all the exhibitions we have sponsored are interrelated and informed by the same spirit which has motivated our acquisitions policy. For these reasons, we feel that our decision to sponsor art photography, a relatively new medium, has been the right one for the contemporary scene.

From the outset, the collection has been conceived with a view to transparency. Now that a selection of photographs from our collection comprising the work of over one hundred artists is going around the world, we are living up to what we have always claimed as our priority. As the fruit of our first five years of collecting art photography, the exhibition sums up our commitment to a work still in progress. Our collecting activity, like our commitment to exhibitions, is not primarily directed to what has been in the past years but to what will be in the years to come, in short, to looking forward. Both our acquisitions and our exhibition policies may be credited to the future as an investment in what we can expect to be the focus of future interest in art.

We would like to thank all those whose commitment, goodwill, and expertise have made possible this exhibition, the interim balance of our activity in the field of collecting and sponsoring art photography.

The Board of Directors
DG BANK
Deutsche Genossenschaftsbank
Aktiengesellschaft
Frankfurt a. M.

Contents

Introduction

5 **Foreword**

9 **Luminita Sabau**
 On the DG BANK Collection

12 **Christian Caujolle**
 A Visit

Essays

19 **Paul Virilio**
 Photo Finish

25 **Boris Groys**
 The Promise of Photography

33 **Rosalind E. Krauss**
 Reinventing "Photography"

44 – 345 **Artists**

Appendix

348 **List of Works**
355 **Biographies**

Artists

44	**Adams** Dennis	146	**Graham** Dan
48	**Appelt** Dieter	148	**Graham** Rodney
50	**Araki** Nobuyoshi	150	**Grauerholz** Angela
54	**Arden** Roy	152	**Grčić** Tamara
56	**Baldessari** John	154	**Gursky** Andreas
60	**Baltz** Lewis	156	**Hanzlová** Jitka
62	**Barry** Robert	158	**Hartley** Alex
66	**Basilico** Gabriele	160	**Häusser** Robert
68	**Bayrle** Thomas	162	**Helnwein** Gottfried
70	**Becher** Bernd and Hilla	166	**Henning** Anton
72	**Beckley** Bill	168	**Henson** Bill
74	**Bergemann** Sibylle	170	**Hershman** Lynn
76	**Beuys** Joseph	172	**Hilliard** John
78	**Blume** Anna and Bernhard	174	**Hockney** David
80	**Boltanski** Christian	176	**Höfer** Candida
82	**Bonvie** Rudolf	178	**Hoover** Nan
84	**Brus** Johannes	180	**Horsfield** Craigie
86	**Bustamante** Jean-Marc	182	**Hutchinson** Peter
88	**Chamberlain** John	184	**Hütte** Axel
92	**Clegg & Guttmann**	186	**Iturbide** Graciela
94	**Close** Chuck	188	**Jacobson** Bill
96	**Collins** Hannah	190	**Jetelová** Magdalena
98	**Cooper** Thomas Joshua	192	**Jin Ming** DoDo
100	**Corbljn** Anton	194	**Kabakov** Ilya
102	**Cravo Neto** Mario	198	**Keetman** Peter
104	**Defraoui** Silvie & Chérif	200	**Klauke** Jürgen
106	**Demand** Thomas	202	**Klein** Astrid
108	**diCorcia** Philip-Lorca	204	**Klemm** Barbara
110	**Dine** Jim	206	**Knoebel** Imi
112	**Donzelli** Pietro	208	**Kruger** Barbara
114	**Eggleston** William	210	**Kulik** Zofia
118	**Export** Valie	212	**Lafont** Suzanne
120	**Faucon** Bernard	214	**Lafontaine** Marie-Jo
122	**Fischer** Arno	216	**Lawler** Louise
124	**Florschuetz** Thomas	218	**Le Gac** Jean
126	**Fontcuberta** Joan	220	**Levine** Les
128	**Förg** Günther	222	**Levine** Sherrie
130	**François** Michel	224	**Levitt** Helen
132	**Gelpke** André	226	**Lissel** Edgar
134	**Gerlovina/Gerlovin**	228	**Lüscher** Ingeborg
136	**Gerz** Jochen	230	**Lüthi** Urs
138	**Giacomelli** Mario	232	**Mapplethorpe** Robert
140	**Gibson** Ralph	234	**Mayer** Maix
142	**Gilbert & George**	236	**McBride** Will
144	**Goldin** Nan	238	**Merkel** Florian

240	**Miller** John
242	**Moffatt** Tracey
244	**Müller-Pohle** Andreas
246	**Muñoz** Isabel
248	**Neusüss** Floris M.
250	**Niedermayr** Walter
252	**Orlopp** Detlef
254	**Orozco** Gabriel
256	**Poirier** Anne and Patrick
258	**Polke** Sigmar
260	**Prince** Richard
264	**Prinz** Bernhard
266	**Rainer** Arnulf
268	**Rambow** Inge
270	**Rauschenberg** Robert
274	**Rheims** Bettina
276	**Richon** Olivier
278	**Richter** Evelyn
280	**Richter** Gerhard
284	**Rinke** Klaus
286	**Rio Branco** Miguel
288	**Roehr** Peter
290	**Rosenbach** Ulrike
292	**Rousse** Georges
294	**Ruff** Thomas
298	**Salgado** Sebastião
300	**Sasse** Jörg
302	**Schmidt** Michael
304	**Scully** Sean
306	**Sherman** Cindy
310	**Shore** Stephen
312	**Sieverding** Katharina
316	**Simpson** Lorna
318	**Štrba** Annelies
320	**Streuli** Beat
322	**Struth** Thomas
324	**Sugimoto** Hiroshi
326	**Tillmans** Wolfgang
328	**Turrell** James
330	**Uecker** Günther/**Schroeter** Rolf
332	**Vostell** Wolf
334	**Warhol** Andy
338	**Waters** John
340	**Wegman** William
344	**Wittenborn** Rainer

On the DG BANK Collection

A collection always constitutes an allegorical portrait of collectors themselves. It reflects their preferences, tracing their voyage of discovery through art. Although the DG BANK Collection is a "corporate collection," it does not, however, represent a collective portrait. Instead, it has grown around the ideal of service to those who respond to it and not as a reflection of or on them. Each work in the exhibition is based on one before it, thus representing a step forward on the didactic path to conveying what art is. Each group of works and each artist taken into the collection are interrelated, forming the building-blocks of this collective approach to art. The didactic discourse is not the only one; there is a theoretical objective, the attempt at investigating a fundamental tenet of Modernism with new means. This is the hypothesis that art and life do not represent a contradiction in terms. Thus, the collection has also become a record of experimentally testing this hypothesis, which is based on the hope that, particularly in the specific context of modern working life, aesthetic experience is possible and can inspire one to reflect on non-aesthetic practices, to perceive them differently and to transform them.

Why photography?
We have focussed our acquisitions policy on the medium of photography as an integral part of contemporary art for many reasons. First, photography was the first visual mass medium (Paul Virilio) and is the key to all technical generation of images. More than any other visual idiom, photography has shaped both the collective and the individual memory of our times. Photographs are the images that stand for the historic events of our century. Also, the personal histories of individuals are captured in photo albums. Referring to Walter Benjamin, Rosalind Krauss speaks of "photography's hooking into the cognitive powers of childhood." Intensive preoccupation with the photographic image in the context of contemporary art is a response to the ubiquity of this medium in our lives. The fundamental importance of photography is no longer even noticed in science, technology, and industry, yet it pervades our very culture, which makes a cult of the photograph. The triumphal entry of the virtual into many areas of our lives has stirred up our yearning for a reliable view of the world. One can depend on truth. And, for historic reasons, photography has been credited with great veracity. Thus, photography has made it possible

for us to approach reality where it has already been imaged. Moreover, the great popularity that photography enjoys today can be viewed as a response to the ever increasing pace of our times, for photography conveys, more than any other art medium, a feeling that the time which has been recorded in photographic pictures can be captured in its essence. In concentrating on a single picture, one can evade the images flooding us. Viewed in this light, our decision to devote ourselves to photography as a contemporary art medium also represents an attempt at establishing a criterion for ordering the visual white noise which, according to Virilio, informs the general disposition of perception.

In addition, photography has long since become emancipated from its original documentary purpose. Contemporary studies on nineteenth and twentieth-century painting furnish impressive proof that photography itself has become the point of departure and inspiration for the creative process. Boris Groys, for instance, comes to the conclusion that: "In retrospect we can perhaps say that the slow transition from the painted to the photographic image was the true art event of this century." In contemporary art, photography has become less pragmatically technical and more creatively poetic, that is, a process rather than a medium. Moreover, the focus of this collection on the photographic image in all its diversity allows us to sharpen the way we view the variety of developments in contemporary art. In focussing on photography, we are documenting the interrelationship of genres in contemporary art and the further development of painting with the means offered by photography.

Last but not least, our decision for this medium represented, in the early 1990s, a marketing strategy of great weight in the broader context of cultural commitment. The importance of photography within the framework of contemporary art offered us the necessary potential for diversifying our young collection.

The structure of the collection
It is essential for our collection, as a young corporate collection, to be aware of our own limits. Regardless of Groys' perspective, which embraces an entire century, and the particular role played by the photographic image in art since the 1960s (known as "getting out of the picture"), which Rosalind Krauss describes in her contribution to this publication, this collection is limited to work which is acutely contemporary

A Visit

Having access to a private collection is a privilege. A rare privilege. For various reasons, most owners of collections on a grand scale are, in fact, not at all forthcoming about the treasures they have amassed with such passion. A certain degree of obsession generally accompanies collecting. There are, of course, exceptions which only confirm the rule and, fortunately, many collectors are willing to lend their collections. They rarely, however, open their doors and give one free access to the precious quarry they have hunted down. That is why a visit permitted by a spirit of friendly cooperation to one of the most important contemporary collections of photography has been a gift beyond price. Fired up by excitement which was accompanied by real curiosity, I found the visit full of surprises.

One must distinguish between collections belonging to private individuals and those owned by institutions, public or private. What both categories of collections generally have in common is that they are invisible from outside. Lack of space permits the exhibition of only a small part of a private collection at once. The remaining inventory may be stored in cartons, drawers, boxes, and chests. The most important pieces are protected from light in vaults and even in warehouses where they cannot be viewed. Collections belonging to public or private institutions are essentially invisible. Only the offices of members of the Board of Directors and conference rooms used by top management have the privilege of displaying distinguished art objects.

Most of the time one spends studying a collection is occupied with opening boxes and portfolios and visiting vaults in the company of the collector – a ritual of collusion which underscores how exceptional the privilege is which one has the honor of enjoying. And the situation is not much different when one has access to the magazines of museums which, as is well known, contain the bulk of works in public collections. The public which finances such collections has, at best, only very limited access to them. But that is a different story altogether, even if it does have some bearing on the complex matter at hand and has inspired some thoughts on it.

The first surprise when one has been granted access to the DG BANK Collection is that it is on view, every day and for everyone working at the Bank's headquarters, and under circumstances and placement which have been clearly thought out and make good sense. Hence a monumental piece[1] executed on the spot with the active and voluntary participation of some employees is exhibited in a place that everyone has to pass through, a corridor linking two buildings. Handing a vision of one's image – in which one has agreed to participate – to others is something not frequently encountered. An attitude like this says a lot about the respect felt for the artist's work – shown because it has been produced to be seen – and the respect felt by those who have willingly assumed the risk of letting themselves be portrayed. It opens up to everyone the possibility of making a work of art one's own, of identifying with the place where it is shown – in this case the daily workplace. It stems from a good understanding of what education is all about and from a form of respect – normal but rare – towards others. This attitude immediately exonerates an act of contemporary creativity from the so frequently encountered charge of elitism. As it confronts everyone alike, the work demands to be understood, questioned, and even criticized. The initial surprise of this encounter is repeated in multiple variations throughout the building. One is left rejoicing at the astonishing circumstance that this private collection should above all be concerned with the welfare of the public.

A visit to it, which gives unlimited food for thought, highlights two essentials, always respected here although they are generally overlooked by those both in the know and in power. First, there is the fact that hanging a work means having a sure sense of how to set about it, being aware that installing a particular work in a particular place, and not in another, is in itself significant. What stems from communal efforts, sustains a relationship, and generates a point of view is possibly a basis for reflection. To achieve this, one must always eschew the conventional notion of art – shared by the majority – that art must be pretty or beautiful, in a word, decorative. When walking through the corridors of the DG BANK, one cannot help but be struck by the fact that a work installed near a market hall raises questions which it would not have if it had been installed in the post office. And that works installed in the post office are in the right place there, because their color and their discourse refer to a play on fiction, history, and figuration. They are in a more natural

1 I have chosen not to mention artists by name in order to avoid subjecting the works themselves to commentary and entering on a "critical" discussion of what the collection contains. I would otherwise have been obliged to comment on them, which would have impeded this presentation and obscured what the visit meant.

state of osmosis with those who work there than with others, are more conceptual or encoded in a more complex manner. Sensitive attention paid to where to hang a work ensures that, from the outset, beholders are in a situation in which they do not simply appreciate the importance or relevance of the work concerned. They are also reading points of view which, often humorously, speak to us, not of Art with a capital "A" but of the function of the artist. One is quickly aware that the images which are there are the act of those artists who question the assumptions of our society. They are speaking of today and wondering about the whys and hows of the present situation. One also realizes very quickly that they are resisting prevailing conventions by virtue of the coherence of their language. One has the feeling that one is always being regarded as a responsible adult, being asked questions and invited to reflect. The whole collection is suffused with serenity and lightness. It is without dogmatism because the ways in which it is presented are novel, at times disconcerting. The presence of a hilariously funny canine alphabet in a room devoted to the most sophisticated communications technology weds smiles and pleasure. A stringent command in a conference hall questions the manner in which workplace hierarchies are organized. A video in a hall projected into the space where it was produced opens up readings of the abyss as well as curiosity at the casualness with which one passes on questioning the environment. The effect achieved when important pieces by important makers are involved makes one forget the market value of the objects exhibited. Instead, what is at stake in this discourse is underscored. Taken straight from the art market to be installed in a place where money reigns, these works of art on offer to all simply gamble on reflection. Clogged with contradictions, they retain only generosity of conception and the project's profound sense of accountability.

The second part of the "exhibition" in the building is different. Nevertheless, it is informed with considerations of a similar nature. This is an installation of ensembles in the corridors on each floor of the various departments. The works have been chosen from the collection by those who are going to encounter them on a daily basis. As a point of departure, this, too, is unique or, at least, again an all too rare occurrence. What happened was that employees with little or no knowledge of the contemporary art scene were asked to choose works with which they would live for one year. It is easy to imagine the good done by the discussions that this approach sparked off. At a time when reactionary talk of fraud and swindle being perpetrated by entire strata of the contemporary art scene is filling the papers, such percipience obliges employees to take stock of the nature and the meaning of the works in the collection amassed by the business that employs them, by asking what is interesting about them, indeed what is at stake here. It is hard to imagine a form of art education more suited to helping everyone develop taste, knowledge, and critical judgement about works of art chosen, of course, with discrimination and discernment. This way of making people take a stance, people who may feel they are not "competent" to do so, on choices made by "knowledgeable people" attests to the willingness to take risks. This means confronting art criticism head on and shows healthy humility, another rare commodity. The result has been quite spectacular. When going from one floor to another, one is invited to look at ensembles arranged as monographs and others which are thematically linked. One sees that the way artists view flowers differs strongly from continent to continent. Reporting in black-and-white yields to basic research on color in landscape or to sophisticated settings for texts in landscape. Walking through these corridors, one realizes they are not always the ideal place for hanging pictures. One of the collection's great strengths lies in the fact that it did not grow up around the accumulation of isolated works. Instead, it represents groupings of ensembles significant for each artist concerned.

With only a few exceptions due to the exigencies of particular media, the approach to choosing works for exhibition has perforce been "picky" about which of an artist's works have been selected. As a result, the thematically linked collections bear the imprint of the people who have assembled them, their interests, or even obsessions. Other collections are noticeably limited to particular artists, periods, or trends. When one considers how generously collecting has been funded, the DG BANK ensemble allows one to place each artist. Each individual work is, of course, anecdotal, whereas a whole allows one to distinguish the approach used. The fact that ensembles are always chosen clearly signifies that it is not enough to look at contemporary art, to appreciate it or place it in an ideational frame of aesthetic reference. On the contrary, contemporary art is intended to be read and understood because it has been made by artists as authors who have adopted a stance governing its internal coherence.

Noticing the importance of ensembles, one is soon aware of the logic underlying the structure of the collection. Unlike so many other collections – and this is not meant as a disparagement of their quality – this one is not merely an assemblage of "masterpieces." Of course, it contains no lack of them. It is

just that this one represents a corpus which resists unequivocal definition.

All collections are a reading of the objects constituting them. One knows "photography" collections, collections of "contemporary photography," of work by "artists who are photographers." Such collections perpetuate two traditions, both of them questionable. One is based on the alleged autonomy of "photography as an art," a corporatist vision of something "specific" which the medium claims of and for itself. The other is based on a pictorial approach to photography which, ultimately, would only be one of many historical manifestations of the fine arts – albeit one that utilizes unusual technologies – that is, visual arts written in capital letters. The DG BANK Collection is defined as a collection of photographs within contemporary art, not a collection of "photographs of contemporary art." That is what makes the big difference. The result is a unique ensemble. Its richness and diversity question the assumptions of the various currents of contemporary art and of the new medium of photography which is distinguished a priori by a unique relationship to time. The collection is not overly preoccupied with the established categories and conventions by which the various genres of photography are classified. At liberty to choose and acquire a work solely on the basis of its intrinsic quality and the coherence of its écriture, the collection bypasses such conventions. Documentary photographers working for the press in black-and-white are given equal billing in the collection with art-market stars who only work in huge formats and in color. This is so simply because the former are asking the right questions. And their approach makes sense in a collection which is only under one constraint: not to buy photographs which are not on a photographic support.

This position does not simply represent orientation. It is based on a "critical" standpoint – in the sense that the term is synonymous with analysis – on contemporary art. It affirms the importance of a medium with its own techniques, one that is new in the evolution of the aesthetic and the shaping of representation, a medium that has not yet been systematically studied in sufficient depth. This is a standpoint which rejects squeamish attitudinizing. Photography is not regarded as a mode of expression independent of other currents of contemporary art. Ours is a conventional age. The laws of the marketplace have established links to galleries, museums, critics, and collectors alike, often solely for financial reasons. The DG BANK Collection, on the other hand, asks whether it has become necessary to rewrite the history of art since the invention of photography, and it is asking this question in a

refreshingly forthright manner. The important ensemble that has already grown up around this standpoint questions our assumptions on the interaction between painting, cinema, music, literature, sculpture, and photography. It tells us that certain individuals living in a stereotyped age are expressing themselves visually. They have put into their work the complex interrelationship between sensitivity, emotion, and sense of form, as well as their questioning and need to clarify their standpoint and distinguish their way of viewing the world from that of their contemporaries. Their standpoint is based purely and simply on stating what should be a self-evident truth: photography is one of today's modes of expression. That's all there is to it. It seems, however, that their self-evident truths are not the ones most of the world shares. All collections are based on choice, choices which entertain a dialogue with the succession of choices ending, as far as the artist is concerned, with the production of work. Choosing means excluding. I have already mentioned how greatly the collection which everyone cruises past in the corridors of the headquarters of a large bank eschews the decorative. Purely in its capacity as technology, photography is unique in permitting the rapid realization of a great number of pictures. Thus, the collector must choose ensembles which reveal the relevance of their premise from within œuvres which are often multiform. Always. Choice is guided, as is so often the case with private collectors, by the simple affirmation of "liking" that work. The collector's choice is obviously guided by a profound awareness of what is at stake behind the pictures and their fragility. Walking through the exhibition, one observes with pleasure how major artists as authors, whom one would say were "under an obligation," clarify in their work where they stand on the issues of the art market and museums as institutions. The DG BANK Collection has chosen atypical work. Works derive their meaning from within the collection itself or from the possibilities they offer of being installed in particular spaces where they will be in a situation to question. That is where photography stands in contemporary art. Rigorous, free, contemplative and enthusiastic, detached from the conventions and forces of the marketplace, a collection is offering itself up to you as a handsome affirmation of both decisiveness and humility, of understanding for artists and their need to show commitment. The collection sketches a vision of contemporary art. It utilizes photography because this medium consciously ignores the official history of art so that it can concentrate on authentic values developed by artists working in apparently contradictory aesthetic movements. This approach has

rendered the collection capable of suggestion and reflection like no other. It confronts the crisis in representation by simply suggesting that dialogue should be conducted on the world via structured yet variegated discourse. And, should the future pass or bypass this dialogue?

A collection is also the portrait of whatever it contains and of whoever happens to compose and develop it. Both during and after a visit to this one, I could not help thinking how reassuring this involuntary portrait of a distinctive and volitional personality was. It has the advantage of never being deceptive, of taking the risk of possible disagreement, and of taking on choice.

This collection is in part going to transcend its natural bounds by virtue of its commitment to looking outwards as a logical consequence of the principle of generosity on which it is based. It will permit spectators to discover that they love particular works and artists. They will discuss them and share in them. But the very readability and outward-directedness of the collection will be challenged by the places which will welcome it. Often they will be the standard venues of contemporary art. Will it be possible, therefore, to recapture the feeling one experiences when visiting the collection as it is presented in the corridors and spaces of the Bank headquarters? This seems like a difficult proposition. And, after all, being granted access to a private collection remains something of a privilege ...

On leaving the DG BANK Building, the further I was from the works I had discovered and been enthusiastic about, all I could think of was how best to define two adjectives: accountable and generous. And I said to myself that, unlike what one often tends to think of collectors, sometimes they do indeed merit these two accolades.

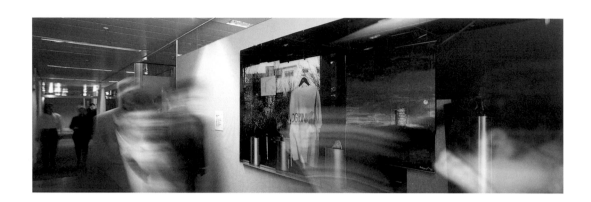

Essays

Photo Finish

"Art is in much more than a crisis. For the time being at least, art is a value that has ended its existence," declared Giulio Carlo Argan shortly before passing away.

The key phrase in this quotation is, of course, "for the time being." The Roman art historian is not announcing the end of art, as Francis Fukuyama recently announced the end of history, but is indicating an interruption, a pause in modern representation.

"I think," Argan continued, "that art is the metaphor of death, which gives existence its savor, its character, and its value. In our mental systems, death is something hypothetical, and I believe that that may provide this idea of the 'death of art' as a necessary metaphor for thought."[1]

Photography in fact seems to me to be the symptom of this bracketing of art, a sort of sudden substitution; the photograph has never been an imitation or a simulation, but a phenomenon substituting for the overall corpus of contemporary representations.

A question of terminology nevertheless arises: is photography the clinical symptom of the end of art, or the origin of the art of the end of art? Is it the art of the end or, more precisely still, the freeze frame of a sudden mechanization of all representation? Or perhaps it is an indication of the new importance of time in the space of representations.

Obviously, representation is not to be understood here in the ordinary sense of a mental portrayal of an absent object or even as a simple metaphor. Representation means: that which makes present. Hence the ambiguity over recently developed technologies involving visual and auditory representation, but equally around the very term "representation" today.

In fact, a photograph is not the representation of an absent object, but of an object present for a brief moment of time in front of the camera lens, the iconic proof of its passage: the transit, or passage of the image, that confirms its concrete presence, here and now, before the viewer.

Thus, photography makes present the act of passage itself; the object passed this way along its path.

The photostatic objectivity of the photo is thus nothing more than the photodynamic imprint of its "trajectivity," in other words, the photosensitive character of its presence in the world – a cinematic character usually overshadowed by the importance given in philosophy to subject and object, to the detriment of path.

If one accepts the above premises, the depth of time of passage becomes prominent by comparison with the depth of space of the classic image – this unnoticed event when the perspective of the fifteenth century is superceded by that of photography, and shortly afterwards by cinematography.

All photography is therefore a photo finish, the recording of the arrival of the end of a path that is generally unknown to viewers.

It is here that photography foresees not merely the seventh art – cinematography, which incorporates all the other arts – but the end of art, a once contemporary art of the space and time of all the others.

But let us avoid any misunderstandings and repeat one more time: this is not the announcement of the disappearance of the plastic arts, but only the emergence of an aesthetic of disappearance which, thanks to the instantaneity of photography, has come to dominate the aesthetic of appearance, the emergence over many centuries of a line, a mark, or sculpted volume and its ponderous mass.

A recent invention, linked to the rise of the digital image, corroborates this point of view. Following on from the photo finish, which is able to determine the winner of a race on the sports track, has not the "photo weigh-in" just been introduced? This is a method of calculating the weight of an animal immersed in its element, in the case of the dolphin, thanks to a series of mathematical equations applied to the animal's morphology. With the aid of this software, the marine mammal's volume is multiplied by its mean density to determine its weight. With a minimum of statistical approximation for the species, it is thus no longer necessary to approach the dolphin physically during its development in the sea. To find out about the health, and thus the capacity for survival, of the species in question, it will in the future be enough to have a digital photograph or, better still, a film.

Thus the speed of photography of the object on its path and the speed of calculation of the computer allow the subject to be weighed. The digitalized photo finish becomes a weighing machine for a marine mammal.

Here, the freeze frame is no longer solely the figuration, or representation, of the instant that has passed, but the assessment of the present mass of an entity, the freezing of its

1 Remarks collected by Alain Jaubert and Marc Perelman in 1991 and published in the magazine Urbanisme (July/August, 1997).

physiological density, the weight and dimensions of a living being in motion.

Fixed, animated, or calculated image: will photography to-morrow become the last figuration?

Will photoscopy replace scopic forms of representation? Will one day soon graphic illustrations yield to computer-gener-ated images? We should not forget that the electronic com-puter is about to give way to the photonic computer, which calculates at the speed of light.

These are the questions raised today as a result of the evolu-tion of art and contemporary techniques, the importance of which is illustrated in the catalogue raisonné of the DG BANK Collection.

In the beginning, photography is the revelation of light and the writing of shadow: this is Henry Fox Talbot's famous skia-graphia, emerging from the photosensitive plate and its chemical substrate.

Its movement, for there is already some in the fixed image, is that of the appearance of the negative and the development of the positive. But this movement on the spot of the photo should then be considered with that of the succession of the photographs themselves.

With these two types of movement of the fixed image, one should also assess that of the speed of photography, then of its growing acceleration up to the crucial introduction of the snapshot, which will permit the inauguration of cinemato-graphic art.

Starting from this last development, the art of photography gradually loses its photostatic character. The fixed (and mute) image appears like a break, an interruption, in the phases of a sequential movement that everyone imagines.

In fact, let us recall that there are no optical images (and therefore no graphic or photographic ones) without mental images.

With the experiences of the perceptive modern mentality thus complementing those of the binocular vision of relief and movement, early photography gives way to the freeze frame, to this idea that a single shot is never more than a weakness, a handicap of vision, the remains of a sequence imagined by the viewer.

Talented photographers do not remain unaware of this cine-matographic dimension of the fixed image for long. Ad-vances in the mechanization of equipment and the expansion of cinematographic dynamism soon overturn the very con-cept of photography, to make of it, following the model of statuary, an apology for inertia, worse, for the brutality of

temporal freezing – in a word, an accident of photosensitivity and its customary light.

From then on, the dynamism of the hidden but nevertheless imagined sequence contaminates the freezing of the photo, which the boom in stroboscopic and sports photography of the thirties makes even more obvious.

It is ultimately in this sudden disengagement from the freeze frame that contemporary photography finds its originality, a cinematic originality that soon surpasses the limits of the photostatic.

Let us now try to analyze this iconic disruption of modern representation.

First of all, with the growing importance of collage and pho-tomontage arising from Cubism, then with the role accorded to the serial nature of the contact plate, and finally with the primacy given to the polemical documentary illustration of certain works both artistic and political,[2] an art of photo-graphic cutting and montage emerges which can bear com-parison with that in the cinéma vérité of someone like Dziga Vertov.

With the end of the illustrations in rows of the photo novel, appropriate to the linear character of a narrative, we witness the elimination of chronological order.

The choice of a systemic tilting of the composition, and the brutal telescoping of the planes therefore cannot help but recall the beginnings of the famous montage cuts of, for instance, Sergei Eisenstein or Jacques Tourneur.

So many breaks in emotion which soon mark the end of pho-toscopic statics and the freeing of photodynamism in the contemporary image, and of aerodynamics in vehicles, as well as aerostatism in some modern architecture, for exam-ple that of Erich Mendelsohn.

But a completely different type of optical movement is emerging from advances in the photographic lens itself, with the crucial invention of the telescopic lens and its expansion of the scopic horizon.

Since it is not possible to make further progress with the lat-eral procession of photographic images – following the mod-el of the cinematographic sequence – the zoom introduces a telescopic magnifying effect which is soon used and abused by press photographers to eliminate what is near at hand and pick out figures in the distance.

The freeze frame, devoid of linear narrative, then establishes the thickening of the spatial volume of the representation by

2 For example, American Photographs by Walker Evans (1938) and An American Exodus by Dorothea Lange and Paul Taylor (1939).

telescoping the different horizons of the optical representation. This takes place at a period of history when electronic television is being developed in the United States by Vladimir Zworykin.

From the thirties and forties onwards there are therefore no more objective images: all images (animated or not) aim continuously to construct and deconstruct optical reality, on the basis of frontal distance, a kind of distancing of a reality that has become less objective than tele-objective.

Subsequently, after the end of the Second World War, it is no longer possible to consider the development of video art and its installations without recognizing the disproportionate importance of this depth of field which, with the new mass media, will turn our perceptions upside down at the end of the twentieth century.

Whether we are dealing with the fixed image of the earlier plates, the photostatic icon, or the photodynamic image of the Leica or Rolleiflex contact plate, the photographer's art is no longer that of the writing of shadow. It continues to free itself from its initial inertia to represent movement on the spot, to represent the living, the liveliness of displacement without displacement, the space of an instant.

From the unexpected originality of cropping to select facets of reality, to the special effects perfected ceaselessly thanks to advances made in (geometrical) optics and soon (undulatory) electronic optics, culminating in the invention of the synthesized imagery of computer graphics, photography never stops questioning its own immobility.

In the same way as a drawing, it organizes and reorganizes the movements of figures. Like graphic arts (graphism), "photographism" is thus a dynamic of the stability of the recording surfaces. It composes and decomposes the art of seeing, of looking.

If there is indeed an art where the viewer produces the work, as was Marcel Duchamp's hope, then it must be photography. Photostatic or dynamic, the photograph is to the animated image (from cinema via video to computer graphics) what a drawing is to a painting.

At the precise moment when everyone is desperately trying to save the phenomena of cinematography and videography in the face of foreseeable upheavals caused by radio, television, and multimedia, certain filmmakers, taking the line of Andrei Tarkovsky, claim that "If the cinema finds its way, this will be thanks to painting,"[3] thus repeating the

mistake made by pictorialism at the start of the century. Yet we should first understand that if the cinematism of the new image and sound technologies does eventually find its way at the end of this century, it will be thanks to photography – photography, this "art of line and shade" which resisted all color for such a long time before taking the plunge, but which today again finds itself at the center, the epicenter, of an iconographic maelstrom. This is because shortly, in ten years at the most, analog representation of figures will give way to digital representation, the calculated image of electron optics finally dominating the filmed image of geometrical optics.

The time of chronological succession and the linear narrative of events and of history is today being replaced by chronoscopic exposure time, which emerged long ago from Nicéphore Niepce's Pandora's box.

Configured to the speed of passage of phenomena, electro-optical transfiguration no longer allows real forms to have their proper time – this local time which thus yields its historical supremacy to the global time of computer teletechnologies, to such an extent that the real time of the instantaneity of telecommunications is prevailing over the deferred time of classic communications; the chronological order of facts has yielded its age-old importance to the chronoscopic order of multimedia imagery.

In much the same way as the introduction of the snapshot paved the way for the appearance of the cinematographic sequence, transmission of the video-recording in real time is turning all our modern modes of representation upside down. Suddenly, the real time of the video image is gaining the upper hand over the deferred-time image of the photo.

This reversal of priority is moreover general since, with the space of virtual reality, it affects all actions (economical, political), and since DIRECT LIVE is becoming the reference time of globalization, the single time of the networks' cybernetic space.

From this point on, exposure time is at the heart of all activity, or rather, of all interactivity, and it has ousted the former time of classic historical succession. It is therefore in relationship to time and to the instantaneous speed of transmission and reception that the status of any representation is organized today.

This is also true of the art of the end, a motor art caused by the permanence of the instantaneity of a present which dominates the past, but also the future – whence the setting aside of the very concept of "re-presentation" and the advent of a

3 Alexandre Sokourov, filmmaker and director of Mère et fils, in an interview in the weekly Telerama in 1998.

pure and simple "presentation" which prolongs the fixity of the photo, the inertia of photography, the famous "Don't move!" of portraitists at the beginning of the century.

Chronoscopic exposure (underexposure, exposure, overexposure) is currently replacing chronological succession (past, present, future), and photography is suddenly regaining its importance, since the invention of the latter is essentially that of the frozen figural instant.

The visual exposure of the photographic present of the snapshot is thus at the origin of the real-time audiovisual exposure of video-computer graphic instantaneity.

It is impossible, then, not to guess the new role of inertia in this chronoscopic presentation of facts that is suddenly interfering with the chronological presentation of the things around us: real-space inertia of the fixed image, on the one hand, and real-time inertia of the animated image, on the other.

The fixity of the permanent present therefore tends to prevail not merely over that of the daguerreotype image, for instance, but also over the linear succession of history and its narrative.

The motor art of the electro-optical camera thus meets up again with that of the optical camera, but this time it is time which is frozen in direct-live instantaneity and no longer the space of the snapshot.

The figures move, are animated certainly; the space of the bodies changes its shape at will, but time no longer passes; it is content to be exposed indefinitely. What remains is the eternal media present of a unique, universal time, a global time which dominates the specific times of the different countries' zones, the local time which once knew how to make history.

An announcement of the passage from history to post-history, the snapshot thus foreshadowed a century ago the boom in real-time technologies, the transmission of live coverage in the era of contemporary cybernetics.

How can we not guess the reason for the new artistic attitudes, the "photosophical" dimension of some of the works presented in this catalogue?

The classic cut of the photo still has been joined, in fact, by that of the videogram and its texture, this fragmentation of successive time which no longer benefits anything but the present live sequence, this surprise of shot that finally nullifies all shot taking.

Intensity of the instant, acceleration not just of history as before, but of reality itself ... how can we not foretell the next mutation of reality? The split taking place in front of our eyes between the actual reality of a subject, an object, and the virtual reality of the instant path of images and sounds. In fact, a striking relief effect is being revealed in our time, and this effect of reality is perceptible everywhere: in art, as in contemporary politics.

Whereas the real-space perspective of the fifteenth century inaugurated the volumetric relief of earlier figures, the real-time perspective of the twentieth century is installing a chronometric relief which surpasses all classical representations.

Based on the example of stereoscopy, or better still the low and high notes of stereophony, we are witnessing the beginnings of a sort of stereo-reality, whose field effect results from the juxtaposition of the concrete volume of things or beings (low notes) and the discrete volume (high notes) of what is instantaneously conveyed over distance, to the point that the extent of the object or subject's real space is suddenly amplified by the real time of their transmission.

But this virtual thickness of the stereo-reality of telecommunications media will soon augment the volume of actual reality, provoking a kind of exoticism of a new type that is allied to the devastating effects of the loss of a sense of reality for viewers to whom the concrete reality of things is becoming less objective than tele-objective. From the nearest to the most distant, from the familiar to the strange, everything is becoming surprising, exotic to the point of excess.

Formerly discontinuous television programs are thus giving way to the random character of continual telesurveillance of everybody's activities, following the LIVE.CAMERA.ON.LINE examples installed recently on the Internet.

But let us return to that freeze frame which symbolizes the end of the plastic arts, but also the start of those moving arts for which the English term is "motion pictures."

If all photography is indeed the halting of a hidden sequence, a stop of imagery in progress, between the object aimed at and the fixity of the snapshot, then aesthetic privilege belongs to the path, to that movement of actualization that allows passage from one to the other, a movement which constitutes if not the truth then at least the topicality of both.

This movement on the spot consists of the operation of mediation, or rather "intermediation," and photography may therefore legitimately be recognized as the first of the VISUAL.MASS.MEDIA, notably with the proliferation of postcards.

Linked to the development of the tour circuit, or more accurately, the first guided tours at the beginning of the twentieth century, the postcard is another type of photo finish.

It is, moreover, highly revealing to find this exotic object present again today with the growth in multimedia, this time not thanks to the snapshot technique but to the revolutionary real-time technique of on-line transmission through computer networks.

On an Argentinian Internet site, Tour of the World in 80 Places, a click is all it takes to get you from, say, a town on the cape to the harborfront at Hong Kong, or to the Berlin Zoo. The creators of the site explain: "This tour of the world does not claim to be anything other than a bridge between your curiosity and an assortment of living postcards of our planet."[4] At this site, therefore, photos taken in all corners of the world by webcam, which automatically film the same place at regular intervals, twenty-four hours a day and seven days a week, are displayed in real time.

The Argentinian site offers virtual visitors the bonus of organized tours to skim Asia in a few minutes, from Tokyo to Jakarta, or perhaps to drop in on the port of San Francisco.

The film is no longer that of the traditional tourist documentary, but the live passing of a global landscape accessible thanks to automatic surveillance cameras from the network of networks: permanent telesurveillance which can equally well be directed at people who choose to overexpose their daily intimacies to voyeuristically inclined Internet users.

In this same real-time perspective, American artists display graffiti and tags photographed in more than eighty cities on three continents. Called Art Crime, this virtual gallery also has a network of correspondents who supply it regularly with digitalized photographs.[5]

Here, photographic overexposure dominates the graphic display of works. After the dislocation of figural forms in the past (from Cubism to Deconstructivism) we are now witnessing the delocalization of the painted work, in a "bringing to light" which is, above all, a setting at absolute speed. Thanks to cybernetic performances on the Internet, the real-time light of the photodynamic work is supplied to the real-space lighting of photostatic figures by the rays of the sun or by electricity. If hyperrealism is to photography what pictorialism was to painting, the symptom of the arrival of the end not just of the graphic (plastic) arts but also of photographism, here the virtual-space stereo-realism of the computer networks confirms the interruption of present-day art (announced by Giulio Carlo Argan) in favor of virtual art, the value of which cannot yet be assessed.

4 Le Monde, Internet column, Francis Pisani, January 14, 1998.
5 Le Monde, Internet column, Yves Eudes, January 14, 1998.

In this sense, photoscopy is indeed the aesthetic equivalent of drawing, of this line, this path, which gives plastic significance to the surfaces and the volume of representations of the world.

"I hate movement that displaces lines," declared a painter a century ago – but how can one love a silhouette and hate the vivacity which animates it? How can one not grasp that what is essential is the liveliness, the speed of a living subject? Is not all photography evidence of a gesture, the test of sight? Objectivity, subjectivity. At this end of a century that has seen a revolution in all forms of transport, all imaginable modes of transmission, how can we not dare to use the neologism "trajectivity"?

Finally, is it not strange that the technique of surface photosensitivity freed itself so quickly from the attraction of radiation physics – as was the case with Nicéphore Niepce's heliography – only to attach itself all the more firmly to the chemical dimension of supports and their industrialization? A chemical, mechanical image, the original photo was, it seems to me, even more an optical instrument, a new tool for experimenting with perception, capable of participating more closely in the future overthrow of the vision of the world, quite independent from the rise in scientific cinematography.

Even if the growing sensitivity of film has kept pace with advances in camera lenses and increasingly rapid shutter mechanisms, one can no longer deny that the mechanical and purely optical technologies of recording cameras has finally given them the edge over chemical improvement of the supports for recording the image (plates or film) – to the extent that, with the invention of magnetic tape and, especially, the computer disk, film is on its way out.

In conclusion, let us again point out that the "crisis" Argan referred to which we have touched on in this essay affects not just contemporary art but all images, and hence all representation.

Dislocated by the fractal geometrization of computer science and delocalized by its instantaneous transmission from one end of our planet to the other, figuration has lost – with the hic et nunc – its spatio-temporal landmarks and suddenly has turned into transfiguration.

A skillful zapper, the virtual visitor is no longer a real viewer. He no longer produces any work and is happy to navigate on sight in an ocean of electromagnetic radiation generating optical illusions of all kinds, where the splitting of concrete reality favors the sudden, untimely appearance of specters – clones, avatars, discrete figures of a morphological split

Reinventing "Photography"

This essay is about looking back: looking back at the path that led to the triumphant postwar convergence of art and photography that began in the 1960s, but looking at it from that moment at the end of the century when this "triumph" must be bracketed by the circumstance that now photography can only be viewed through the undeniable fact of its own obsolescence.[1] It is also about looking back at the theorization of this aesthetic convergence in the hands of all those post-structuralist writers who were themselves considering the historical reach of its operations by looking back at Walter Benjamin's announcement of its effect in his "Work of Art in the Age of Mechanical Reproduction." It will be significant, furthermore, that although Benjamin's text was interpreted in the thrust of its predictive and positive orientation to the future, his own favorite posture was that of looking back, whether in imitation of the Surrealists' connection to the outmoded discards of recent history, or in the guise of Klee's Angelus Novus, who greets historical progress only by looking backwards at the storm of its destruction.

Several strands braid together, then. The first could be called photography's emergence as a theoretical object. The second could be identified as photography's destruction of the conditions of the aesthetic medium in a transformative operation that would affect all the arts. The third – since it is a braid – could be named the relationship between obsolescence and the redemptive possibilities enfolded within the outmoded itself.

Whether it was as the prime example of Roland Barthes' mythology or of Jean Baudrillard's simulacrum, by the 1960s

photography had left behind its identity as a historical or an aesthetic object, to become a theoretical object instead. The perfect instance of a multiple-without-an-original, the photograph – in its structural status as copy – marked the site of so many ontological cave-ins. The burgeoning of the copy not only facilitated the quotation of the original but it splintered the supposed unity of the original "itself" into nothing but a series of quotations. And, in the place of what was formerly an author, the operator of these quotes, in being redefined as pasticheur, was repositioned to the other side of the copybook to join, schizophrenically, the mass of its readers. Barthes, in particular, was further interested in the structural irony that would allow photography, this wrecker of unitary being, to perform the semiological sleight-of-hand, whereby in the seamlessness of its physical surface the photograph seemed to summon forth the great guarantor of unity – raw nature, in all its presumed wholeness and continuity – to cover the tracks of photography's own citational operations. Its participation in the structure of the trace, the index, the stencil, made photography thus the theoretical object through which to explore the reinvention of nature as "myth," the cultural production of it as a mask behind which the operations of history and of politics could be kept out of sight.[2]

In Baudrillard's hands, this mask became the model of a final disappearance through which the object-conditions of a material world of production would be replaced by the simulacral network of their reproductions, so many images peeled off the surfaces of things to enter the circuit of commodities in their own right. If in an earlier version of commodity culture the mobility of exchange-value relentlessly replaces the embeddedness of use-value, in its latest manifestation, then, both of these yield to the phantasmagoria of Spectacle in which the commodity has become image only, thus instituting the imperious reign of pure sign-exchange.[3] But photography's emergence as a theoretical object had already occurred at the hands of Benjamin in the years that elapsed between his "Little History of Photography" in 1931 and his more famous text of 1936.[4] In 1931 Benjamin is still interested in the history of photography, which is to say in photography as a medium with its own traditions and its own fate. He believes the genius of the medium to be the endering of the human subject woven into the network of its social relations. Stamped on the photographic portraits made during the first decade of the medium's existence was

1 Art and photography first converged in the 1920s, in Soviet photomontage practices and in Dada and then Surrealist integration of photography into the very heart of their movements. In this sense the postwar phenomenon is a reconvergence, although it was the first to affect the market for "high art" itself in a significant way.
2 Roland Barthes, Mythologies (Paris: Seuil, 1957). Barthes's theorizations of photography include "The Photographic Message," "Rhetoric of the Image," and "The Third Meaning," in Image/Music/Text, trans. Stephen Heath (New York: Hill & Wang, 1977) and Camera Lucida, trans. Richard Howard (New York: Hill & Wang, 1981).
3 Jean Baudrillard, For a Critique of the Political Economy of the Sign, trans. Charles Levin (Saint Louis: Telos Press, 1981).
4 The "Little History of Photography" was published in Literarische Welt in the September and October issues of 1931. Benjamin wrote a first draft of "The Work of Art in the Age of Mechanical Reproduction" in the fall of 1935 (completing it in December). He began to revise it in January 1936 for publication in the French edition of the Zeitschrift für Sozialforschung (translated by Pierre Klossowski). Because the French version imposed various cuts in Benjamin's text, he reworked the essay again in German, this ultimate version to be published only in 1957.

the aura of both a human nature settling into its own specificity due to the length of the pose and a social nexus exposed in terms of the intimacy of its relationships due to the amateur status of these early practitioners (Hill, Cameron, Hugo) making portrait pictures for their circle of friends. Even in the early stages of photography's commodification, after the spread of the commercialized carte-de-visite, the celebration of photography's inherent technical possibilities meant that precision lenses would marry the confidence of a rising bourgeois class to the technological prowess of a new medium.

The "decadence" that was soon to engulf this medium was thus not just due to its having yielded to the commodity but to that commodity's having been swallowed by kitsch, which is to say, the fraudulent mask of art.[5] It is artiness that erodes both the aura of this humanity and its possessor's authority, as the gum-bichromate print and the accompanying penumbral lighting betray a social class under siege. Atget's response to this artiness is to pull the plug on the portrait altogether and to produce the urban setting voided of human presence thereby substituting, for the turn-of-the-century portrait's unconscious mise-en-scène of class murder, an eerily emptied "scene of the crime."

The point of Benjamin's "Little History" is, then, to welcome a contemporary return to the authenticity of photography's relation to the human subject.[6] This he sees occurring either in Soviet cinema's curiously intimate rendering of the anonymous subjects of a social collective or in August Sander's submission of the individual portrait to the archival pressures of serialization.[7] If he also deplores the photographer's benighted struggle to acquire aesthetic credentials "from the judgment-seat he has already overturned," this does not assume the radically deconstructive position Benjamin would take five years later, in which photography is not just claiming the specificity of its own (technologically-inflected) medium but, in denying the values of the aesthetic itself, will cashier the very idea of the independent medium, including that of photography.

In becoming a theoretical object, photography loses its specificity as a medium. Thus in "The Work of Art in the Age of Mechanical Reproduction," Benjamin charts a historical path from the shock effects courted by Futurism and Dada collage, to the shocks delivered by the unconscious optics revealed by photography, to the shock specific to the montage procedures of film-editing, a path that is now indifferent to the givens of a particular medium. It is as a theoretical object that photography assumes the revelatory power to set forth

the reasons for a wholesale transformation of art that will include itself in that same transformation.

The "Little History" had pictured the decay of the aura as a tendency within photography's own history; the "Work of Art" essay will now see the photographic – which is to say mechanical reproduction in all its modern, technological guises – as both source and symptom of a full-scale demise of this aura across all of culture, so that art itself, as celebrator of the unique and the authentic, will empty out completely. Its transformation will be absolute: "To an ever greater degree the work of art reproduced becomes the work of art designed for reproducibility," Benjamin states.[8]

The change that the theoretical object makes clear to Benjamin has two faces. One is in the field of the object where, through the structure of reproduction, serialized units are rendered equivalent – much as in the operations of statistics – with the result that things are now made more available, both in the sense of more proximate and more understandable, to the masses. But the other is in the field of the subject for whom a new type of perception operates, "a perception whose 'sense of the universal equality of things' has increased to such a degree that it extracts it even from a unique object by means of reproduction." Benjamin also describes this extraction as prying objects from their shells.

In an unpublished variant of one of the sections of his essay, Benjamin comments on the recent appearance of a theory of art focussed precisely on this perceptual act of prying objects from their contexts, which in and of itself can now be reinvested with aesthetic force. Referring to the position Marcel Duchamp elaborates in The Green Box, Benjamin summarizes it as follows: "Once an object is looked at by us as a work of art, it absolutely ceases its objective function. This is why contemporary man would prefer to feel the specific effect of the work of art in the experience of objects disengaged from their functional contexts [crossed out: torn from

5 Benjamin speaks of the "decadence of taste" that overwhelms photography by the 1880s.
6 Benjamin, writing after the 1929 stock market crash, comments: "It would not be surprising if the photographic practices that today, for the first time, recall this pre-industrial flowering were in subterranean relation with the crisis of industrial capitalism."
7 On the relation between Benjamin's analysis of Sander and the debates about photography engaged in by the Soviet avant-garde, see Benjamin Buchloh, "Residual Resemblance: Three Notes on the Ends of Portraiture," in Face-Off: The Portrait in Recent Art (Philadelphia: Institute of Contemporary Art, 1994).
8 Walter Benjamin, "The Work of Art in the Age of Mechanical Reproduction," in Illuminations, trans. Harry Zohn (New York: Schocken, 1969), p. 224. Hereafter citations will be in the text.

this context or thrown away] rather than with works nominated to play this role."[9]

Thus acknowledging the intersection between his own theoretical position and that of Duchamp, Benjamin's "work of art designed for reproducibility" is seen to have already been projected as the readymade; and the perceptual act that extracts "the sense of the universal equality of things," even from a unique object, is understood as that of the photographer framing pieces of the world through the camera's lens, whether he or she takes the picture or not. That this act alone is aesthetic means that an entire world of artistic technique and tradition drops away, not only the skill required to make the older forms of "works nominated to play this role" – painting, say, or sculpture – but also the technical skills of exposure, developing, and printing requisite to photography itself.

The triumphal convergence of art and photography which begins in the late 1960s is contemporary with the sudden explosion in the market for photography "itself." But, ironically, the institutions of art – museums, collectors, historians, critics – turn their attention to the specifically photographic medium at the very moment when photography enters artistic practice as a theoretical object, which is to say, as a tool for deconstructing that practice. For photography converges with art as a means of both enacting and documenting a fundamental transformation whereby the specificity of the individual medium is abandoned in favor of a practice focussed on what has to be called art-in-general, the generic character of art independent of a specific, traditional support.[10]

If Conceptual Art articulated this turn most overtly (Joseph Kosuth: "Being an artist now means to question the nature of art. If one is questioning the nature of painting, one cannot be questioning the nature of art.... That's because the word 'art' is general and the word 'painting' is specific. Painting is a kind of art."[11]) and one branch of its practice restricted the exploration of "the nature of art (in general)" to language –

thus avoiding the visual because it would be too specific – most of Conceptual Art had recourse to photography. There were, perhaps, two reasons for this. The first is that the art that Conceptual Art was interrogating remained visual, rather than, say, literary or musical, and photography was a way of adhering to the realm of the visual. But, second, its beauty was precisely that its way of remaining within this realm was itself non-specific. Photography was understood (and Benjamin once again was the first to pronounce it so) as deeply inimical to the idea of autonomy or specificity because of its own structural dependence upon a caption. Thus as heterogeneous from the outset – an always potential mixture of image and text – photography became the major tool for conducting an inquiry on the nature of art that never descends into specificity. Indeed, Jeff Wall writes of the importance of photoconceptualism that "many of Conceptual Art's essential achievements are either created in the form of photographs or are otherwise mediated by them."[12]

It is this inherently hybrid structure of photography that is recognized in one of the major gambits of photoconceptual practice when Dan Graham's Homes for America (1966) or Robert Smithson's Monuments of Passaic (1967) assume the guise of photojournalism, marrying written text to documentary-photographic illustration. This would become the model for many other types of photoconceptual work – from the self-imposed shooting assignments of Douglas Heubler or Bernd and Hilla Becher to the landscape reportages of Richard Long or the documentary pieces of Allan Sekula – as it would also be generative of a variety of narrative photo essays, from those by Victor Burgin or Martha Rosler to younger artists such as Sophie Calle. Its historical origins, as Wall points out, are to be found in the avant-garde's original embrace of photojournalism in the 1920s and 1930s as a way not only of opening fire on the idea of aesthetic autonomy so carefully preserved by "art photography" but of mobilizing the unexpected formal resources in the look of "non-art" contained in the haphazard spontaneity of the documentary photograph.

Indeed photography's mimetic capacity opens it effortlessly onto the general avant-garde practice of mimicry, of assuming the guise of whole ranges of non- or anti-art experience in order to critique the unexamined pretensions of high art. From Seurat's emulation of Art Nouveau posters to Pop Art's travesty of cheap advertising, a range of Modernist practice has mined the possibilities of turning imitation to its own use. And as the whole cohort of appropriation artists demonstrated in the 1980s, nothing is so inherently equipped for

9 Walter Benjamin, Ecrits français (Paris: Gallimard, 1991), pp. 179 – 80.
10 The theorization of the move from the specific to the generic which dominates artistic practice of the 1960s, although ultimately deriving from Duchamp, has occupied Thierry de Duve in essays such as "The Monochrome and the Blank Canvas," in Reconstructing Modernism, ed. Serge Guilbaut (Cambridge: MIT Press, 1990), pp. 244 – 310, and "Echoes of the Readymade: Critique of Pure Modernism," October, no. 70 (Fall 1994), pp. 61 – 97.
11 Joseph Kosuth, "Art after Philosophy I and II," Studio International (October and November 1969), reprinted in Idea Art, ed. Gregory Battcock (New York: Dutton, 1973), p. 79.
12 Jeff Wall, "'Marks of Indifference': Aspects of Photography in, or as, Conceptual Art," in Reconsidering the Object of Art: 1965 – 1975 (Los Angeles: Museum of Contemporary Art, 1995), p. 253.

this strategy of impersonation as the "mirror with a memory" that is photography.

If photoconceptualism chose, as its second strategic dimension, the mimicry not of photojournalism but of brutishly amateur photography, this was because, Wall further argues, the look of the utterly dumb, hapless picture, the image divested of any social or formal significance – indeed, stripped of any significance at all – thus, the photograph in which there is "nothing to look at," comes as close as photography can to the reflexive condition of a photograph about nothing but its maker's own persistence in continuing to produce something that, in its resistance to instrumentalization, its purposeful purposelessness, must be called art. A reflection thus on the concept of art itself, which as Duchamp had once put it can be seen as nothing more than the "impossibilité du fer" – his pun to announce the impossibility of making[13] – Ruscha's pointless gas stations or Los Angeles apartment buildings or Huebler's utterly artless duration pieces exploit the amateur's zero-point of style to move photography to the center of Conceptual Art.

Photography's apotheosis as a medium – which is to say its commercial, academic, museological success – comes just at the moment of its capacity to eclipse the very notion of a medium and to emerge as a theoretical (due to being heterogeneous) object. But in a second moment, not too historically distant from the first, this object will lose its deconstructive force by passing out of the field of social use and into the twilight zone of obsolescence. By the mid-1960s, the amateur's Brownie camera and drugstore print, which the photoconceptualist exploits in order to obtain the look of "no art," have yielded to a new phase of photo-consumerism in which, as Wall notes, "tourists and picnickers sporting Pentaxes and Nikons" mean that "average citizens come into possession of 'professional-class' equipment," and "amateurism ceases to be a technical category."[14] What Wall does not say, however, is that by the early 1980s those same tourists would be toting camcorders, signaling that first video and then digital imaging will replace photography altogether as a mass social practice. Photography has, then, suddenly become one of those industrial discards, a newly established curio, like the jukebox or the trolley-car. But it is at just this point and in this very condition as outmoded, that it seems to have entered into a new relation to aesthetic production. This time, however, photography functions against the grain of its earlier destruction of the medium, becoming, under precisely the guise of its own obsolescence, a means of what has to be called an act of "reinventing the medium."

The medium in question here is not any of the traditional media – painting, sculpture, drawing, architecture – including that of photography. So the reinvention in question does not imply the restoration of any of those earlier forms of support that the "age of mechanical reproduction" had rendered thoroughly dysfunctional through their own assimilation to the commodity form. Rather, it concerns the idea of a medium as such, a medium as a set of conventions derived from (but not identical to) the material conditions of a given technical support, conventions out of which to develop a form of expressiveness that can be both projective and mnemonic. And if photography has a role to play in the reinvention that seems to be taking place at this juncture, which is to say at this moment of post-conceptual, post-medium production, Walter Benjamin may have already signaled to us that this is due to its very passage from mass-use to obsolescence.

But to grasp Benjamin's theorization of the outmoded, itself triggered by specific works of Surrealism, and to interrogate its possible relation to the "post-medium" condition I've been sketching, one must follow Benjamin's example by addressing particular instances in which the obsolescent could be said to have a redemptive role in relation to the very idea of the medium. I therefore wish to pursue such an instance, examining its various aspects – not just its technical (or physical) support, but the conventions it goes on to develop. This examination can lay before us, with greater vividness than any general theory, what the stakes of this enterprise might be.

The case I have in mind is that of the Irish artist James Coleman who, evolving out of and past Conceptual Art in the mid-1970s, has used photography in the form of the projected slide tape as the almost exclusive support for his work. This support – a slide sequence whose changes are regulated by a timer, and which may or may not be accompanied by a soundtrack – is of course derived from commercial use in business presentations and advertising (we have only to think of large displays in train stations and airports) and is thus, strictly speaking not invented by Coleman. But then neither is the illuminated advertising panel adopted as the support for Jeff Wall's post-conceptual photographic practice invented by him. In both practices, however, a low-grade, low-tech commercial support (although in each case a different one) is

13 Duchamp said this in an interview; see, Denis de Rougemont, "Marcel Duchamp, mine de rien," Preuves 204 (February 1968), p. 45, as cited in Thierry de Duve, Kant after Duchamp (Cambridge: MIT Press, 1996), p. 166.
14 Wall, op. cit., p. 265.

pressed into service as a way of returning to the idea of a medium. In Wall's case, the medium to which he wishes to return, taking it up where it left off in the nineteenth century just before Manet would lead it down the path of Modernism, is painting, or more specifically history painting, desiring to forward that traditional form but now with constructed photographic means.[15] Thus though Wall's activities are symptomatic of the present need to reconsider the problem of the medium, they seem to partake of the kind of revanchiste restoration of the traditional media that was so characteristic of the art of the 1980s.

But Coleman cannot be said to be returning to a given medium, although the fact that the luminous projections occur in darkened rooms sets up a certain relation to cinema, and the fact that in them actors are portrayed in highly staged situations evokes a connection to theater. Rather, the medium Coleman seems to be elaborating is just this paradoxical collision between stillness and movement that the static slide provokes right at the interstice of its changes. This, since Coleman insists that the projection equipment be placed in the same space as the viewer of his work, is underscored by the click of the carousel's rotation and the new slide's falling into place, or the mechanical whir of a change of focus on the double projectors' zoom lenses to create the effect of a lap dissolve.

Roland Barthes had circled around a similar paradox between stillness and movement when, in his essay on "The Third Meaning," he found himself locating the specifically "filmic" – which is to say what he thinks of as film's genius as a medium – not in any aspect of cinematic movement but rather in the photographic still. It is in the horizontal thrust of movement itself that Barthes sees all of narrative's drive towards symbolic efficacy, which is to say, the various levels of plot, theme, history, psychology, on which narrative

meaning operates. What the photographic still can deliver in opposition to this is something that strikes Barthes as "counter-narrative," which is to say a seemingly aimless set of details that set reversibility against the forward thrust of diegesis, producing an effect of dissemination against the interweaving of narrative form and giving off a sense of permutability that acts against the focalization of the story.

This counter-narrative, which opens up a different sense of time, one not hurried along by the 24 frames-per-second mechanics of verisimilitude, is where Barthes looks for the specifically "filmic." Locating this in the still's capacity to generate "an inarticulate third meaning," which he will also term an "obtuse" meaning, Barthes explains that experiencing the still is not the same as looking at a photograph or a painting, neither of which unfold their contents against what he calls the "diegetic horizon" of the rest of the story. Rather, the still, which is not a sample of the story, not a "specimen extracted from the substance of the film," is the fragment of a second text which itself must be read vertically. This reading, open to the signifier's permutational play, institutes what Barthes calls "that false order which permits the turning of the pure series, the aleatory combination ... and the attainment of a structuration which slips away from the inside."[16] And it is this permutational play that he wishes to theorize.[17]

It might be possible to think of a film like Chris Marker's La jetée, made up entirely of stills, as having proposed an instance of such theorization in practice. For La jetée is about staging the film's final image – in which the hero sees himself in the impossibly suspended, immobilized instant of his own death – as a vision that can be prepared for narratively but can only be finally realized as an explosively static "still." For all its focus on stillness, however, La jetée is intensively narrative. Proceeding in what turns out to be a series of extended flashbacks – memory images, each of them understood as grasped from the flow of time and slowed to a stop – La jetée moves slowly but relentlessly towards what turns out to be the retrieval and explanation of the barely intelligible glimpse of the hero's collapse with which it had opened. Indeed, in its peculiar drive toward climax it might be said to want to essentialize film itself in terms of that framing moment in every movie where "The End" hangs as an extended mark of motionless punctuation against a blackened screen in an apotheosis of narrative understood as the production of an all-embracing, all-explaining structure of meaning.

In counter-distinction to this, many of Coleman's works evoke endings in the form of actors lined up as if for a final curtain call – in fact Living and Presumed Dead is nothing but

15 That Wall wishes to "re-do" the masterpieces of nineteenth-century painting is obvious from his decision to stage a variety of recognizable narratives, such as Manet's Bar at the Folies Bergère in his Picture for Women, or Courbet's Source of the Loue in his The Drain, or a combination of Gericault's Raft of the Medusa and Meissonier's The Barricades in his Dead Troops Talk. Wall's supporters see this staging as a strategy for reconnecting with tradition. I feel, however, that such a reconnection is unearned by the works themselves and must therefore be characterized, negatively, as pastiche.

16 Roland Barthes, "The Third Meaning," in Image/Music/Text, trans. Stephen Heath (New York: Hill & Wang, 1977), p. 64.

17 "If the specific filmic lies not in movement, but in an inarticulate third meaning that neither the simple photograph nor figurative painting can assume since they lack the diegetic horizon, then the 'movement' regarded as the essence of film is not animation, flux, mobility, 'life,' copy, but simply the framework of a permutational unfolding and a theory of the still becomes necessary" (ibid., p. 67).

forty-five minutes of such a line up – although since these are staged and restaged within the works as finality without any closure, they both underscore the motionlessness of the slides themselves and set the image of the final curtain into what Barthes had called the permutational play of the still's relation to the diegetic horizon of the sequence. Indeed, Coleman's Living and Presumed Dead is entirely conceived on the idea of permutation, as its linear assembly of serialized characters (generated by alphabetic sequence: Abbax, Borras, Capax...) do nothing throughout the work but change places among themselves to form different enigmatic groupings in the exaggeratedly horizontal line-up.

In Coleman's work, the "diegetic horizon" is not only registered in the naked fact of the photographic sequence itself but is further coded into the individual images by the sense many of them give off of having been shaped by other types of narrative vehicles, most specifically the photo novel. And indeed it is the resource of this most degraded form of mass "literature"– comic books for adults – that Coleman will exploit in his transformation of the physical support of the slide tape into the fully articulate and formally reflexive condition of what could finally be called a medium.

For in the very grammar of the photo novel, Coleman finds something that can be developed as an artistic convention, both arising from the nature of the work's material support and investing that materiality with expressiveness. This element is a concentration in scene after scene on a particular shot (one also shared by comic books), which we could call the "double face-out." It occurs when two of the characters are in an exchange to which at least one is having a strong reaction. In a film this situation would be handled by "point-of-view" editing as the camera looks away from one of the interlocutors to get a reaction shot of the other's face. But since, in a book of stills, this would endlessly dilate the progress of the story, the "reaction shot" is conflated with the image of its instigation and both characters appear together, the instigator somewhat in the background looking at the reactor who tends to fill the foreground, but, back turned to the other, is also facing forward out of the frame. The advantage of this for the efficiency of the photo novel or the comic strip's production is that both shot and reaction-shot are now projected within a single frame. Consequently, in passages of greatest emotional intensity, one confronts the mannered unlikeliness of the "double face-out" in which one of the two protagonists is not looking at the other.

But if the double face-out strains dramatic credulity, it can be seen to have distinct structural advantages for Coleman's project. For one thing, it manifestly subverts "suture." In film, the binding of the viewer into the weft of the narrative space is itself a function of "point-of-view" editing, since it is as the camera no longer looks head-on at an object but turns away to look at something else, that we as viewers leave our externalized positions outside the image to identify with the turning camera, thereby being visually and psychologically woven – or sutured – into the fabric of the film.[18]

Yet this very refusal of suture allows Coleman to confront and underscore the disembodied planarity of the visual half of his medium, the fact that being photographically-based, there is no other recourse than to unroll the density of life onto a flat plane. In just this sense, the double face-out's own flatness takes on a compensatory gravity as it becomes the emblem of this reflexive acknowledgment of the impossibility of the visual field to deliver its promise of either life-likeness or authenticity.

It is not only the frequency with which Coleman uses the double face-out that secures it as both the resource he is mining from the photo novel and a major grammatical component of the "medium" he is using it to invent. It is also the way this resource can be doubled at the level of the soundtrack that gives it added gravity, as when in a work like INITIALS. the narrator keeps returning to a question that serves as the poetic description of just this convention: "Why do you gaze, one on the other ... and then turn away ... and then turn away?"

The fact that this question is quoted from a dance drama by Yeats, his 1917 The Dreaming of the Bones, signals, though it does not insist on, the seriousness with which Coleman intends to invest the lowly materials from which he is fashioning his "medium." For if Coleman turns towards the now outmoded, low-tech support of the promotional slide-tape or the degraded mass-cult vehicle of the photo novel, it is not with the postwar avant-garde's attitude of a parodic embrace of the trashy look of non-art or its violent critique of the alienated forms of Spectacle. It is not, that is to say, in the conviction that there is no longer a possibility for something like a medium to exist. Rather in this drive to "invent a

18 The classic text on "point-of-view" editing and suture is, Jean-Pierre Oudart, "Cinema and Suture," Screen, vol. 18 (Winter 1977–1978).
19 In Cindy Sherman's adoption of the "film still" as the beginning of a photographic practice that will go on to evoke other narrative forms, such as the love comic, the fairy tale, the horror story, etc., we see another highly consistent and sustained practice of the kind of permutational play against the diegetic horizon that Barthes is theorizing in "The Third Meaning." It is clear that Sherman's work needs to be examined in relation to the phenomenon of "inventing a medium" rather than the almost exclusively photoconceptualist concerns that have been projected onto it.

medium," Coleman's determination to mine his support for its own conventions is a way of asserting the redemptive possibilities of the newly adopted support itself.[19]

The photo novel had been named by Barthes as one of several cultural phenomena to have access to the "third meaning" as a signifier at luxuriant play against, but not in service to, the background of narrative. Characterizing these collectively as "'anecdotalized' images, obtuse meaning placed in a diegetic space," he singles out the photo novel from among them. "These 'arts'," he says, "born in the lower depths of high culture, possess theoretical qualifications and present a new signifier (related to the obtuse meaning). This is acknowledged as regards the comic strip," he adds, "but I myself experience this slight trauma of signifiance faced with certain photo novels: 'their stupidity touches me' (which could be a certain definition of obtuse meaning)."[20]

Not all of Barthes's examples of this kind of pictogram, however, are from the lower depths of culture. The images d'Epinal – cheap, colored woodcuts popular in the nineteenth century – do share this condition, but not other examples on Barthes's list, such as Carpaccio's Legend of Saint Ursula or the general category of stained glass windows.

Perhaps it is Barthes's deep allegiance to Proust, as intense as Benjamin's own, that provides the context in which the relationship between these various objects seems not only justified but somehow satisfying. For we only have to think of the opening pages of Swann's Way and the young Marcel's enchantment with the projections of the magic lantern slides on his bedroom walls to realize that childhood's endless capacities for narrative invention married to the dreaminess of the luminous image are preparing us for Marcel's later glimpse of the Duchesse de Guermantes kneeling below the stained glass windows of Combray Church.[21]

The argument has been made that for Benjamin, too, the magic lantern show was endowed with a complex power. For not only could it be said to be the very embodiment of phantasmagoria as ideological projection, but it could also be thought to produce the inverse image of ideology, which is to say phantasmagoria as constructive rather than merely reflective, the magic lantern as the medium of the child's permutational powers at play against the diegetic horizon.[22] Indeed the magic lantern functions in Benjamin's thought as one of those outmoded optical devices, like the stereopticon slide (Benjamin's model for the dialectical image), which can brush the phantasmagorical against its own grain, to produce an outside to the totality of technologized space.

For Coleman as well, this resource of the magic lantern show, lodged within the commercial slide-tape as a kind of genetic marker, is central to his project. It tells of an imaginative capacity stored within this technical support and made suddenly retrievable at the moment when the armoring of technology breaks down under the force of its own obsolescence. To "reinvent" the slide-tape as a medium – as I am claiming it is the ambition to do here – is to release this cognitive capacity, thereby discovering the redemptive possibilities within the technological support itself.

Benjamin's "Little History of Photography" had already described certain photographic practices of his own day performing a retrieval of the "amateur" condition of photography's first decade, although he was not using "amateur" in the sense given it by a postwar avant-garde to mean incompetent. Rather it conveyed what Benjamin thought of as the ideal of a relation to art that was non-professional in the sense of non-specialized. Benjamin had spelled out such an ideal in a text he wrote one year after "The Work of Art" essay, his "Second Paris Letter: On Painting and Photography," undertaken for the Moscow edition of Das Wort but refused for publication. There, he connects the amateur status of early photography to the pre-Impressionist situation, in which both the theory and practice of art arose from the continuous discursive field maintained by the academies. Claiming that Courbet was the last painter to operate within this continuity, Benjamin pictures impressionism as the first of the modernist movements to have courted a studio-based esoterica, with the result that the artists' professional jargon both gave rise to and depended upon the critics' specialized discourse. Once again, then, this first decade of photography's history operates as a kind of promise folded within its medium of the possibilities of an openness and invention before the rigidification of the image as commodity.

In 1935 Benjamin had articulated his idea of the onset of obsolescence as a possible, if momentary, revelation of the utopian dreams encoded within the various forms of technology at the points of their inception. If he had steadily

20 Barthes, "The Third Meaning," p. 66. Taking up Julia Kristeva's term "signifiance," Barthes is using it to signal the play of the signifier as it eludes meaning (the signified) and registers instead the rhythms and the materiality of the body's opening onto pleasure.

21 Proust himself compares the effect of the slide projection to the colored glass: "In the manner of the masterbuilders and glass-painters of gothic days it substituted for the opaqueness of my walls an impalpable iridescence, supernatural phenomena of many colors, in which legends were depicted, as on a shifting and transitory window" (Marcel Proust, Swann's Way, trans. C. K. Scott Moncrieff [New York: Random House, 1928], p. 7).

22 See, Margaret Cohen, Profane Illumination: Walter Benjamin and the Paris of Surrealist Revolution (Berkeley: University of California Press, 1993), pp. 229ff.

Dennis Adams

Even though Dennis Adams occasionally exhibits his work in museums, he is primarily active in public urban spaces, which are always changing. This preference springs from a deep distrust of the traditional mediating venues of the art establishment, museums and galleries: "I am fascinated by archives as an endangered species in late capitalism. I want to lay down historical and political tracks which are not mediated by conventional storage systems."

Adams likes to realize his most impressive installations in what he calls shelters (at bus stops), kiosks, and pavilions, ephemeral and transposable functional structures which metropolitan urban dwellers notice only in passing. In so doing, Adams is harking back to the transitory structures of Russian Constructivism such as those designed (but not built) by El Lissitzky and Gustav Kucis in the functional context of political activism. Adams constructs temporary, anti-monumentalist monuments to "express the traces of collective memory." For his installations Adams resorts to advertising techniques, working with the media of photography, video, and posters. He never uses his own photos. Instead he appropriates picture material such as press photos which have become familiar to the public at large, yet have lost their immediacy. Architecture and photography always enter on a symbiotic relationship in his work so that our faculties of perception, numbed and cliché-ridden as they have become through over-stimulation, may be positively stimulated in a public space. Adams' installations seem both casual and subversive. The ephemeral effect of his images is calculated: on the one hand because they are only presented publicly for a limited time and, on the other, because people strolling through modern cities only give them a cursory glance.

Before executing these works, the artist researches into the socio-political and economic context as well as the history of the place itself. One of Adams' most impressive works, in which he takes a stand against collective amnesia and suppression of historical events, is a bus stop with photos of Klaus Barbie and his lawyer, Jacques Vergès. This reticent, certainly unspectacular intervention took place at the 1987 sculpture exhibition in Münster.

His 1979 installation Patricia Hearst – A thru Z aroused public indignation on its first presentation in a Manhattan garage. The Hearst Corporation had the pictures removed. The life story of Patricia Hearst, the daughter of the owner of the influential American media firm, had aroused the public more than any other media event of the time. After the sensation of being kidnapped by the Symbionese Liberation Army (SLA), the young woman joined her captors, embracing their goals. After serving a short prison sentence following her arrest, Hearst married one of her bodyguards and settled down to a secure middle-class life. Adams was of course interested in the spectacular story of such a split personality. The "image" of Hearst was first "invented" by the media and then "reinvented" by her parents, the SLA, the FBI, psychiatrists, and lawyers. Consequently, the Hearst case reflects the media coverage of the time, which bordered on hysteria, and the shattering crisis to which the American value system was subjected by Hearst's confusing array of changing identities. Using twenty-six portraits of Patricia Hearst which he had reproduced from illustrated magazines, Adams created a pictorial language with which he could form sentences and draw apt conclusions on the condition of American society. When the work was installed in 1979 at the Minneapolis College of Art and Design, two policemen guarded the Hearst alphabet which follows the heiress to the mighty media empire from Communion to marriage. What is striking is the collision of two different sign systems, which confuse the beholder because paradoxes arise in the juxtaposition of picture and text. Adams was not interested in representing the psychology of Patricia Hearst as a person. On the contrary, his installation is effectively thought-provoking as a parable on the identity of an individual as it is analyzed in the contradictory interaction of the media, politics, and society in the United States of America.

Ulrich Pohlmann

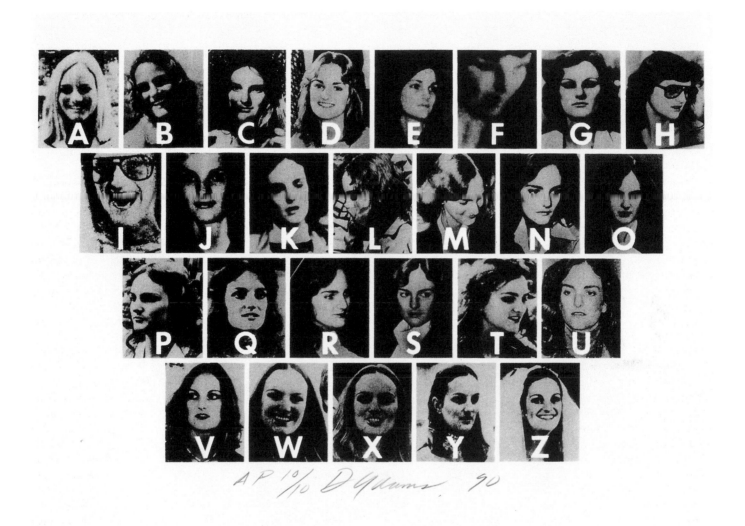

AP ¹⁰/₁₀ D Adams 90

AP 1/10 P Gdeuer 90

Dieter Appelt

Dieter Appelt exposes fields of memory. With his own body acting as a vehicle to express physical measurement and organic growth, he creates an archeology of the phenomena between becoming and passing away. The Promethean process of creation is grasped realistically from its mythic origins by means of photographic self-perception as far as the stage of reunification of the body with rocks and earth. Appelt's mises en scène of the extremely tensed body, photographically lifted from nature and sinking back into it, give shape to the memory of origins and the ultimate death of humankind.

"I want to remind people of time that has passed, of matter, and often, with time exposures lasting for several hours, set the contours where I want them to be," the artist explains. By means of multiple exposures he crosses the threshold from reality to a materially undetectable state, as though he wished to transport back to reality the phenomena discovered in the field of conflict between nature and physics. The body is consequently the organic central motif of the vegetative and mineral structures faded in layer by layer. Six large-format photos from the series Die Schatten erinnern an nichts II (the shadows remind you of nothing: 1991), printed on colored paper, reveal their unique symbolism of transience in the oscillating play of light and shade: they seem to be a physiological fusion of germ cell and hourglass. The appearance of an organic form associated with time, memory, and transience is reflected in the measuring instrument itself, so that the viewer believes he has glimpsed the blossoming and extinguishing of a (still) undefinable phenomenon of light. Der Fleck auf dem Spiegel, den der Atemhauch schafft (the spot on the mirror your breath makes: 1977) is a symbol of the photographer's intellectually tinged animism. He himself wishes

to give life to something in order, ultimately, to lead it back to death in a concentrated fashion. It may be that this wish to give life was awakened in the son of a painter and interior designer, who died during the war years, as he handled his dead father's photographic equipment. Dieter Appelt did not even put the camera down between 1954 and 1979, the period when he was training as a singer and was employed at the Deutsche Oper in Berlin. He finally made photography the sole creative tool of his existence. Perhaps he perceived the geometric axis in the whirlwind of creation (a futuristically tamed chaos formula of the English Vorticists) during his first years of study in the home of a Leipzig soprano who owned an art collection. A student of Kasimir Malevich, she introduced Appelt to the visual principle of Suprematism.

In Dieter Appelt's "transreality," the rituals of earlier cultures and Far Eastern concepts of consciousness are used for modern self-determination. For example, an apparently mummified being divests himself of bandages of tree-bark and encrusted mud as though sloughing off a scaly second skin. The artist's strategy of digging up memories from the depths merges poetry and suffering through many hundreds of layers as the aperture increases. The chalk-white flesh covering of the Man of Sorrows appears to be in transition from the pre-natal to the post-mortal phase. It is associated with rusty metal and the branches of a tree, the structure of stones, the desiccated earth. The photographs are stations on a voyage through time back into myth. In twenty-five phases Appelt has photographed the Zirkulations-Feld (circulation field: 1993) of his own, screwed-in head, slowly rotated by 25 degrees. The magic of the instrument seizes the body and transports it to a metaphysical plane of the imagination.

Günter Engelhard

Nobuyoshi Araki

Nobuyoshi Araki was born in 1940 in Minowa, a former prefecture and a typical old-established business district in the historic center of Tokyo. Araki lives and works in this city, which he only seldom leaves and to which he is entirely devoted. He has meanwhile become a part of Tokyo himself. For more than twenty-five years Araki has published his photos, preferably in magazines and in more than 130 books to date. From 1959 to 1963 Araki studied photography and film at Chiba University in Tokyo. In 1963, the then twenty-three-year-old had busied himself with a 16-mm film project: a portrait of a small boy and his brother from the neighborhood and their playmates on the street. Araki identified very strongly with the boy and saw in him a part of his own childhood. In 1964 Araki won the photography contest "The First Taiyo Prize" for the other photos taken at the same time. The photos were not published until thirty years later, in the book Saatchin and his Brother Mabo. Tokyo was already at the center of Araki's interest in this series of children's photos. The liveliness of the children's games and the grimacing at but also the openness toward the photographer testify to Araki's familiarity with the situation and his ability to participate.

Tokyo, the modern megalopolis, has undergone three drastic upheavals in this century owing to its near-total destruction in the war and subsequent reconstruction. First came the great Kanto earthquake of 1923, followed by the aftermath of the bombing in 1945 and, finally, the broad-scale redevelopment of the city in the eighties at the height of the so-called Japanese "economic miracle." In no other city has the visual character changed so much due to a continuous process of building and demolition. Traditional and modern clash in the form of adjacent wooden houses and skyscrapers, glittering urban shopping malls are replaced by wasteland, and the sky is crisscrossed by a confusion of overhead power and telephone lines. Many of Araki's published series bear the name Tokyo in the title. His entire œuvre appears to be a homage to this city. They are the urban perspectives of his own feelings, comparable to a clandestine love affair with a woman named Tokyo. It is often the unconscious, concealed spaces of the metropolis and not the obvious urban characteristics that are revealed. With tenderness and desire, Araki photographs the nakedness of his city, the gender of the city of Tokyo. In a sheer insatiable hunger for images, the artist photographs incessantly; his "drug" is photography. Forty rolls of film in one day is nothing unusual.

Araki's work is strongly influenced by the everyday aesthetic of modern Japan, the lifestyle of the Japanese metropolis with all its good and bad sides. Public and private spheres permeate each other. Some aspects are captured in casual snapshots; others are arranged in a highly artificial manner such as traditional puppet-theater or the blossom splendor of the Japanese ikebana. The use of plate cameras for studio shots is equally as important as the use of a compact camera which accompanies him everywhere he goes. Araki's preference is for small-format cameras with an automatic date superimposition. The flow of time, but also the documentary and diary character of his photography is thus emphasized. This photography may be described as a kind of "personal novel."

In 1991 Araki published photos of his wife, Yoko, who had died one year previously, in a volume entitled Sentimental Journey/Winter Journey. Here it is always flowers – from the magnolia stalks in the hospital room to the orchids wreathing Yoko's head in the open casket – which represent the beauty of woman and at the same time the transience of human life. Later he made entire series of so-called "black flowers," black-and-white photos of sometimes greatly wilted blooms. "After Yoko's death I wished to photograph nothing but life. Yet each time I pressed the shutter release I found myself feeling near to death; for when one photographs, one makes time stand still. I want to tell you something, listen closely: photography is murder."[1] With this, Araki describes a route winding between the frontiers of eros and thanatos.

Mario Kramer

1 Nobuyoshi Araki, Camera Austria International, no. 45 (1993), pp. 15f.

Roy Arden

Born in Vancouver, British Columbia, to Finnish immigrants, Roy Arden brings to his scrutiny of his home town both a native's familiarity and a foreigner's inevitable experience of dislocation. In his photographs, which trace the collapse of the Vancouver that was and its replacement by a deracinated, affectless corporate/suburban milieu, he contemplates the environment that has vanished during his lifetime and critiques its relentless replacement.

Vancouver was never a beautiful city; its early immigrant inhabitants swiftly recapitulated all the squalor of Victorian-era British industrial towns. The closest one comes in Arden's photographs to local color is in his melancholy images of decrepit wooden houses from 1994–1995 and the subsequent Basement series of 1996.

The former, unlike the architectural studies of Walker Evans, to which they refer with their detached style, do not venerate the structures, which are graceless and, in any case, were nothing more than their era's drab, pre-fab versions of the tract houses of our period; they simply scrutinize them in their senescence. The latter–ten color studies accompanied by ten black-and-white pictures–record the apparently random accumulations of detritus in one or more basements: mere heaps of stuff, consumer goods no one cares to consume, held on to out of habit though not particularly desired by its owners, described bluntly in the images but not even catalogued by Arden in a way that would make it interesting (as Daniel Spoerri did in his "anecdoted topography of chance"). Nothing in either set of pictures appears worth saving.

If the disappearance of "old Vancouver," as represented by these buildings and possessions, is no loss, then what comes to substitute for them represents no gain. The Model House, Richmond, B. C., with its splendid view of the nearby Honda factory, will never let its occupants forget the proximity of Pacific Rim financial matters to their most intimate and private moments. The pathetic, leafless trees growing out of Landfill, Richmond, B. C. do not promise to recover for nature – or even for human visual pleasure – the bleakness of the site that overwhelms them; the eventual fate awaiting them will most likely be that of the bedraggled, uprooted Tree Stump, Nanaimo, B. C.

Arden's work, like that of many of his contemporaries in North America, the U. K., and northern Europe, situates itself in a dialogue between photojournalism and documentary photography – particularly one documentary tendency that historian and curator William Jenkins named "New Topographics," and another that curator Thomas Garver dubbed "social landscape" – and what is loosely called "Conceptual Art." The photographers involved in this discourse today range from Lewis Baltz, Robert Adams, and Lee Friedlander to Dan Graham, Jeff Wall, and the team of Bernd and Hilla Becher.

Some, like the Bechers, seeking a scientific premise, use a strict and taxonomic methodology, while others employ a more fluid, poetic approach. Regardless of conceptual and/or stylistic strategy, most trace their tendency back to Walker Evans, some even further to Eugene Atget. The historian Shelley Rice, in her 1997 book, Parisian Views, concerning the Second Empire's radical reconstruction of Paris under Napoleon II and Baron Haussmann between 1852 and 1870 and the photographic response thereto, implies that the origins of this critical impulse may be found in the projects of Nadar, Marville, Le Secq, Baldus, Le Gray, and others.

Curiously, most of those drawn to this mode are male; perhaps, like Henryk Ibsen in his play The Master Builder, they have been drawn to meditate on the social and political consequences of the masculine impulse to build and destroy – its fundamental hubris, and the inevitable nemesis it calls forth.

A. D. Coleman

John Baldessari

After studying painting and art history, John Baldessari has been chiefly occupied with photography since the 1970s. The basis of his œuvre is the popular imagery of the mass media. Besides his own photos, he uses examples of photojournalism, pictures from illustrated magazines, and film stills as material for his photo series, collages, and illustrations.

In the early eighties Baldessari was mostly interested in the mechanisms of representation. He works with fragments taken from film stills and uses their narrative power to investigate the effect of gestures, the meaning of body language, and stereotypes of vision with the help of ever-new combinations. One of the most succinct means with which he draws attention to forms of expression – such as body language – involves covering people's faces with circular shapes. Through this intervention, the "hierarchy of vision" (Baldessari) oriented toward faces is thwarted and an unambiguous "reception" frustrated. In other works such as Floating: Color (1972), Baldessari inserts purely formally conceived shapes corresponding to the visual spectrum into the photo of a normal house front so that a fluctuating assemblage of formal and constitutive levels of meaning are presented. Although Baldessari manifests the mechanism and strategies of popular images, he is not primarily concerned with making a political or morally substantiated cultural critique. In his works the analytical dimension never becomes an end in itself but is carried by ironic ambivalence. Especially in his more recent works, it is the narrative dimensions and not the purely formal aspects which are prominent. Thematically it is the feelings, personal recollections, and myths that attach themselves to these seemingly familiar pictures and call forth specific associations.

John Baldessari conceived of the work Six Color Coded Notepads and Six Color Coded Lamps especially for a conference room of his own choice at the DG BANK. The installation consists of eight photographs. These are fragments from film stills that Baldessari enlarged and partially painted over using acrylic paint. Six Color Coded Notepads and Six Color Coded Lamps have been placed one over the other on the wall opposite. One part of the work shows a reflecting tabletop on which representative, neatly ordered writing instruments are visible – an official arrangement that can be seen on the television news every evening. Evidently, important things are decided at this table. The persons involved, however, remain anonymous; their presence is marked only by their hands resting on the table and their serene gestures. Who decides on what is an open question.

Looking more closely, one recognizes that both parts of Six Color Coded Notepads consist of one and the same photo reflecting back on itself as a mirror image. They are decidedly different from one other owing to the allocation of color. While in one picture the notepads at the extreme left are marked yellow, orange, and red, those on the extreme right are painted in violet, blue, and turquoise. In addition to the narrative content comes the formal level; aspects of symmetry and abstract color relationships come into play.

If one views Six Color Coded Lamps on the opposite side, one again discovers the six colors of the visual spectrum, which are allotted to the shades of six different table lamps. The color coding from left to right follows the color wheel, and this produces a relation to the opposite side which runs right through the whole space. A relationship can also be recognized on the narrative level. While the anonymous participants of the conference are themselves color coded by their writing materials, this categorization is now applied at quite a different level, namely that of private furnishing and its respective counterpart. The role-like nature and anonymity of the individual in professional life is confronted with personal preference in interior design.

These complex references within different levels of meaning are intensified still further by the function of the room in which the work is displayed. The real courses of action in the conference room of an office building are reflected by a work of art, which in turn represents events at a conference whose own origins are based on a motion picture.

Iris Cramer

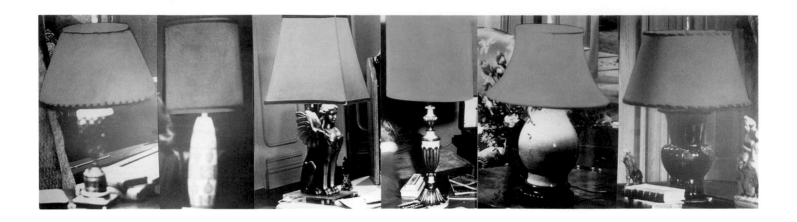

Lewis Baltz

When we compare the early photographic work of Lewis Baltz with his projects over the last ten years, it becomes possible to speak of a veritable change of paradigms with respect to his artistic strategy.[1] What at first glance may seem to be a breakaway becomes visible upon closer scrutiny as a consistently artistic-philosophical stance, one which precisely and sensitively reacts to and reflects on the enormous changes in the relationship of the image, visibility, and reality of the past three decades. A comparative view of his entire œuvre also enables us, in a certain sense, to embark upon a visual trip through time into a pictorial world which was characterized primarily by the American history of photography and its self-conception after 1945.

The individual works presented here all originate from larger series and work complexes developed by Baltz at the end of the sixties and beginning of the seventies.

What is significant is his concentration on architecture, presented, as it were, as a topology of itself. In contrast to later works, the centering of the subject to the middle of the picture, that is, the minute photographic composition, is essential. The artist's great interest in architecture and urban themes is already recognizable in these works (themes which in the nineties are at the focus of Baltz's attention, for example the large-format installation Ronde de nuit [night rounds: 1992]).

The landscape – an important theme in American art since the nineteenth century – almost inevitably becomes a topography of architecture owing to the tremendous processes of urbanization in the twentieth century. From a contemporary viewpoint, Baltz's early photographs distinguish themselves by a marked semiotic significance; to a certain extent one can even speak of a dissolution of architecture into its graphic elements (particularly in Santa Cruz and M 70). Thanks to this subtle photographic perceptual gesture, the subject of the picture becomes a counterpoint of bold, striking, public architecture. The anonymous, apparently inconspicuous, incidental and commonplace acquires relevance and becomes a succinct theme of the "New Topography," of which Lewis Baltz is one of the most important representatives.

The photographic "labor" of seeing, which we rediscover in the pictures, avoids the pictorial idiom as we know it from the work of Robert Frank or Pop Art. The aesthetic strategy is photographically founded in its documentary stance while questioning the significance of seeing in general. It is remarkable how strongly the belief in the possibility to depict the world, to depict reality, is still formative in this phase of Baltz's work. Photography is witness to that which it shows. Thus, every classical photographic discourse remains closely attached to visual reality but is not liable for it. Above all, it shows itself as a medium which constructs pictures and thus constitutes reality.

Lewis Baltz's work is in its complexity an investigation not only into the possibilities of depicting reality, but also into its perceptibility. The narrative element is not a result of that which we think we recognize in the pictures, but rather of the specific way that they constitute the sense of seeing for the viewer.

Carl Aigner

1 Cf. Carl Aigner, "Pikturale Interfaces. Zu neuen Arbeiten von Lewis Baltz," Eikon – Internationale Zeitschrift für Photographie & Medienkunst, no. 12/13 (1995), pp. 17f.

Robert Barry

Untitled, (DG BANK piece #8), 1997
(View of the installation)

Untitled, (DG BANK piece #4), 1997 100 x 100 cm
Untitled, (DG BANK piece #6), 1997 100 x 100 cm

If you did not personally experience art being produced in the late 1960s and early 1970s, you would hardly be able to form an idea of the intense controversy which Conceptual Art aroused. This was the last American art movement on an international scale to merit being termed "avant-garde."

Robert Barry took part in all the major exhibitions of Conceptual Art. He was indeed a pioneering member of the movement. A few remarks on Barry's early work seem called for. Before 1967 he was busy with Systematic Painting.[1] The awareness that pictures change the way they look with the room in which they are exhibited finally led him to start making wire sculpture. This meant that two points in a room might be linked by a horizontal. The choice of location for works of this type stands for countless possibilities. Once decided on as a venue, however, a room was defined. A further step Barry took in 1969 involved releasing inert gas, which is invisible, into the atmosphere. The escaping gas incalculably defined a different spatial volume each time. Photos of this action always show the venue, for instance the Mojave Desert. The caption or legend only refers to the action and the inert gas used (usually argon, xenon, or neon). An essential element of Conceptual Art was blurring the boundaries between all the genres and media. In 1969 Barry stated in an interview with Arts: "I not only question the assumptions of our perception but also the validity of what we perceive each time." In the catalogue of the Prospect '69 exhibition in Düsseldorf, he has gone so far – as far as overstepping and blurring the boundaries between the arts are concerned – to tell his interlocutor that his work consists of the ideas and conceptions of the readers of the interviews. After that, Robert Barry devoted himself almost exclusively to the medium of language, on the one hand via words projected by means of slides and, on the other, in the form of text arrangements whose appearance recalled visual poetry. "Language," says Barry, "fascinates me because it belongs to everybody. Language is an extension of our being; it is the expression of things. It moves us within things which are indeterminate in space and time. Language enables us to cross spatial and temporal boundaries."[2]

If you take the words scattered like splinters throughout the DG BANK, you do not at first see that they make any sense. Nevertheless, any beholder would be familiar with the meaning of the individual words, for instance, the German equivalents of: "expect," "meaning," "feel," "wonder," "personal," "remember," "openness," "continue," "achievement," "question," "together," "link," "need," "necessary," "purpose," "set." All such words are painted in capital letters in such restrained color that you cannot remember what color they were (gray). In other words: the decorative aspect of color has been deliberately ignored. Each such word can open a conscious space in beholders/readers, linking them with both professional and personal life. What Robert Barry has so superbly succeeded in doing, thanks to so many talks with the Bank's employees, is linking the two areas via nouns, verbs, and adjectives. What is true of a business is equally true at home, in the family, or among friends. Another work group consists of portrait photos of employees (100 x 100 cm), which have been painted over with translucent acrylic in purple, red, green, and gray so that the sitters are hardly recognizable. These eight employees represent the entire staff, yet their names are not mentioned and the works are untitled. This does not represent a contradiction in terms because, as individuals, they also represent everyone. In these color portraits, Robert Barry has also discreetly employed words as a second level of meaning on the same principle of scattering as in the subterranean passage to the canteen. This time the words are in English: "found," "careful," "celebrate," "already," "look," "expect." Some of these words have, like those in the passage, been cut into and turned upside-down. These Robert Barry works have been astonishingly well received by the Bank employees, as reported by a documentary film commissioned by the DG BANK in 1997.

Jean-Christophe Ammann

1 See Cat. Systematic Painting, Solomon R. Guggenheim Museum (New York: 1966).
2 Interview with Achille Bonito Oliva in Domus, no. 525 (Milan: August 1973).

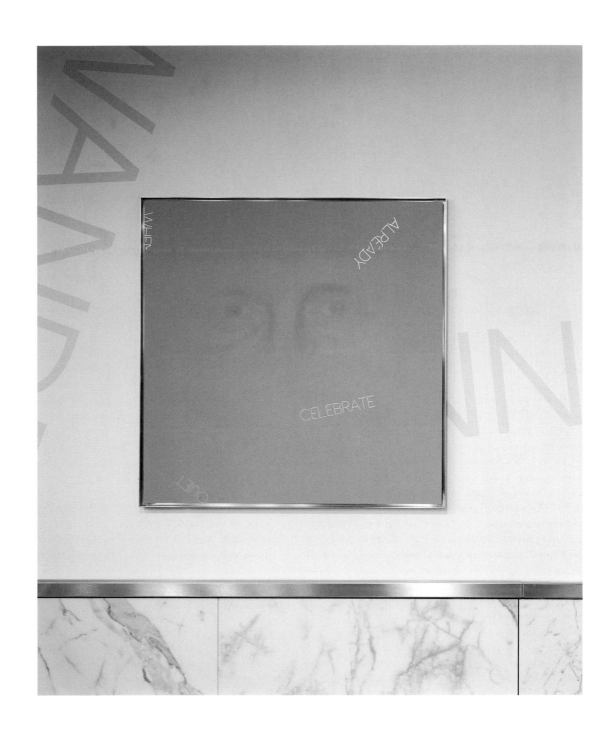

Gabriele Basilico

After studying architecture, Gabriele Basilico embarked on a professional career as a photographer in 1973. At first he did social reporting. His first book, Dancing in Emilia, deals with the pleasures of the dancehalls in the Italian province of Emilia-Romagna. Another series, In pieno sole (blazing sun), executed in 1977, consists of studio portraits on the effects of the blazing sun, the suntan as an aesthetic phenomenon. Basilico soon found, however, what he was really interested in as a photographer: architectural and landscape photography, genres which he has hardly left since 1978. His Milano, Ritratti di fabbriche (Milan, portraits of factories) series of that year already shows elements which would resurface in later work. Basilico works exclusively in black-and-white. There are no people in his pictures of the Milan industrial district. Buildings, streets, smokestacks, and silos loom as block-like geometric forms. Sunlight creates an effect of stark contrasts. Basilico's view is that of the aesthete rather than the social critic. He is interested in structure, which may mean wires running parallel to a wall or the uniform pattern made by identical roofs or smokestacks which seem to rise up into the sky out of a massive wall. He himself sees his pictures grow out of a process of abstraction, isolation, and absence.[1] The second focus of Basilico's œuvre is, with revealing structure, on creating a typology of places. Consequently, he is always taking part in projects which deal comprehensively and exhaustively with a city or a landscape and involve the collaboration of several photographers. Viaggio in Italia (journey through Italy), a study of the contemporary Italian landscape, is a series executed jointly in 1984 with Luigi Ghirri. The Milan municipal energy company commissioned Basilico and four other photographers to deal with the theme of the city at night and the result was Le invenzioni dello sguardo (the inventions of the gaze). What is probably Basilico's most comprehensive study is devoted to the French landscape. The French government Mission Photographique de la DATAR commissioned numerous European and American photographers such as Robert Doisneau, Josef Koudelka, and Lewis Baltz as well as Basilico to collaborate on the project. Basilico chose Bord de mer (by the sea) as his theme. In the course of this group project, Basilico's angle of vision widened. At first he had concentrated on architectural photography, focussing on only a few objects. Now, the panorama of landscape with its sweeping view of the complexity of the subject captured his imagination to be used as an equivalent detail of the whole.

As in his early series, Milano, Ritratti di fabbriche, he allows things in Porti di Mare (sea ports) to take their course; human beings are absent. Basilico does not deal with the hustle and bustle of a modern port as a high-tech industrial enterprise, the loading and unloading of cargo, nor the tourist trade when a car ferry is pulling out. His places are frozen in a peculiar state. His buildings are uninhabited and therefore devoid of function, present only as forms. No one reads what is on the signs he depicts. Traffic lights stop no cars – signs remain a closed company. When a person is spotted, he only appears, as an individual or in a small group, for the purpose of enhancing the scale of the sea or the vast port buildings and the ocean-going freighters. People appear lost in these photos, conveying an impression of loneliness and alienation. In contrast, the massive bodies of the ships in their berths appear massive and seemingly immovable. Even when they are sailing out to sea, they seem to be in suspended animation rather than moving. Basilico thus builds up tension between this state of suspension and the symbolism generally associated with the motif of ships and ports. They stand for change, transition and farewells. In Basilico's photographs, these references are linked. He freezes these places of transition in time. Photographing the port facilities, he views them as an archeologist would, as if the present were past, as if they were monuments of this vanished time which one gazes at with a feeling of melancholy.

Martina Weinhart

1 Cf. Gabriele Basilico, "Per una lentezza dello sguardo," quoted in: Bord de mer (Udine: 1992) p. 10.

Thomas Bayrle

Guitar: Elvis Presley, 1996 24 x 32.2 cm

The title of the work by the Frankfurt artist Thomas Bayrle represented in this collection, Grid, is both a description of Bayrle's central category of form as well as of whole areas of art since the sixties: from Andy Warhol's pictures of soup cans, via Donald Judd's minimalist sculptures of identical elements of industrially-manufactured materials to, for instance, Tischgesellschaft (table gathering: 1988) by Katharina Fritsch, where thirty-two identical male figures sit around a table. Grids, screens, lattices, rectangular layouts, (mains) circuits, and the serial all lie within the field of significance of this title. As early as 1968 Bayrle described the basics of his method in concise terms: "I select a symbol (e.g. cup, ox, shoe) and reproduce it phototechnically until I have enough for a grid repeat (measuring approx. 70 x 100 cm). The parts are mounted as closely together as possible – this produces a serial grid of the same objects. The cow lattice, for example, is now colored differently in places so that a new, different picture is produced in large format ... The large and the small picture then have a really funny correspondence to one another (private poetry). The laughing cow – the giant woman, the yellow-green shoe – the giant duck, the small coffee cup – the giant coffee woman ..."[1]

Via the grid Thomas Bayrle undertakes a sort of "screen search" – the ambiguous title of a book of graphic works he produced in 1981 – whereby the "funny, private poetic correspondences" play a decisive role. They refer namely to the allegorical content of the forms and processes themselves. Just as the collage is not merely one form among many possibilities but aims at an epistemological added value – the whole is greater than the sum of its parts.

Grid, dating from 1995, represents an extension of the artist's method at the start of the digital age. This work is a typology of twelve laser prints (each 24 x 32.2 cm) created in collaboration with Wakao Yoshihiro during a stint as visiting professor at the Tohoku University of Art and Design in Japan. Pictorial symbols drawn from the field of rock music, especially faces of stars – from Elvis Presley to Jimi Hendrix to the Ramones – are downloaded from the Internet and laid over three-dimensional representations of either a drum, a microphone, or a guitar. These in their turn are silhouetted against a two-dimensional grid repeat of the same visual symbol. The instruments – in which the angular, distorted, and often dynamized internal forms remind one, for example, of the distorted sound of a musician such as Hendrix – form an exact contrast to the rectangular grid of the picture backgrounds and overall another grid in front of the basic grid. These digital images look like classic, analog C-prints, particularly because of the paper used, which is available in Japan. Thus not only is the basic opposition between figure and background created that is essential to all illusionistic depiction, but an allusion is also made to the socio-psychological dynamics of the star cult in popular culture. The picture series, completely built from iconicized elements, represents something like Pop Art in a concrete, literal, as well as an ironic sense. In 1996 the Kunsthalle in St. Gallen, Switzerland produced in book form a catalogue of the material for these grid typologies by Thomas Bayrle.

Thirty years after classical Pop Art works such as George Segal's Rock and Roll Combo (1963), Bayrle shows that the recycling of pictorial and musical elements is not at all new, that the digital picture is already laid down in analog, and that the grid template, as used earlier in the work of Andy Warhol and Gerhard Richter, is still an important factor. The closeness of Bayrle's creative logic to that of Peter Roehr, Hilla and Bernd Becher, Anna and Bernhard Blume, but also of Thomas Ruff, is thus not solely a question of generation.

Hubert Beck

1 Big Book (Cologne: Verlag der Buchhandlung Walther König, 1992), inside cover.

Bernd and Hilla Becher

The first publication of photographs by the Bechers in 1970 bore the precise, descriptive title Anonyme Skulpturen – eine Typologie technischer Bauten (anonymous sculptures: a typology of technical constructions). This addressed a number of fundamental issues that are still relevant today: it is true that the objects depicted are "technical constructions," in this case water towers, but at the same time in their appearance they resemble sculptures by sculptors unknown. The discovery of formal severity and of aesthetic qualities, of symmetry and variability with the same functionality consciously evokes an association to minimal sculptures, just as the word "typology" is a reference to the serial character of the photos. The Bechers' method corresponds exactly to the Brockhaus encyclopedia definition: "Typology in the sense of differentiation of basic shapes or model shapes that can be isolated everywhere either concretely or conceptually forms the elementary part of the sciences, which begins with the ordering of the diversity of the material."

The Bechers phrase it like this: "The idea is to create families of objects." This points to the comparability of the similar and to the possibility of more precisely differentiating the apparently alike, which only develops its own character in juxtaposition. There are frequent references to pioneers of the twenties: August Sander with his "cultural work in photographs," Menschen des 20. Jahrhunderts (people of the twentieth century), divided into seven groups according to social class and comprising around forty-five folders, as well as Karl Blossfeldt's Urformen der Kunst – Photographische Pflanzenbilder (early forms of art: photographic pictures of plants). Both these photographers captured their subjects, Sander his people and Blossfeldt his plants, in relatively similar conditions: directly frontal as far as possible, almost symmetrical in the center, motionless, still, in front of a neutral background. Even though, early on, the Bechers themselves collected industrial photographs in original and in company publications, the contemporary Conceptual Art and Minimal Art movements provided a far more important source for their artistic theories.

During the sixties the Bechers increasingly fine-tuned their photographic technique, their clear, no-nonsense look at objects belonging to a technical world of heavy industry, with its steelworks, derricks, and blast furnaces or, as here, water towers, that in places was rapidly disappearing. This world of the nineteenth century and the first half of the twentieth century was only rarely and exceptionally recognized as being of artistic value when the stylistic forms of "high art" were readopted, for example Art Nouveau or the Modernist movements of the twenties or fifties. But the great majority of functional constructions, which were usually built anonymously, changed with alterations in their functions; probably more than two-thirds of the objects photographed by the Bechers have already long since disappeared, and their work is therefore also of importance from the point of view of industrial history. The regional forms, but also the idiosyncrasies of particular types of businesses, render international boundaries irrelevant. "It is not our intention to make relics of old industrial buildings, but we would like to produce a more or less unbroken chain of the various forms," the Bechers wrote as early as 1969.

For the art scene of around 1970, however, this approach was fascinating, and this made the Bechers' works stand out in exhibitions of Conceptual and Minimal Art. Their photographic work is always executed in black-and-white, since color would introduce more or less coincidental accents that would distract attention unnecessarily from the sculptural shapes. No special tricks, aids, or compositional elements seem to be used: the objects are presented in matter-of-fact and peaceful clarity, the sky is kept an even, neutral gray, the foreground is devoid of accentuation through human activities or floral features. The Bechers achieve this through long exposure times (approx. 10 seconds) using an f-stop of 45. Everything subjective and accidental thus drops away from the location, which is selected after careful consideration and depending on the time of year.

The sculptural power of an object, the quality of its plastic form, the slight differences in the internal structures can then be compared with one another, given the same external conditions of photographic works printed all the same size. Thus, functional buildings that have so far largely been ignored are for the first time recognized as aesthetic forms, and at the same time the serial principles in the art of the late sixties are not just conceived as Minimal Art, but are given a socially explanatory content.

Wulf Herzogenrath

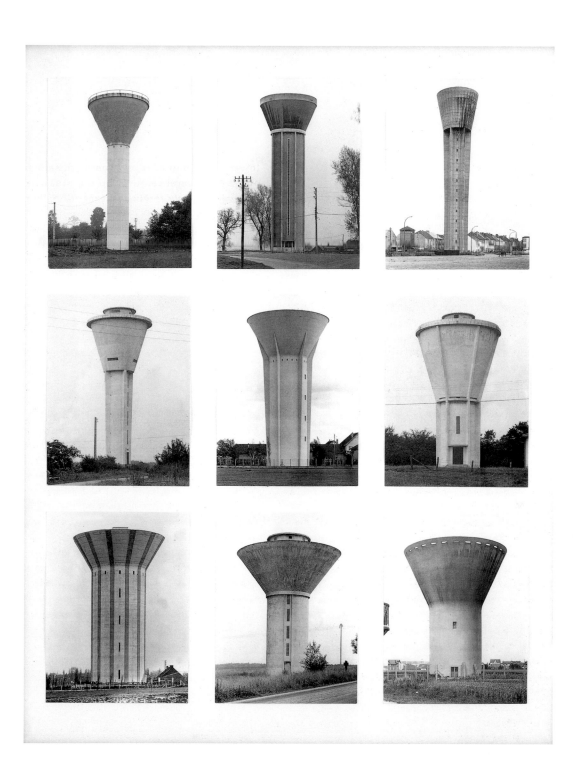

Bill Beckley

Roses Are, Violets Are, Sugar Are ..., 1974 226 x 353.5 cm

Bill Beckley's work is often beautiful and not "despite itself" but consciously, willfully so. And he is not only widely and deeply read but has long been involved with writing: carefully wrought, stylish fictions and other autonomous texts for print publication, gnomic texts he has incorporated into his works for exhibition, texts he has used as titles for his works that function in relation to them as, in Marcel Duchamp's term, "invisible colors." Nowadays he even considers some of the elements of his pieces, the literal subject matter of his photographs – slices of leek, for example – as effectively textual in function.

All of this implies a concern with both elegance of form and narrative structure, which bind together his works from the past three decades and inform his use of photography in most of them. Beckley perceived early on the photograph's capacity for deception and thus for fiction. He uses the medium as might a sly, oblique storyteller, spinning cryptic, elliptical image-text tales that end before they're supposed to, turning back restlessly onto themselves, spare and inconclusive yet richly suggestive, unsettling like the nouveau roman of Alain Robbe-Grillet.

"The photograph," in Beckley's opinion, "has taken its place in full maturity alongside painting and sculpture." Beckley hews to the Cibachrome print for his photographs, because he likes the contrast range and tonal palette – "It's kind of advertising-y" – and for its supposed longevity: "They claim it'll last 200 years." The photographs he works with are of his own making. "I never got into the appropriation thing," he explains, "because I come from a puritanical background. And If you keep the Puritanism active, but restricted in that area of art-making, you can be free in the others, like the sexual." He senses something apposite in Ruskin, whose mother, he notes, "was a strict Scottish Puritan. For Ruskin, like many of us before and after, art was a way out of that pickle."

Beckley views the piece Roses Are, Violets Are, Sugar Are ... from 1974 as pivotal in his œuvre. The title and generative idea come from the old doggerel, "Roses are red, violets are blue, sugar is sweet, and so are you." The piece's five Cibachrome images describe the thorny stem of a rose against a red background, the smooth green stem of a violet against a blue background, and a thin line of white powder – sugar, presumably – against a yellow background. The singular "sugar is" of the verse has turned into the ungrammatically plural "sugar are," however; and missing from both title and image sequence is the supposed point of it all, some version of "you," here left strictly in the imaginary, for the viewer to either fill in or come to terms with as a permanent absence.

For Beckley, this piece – which, coloristically, harks back to an earlier one, Hot and Cold Faucets with Drain (1975) – served as a springboard for much subsequent work, including a recent series of "drain" constructions. "But," according to Beckley, "it also derives from Barnett Newman's question, 'Who's afraid of red, yellow, and blue?'" The resulting piece, undeniably, responds to and comments on color-field painting in a way simultaneously knowledgeable, witty, and respectful. That intricacy of association suggests the necessity of an awareness of the contemporary field of ideas as the premise for full engagement with Beckley's work, and certainly his art-historical, philosophical, and other cultural references are not readily accessible to those who have not tracked the discourse in recent years. Yet Joyce, even at his most difficult, can be read (especially aloud) and enjoyed by any literate person, and Beckley rewards all those who make the effort. His photographic works are clearly crafted by a man who enjoyed himself in their making. "Maybe we feel in the play of art the core of our life as a child," he has written, adding, "Humanity is respect for what humans have made."

A. D. Coleman

Untitled, 1986 46 x 56 cm

"What interests me is the edge of the world, not the middle. Only the non-interchangeable is of significance. If something doesn't quite fit in faces or in landscapes, it starts to interest me."[1]

In the sixties and seventies Sibylle Bergemann was an authoritative contributor to the women's magazine Sibylle and, together with Arno Fischer, developed it into the most important illustrated magazine in East Germany. That was when her first fashion photographs were produced, which she calls an "astonished reality." She places imaginative fashion in everyday contexts, producing a rich contrast, and precisely because of this association evokes an almost dream-like situation which makes the clothes seem like costumes from another world.

In 1974, the East German government awarded the sculptor Ludwig Engelhardt the commission to create a monument to Marx and Engels. Twelve years later, in 1986, the Marx-Engels-Forum was handed over to the public by the head of state and party leader Erich Honecker. Sibylle Bergemann was commissioned by the Ministry of Culture at East Germany's Council of State to document the monument's creation process in photography from beginning to end. Anyone who knows Bergemann's work will know that no objective documentation was possible, only subjective observation of the situation. She produced a black-and-white series: droll, almost ironic photographs of the individual work stages. The

monument changed constantly during its course of development. Stored in the open, it had to be well wrapped up to withstand the weather and then constantly unwrapped again, until the plaster model was finally cut up and carted off to be cast in bronze. Every important stone that contributed to its completion was recorded by Bergemann in her own special way.

The headless, bound forms illustrated here as representative of the entire series appear surreal – "instead of their heads Magritte-like cloud formations rest, supported by sports jacket and frock coat" – amid a lonely landscape.[2] Bergemann did more than document; with this work in particular she exposes the absurdity of this political commission. The dismantling begins, formerly important values are taken to absurd lengths, and the fragility of an apparatus of state that was to disintegrate three years after the ceremonial unveiling of the monument at the eleventh party congress of the SED (Socialist Unity Party) becomes apparent.

Peter Voigt refers in this connection to the satirical provocation of John Heartfield's photomontages: "... the effect begins where the laughing stops."[3]

Petra Kirchberg

1 Sibylle Bergemann, in Verwunderte Wirklichkeit (Berlin: 1992), p. 73.
2 Peter Voigt, "Nachwort," Heiner Müller: Ein Gespenst verlässt Europa (Berlin: 1990).
3 Ibid.

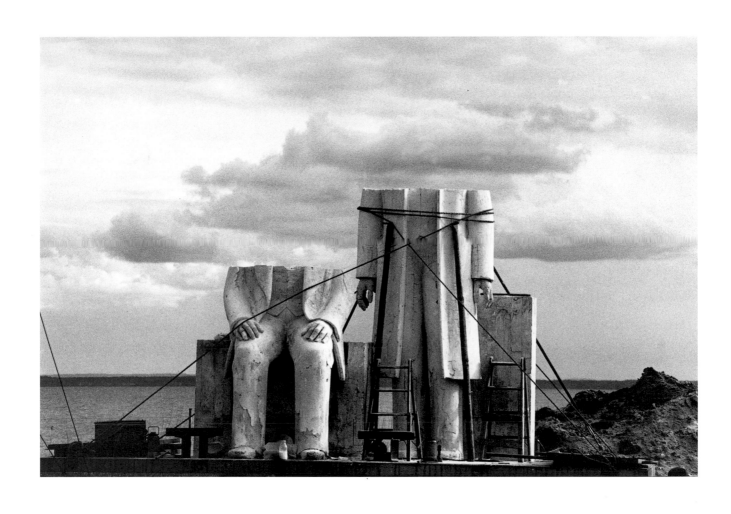

Joseph Beuys

Honigpumpe am Arbeitsplatz, 1974 – 1977
Detail Maschinenraum 34.5 x 22.7 cm

Honigpumpe am Arbeitsplatz, 1974 – 1977
Detail FIU-Raum 34.5 x 22.7 cm

Through photography Joseph Beuys ensured that there would be traces and relics of his journey through life and his working processes. The galvanized metal box with eight colored original photos is like the walled-in offering set in the foundation stone of the college for creativity and interdisciplinary research that was intended to impart the founder's expanded concept of art as a principle of building for life. But no institute for the investigation, animation, and training of creative powers (including dormant ones) was ever built. Since the death of the moving spirit in January 1986, the concept of building for life continues to exert a free-floating effect in the teacher's often misunderstood message that "everyone is an artist" and thus able to influence society creatively, whatever his work. The prerequisite is that he has understood human coexistence as a "social sculpture," by which Beuys means an organism formed from within, to the formation of which his deeds and actions are directed.

On the photos of the "action" Honigpumpe am Arbeitsplatz (honey pump at the work place: 1977) staged in Kassel during "documenta 6," connecting parts of an installation can be seen that symbolize the flow of energy between nature and society. The Plexiglas hoses and the pump system operated by electric motors formed a comparable arrangement for social sculpture right through the stairwell in the Fridericianum: for the formation of the colony (of bees) one needs a warming substance (honey), which solidifies to form a crystalline building material (wax). Energy produces matter. No

political group was more sensuously motivated to reflect than the one which Joseph Beuys started in 1972 during "documenta 5": an organization for "direct democracy via popular vote." (Incidentally, the "man with the hat and waistcoat" was also the man with the rose; he always had one with him as a flourishing example of "organic evolution.")

As a temporary warming sculpture, Beuys shortly afterwards filled cavities in an inhospitable subway on the way to the Stadtschloss in Münster with tallow for the exhibition Skulptur 77. The gigantic blocks of the Unschlitt/Tallow group have in the meantime survived for twenty years; the collector Erich Marx first loaned them to the new museum in Mönchengladbach and then in 1996 moved them to the Hamburger Bahnhof gallery in Berlin. The work therefore still exists; the photos are a reminder of its origin.

Starting with the "exhibition of a wound held together with sticking plaster" (which is how Beuys paraphrased the fact of his birth on May 12, 1921, referring to the severed umbilical cord), the photos taken by the best-known German artist of the second half of the century are primarily reminders for a man who, parallel to the development of his own personality, conceived a survival therapy – with felt and fat, copper and lead, slate and basalt, pitch and sulfur – through the art he lived. His thoroughly romantic teachings about the exemplary nature of the humblest things have preserved the twentieth century's human perspective. Gently moved, we look at the photos he left behind.

Günter Engelhard

Anna and Bernhard Blume

Transzendentaler Konstruktivismus, 1992 – 1994
Sequence, 2 parts, each 126 x 81 cm

In the contradictions, condemnations, and air bubbles of contemporary art, as well as in the crumbling firmament of clever thoughts and publicity slogans that soars above them, Anna and Bernhard Blume uncover the contradictions and strengths of (petit) bourgeois society, which is no longer capable of recognizing the risks of life among the constant babble of communications.

Photography is the medium and, together with "art," the subject of their joint artistic work. Neither of the Blumes can claim any professional training as photographers, although Bernhard Blume was familiar from childhood with the "magic" of the photographic process and the obligatory chemical smells in his mother's photo laboratory at home. Both the Blumes studied at the art academy in Düsseldorf, and Bernhard's friendship with Joseph Beuys influenced his entry into art, as did his philosophy studies at the University of Cologne. Independently, Anna and Bernhard Blume have both created extensive graphic works that touch on the complex links between ego-consciousness, the world, and art.

Since 1980 they have been working together with growing intensity on a "lifelong photo novel." In extensive sequences of mostly large-format photographic images they produce mises en scène focussing on the everyday illusions of the bourgeois existence together with the suppressions that ensure people are not aware of them. First, things were set in motion, both natural and fabricated, then the people; finally, the system that they had created in order to understand and control the world broke apart. What does not exist, what cannot exist, or at any rate not according to the laws of reason, what is not seen and in fact could not be recorded even with the aid of photography, but what nevertheless many suspect, some sense, a few fear – all this becomes visible. The catastrophes in the Blumes' large-format photos reflect nothing out of the ordinary. The German forest in the eponymous series that Anna and Bernhard Blume, as the protagonists of their pictures, attired in neat Sunday garb, visit for relaxation turns out to be a heap of rubble.

The suite Transzendentaler Konstruktivismus (transcendental constructivism: 1986 and 1992 – 1994), declared by the artists to be a "photo-action series," demonstrates with sardonic wit, black humor, and biting comedy the complex interrelationships between art, philosophy, and the world, drawing up designs for shaping artistic trends and their effects on social life. A particular point of the sequences is shown in the fact that they have chosen such a comparatively abstract artistic movement as Constructivism. The artists noted in a statement: "The photo-action series Transzendentaler Konstruktivismus shows the artists Anna and Bernhard Blume mostly as the media and the victims of arbitrary constructs. The whitish shapes of an intelligible material are trying to form logical figures or expanded organs of a purer reason that has not yet fully found itself."

Two diptychs, each with an encounter with a human being on one side and one of the aforementioned constructs on the other, in concrete terms a woman in three-quarter view and a man seen frontally with a square or rectangular "whitish shape," demonstrate the dilemma. The fear at this encounter of a supernatural kind is reflected in the face of the man, as in the face of the woman in a flowery dress; its cause provokes the blurring of outlines through sheer horror. In the male "part" the construct overlaps the two parts of the picture, the result of tireless experimentation, as in neither the one nor the other diptych are the spatial relationships of the picture parts identical. The spatial organization of the photographic pictures is not the same; the viewer's gaze finds no fixed point. Flat picture space contrasts with picture space in perspective. Perceive, think, feel: Anna and Bernhard Blume deliberately stir up a confusing interplay, expose conventional definitions as artificial structures, establish modes of perception as delusion and self-delusion, and provoke productive irritation. Wolfgang Kasprzik interprets the photo-action series Transzendentaler Konstruktivismus as a new stage in the artists' work. "The picture sequences no longer relate the story of a confrontation between human and thing, but show us a formal play with the possibilities of producing a space and a movement through several pictures – the picture of a happening," with exemplary consequences for the subjective attitude towards the world.

Klaus Honnef

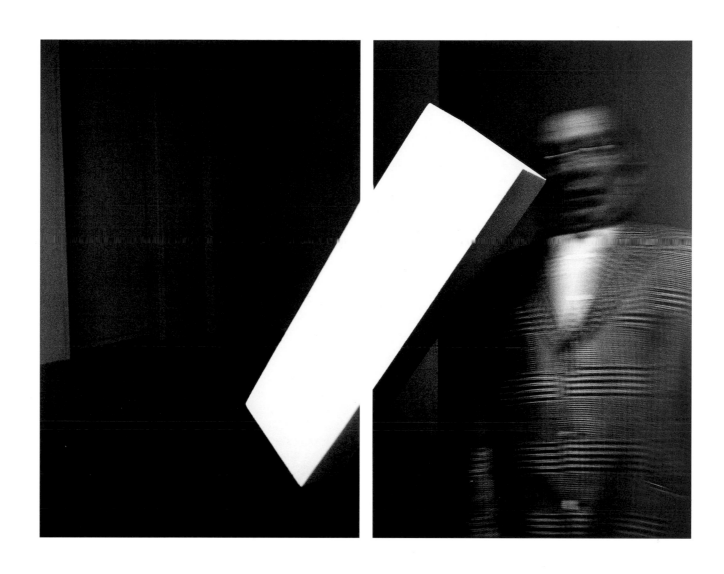

Christian Boltanski

One might resort to paired concepts such as fiction and memory, reality and invention to describe Christian Boltanski's art more accurately. What appears to be a fraught relationship between poetry and truth turns out to be a leitmotif of his art of memory. Strategies of calling up his own and collective memories and dealing with the finality of human existence are involved here. Boltanski investigates them again and again in his work. "Awakening memory and the presence of death" is how Serge Lemoine once defined Boltanski's main themes. These are the banal "archives of extinction" (Günther Metken) such as family photo albums, objects used in daily living, personal documents, letters, and so on. Depriving them of their original function and rearranging them, the artist exhibits them in shop windows, display cases, and in large-scale installations.

These pseudo-scientific presentations of objets trouvés, presented as they would be in natural history or ethnological museums, start with reconstructions of legacies which have been bequeathed by people now dead. Moreover, many relics from the artist's childhood are always cropping up. Recherche et présentation de tout ce qui reste de mon enfance (research into and presentation on everything that remains from my childhood: 1969); Essais de reconstitution d'objets ayant appartenu à Christian Boltanski entre 1948 et 1954 (attempts at reconstituting objects which belonged to Christian Boltanski between 1948 and 1954: 1970/71) and Reconstitution des gestes effectués par Christian Boltanski entre 1948 et 1954 (reconstitution of gestures made by Christian Boltanski between 1948 and 1954) are just a few of the titles given by the artist to some of these fictitious reconstructions of records. Photography plays an important role in this research as a magical substitute for the actual presence of real people. Primarily taken to reconstitute fictitious memory, snapshots represent a pictorial world with an aesthetic sense which is largely independent of the standards set by professional photography and the other visual arts. Christian Boltanski prefers amateur photos and snapshots, pictures from photo vending machines or motifs cut out of illustrated magazines to photographs with any claim to aesthetic qualities. Blurred focus, under- or multiple exposure form just as much a part of the aesthetic idiom of this genre as unusual and unintentional composition.

Boltanski's preoccupation with his childhood is acted out in yet another variant dating from 1974/75, his one-act plays cycle. The artist here played scenes and reconstructed important moments of his childhood, sometimes before live audiences. The main protagonists were his grandfather, mother, father, priests, teachers, or Christian as a child. This cycle reveals him as a magnificent storyteller and quick-change artist who parades the rituals of family life in a bourgeois environment before his audience. Using a minimum of props, he employs clown-like gestures. Christian's Birth, Illness and Death of His Grandfather, Grandpa's Memories, Eavesdropping on a Conversation, Blamed Unfairly, His Parents' Marriage, Punished for Grinning and Mother Getting Dressed are the titles of his one-act plays, which are usually enacted in front of a colorfully painted set in Abstract Expressionist style. The artist always wears the same dark suit and uses very few props. Boltanski has succinctly set the stage for the plots of his sequences in a few terse sentences which resemble theater stage directions. After photographing a one-acter, he worked over the black-and-white prints with brush and drawing pencil.

The figure created by the Munich comedian and comic actor Karl Valentin was Boltanski's inspiration for the series. The two are linked by a similar feeling for the absurd and dramatically grotesque. This instinct for the theatrical is shown in titles like Saynètes comiques, which is the French equivalent of Valentin's one-act comedies. Like Valentin, Boltanski seems to be mocking the rituals and customs of bourgeois life via the role of the clown, a figure both cheerful and melancholy. One might easily misunderstand Boltanski's one-act comedies in viewing them as a record of his personal experience. It is not so important to distinguish between "real" and "imagined" experience. Looking back, the artist found that reconstructing the various phases of his childhood resulted in his "no longer having a childhood. I deleted it by inventing a lot of false memories. An artist plays with life; he no longer lives it."

Ulrich Pohlmann

Rudolf Bonvie

The question of what the real properties of photography and related phenomena are runs like a thread through Rudolf Bonvie's work. As S. D. Sauerbier puts it, the artist is conducting an aesthetic investigation of "the verdicts of perception, both their preconditions and processual results." In several respects Bonvie's work expresses a subversive attitude of denial and a detached reflection on the manipulative ways photography is used, which always confront us in modern media society.

In early works such as J. R. and P. H. (both 1978) or La chasse photographique (the photo chase: 1980), the artist subjected to critical investigation the impact of photography and the spectacular way this is exploited in tabloid sensationalism. In his portraits, he blocked out both eyes and picture captions blown up to reveal clearly the halftone dots with black bars. Paradoxically, this intervention came closer to restoring individuality and its personal aura than to effacing it since the artist eschews the banal voyeurism of collective image reception. Enlarged to a panoramic scale, the censoring block-outs he has used here for the first time are open to associative readings.

Rudolf Bonvie allows social and political connotations to recur in his work. His Rhapsodie nucléaire (nuclear rhapsody: 1986/87) deals with the complex interrelationships between "knowing, conceiving of, and experiencing the devastation nuclear power" (Ute Eskildsen) has wrought in industrial societies. What has been highlighted by montage technique, alienation or mixed techniques, and intermingling picture planes turns out, when examined more closely, to represent an aesthetic stance that is enlightening yet never tediously didactic. Since the late 1980s Bonvie has been working in large-scale horizontal formats. Here abstract texture or monochrome color shapes dominate in extreme enlargement as macrostructure. Close scrutiny of his horizontally tripartite Gelb, Rot, Schwarz (yellow, red, black) reveals various types of caviar, ranging from mustard-colored to black, "genuine" and "fake" Beluga, arranged in a banner-like composition. The title of the work of course awakens primary associations with the German flag and the German state. Is this, therefore, an allegory of recent German history, which symbolizes the degree to which a society can become satiated? A society in which identity and coherence can only be represented as various types of caviar? Interpreting the horizontal triptych only on the political plane, however, would mean ignoring the art historical references which Rudolf Bonvie is seeking in his treatment of American painting, the work of Mark Rothko or Barnett Newman, for example. By dissolving central perspective and concentrating on surface as such, Bonvie has made his pictures into signs. They seem to translate the referential principle of All-over Painting informing Barnett Newman's Who's Afraid of Red, Yellow and Blue? into photography.

Rudolf Bonvie's work is provocative. But this is provocation which is highly sophisticated, its subtlety irritating to the beholder. The five-piece work jointly executed by Astrid Klein and Rudolf Bonvie, Die schönen Künste (the fine arts: 1992) is an enigma, illogical at first glance. Each panel is an autonomous iconic sign, which can be read neither sequentially nor as a narrative. By 1981, Bonvie was voicing subtle criticism of the postcard kitsch that is conventional painting via his installation Les Beaux-Arts. In it, photographs of trivial French painting were superimposed on an empty easel and the graffiti scrawl "Les Beaux-Arts" by means of a slide projector.

Les Beaux-Arts, on which two artists collaborated, can also be read as an ironical commentary on the current situation or function of art in the Western hemisphere. It remains a moot point whether the postcards with erotic motifs refer to the quality and seductive superficiality of 1990s art, on which art on the comptoir des beaux-arts, in the fine-arts trade, has become an art of catwalks and signposts. The lecturn of Arno Schmidt, the writer as recluse, the field-glasses, and philosophical treatises on art lying on discrete levels, all point to an archaic aesthetic position, distinguished by theoretical knowledge and detached voyeurism. Regardless of such efforts at interpretation, the work remains enigmatic and thought-provoking, proof that Rudolf Bonvie's work exposes the relationship fraught with conflict between reproduction and conception.

Ulrich Pohlmann

Johannes Brus

Blaues Pferd, 1979/85 128 x 180 cm

In 1979, Johannes Brus gave viewers the following to take with them on their journey through his pictorial cosmos which leads "to the earth, its moist, Irish brown rocks, thick green fruits and steaming black and blue horses, fire in the forest and intoxicated bottles and cucumbers..." "Much will remain, as it has to me, unintelligible. That may be because you use too much intellect..."[1] One eye should be gazing deeply into the external, the other into the inner "space-time." Thus Brus sets off, not without humor, to seek the irrational, the concealed, and the arcane in pictures and things which we think we know. Cucumbers were still whirling through the air in his first photographs, probably as a travesty of the still life as a genre. Now, his interest in things has been extended to questions which incorporate ethnological, scientific, or mythological traditions and how they are pictorially represented. He juxtaposes them to create unusual relationships, combining the contemporary with the past. In his photos, which are often in large formats, Johannes Brus transforms the predefinitions of reality into poetically sensuous pictures, which conceal only vague memories of them. Distrusting precise high-gloss photos and the assumption that they can reproduce objectively what has been seen, he links – as one of the first to use photos in a radically unfamiliar way – motifs of diverse origin through collages, double and subsequent exposures, combining them into a reserved whole. He exploits all possibilities of manipulation imaginable to achieve new pictorial statements. The artist intervenes even at the exposing and developing stages. Through chemically altering the black-and-white prints he achieves strangely subtle color effects, throws the image out of focus and allows scratches on his negatives, flecks and spots that occur during developing and fixing to become shaping elements of pictorial form. He welcomes the coincidental and unpredictable to break what is static and calculable. Painting has fostered these photos. They are distinguished by gesture, traces of brushwork, high-value light-dark contrasts, spatial overlays and schematic configurations, plants, animals, or objects which seem to be embedded in an undefined landscape.

Photography, which Johannes Brus at first only used to sketch ideas for sculpture, has since the early 1970s been an autonomous medium in its own right in taut analogy with his sculpture. The latter is primarily peopled with life-sized human figures, animals, and mythical beings which are grouped into still lifes so that dialogues can develop between man and nature, mythology, culture, and civilization. The colored plaster sculptures represent the typological rather than individual, recalling archetypes. A green rhinoceros, a unicorn, Anubis, a bird of prey or a human: we meet them all again in widely varying contexts in his photos. Consequently, the horse, which found its way via a snapshot into his photographic œuvre to run through it as a frequent motif, is also present in his sculpture. Combined with a tower of plaster and chocolate, as well as an abstract relief of a bird, it represents nature, naturalness and freedom, recalling the past and the original inhabitants of the country in the ensemble Drei Plastiken für Amerika (three sculptures for America: 1978). Since it is covered with blue paint, however, its symbolic content is even more extensive. Blue is the color of romance, of yearning, of unfettered imagination. References to the history of art also open up. One need only recall Yves Klein's immaterial blue or Franz Marc's horses. There is a blue horse in a series of photos whose quiet grazing in a real-unreal landscape surrounded by a bright aura echoes the pose of the sculpture. The contours of the horse in the photo blur into the background, creating an impression of evanescence as well as movement. Sometimes Johannes Brus' horses bear riders and, as in Zwei tibetanische blaue Reiter (two Tibetan blue riders: 1988) and the figure in Mit Franz Marc bei den Wilden (with Franz Marc and the savages: 1975/76), lead the spectator into misty landscapes. The imaginary adventurers of Während einer Expedition in mein Unterbewusstsein zeigt F. Marc S. Freud den Berg "Wildes Denken", worauf dieser rot wird (during an expedition into my subconscious F. Marc shows S. Freud "Wild Thinking" Mountain so that the latter blushes: 1979) are also riding blue horses. This is yet another indication that the artist is always concerned with setting out into the unknown realms of the eye and the spirit.

Beate Ermacora

1 Johannes Brus, Johannes Brus – Arbeiten von 1971 – 1978, Galerie Defet (Nuremberg: 1979), n.p.

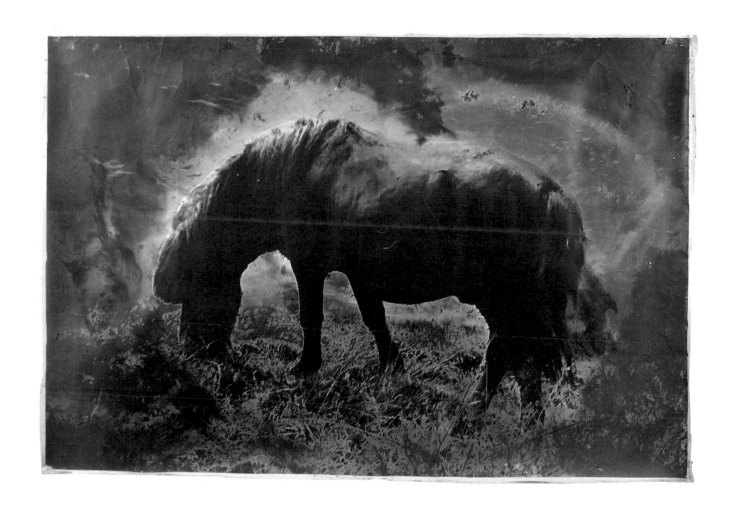

Suspension I (Lumière), 1997 134.7 x 185.2 cm

On his nomadic wanderings, Jean-Marc Bustamante finds arresting photographic motifs on which to base his social-architectural topography in art. Through material associations in the form of wall or floor pieces, his concept of dialogue assigns the photo a dominant position between sculpture and installation. Like Minimalist markings, at a distance, Bustamante fastens to walls serigraphic photos of interiors transferred to Plexiglas (Lumières). He also consolidates the status of photos on the floor between the vertical and the horizontal, between ornamental or geometrically defined steel cut-outs and concrete sculpture.

As "displacement," this technique opens up an irritating as well as constructive view of the forbidding places captured in the photos to a spatial shift from the materials of art. The deliberately sought conflict between the various visual-arts disciplines forces uninitiated guests in Bustamante's rooms to resort to an attempt at visual coordination, which can be very helpful in orientating oneself in the architecturally disrupted external world. Passages, subways, and bridge systems are represented like blank spaces in communication, the sobering explicitness of purely functional urban architecture. Jean-Marc Bustamante has focussed on this as his principal theme, making it meaningful as a sociological term for "urban inhospitability." Through the originality of his classification, the artist lends the term a poetic facet of meaning.

A native of Toulouse, Bustamante was studying economics in 1978 when he set out to explore the urban fringes of cities. There he started capturing the crumbling facades of urbanization, which was slowly growing behind garbage and rubble. What he caught was a melancholy, painterly mood. He found houses which had been left unfinished and the earthy colors of building sites in his native southern France particularly inspiring. The tableaux which he was already producing at that time reveal a tendency to arranging emptiness in the manner of Pittura Metafisica (metaphysical painting), with its panoramic solitude. Bustamante's approach to his work and the technical preparation he makes for it aim at generating a panorama which only suggests that the emptiness of the painting he has simulated photographically may be inhabited. The decisive choice of motif is, therefore, the precondition for the hard-won static effect he has created photographically. His cameras are not suited to capturing swift motion. On the contrary, Bustamante wants slow motion, "that is, the movement of the earth and also that of decivilization." The process is still manifest throughout the photographic part of his work. Amandes amères (bitter almonds) is the title of his travel book consisting of thirty-eight color plates for "documenta 10." Its contents include representations of the anonymous fringes of Tel Aviv, Buenos Aires, and Miami, all captured in the uniform light of late afternoon.

Between 1983 and 1986, Bustamente collaborated with Bernard Bazile. He placed his photographs within a specifically encoded system of material signs by using the name BazileBustamante. The two artists separated when Bustamante began to aim at something less abstract, making his photos correspond with artificial, sculpturally furnished, and painterly handled space. The geometry of objects used in everyday living, such as shelves, bunk beds, and sandpits, has, on occasion, come to replace laconically abstract geometry. Since then, space has been articulated as a systematically arranged picture straight across a disorganized environment. The picture is not interior decoration. It is, however, located between the coordinates of photography and the reddish rust prevention paint used to color the objects. Works of this type literally seem to arise in stringent architecture. This can be seen in the exhibitions in the Arnheim Rietveld House and in Mies van der Rohe's Krefeld dwellings, which are used as museums.

Günter Engelhard

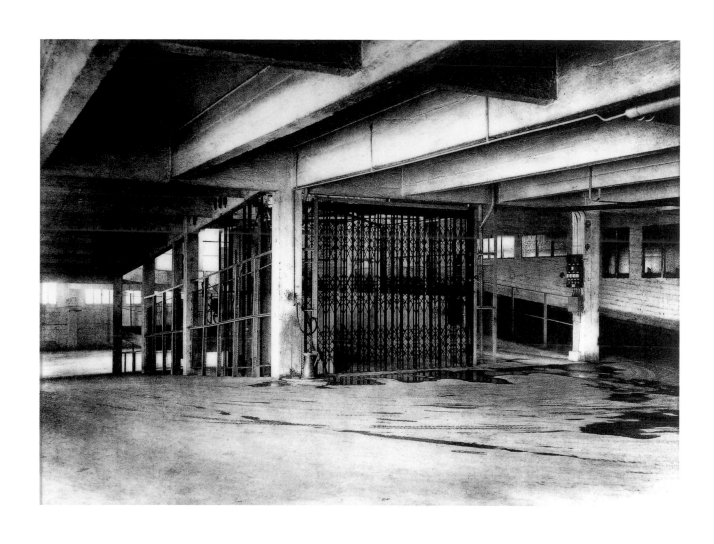

John Chamberlain

As sculptor and as photo-artist, John Chamberlain expresses the thrill of speed: in the crash the splendidly damaged gloss of metal crumple zones freezes elegantly into a baroquely sculptural death pose; photos with lightning-fast blurred rays of light seem like seismographs of the preceding acceleration. The wavy skid marks between the people in front of a house facade out of its setting (Barbihu), the streaks of light of the Studio Lite impressions, the swaying torque forces of Downtown, obliterating all outlines, transform firm bodies and hard material into dramatic calligraphies that follow in the footsteps of American Action Painting.

In fact it was Action Painting that determined the environment in which the artist John Chamberlain started out. He has been photographing ever since 1964, although it was only in 1977 that he started using the Wide-lux camera that enables him to take wide-angle panoramas without distortion, in emulation of the town and landscape photographs of the nineteenth century. Motifs in the periphery are included at a viewing angle of 150 to 360 degrees by panning the rotating lens, with the exposure time depending on the speed. This gives his photos their coloristic turbulence. If anyone really saw things like this he would be overwhelmed by dizziness and lose all sense of orientation, as well as his driver's license, despite the romantic components of evening sky and neon light. At a run, Chamberlain sets all the fixed objects along his camera's course into motion: the photo distorts things and dissolves them as phenomena that have moved in the extended field of vision. What we see are not photos of an action, but photos from the point of view of the action. The dynamization of the motif through movement that the Futurists strove for has become independent – like a discus that throws its athlete.

The outcome of all this has been known since 1958. That was when the American, born in the catchment area of the Indianapolis racetrack, drove the car through the scrap crusher into the zone of art experience and achieved a dramatic gesture with metal at the height of the Pop era. Impressed by the arrow-swift catapulting of an elegant asphalt missile into brutally distorting compression, he undertakes the transfiguration of bolides, fireballs. The movement registered by the rapidly panned camera is then captured and materialized as a mind-stopping effect. The structures freeze in folds that have been compared to Leonardo da Vinci's studies of the folds in garments. Just as Leonardo wanted to drape the fabric "so that it doesn't look uninhabited," so Chamberlain crushes his metals into corporeal form.

Dooms Day Flotilla, a multi-part floor sculpture dating from 1982, achieves such a beautiful color dramaturgy that it should be taken as homage to that existential absoluteness that the sculptor David Smith and the painter Jackson Pollock shared with the film idol James Dean in the years when Chamberlain was starting out; all three departed this life courtesy of the automobile. A pointed sarcasm lurks behind some of Chamberlain's titles: Daddy in the Dark – a white twist of metal for a father who died in an accident; End Zone Boogie – a dancelike end to a dream ride at night under the influence of alcohol. These are almost film titles, and in fact Chamberlain did make experimental films for seven years (up until 1974) in friendly proximity to Jonas Mekas and Andy Warhol. Eager and uncontrolled, the films follow his friends as they wile away the time in a dissipated fashion. Often the handheld camera swerves away on its own during nervy zooms, so that those very movements are recorded on film that positively invite the retention of a quite separate status as "chance ornamentation" in photography with a painterly touch. Textile patterns, advertising billboards, chrome accents, and light shows demand that one remains in the moment created by photography.

Günter Engelhard

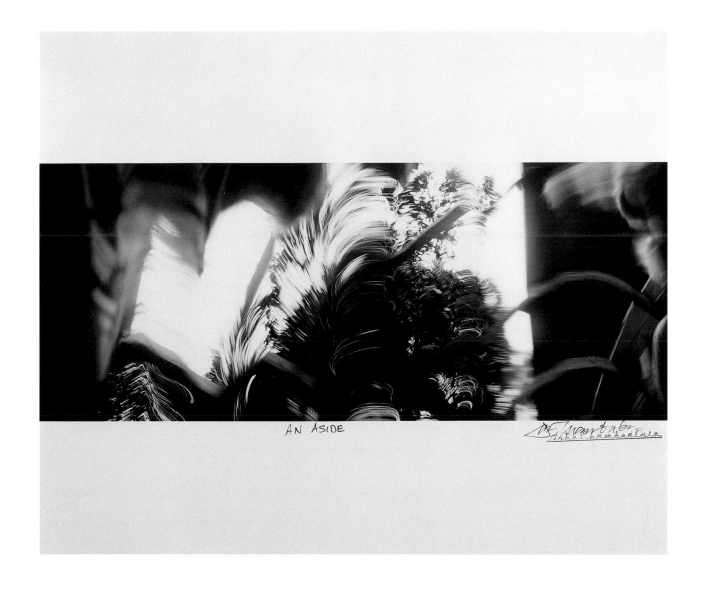

AN ASIDE

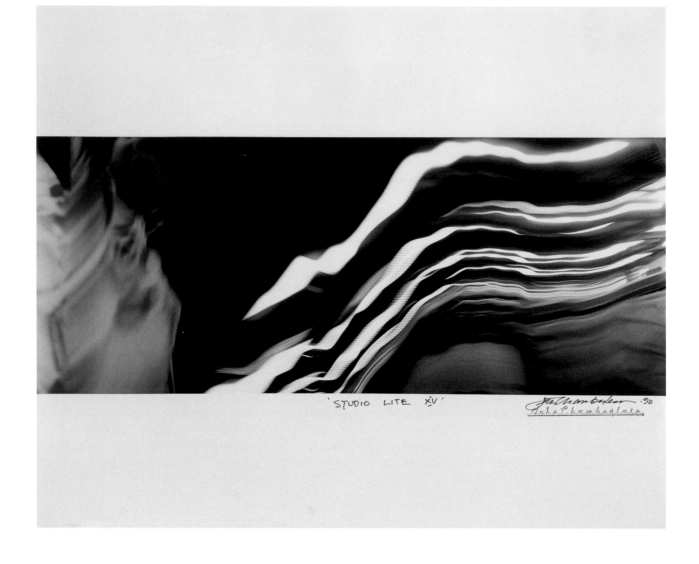

'STUDIO LITE XV'

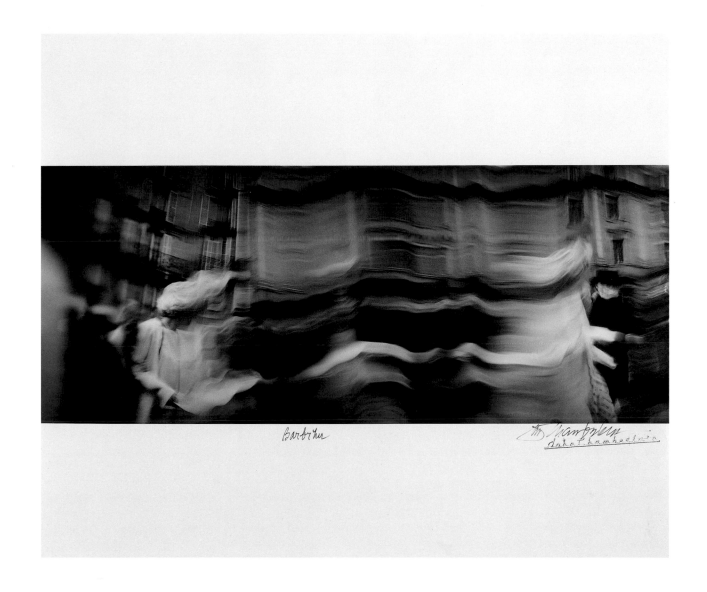

Barbara

Clegg & Guttmann

The American artists Michael Clegg and Martin Guttmann, who produce work jointly under the name "Clegg & Guttmann," are involved with projects on the theme of the "portrait" in its widest sense, although these projects at first sight differ greatly from one another. The emphasis is less on portraits of individual people and their idiosyncrasies, and rather more on portraits of particular groups or communities.

Clegg & Guttmann became internationally known with their large-format photographs, the Group Portraits, which were produced from the end of the seventies. The starting point for these works were executive group portraits of the type used in the annual reports of big companies. Clegg & Guttmann were interested in the way in which power, responsibility, respect, and hierarchy were expressed in these pictures, both in their overall staging and in the poses of the individuals. They took this "rhetoric of pictures" (Tilman Osterwold) as the theme for their own works by using alienation – unusual lighting effects, annoying mises en scène, elements of collage – to introduce uncertainty into supposedly real scenes. These interventions intrude on the matter-of-fact way in which we normally look at such depictions. They provoke us to examine them more closely, so that, for example, the polished self-presentation of the participants as such becomes obvious. These works by Clegg & Guttmann thus reflect not only the "code of power," but they also show the act of portraiture as a blueprint for fiction.

In a more recent series of projects called Die offene Bibliothek (the open library), the artists are concerned with portraits in an extrapolated sense. In these, the actions of the participants take on an even more obvious central role than in the staged portraits. Die offene Bibliothek has so far been set up as a temporary installation in Linz (1991), Hamburg (1993), and Mainz (1994). The basic pattern of this project consisted of setting up bookcases in public zones in various places and leaving them for the use of the local residents, who themselves also occasionally made books available. A notice in several languages gave the ground rules for use. Beyond that there was no further management or supervision of the installations.

With such projects Clegg & Guttmann start from the premise that the participants – e.g. the residents of certain neighborhoods – will be encouraged by their joint activities and by the resulting discussions to define themselves as a community. As the same time a project such as Die offene Bibliothek can be read as a portrait of these communities. It is not recorded in any photographic documentation but develops during the course of a living process that is reflected in the unobtrusive evidence of the action.

Again, in Museum for the Workplace, which Clegg & Guttmann developed at the DG BANK, it is a question of the process of portraiture and the involvement of those who are to be portrayed. Employees from various departments of the DG BANK were asked to provide art objects from their private collections for a short-term installation. These could be artworks in the broadest sense: paintings, small sculptures, posters, photos, postcards, anything and everything dear to the heart of its owners. These loans were compiled into four groups by the artists at the DG BANK and photographed. The photos were enlarged to produce large-format pictures in which the varying sizes and materials of the individual objects recede in favor of the overall impression. The various objects, whether a child's shoe, a postcard, or an oil painting, become works of equal status in the collection of the Museum for the Workplace, which is linked into the architectural context of the DG BANK.

The objective of this work by Clegg & Guttmann was to compile a portrait of a "working community." People are represented by various objects, the only common characteristic being the fact that they all come from the private sphere. They point to aesthetic preferences, are evidence of their owner's own creativity, or incorporate particular memories. As a result of the installation of these objects within modern, anonymous office architecture, a strange, tense relationship is produced between the public and the private spheres. This confrontation forms the perfect solution for Clegg & Guttmann's aim to "stimulate the collective identity and motivate to self-reflection" via the Museum for the Workplace.

Iris Cramer

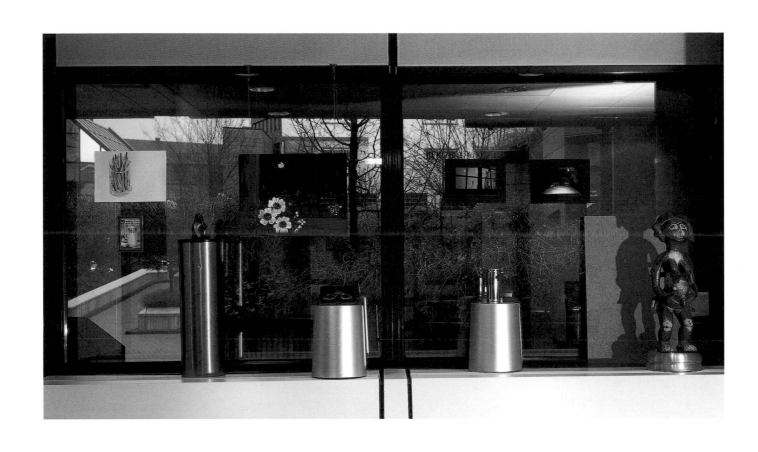

Chuck Close

Chuck Close photographs faces with a large-format Polaroid camera in order to reanimate them for subsequent portrait painting on canvas. Relatives and friends – such as the painter Roy Lichtenstein shortly before his death – offered their images for the data storage system of "biomorphic abstractions" (Close). The digital ink-print of the photo Roy II (131.5 x 99.5 cm) contains, as a model reproduction, "skin-deep" information which is only waiting to be called forth to a new artistic "life" using the brush. From the microorganism of many hundred ornamental cells, it is as if a programmer, armed with a radar unit, were to conjure up all the phenotypical reality of the human face, in close-up an abstract mosaic which at ten meters' distance coalesces for more exact recognition.

As a rule, the frontal shots are made under the artist's direction in 100 x 84, 72 x 60 and 36 x 30 cm format instant pictures. By virtue of their size and the streaky picture edges – caused by the developing fluid – they challenge the painting process: it is subsequently consummated within a grid which initially subdivides the photo and, in corresponding enlargement, the image carrier as well. The geometric network of tiny squares is filled with thousands of colored particles so that the photograph, through painting, can again be attributed those qualities of timelessness and spacelessness that are credited to the individual photo owing to its removal from the flow of time. This involves approximately four months per painting. Thus, the purely labor-related expense justifies the market value: a price of up to US $500,000 has been named in connection with the 1998 retrospective in The Museum of Modern Art in New York.

"I wanted to bowl people over!" Chuck Close explained on the occasion of his first aggressive, enlarged passport photos in 1968. These immediately followed the portrait of his composer friend Philip Glass. Meanwhile the time that he needs for a work has greatly increased due to a tragic handicap. Since the failure of an artery in the artist's spine, he has since 1988 had to sit in front of the easel confined to a wheel chair. The paralysis has also robbed him of sensation in his fingers. Now he has to adjust the brush's position using an arm sling to stabilize his hand. He has mastered the mechanics of this to such a remarkable degree that he has retained precision and sensitivity as tangible components of his art. Dabbing and circling, Close transfers the photographic reality of the human face to Albrecht Dürer's coordinates in painting. During the actual painting the canvas is drawn up out of the floor from a slit; the picture emerges analogous to the manner in which a photo emerges from a Polaroid camera, only far more slowly. As image-maker who records his environment primarily with his eyes, Chuck Close "adds" his character portraits from top to bottom and from left to right on a downward slant and in a syntactic procedure from minimalist units such as rings and strokes, molecular fibers, and electronic impulses. The painter's simulation of the exposure and development process has, besides Roy Lichtenstein, found devotees among mainstream artists such as Richard Serra and Jasper Johns, Robert Rauschenberg and Eric Fischl, and Cindy Sherman and the instructor Alex Katz. In the depictions we find the essential streams of American art since Action Painting, Pop Art, and photographically intended Hyperrealism, up to Minimal Art and Conceptual Art, the possibilities of which have enabled the disabled Chuck Close to plan his future work firmly upon a photographic foundation. And so it was that the artist has meanwhile acquired, according to The New York Times, a reputation as the "leading portrait painter of the Electronic Age" – without competition.

Günter Engelhard

Hannah Collins

Loss, 1996 220 x 160 cm

Documentary photography is a specific category of photography. In it, content prevails over form. Content refers to something that is factual, something which has historical, political, or social content. The essential thing is that what is shown actually exists. In documentary photography, the representational character of photography must be retained or the photo cannot be a document. The historical development of documentary photography from its beginnings to the present has, however, shown that the boundaries between documentary applications of photography and purely aesthetic ones are blurred. This has happened against a background of a rising flood-tide of images which has overwhelmed all differentiation between form and content, whatever they may be.

Hannah Collins' photographic work offers a potential for resistance against it on several planes at once. Her photographic cycles such as Signs of Life or The Hunter's Space are produced in the field. To ensure that this is so, the artist undertakes extensive journeys to the regions she documents in her work. Unlike the photojournalist whose work is commissioned by magazines or newspapers, she is her own boss. The freedom of viewpoint thus gained is what allows the approach to subject matter, which lends documentary work its specific status. Hannah Collins captures situations which are to be interpreted as pointers to social conditions. People are rarely shown in her work. This is due not so much to lack of direct encounters as to respect for human beings as such. In contrast to shrill tabloid journalism, which feeds on the sufferings of others, Hannah Collins' photos are not staged to create superficial effects. They radiate a peculiar melancholy all their own. This quality becomes apparent in the work included in this collection. The title Loss might be taken to stand for Hannah Collins' work generally, for these photos usually record loss, a distinguishing mark of melancholy.

The artist works in oversized formats. Photographs from her In the Course of Time series measure 2.30 by 5.45 meters. The size of these photos represents a specific constituent of expression; each of them can only be grasped as forming part of a whole when viewed from a distance. The observer of this work is compelled to decode what is representational by interpreting its individual constituents. Unlike photos in the print media, which can be grasped at a glance, these are works that exact of viewers that they read them in order to interpret them. Content and form in Hannah Collins' photos suggest stylistic parallels to cinematography. Thus the vast scale of the works approaches the dimensions of a cinema screen. The element of time in Hannah Collins' work is revealed in this parallelism. On the one hand, the photo cycles mentioned above are contemporary records documenting a historical period of time. On the other, the act of "reading" Hannah Collins' photos is in itself a temporal process. Nevertheless, these pictures are equally effective against a background of painterly topoi such as the landscape and the still life. Static representation and stringency of form refer to this background. In the ambivalent tension between "painterly" statement and historical document, Hannah Collins is resisting the "fury of the evanescent" in which the world and the possibilities of representing it seem to vanish.

Thomas Wulffen

96

Thomas Joshua Cooper

Mythic Stone – Message to Timothy H. O.,
Sullivan Gullfoss, Iceland, 1987 43 x 60 cm

He is a wanderer between the worlds. Between a safe, secure world and ruin. Between the familiar and uncertainty. Between the present and the distant past. Between life and death. He is a wanderer between the worlds who teeters with his camera on the ridge which makes it possible to wander between worlds that are absolutely antithetical.

He started off wandering between the times. That was in the 1970s in his home state of California. In the Sierra Mountains by hidden waters, in consecrated places once sacred to the Mojave, the Yurok, the Monopaiute and the Yokut. There he sought the spirit of time past. He sought to conjure it in the stillness of nature in images permitting contact through a world gone forever.

Not long afterwards he came to Europe. At first to England, then to Scotland, where he now lives. A descendant of seafarers, he was drawn to that boundary at which his ancestors might have been confronted with the last possibility of a decision before leaving their original home: the rocky coast of Scotland, at the western end of Europe, on which the unpredictable waves of the Atlantic inscribe their concept of time in endless patience.

Yet again he was striding towards a boundary where he could still go. It was the boundary between land and sea, between cliff and water, between hesitation and departure to return no more. For him it again meant a way between his present and a distant past. A past that he could link with the names of Scottish clans whose sons fled the shackles of Puritan dungeons for the New World beyond the horizon. Here he made pictures with titles like Rubha Na Moine or The Northernmost Point.

Then he was drawn further south, far southwards. To the place where centuries before the ships of Fernão de Magalhães, Ferdinand Magellan, set out to cross the rim of the known world for the unknown. The World's Edge is what he has called the work he did there. Eight pictures, eight meditations, as he calls them himself, taken high above the rocky cliffs of the Portuguese coast. There, where once the sails vanishing over the horizon were longest visible.

These photographs are meditations because they compel you to contemplation, to tranquillity, to surrender to the depths of time. The observing glance and thoughts follow the slight surf into the mist and the night across the horizon. You stand in front of these vast pictures, touch the earth and the past with your feet and look into an uncertain future. That is the tale told by Cooper's photographs. He often calls himself a "storyteller," a teller of tales.

When Thomas Joshua Cooper takes photographs, he is letting himself in for adventure. He always exposes just one negative in his plate camera made of wood, brass, and leather. He eschews the convenience offered by the photographic technique of using several different exposure settings ("bracketing") to ensure a high degree of success. What fascinates him in his craft is the conflict between certainty and uncertainty. Certainty and uncertainty were the same psychic forces that moved the seafarers of yore. The forces whose traces Cooper makes visible in his photography, an element that preserves no traces. Thus he entices the viewer of his pictures into a condition of the imagination which may on occasion extend to the sense of hearing. The waters of the sea have a voice.

Peter-Cornell Richter

Within these particular regions my work explores an unexpected history of being lived in, perhaps an external space of the domestic. This contemporary domestic space is not forced or domesticated. It resounds as a space of palpable intimacy – as a space in which contact takes place. Here the need for the domestic, the undeniable but often irreconcilable yearning that we feel for belongingness, can finally unfold and be satisfied.

Anton Corbijn

For the Dutch photographer Anton Corbijn, who lives in London and Los Angeles, photography is only one way of expressing his visual creativity. The son of a pastor and self-taught in photography, he started taking photographs at pop concerts when he was seventeen. What was at first a passion soon became a commercial success, and today Corbijn is undeniably one of the most famous and most interesting portrait photographers on the international pop and rock music scene. Many of his motifs decorate record sleeves and CD boxes or have been published in music magazines. Musicians and bands such as Steely Dan, Clanned, Bryan Adams, and U2 have come to depend on his aesthetics of portrayal. Yet Corbijn is just as much at home in the world of moving pictures, as an abundance of music videos and films on singers and bands such as Golden Earring, Echo & The Bunnymen, Depeche Mode, Joni Mitchell, and Peter Gabriel shows. Moreover, since his spectacular solo exhibition in the Hamburg Deichtorhallen in 1996, Corbijn's photographs have also found their way into German museums.

One might naturally raise the objection that his portraits were made primarily for the purpose of supplying the billion-dollar industry represented by the mighty media concerns with dazzling pictures, thus promoting the commercial interests of the star cult. Nevertheless, Corbijn supplies the finest and most intelligent pictures from the trade, which is always demanding new and impressive motifs. His portraits bring across the glamour, the aura surrounding film stars, writers, musicians, and artists in a way totally different from the restlessness of video clips, dominated by endless intercutting, or conventional star photography.

Only very rarely have these photographs been taken in the studio with the conventional props. Corbijn prefers to shoot his portraits outdoors so that he can be absorbed and inspired by the here and now of the situation away from the stage. These are not so much candid snapshots as the result of a game in which the photographer and those portrayed are equally involved. The intimacy of the moment captured here of course represents pseudo-privacy, yet it is staged by mutual agreement and in the relaxed ambience which Corbijn is able to summon up as if by magic just by being so flexible. As a result, his work does not confirm the stereotyped cliché of the extroverted personality which is used to living in the limelight. On the contrary, Corbijn brings out new facets of each artist's personality. As Brian Eno, who has often worked with Corbijn, puts it: "At the end of the process you don't have the feeling you've lost your soul. Instead, you've tried out a few new ones. And that is one of the games at the heart of pop culture. The game where you say 'What else could I be as well?'" Corbijn's portraits of Johnny Cash, David Byrne, Johnny Depp, Martin Scorsese, Bruce Springsteen, Jon Bon Jovi, Dennis Hopper, Keith Richards, Mick Jagger, William S. Burroughs, Frank Sinatra, Boy George, Billy Idol, and Isabella Rossellini, in which the stars have abandoned much of their posturing and aloofness, are similarly testament to his skills. Corbijn's photography reveals them as more vulnerable, sensitive, and introverted or introspective, showing them either rapt in contemplation or even in a mood of bleak melancholy. Since his books Famouz and Star Trak were published, Corbijn's reputation as an excellent black-and-white photographer has been assured. His dramatic sepia-tinted portraits place him close to William Klein and Robert Frank. He is experimenting more with color photography. It remains Corbijn's secret whether he achieves his wild color effects in the darkroom or by means of High Key while taking his photos or by means of special filtration techniques. At any rate, the resulting psychedelic luminosity of this work bears almost no resemblance to conventional color photography. It is really more reminiscent of Andy Warhol's silkscreen prints.

In the group portrait of the Irish pop band, U2, whose members Bono, The Edge, Larry Mullen, and Adam Clayton recur constantly in Corbijn's photo productions, the actors have become schematic patterns in color and are no longer distinguishable as individuals. Corbijn is not interested in a mimetic translation. He has produced an abstract composition of magical colors which enters into a relationship of synesthesia with the music, inducing a sound experience which is both musical and visual.

Ulrich Pohlmann

Mario Cravo Neto

Odé, 1989 47.9 x 47.9 cm

Mario Cravo Neto was born in Salvador Bahia, Brazil, in 1947, and still lives there. The artist, who today works almost exclusively in the medium of photography, is the son of a distinguished Brazilian sculptor. Mario Cravo Neto also trained as a sculptor and attracted attention in the 1980s with installations. His current work embraces both documentary and staged photography. As a documentary photographer, he concentrates on his native Bahia in northeastern Brazil and its colorfully syncretistic culture. What fascinates him is black Brazilian culture and its traditions. Since he feels that he is part of this world, his photographs are distinguished by a profound understanding of the cultural, ethnic, and religious heritage of the people who live within it.

The culture revealed in his photographs is rooted in myth, and its spiritual home is a religious world view. The exotic world of Afro-Brazilian culture informs these pictures. Reflecting Brazilian culture as a whole, they reveal its magical blend of tribal life, customs, and religion brought from Africa and the Baroque aesthetic of the Portuguese side of Brazil. Mario Cravo Neto, however, is not an ethnologist. His pictures are powerful just because they are open to all aspects of this culture and because most of them cannot be assigned to any particular cult. One series can be linked with archaic Afro-Brazilian "Cóndomblé" rites, with their cosmic vision and liturgy, at least within a broader framework. These photographs allow the observer to bridge cultural gaps, but one's approach to them must be emotional rather than intellectual.

The photographer concentrates on essentials: bodies, body parts; elementary objects of an identical world for all people. In this way he conveys the interrelationship of things and people in this social context with urgency and immediacy.

The models he has photographed in staged settings are fully conscious of their dignity and beauty. Space and setting enhance the referential character of the chosen detail, allowing scope for powerful visual metaphors. Mario Cravo Neto leads the observer close up to this space so that objects advance from or recede into its darkness. Bodies, faces, and, above all, the head as the seat of the intellect and emotions are given significance. The photographer seems to have internalized the function of the senses symbolically represented by the body orifices: the ear, mouth, and eye. He has his models practice meditation, losing themselves in themselves, yet entering into a dialogue with the objects he has chosen. Neither models nor objects are arbitrarily interchangeable; each is distinctive and authentic. These are pictures which convey affirmation of life, physical energy, and elementary spiritual power.

Mario Cravo Neto chooses to heighten the personal dignity and authority of his models by photographing them frontally, by selecting the definitive detail in each case, and by dealing with light in a masterly way. This handling of his medium is evident in details such as twigs which a mouth seems to be releasing like a scream. Again, concentration and isolation emphasize the muscles of a crouching man, whose black skin contrasts sharply with the white feathers of a bird. In another photograph, fish hang over a man's back. The tactile properties of all these details are fraught with taut energy and concentration. What Cravo Neto does with light and the abstract black-and-white of these studio photographs with their props enhances the beauty of archaic physical presence.

The models' gestures and glances involve the observers, including them in the photographic space. Mario Cravo Neto's works are archetypal images of buried experience. Beautiful and powerfully poetic, these are photographs which are symbolic of the fecundity and animal quality of life. Representing the duality of life and death, they reveal inspirational thought and speak of apotropaic powers as well as innocence.

Peter Weiermair

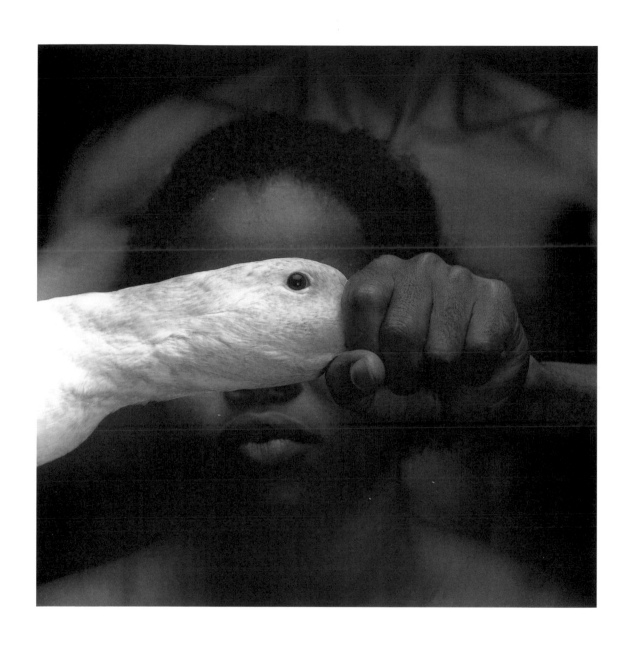

Silvie & Chérif Defraoui

"In 1975, in other words, twenty-five years before the turn of the millennium, we began to do certain works together. We also decided that they would all belong to one project, called Archive der Zukunft (archives of the future). This became a journey through the variety of history and histories. Every work group is a point of reference, where sense and non-sense meet."[1]

These deliberately staged contrasts produce fields of tension within the most recent works by Silvie & Chérif Defraoui whose focus is aimed at perception – an instigation to relinquish customary systems of observation, to encourage a new understanding of the phenomena of form and color.

In this context, for example, there is the work group Rooms (1976), the installation Conservation sur un radeau (keeping on a raft: 1983), as well as the cut-out photographs in the object Image liquide (liquid image: 1991). At the end of the eighties the artists also became increasingly involved with the theme of alienation. Within a further work group, consisting of a series of individual depictions of exotic fruits, the latter are represented as oversized bodies; their colors, as one dominating characteristic, are extracted via precise black-and-white photography. A monochrome yellow layer of wax covers two thirds of the work as a semi-transparent veil. The intrinsic permeability of the beeswax permits the organic contours underneath to show through that which has been painted over it. "In order to perceive something, one must simultaneously lose it."[2] The over-lifesize portrayal of fruits that (in reality) are as large as the palm of one's hand surprises the viewer; the monochrome surface reaching

down almost to the floor leads him into the picture. Only the wide, rosewood-colored frames prevent him accepting this invitation.

In these works, a polarity is created between the precise, machine-made black-and-white photo and the colored wax layer that is applied by hand. The plastic color surface produced in this manner underlines the sculptural character of the object portrayed. The starfruit, which invites inspection through the close-up view, at the same time prevents any closer approach because of the yellow veil in which it is partially enshrouded. The resulting field of conflict means that the fruit, otherwise perceived as an ordinary object, is seen in a totally different light.

Spatial depth is produced by erecting staggered levels which correspond to the layers of perception on observation. The trueness to scale, the overdimensional representation, and the overall composition result in a completely new context. The viewer's readiness to become deeply involved with this work is sensitized by means of polarity, layering, and alienation. The "appearance" of the fruit is reduced through abstraction to its essence so that the latter is recognized and can elicit a response from the viewer. The intentional blurring, the veiling, and "the recognition that we see better what is taken away from us" form the central theme of this work.

Petra Kirchberg

1 Silvie & Chérif Defraoui, Bilderstreit, Kunsthalle St. Gallen (1987).
2 Silvie & Chérif Defraoui, Übergang, Kunstverein St. Gallen (1991).

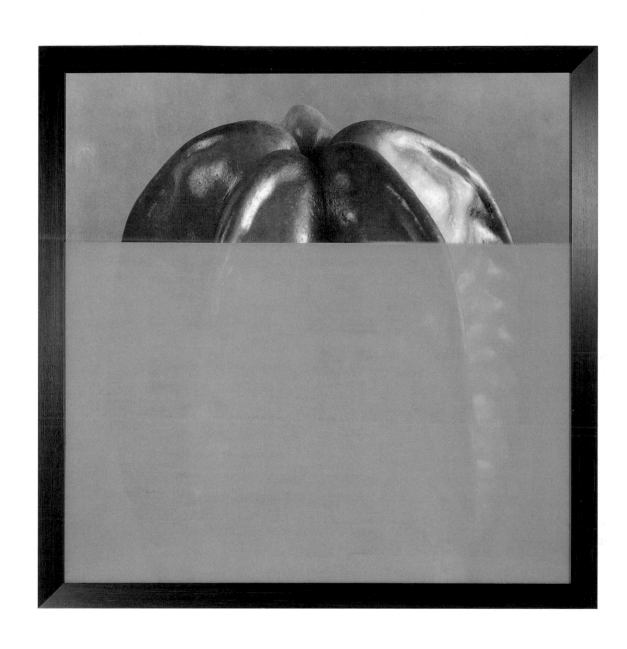

Thomas Demand

Büro, 1995 183.5 x 243 cm

Thomas Demand works in photography as a medium, yet, like so many of his contemporaries who come from a fine-arts context, he does not view himself as a photographer. What interests him is the old question of the reality and the veracity of images. He approaches the issue, however, from an angle different from the one popular in the sixties and seventies, dealing not with moral philosophy but spectator response, the irritation felt by spectators. His rooms or scenes, which are devoid of people, have already been published in the print media. Demand proceeds to reproduce these scenes, places, and views of rooms as models. He builds these "places" from two-dimensional materials such as paper and cardboard and enlarges the models in his prints.

His early work refers to personal memories which, however, are the nexus of collective memory because they are reflections of architecture and street scenes. The powerful highway overpass or the swimming pool with its towering diving board that looked so perilous to him as a boy are reconstructed. These photographs reveal what is lacking. Like early film sets, they are recognizably an illusion. Through the refraction of distance, the artist draws what is anecdotal in our background histories out of our immediate perceptions.

Later Thomas Demand added historically significant photographs to his personal archive. They include Adolf Hitler's office, destroyed by a would-be assassin's bomb, and the scenes of serial killer Jeffrey Dahmer's crimes. Spectators load these places with the connotations of their own knowledge and feelings and, detective-like, investigate these "places" which radiate an eerie emptiness. The imaginary worlds Demand generates, although he is always careful not to allow illusion to take over, makes the world look as if it had been deprived of its substance. It almost seems virtual. Stuart Morgan says that Demand, a skeptic, creates his own vision of what we so casually term "facts." What matters in this process is the moment of translation itself, not the result. Demand, however, playfully draws an analogy between photography (as a two-dimensional medium) and the two-dimensionality of real materials, be they leaves, paper, or wallpaper.

This is the process that Thomas Demand uses to deal with the reception of reality, with perception, with the reconstruction of what has been seen, and with the identification of what should be seen as real.

Peter Weiermair

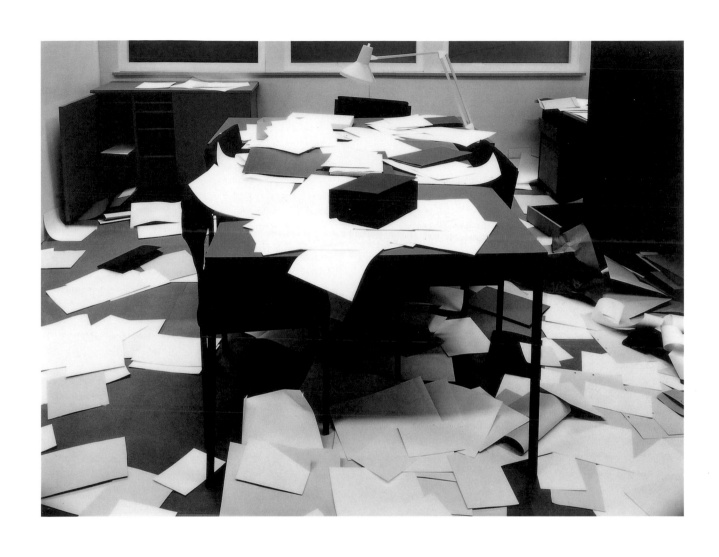

Philip-Lorca diCorcia

Tokyo, 1994 76 x 101 cm

Philip-Lorca diCorcia takes people in the street in his sights. He captures a face from the crowd with his camera and flash and places it at the disposal of our imagination. He is a consummate master of technique, since he has honed it from the outset in documentary reporting and commercial art. Like Cindy Sherman (in her Film Stills), albeit with formally different results, diCorcia has been influenced by the film classics of Fritz Lang, Jean Renoir, Alfred Hitchcock, and François Truffaut. As a result, his photos seem like hidden dramas. The artist's affinity with film makes it possible to see this photographer as the innocent little brother of the professional killers whose telescopic sights are aimed from high-rises and from rows of front windows at anonymous passersby. Still, diCorcia admits he is guilty of placing his tripod in the street or on sidewalks to highlight a passerby by means of exactly spaced flashes. Whether his or her history is interesting or meaningless, tragic or ridiculous, remains unknown. We cannot learn anything about it because the medium is unable to convey biographical detail or facts. As Philip-Lorca diCorcia sees it, photography is a foreign language which everyone thinks they can speak. He is alluding to the fact that photography merely conveys an illusion of reality. To decode it, one needs other knowledge.

Philip-Lorca diCorcia prepares very thoroughly for the moment of encountering a gaze, yet he does not stage anything. Here he is very different from his Canadian colleague Jeff Wall, who carefully arranges each "documentary" scene, including the characters, to make it look deceptively realistic. The American photographer is looking down the same street as Wall, but he is not trying to make his one unknown extra look mysterious in the natural light of everyday life. Instead, diCorcia is showing his anonymous passerby as the actor in a biographical narrative in transition from reality to fiction. Thus the figure captured immediately disappears from one's field of vision for an unknown destination.

Joel Meyerowitz is one of diCorcia's heroes, along with diCorcia's teacher Tod Papageorge and the latter's idols Walker Evans and Garry Winograd. Unlike in the work of Joel Meyerowitz, however, the streets and squares into which diCorcia's anonymous characters emerge play a subordinate role. It does not matter whether they are in Naples, Paris, Los Angeles, New York, London, Berlin, Tokyo, or Odessa. The distinctive characteristics of a city are not as important as the uniqueness of a person. The people diCorcia photographs are not dramatic. What is dramatic is the enigmatic way he isolates them in his photographs. As in Peter Handke's mute play Die Stunde da wir nichts voneinander wussten (the hour in which we knew nothing about each other), the people, no matter what their professions are and what their personalities are like, whether they are brokers or junkies, old ladies or prostitutes, matter only as isolated individuals in the context of Street Photography. The only thing that is special about their faces is an indeterminate condition of vague expectancy. This quality can already be seen in the snapshot the photographer took during the Christmas holidays in 1978 of his brother Mario, caught in the act of raiding the refrigerator. Triggering Philip-Lorca diCorcia's personal way of viewing things, this snapshot marks the beginning of that mysterious heightening of casual activities and encounters which was to become the hallmark of the photographer's personal style. Behind it are unexplained dramas; diCorcia's photographs have the potential to become frozen visual surrogates for narratives that have never developed. It is up to us to charge them with our own dreams and experiences.

Günter Engelhard

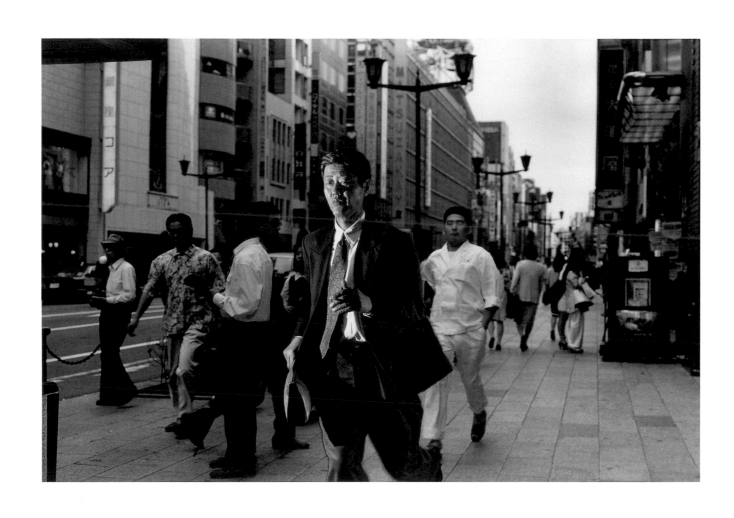

Jim Dine

Through photography Jim Dine gains access to the sophisticated vanitas side of the very consumer art he helped so effectively to promote thirty-five years ago. Through Pop Art, Roy Lichtenstein, Claes Oldenburg, James Rosenquist, Andy Warhol, and Tom Wesselmann propagated motifs from the world of consumerism. Jim Dine differs from his companions on this journey inasmuch as he has, like Richard Hamilton and Ronald B. Kitaj before him, obviously aligned himself with the ironical artists under the banner of Surrealism. Furnishings, tools, and suits became colorful art. Moreover, Jim Dine enlarged the scope of Pop Art. Paralleling Robert Rauschenberg's more dramatic Combine Paintings by mounting everyday props on the picture plane, Jim Dine added a dimension of parody. He has remained indebted to the Action painters of American Abstract Expressionism, whose work was invigorated by a touch of reality. Jim Dine's lavish, gestural painting, with its vibrant handling, owes much to them in the way it intimates the presence of figurative phenomena behind the colors and the objects tied into them. Over the years, Jim Dine came to eschew happenings and Object Art, returning to painting, drawing, and print-making. He produced sculpture and was inspired by literature. His palette became ever grayer until he finally reached the romantic, poetic side of his nature. Now there is also a photographic record of this development.

The record shows that the painter is now using the poster-like flatness of Pop Art as an adjunct to simultaneous association with one or several background motifs. There is no perspective staggering of picture planes. As in poetic reflection, past, present, and future are directly connected to the associatively enriched objects. In one work from the DG BANK Collection, a raven in full view turned to the background, an owl looking out of the picture to the side, and a human hand unite the temporal planes. On one and the same plane, what is living enfolds a "clutch" of skulls. A nature morte, this work is both painterly and graphic. Hovering somewhere between the spectral plane and reality, it resembles the translation of mythology as poetry into a photo, evoking for instance Edgar Allan Poe's The Raven (1845). The reporter from the soul's nightmare territory tells of the nightly visits paid to him by a raven. The sepulchral bird refuses to leave the place it has taken upon the sill in the room of a mournful lover, answering every question with "nevermore" and eventually driving him mad. The Pre-Raphaelites, later Art Nouveau and Jugendstil artists, and finally the American horror film industry have used Poe's raven as a symbol of looming disaster in ghostly landscapes.

In an again current phase of his work, informed as it is with magical tendencies and lyrical daydreaming, Jim Dine has resorted to this motif deliberately. Against the background of white skulls, the crow's feathers look like the symbolic utterance of the expressive color actions and pandemonium perpetrated by the grotesque myths of an Asger Jorn. Jim Dine was, in fact, fascinated in his formative years by the work of his Danish colleague. Now a spectral quality, long absent, has seeped back into Jim Dine's own painting. Because he no longer wanted his pictures to feed on "other peoples' secrets" back in the 1960s, Jim Dine eschewed objects and material qualities in his work, deliberately rejecting whatever was ghostly. Now the ironical phase of colorfully bleeding hearts and monochrome impressions is also long past. The photo may be an indication that Jim Dine the poet has begun to point out the phenomenon of transience to Jim Dine the painter. The Pop artist ends his colorful show with the croaking of a raven.

Günter Engelhard

Pietro Donzelli

Pietro Donzelli describes his discovery of photography as a coincidence: within the scope of his activities as archivist at an Italian telephone company, he stumbled on a crate filled with photographs which showed him an Italy he never knew, although he grew up in Milan. On dusty streets, old cars made their way through herds of sheep, poorly clad workers from Calabria were underway with hoes and shovels, while women carried heavy sacks of cement on their heads. These pictures of aloof landscapes and barren rural scenes fascinated him; they were utterly different from the familiar, traditional artistic photos which oriented themselves toward the model of painting.

When Donzelli took up photography on his own after the war, he was impressed by the films of Italian Neo-realism. He observed the working methods of directors and cameramen in the Milan studios of the ICET. The themes which were addressed in these films and the aesthetic means with which they were implemented formed the basis of Donzelli's photographic quest. A central source of his motifs was the Po Valley, a vast plain that he had visited for the first time at the end of the Second World War and which profoundly impressed him by its untouched state. It became his second home, one to which he returned again and again. The wide expanse of the riparian landscape and the hard life of the people who had to fight a constant battle against high water and flooding represented a starting point from which Donzelli went on to develop his own, individual pictorial idiom. In the series Land Without Shadows, dating from the beginning of the fifties, Donzelli depicts life in this area between earth and water. The wide, calm river with its tributaries and canals is almost always in the picture. It determines work and leisure; it offers the basis for fishing and fish-hatching; it waters the fields and provides the background for melancholy Sunday afternoons.

Signs of technical progress appear only rarely in Donzelli's works, and when they do, then in a specific way. His Cinema a Pila (cinema in Pila: 1954/94) consists of an open-air screen. It is surrounded by a roughly built latticework to prevent unauthorized viewing. For legitimate guests, there are benches and chairs in orderly rows and separated according to price category, to give an atmospheric cinema ambience under the night sky. Donzelli, however, shows the cinema by day. The gleaming white screen seems particularly lost and out of place in front of the provisional architecture; the seating rows are abandoned and evoke only the recollection of past pleasures and dreams.

In his œuvre, Donzelli chooses as his major theme the conflict between the old and the new, between the archaic rural and the modern. With his serene and intense pictures he makes conscious the fact that the irreversible processes of progress go hand-in-hand with an inevitable erasing of memories. Pietro Donzelli, who is also avidly involved in the theoretical discussion concerning photography, has always expressed the documentary aspect of photography in his essays and has taken a decisive stand against the one-sided monopolization of the formal. He is concerned with keeping the ethical and aesthetic dimensions in harmony and in balance and to demonstrate that, "among all means of expression, photography has the prerogative of making people acquainted with that which belongs to them."[1]

Iris Cramer

1 Quoted according to Ennery Taramelli, "Land ohne Schatten," Pietro Donzelli – Das Licht der Einsamkeit, Kunstmuseum Wolfsburg (1997).

William Eggleston

Sumner, Mississippi, Cassidy Bayou, before 1975 53 x 67 cm

Near Minter City & Glendora, Mississippi, approx. 1970 46.4 x 57.2 cm
Southern Suite, 1981 40.5 x 50.5 cm

Born in Memphis, Tennessee in 1937, William Eggleston has been one of the most inspiring recent photographers. His work first became widely known in 1976 through an exhibition at The Museum of Modern Art in New York. The general repudiation of that exhibition would seem to indicate that his approach was avant-garde even then. Nearly all New York critics at the time thought that Eggleston's pictures were vulgar and without aesthetic stringency.

What is so forceful about his work? Eggleston and Stephen Shore were the ones who made color photography a full-fledged art medium. Until then, color photography had been something engaged in mainly by studios of the advertising industry. Until the 1960s, photographers who viewed their work as art were rooted in black-and-white photography. Thus they could not relate to the structure of the new medium of color. Black-and-white photography had built on linear compositions of light and dark zones; color photography would have demanded of them a fundamentally new concept. Even Walker Evans, who tried color, soon gave it up. At the same time, Evans was one of the few to realize how radical Eggleston's aesthetic really was. As Evans said, it was true that color photography was a vulgar medium; for that very reason, however, it was particularly well suited for representing that which was vulgar. In his work at the time, Eggleston differed from the few photographers who worked in color in that he did not treat color as a discrete pictorial element. Instead, he used it as a natural means of expression, that is, as an integral part of the visible world that we all know. This means that, for Eggleston, color has always been a quality of light, that is, of nature in general. He definitively closed the gap in photography between the phenomenon photographed and its distinctive colors. In his work, color became the aesthetic driving force, something specific that was essential yet lost in black-and-white prints.

Eggleston's pictures are obviously close to the mundane forms of expression common in everyday life. Pop Art also emerged in the 1960s; Eggleston's aesthetic, like that of Pop Art, took as its point of departure the development of a personal idiom which had hitherto been unknown. Both Pop Art and Eggleston's work are distinguished by the rapid paradigm changes which are characteristic of modern art. However, Pop Art and Eggleston's work developed strategies for dealing with the aesthetic of TV, film, illustrated magazines, and postcard photography. Devoid of profound contemplation, Eggleston's photography is the expression of a roaming, highly personal imagination. It is the restless movement of an inner eye, with the small-format camera as its adjunct. The small-format camera can react immediately to phenomena, particularly, however, to fringe phenomena which are just caught on the edge of perception. Eggleston's work is seemingly devoid of political or social commentary. His pictures allow glimpses into the artist's private world: streets, houses, gardens, interiors, and interrelationships in nature. Nowadays we realize that Eggleston has indeed achieved a fresh perspective, one that is not confined by the photographic conventions that had hitherto prevailed. On the contrary, Eggleston's photography always seems to be expressing a view of things as they have "never been seen before." Both the origin and intention behind his way of seeing resist stringent analysis. His pictures look, superficially at least, like amateur photography. Yet this seemingly amateur aesthetic is what lends his pictures a stringency that, in its own way, is also cryptic. European observers have often found American life synthetic and banal. In his photographs, Eggleston has heightened this synthetic banality to myth. This is work that deals with pride, irrationality, vice, and the fun of questioning conventional assumptions.

Heinz Liesbrock

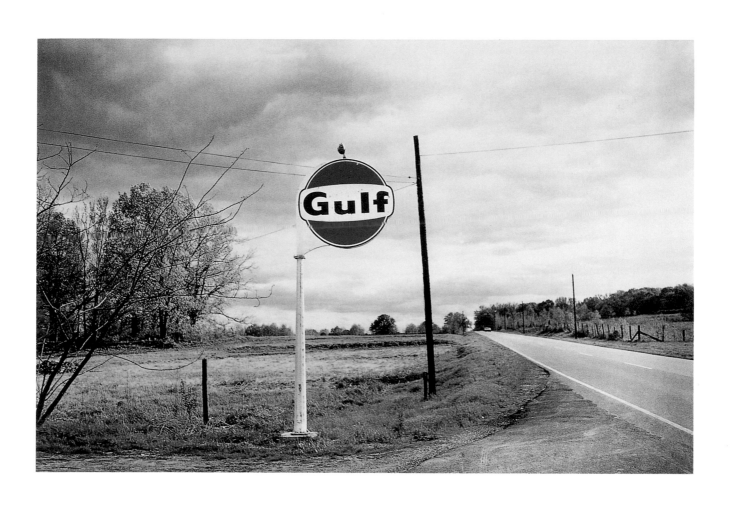

Valie Export

Valie Export's Zeitgedicht (poem of time) consists of twenty-four snapshots which were all taken from the same camera position – the window of the artist's apartment – at one-hourly intervals. Groups of six consecutive photos were then mounted, each forming a tableau. Within the predetermined, fixed reference framework of the picture detail, there is thus a change from picture to picture over the twenty-four-hour period. A rhythm is produced that can be compared to that in the tableaux of Eadweard Muybridge, produced some hundred years earlier, which instead of the changing light conditions recorded different stages of a movement. In both series of pictures, so different at first glance (with Export the exposures follow at hourly intervals, whereas Muybridge developed his own construction in order to make fractions of seconds possible), the overall impression is not produced by the additive effect of the individual pictures. The arrangement of the pictures in series, beside and over one another, places them in a framework that is perceived as its own, closed unit. The canyon of the street with its tug of perspective into the depths, repeated many times, produces a rhythmic relief; the passing of time, recorded by snapshots at set intervals, appears to be constant, however different the individual "frozen" moments may be.

Zeitgedicht is part of the series of "conceptual photographs," as Export describes a considerable portion of her work of the late sixties to early seventies. Others in the series are her well-known works Zug (train), Landschaftsraum – Zeitraum (landscape space – time space), and Linie durch einen Gemeindebau (line through a local authority building). Common to these works is the calculated starting point, the fact that the artist fixes all the conditions (exposure interval, distance from the relevant object, camera movement, movement of the object, etc.) in advance, and that no "subjective" possibility of choice remains during the actual execution of the work. This is the exact opposite of the method used by photojournalists, for example, who always react to the moment. Valie Export was not the only artist of the period around 1970 who practiced photography in this fashion; she finds herself in the company of such artists as Vito Acconci or Ed Ruscha.

This procedure, at first sight purely formal in its approach, can be understood better from the social-critical and feminist attitudes of the artist. Analysis of visual structures – in the case of Zeitgedicht the visualization of the temporal sequence in simultaneous juxtaposition – takes place at the same time as investigation and uncovering of social structures. Export's work is set at the interfaces between reception of the stimulus (short-term as well as conventionalized), the reaction to this (spontaneous as well as learnt), and the inherent logic of different notation and representation systems. All the materials employed – photo, television, laser, but also glass, metal, and the human body – are used in a way that breaks all the customary rules. Whereas in the "conceptual photographs" the investigation remains on an apparently abstract, media-critical level, in the "body-material interactions" (Export's term for her performances) a sense of irritation, both social and political, is evoked, quite intentionally, at first sight of the artist's "unusual" use of her body. Valie Export's explicit message to her audience concerning the "distortion of perspective," the "rupture of perspective," can be related literally to her photographic works that analyze perception, but also – and primarily – in a much broader, extended sense to her overall œuvre, which to the present day has retained its "offensive," annoying character rooted in the radical political atmosphere of the sixties.

Monika Faber

Bernard Faucon

Un jour nous aurons connu le bonheur, 1991 – 1993 61 x 61 cm

"Un jour nous aurons connu le bonheur" (one day we will have known happiness) is written in glowing letters in the landscape; tall grass is flanked by bushes in the foreground, with mountains and wisps of mist in the background. The letters, which are characteristic of Bernard Faucon's works of the nineties, are made up of wooden rods shaped according to Faucon's handwriting and coated with a light-reflecting substance. These color photos, executed in the coarse-grained Fresson technique, are usually square in format. Photo and message have formed an inseparable unit since the Ecritures (scriptures) of 1991 – 1993. The generally melancholy but beautiful landscape views are associated with serene, resigned aphorisms about life, but they never stand in a descriptive relationship to one another. In the series of miniatures La fin de l'image (the end of the image: 1993 – 1995) Faucon brings the combination of photo and word to its conclusion; he transposes the ever more important text directly onto barely identifiable parts of the body.

Faucon, born in Apt-en-Provence in 1950, started out as a painter but in 1974 also graduated in philosophy. The dimension of the word was important for him from early on. In 1977 came the transition to photography, set out in series and conceived as a mise en scène. The intention is not to depict existing reality, but to revive a past reality or create a new one. In Les grandes vacances (the long vacation: 1977 – 1981) he positions clothed mannequin figures in actual landscapes, sometimes also combining them with living people. In these frozen scenes of enigmatic narrative there is a terrifyingly beautiful fusion of natural space and invention. Who here is the interloper? The beautiful artificial beings who make alien the world with which we are familiar? Is it not rather the living people? The works staged in the landscape of Faucon's home region, Provence, contain references to unforgotten images from the artist's childhood and youth. But they not only repeat memories, they also create visions. The scenes take days of work to set up on the basis of a concept and exist for only a short time; as soon as the photograph has been taken the artist dismantles them again. What remains behind is the picture of a specially created and then destroyed (fictitious) reality.

The series Chambres d'amour (rooms of love) was created during the years 1984 – 1987. In this series devoid of human beings the spatial is mixed with landscape or natural elements; the absent lovers – their secret actions, feelings, hopes, doubts, and despair – can only be guessed at through the surroundings. Despite the shabbiness of many of the rooms, the addition of flowers, grasses, sand, painted decorations, and other arrangements produces views that are refined, even magical, in their color and lighting. When, in 1987, Faucon sensed that he was starting to copy himself with this motif-rich series, he stopped work on it. The courage to keep moving on to something new is one of his characteristic features. Despite the variety of the series or new projects, the consistent factors – in both image and text – are a surreal beauty and a poetry filled with yearning. Is it any wonder that Faucon to some extent sees himself as a poet? In his most recent work he restricts himself to the dimension of sound. His texts are read out by strange voices, usually those of boys. The spoken word, the literary, seems not only to have asserted itself against the image but to have discarded it altogether. "I will probably not do any more mises en scène, any more photos, in the previous manner," Faucon stated in the spring of 1997.[1] All those who are aware of Faucon's conviction that an artist should keep moving will ask themselves when he will exhaust this new phase of work, and whether he will ever return to photography, which he has enriched with a unique mode of manifestation.

Andreas Hapkemeyer

1 Faucon in conversation with the author, Paris, April 15, 1997.

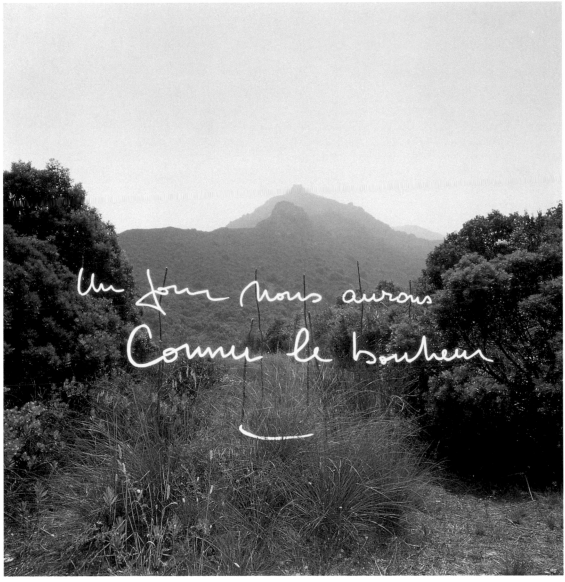

Arno Fischer

West Berlin, 1957 40 x 50 cm

Up until the reunification of the two German states, Arno Fischer was almost unknown in the West. Yet in East Germany he played a leading role as a representative of classic photojournalism and was an influential teacher for several younger generations. The Leipzig school as a germ cell for artistic photography would have been inconceivable without him, or indeed his colleague Evelyn Richter. A major difference from the leading teaching personalities in West Germany, such as Otto Steinert, or nowadays Bernd and Hilla Becher, is that Arno Fischer did not stamp his style, but rather his personality, on younger generations.

Born in Berlin in 1927, he first studied drawing and sculpture at the Käthe Kollwitz school, later continuing his study of sculpture at the art college in Berlin under Professor Drake and at the college of fine arts in Charlottenburg, under Professor Gonda. Encouraged by his teachers he came across photography, which he thereafter concentrated on completely. As a result of Berlin's varied history and his own experiences in the constant alternation between East and West, his eye was drawn to everyday life in Berlin with its millions of inhabitants. Reconstruction and the varying development in the different sectors of the city led him to become interested in people, their work, how they appear in public. He photographed them in their immediate social milieu, depicted mundane situations and scenes in East German life in an impressive manner. In 1956, in Leipzig, Fischer encountered like-minded people in Evelyn Richter and the "action fotografie" group. In his interest in the metaphorical image, Fischer's style is not so far removed from that of the American photographer of the zeitgeist, Robert Frank, even if their respective social worlds had little in common.

The construction of the Wall in 1961 hindered further exchanges with the West. During the following decades until the fall of the Wall, Fischer, like most of his colleagues, worked in isolation. West German trends, shaped as they were in the sixties by the magazine Twen and its photographer Will McBride, had no influence on the Leipzig photography scene. While working for the fashion magazine Sibylle, Fischer nevertheless succeeded in developing his own style, which dispensed with studios, was on a parallel with trends in fashion photography in the West and presented fashion in the context of the everyday. Unlike, for example, Richard Avedon, the American protagonist of shifting fashion photography onto the street, who despite the outdoor shoots retained many more elements of fashion photography, Arno Fischer undertook a much stronger blending of live photography with fashion, setting fashion in a photojournalistic and documentary context, as for instance was practiced in the nineties by Ferdinando Scianna – a novelty for the West. Although with his fashion photography for Sibylle Fischer for the first time disseminated a photographic profile, a style, he never saw himself as a representative of this field. The fascination for him lay in displaying fashion, which after all is designed for ordinary wear, in this setting – that is, basically in creating a mundane situation and yet still giving it prominence in the picture as an expression of individual self-assurance.

Throughout his life Arno Fischer remained a photographer of people, even if he was frequently only dealing with their traces. Cities, streets, and houses did not interest him in their own right but because of their inhabitants, whether the latter were in the picture or not. The imagery of his pictures fuses together the various subjects in his work under the aspect of reflection on human development and human passing. Possibly it is in this context that we should understand his involvement in teaching, initially in the form of lectures in Berlin and Leipzig and later – from 1985 – as professor of photography at the college of graphics and book design in Leipzig. After the fall of the Wall he left Leipzig. He now lives near Berlin and teaches at the polytechnic in Dortmund.

Reinhold Mißelbeck

Thomas Florschuetz

Triptychon Nr. 1, 1988 3 parts, each 100 x 150 cm

Anyone who has come into conflict with the law is subjected to a noteworthy procedure. The top inner surfaces of thumb and index finger on both hands are pressed onto a stamp pad and then individual impressions of them are entered in a card index as supposedly irrefutable evidence of a human identity. These are those parts of the hand that in Thomas Florschuetz's Triptychon Nr. 1 (triptych no. 1: 1988) flank a monstrously blown-up human eye in correspondingly enlarged dimensions, two fingers on the left, one on the right. The medium for the massive triptych is photography. Photography was also once believed to provide irrefutable evidence of human identity. The reason: it too is an impression, produced by light waves. Thanks to photographic methods, something absent can be made present, in a paradoxical reversal, and photography provides an ontological bridge to this absent presence. This is why the Paris chief of police was a committed advocate of photography when it was proposed that the French government should acquire the techniques of Messrs. Daguerre and Niépce and make them freely available to the general public. The idea was that delinquents would be easier to identify among the mass of humanity, even without a likeness, if they had already been recorded photographically in case they should again fall under suspicion. This is why, in addition to taking fingerprints, there is still the photographic procedure, or more precisely the photographic portrait: frontal view, three-quarter view, profile, and even, exceeding the art-historical repertoire, back view. In fact, everybody who has (or is allowed to have) a passport carries their own likeness around with them. Yet, to the degree that photography has conquered the modes of human perception, belief has crumbled in the photographic medium's irrefutable fidelity to the truth. And even the fingerprint is gradually turning out only to be useful within certain limits.

In the meantime, DNA analysis is claimed as the most advanced recipe for irrefutable proof. Human identity, which Florschuetz presents in a radically fragmentary reduction, remains open. A deliberate act, without any doubt. Surveillance by eye and camera is a familar experience in the life of the artist. Whether the decision to bring eye and fingers into graphic association was inspired by the particular history of photography is irrelevant. The context is, in any case, indirectly obvious. Moreover, the eye and the hand are the most sensitive organs of perception; the process of civilization has dulled the sensitivity of the other senses. Yet the eye in Triptychon Nr. 1 seems at the same time like a mouth, because the pupil has been pushed to the far left corner. Irritation is a consequence of the artistic method, fragmentation and at the same time enlargement, which introduces a process of abstraction. In this way the photographic motif becomes a commanding multi-part photographic image. It receives, so to speak, a dual identity. The artistic methods of fragmentation and enlargement are consequently not the aesthetic aim of the work. The aesthetic aim is perception itself, aisthesis, the ancient Greek term for perception in its original sense: instead of a "recognizing" seeing, as in conventional photography, the "seeing seeing" (Max Imdahl) of aesthetic experience. It is true that Florschuetz uses the materials of photography, but in his works photography is reflected as an independent medium, the specific conditions of which transform the objective photographic world. "The [photographic] material brings the image into being through the medium" (Karlheinz Stierle). Florschuetz adds an aesthetic dimension to the apparent plausibility of photographic reproduction techniques. By opening up so far undeveloped possibilities to the medium of photography, merely through visual reflection of its prerequisites and conditions, the artist opens the door to other media in the visual arts. It is no coincidence that his diptychs and triptychs emanate an intense sculptural power, that affinities to the medium of sculpture unexpectedly become apparent. A remarkable incorporeal physicality is evident in his pictures: human fingers are turned into plastic forms, the human eye becomes a disquieting, amorphous manifestation. In Thomas Florschuetz's pictorial images, photography touches on the domain of the imaginary.

Klaus Honnef

Joan Fontcuberta

Cala rasca, 1982 40 x 30 cm

Braohypoda frustrata, 1982 40 x 30 cm

Different elements of photography, the history of painting, and visual histories of other cultural and satirical provenance mingle in the photographic œuvre of Joan Fontcuberta, born in Barcelona in 1955. First of all, he is close to the intention and the surrealistic gesture of expanded reality. In the photogram, a technique that evolved from the history of the modern era and its visual apparatus, he finds the objective process of obtaining a direct likeness of bodies convincing. And a third technique that he uses has already been handed down to us in legends about the origin of the art; it consists of storing up a mimetic and physical likeness of an object through silhouettes. It is the interplay and the ironic synthesis of all these techniques which drive Fontcuberta's photographic language to include astonishing information and images. All in all, the Catalan is carrying on a multiple play with the technique of extreme mystification, deliberate anamorphosis, and distortion, which also dominated Spanish art photography during the Franco era. The genuine, the documentary, the irrefutable: these are the fields in which Fontcuberta applies his fundamental, eccentric reinterpretations. Margit Zuckriegl has coined the term "fake documentation" for the metamorphoses and mutations that Fontcuberta invents, keeping closely to photographic paradigms, leading to the media potential of a technically created visual genre of flora and fauna. In fact, horrific photo science fiction does not stand alone in the procession of sinister masks, chimera, phantoms, and rampant spectral bodies such as inhabit the universes of Goya, Ensor, Munch, and Kubin.

The Historia Naturalis, produced in Fontcuberta's studio, is an analogue visual world for which he uses combinatory techniques. A direct parody of cynicism and its associated rigor, as found in rational science and academic biology, is deliberately used as a tool of realization. To back up his scientific argument Fontcuberta invented a fictitious scientist, "Dr. Anthill," and fitted him out with a fund of expedition material, only to blame him for erratic hybridizations.[1] The process of producing all these motifs and practical procedures is highly complicated. Fontcuberta is not aiming to produce series. The result is always unique. The materials, used only once, deliberately disseminate an aura of natural occurrences. This is the case, for example, with the short-term hybridization of a head of cabbage centered around a fish head. The existence of the photo does not just point in the direction of anormality and paranormality, the hybrid intermixture of the floral and the zoomorphic, it also highlights the dubious, but scientifically feasible practice of interfering with nature's DNA and genetic codes by means of cloning. A few of the grotesque Herbarium motifs also feature this subject matter. The photos in the DG BANK Collection, such as Guillumeta Polymorpha, Erectus Pseudospinosus, and Braohypoda Frustrata, feature forms produced by combinatory techniques. Fontcuberta directs the gaze at the details. These are not cultivated plants. Their unfortunate condition is inherent in society. They are unique, incompatible, non-integrated, and stiff beings from the subliminally anthropomorphic sphere of bio-sociology. In the Braohypoda Frustrata motif dating from 1984, thorns were implanted in the leafless stems, which bear thistle flowers, as though being subjected to torture, but in the reverse direction – as an expression of human sadism.

Gislind Nabakowski

1 Cf. Margit Zuckriegl, "Joan Fontcuberta – Retrospektive des 'Science-Fiction'-Fotografen in Österreich," Noëma, no. 95 (1995), p. 71.

Günther Förg

For me the entire work of Günther Förg is like an enchantment. It follows an invisible score which this century wrote into the time before the Second World War. This was a time of emergences, of beginnings, but also a time of completions, which in the end were to remain without constructive consequences because postwar Europe received a new face. Günther Förg's architectural photos are in no way spectacular, indeed they expressly refuse to be so, but they record the constructive, the characteristics of a room, a facade, a vista. They record proportions. It is not a question of either the grandiloquent eye or the skill of the architectural photographer. Förg's gaze is that of the man in the street, but his eye is the knowing and desolate eye of that man in the street.

This knowing and desolate gaze is enlarged, is transformed into large-format photographs. Somebody might well come along and ask why these photos have to be so monumental when smaller ones would surely be quite enough. But as soon as that viewer understands that it is the manner of seeing and not what is seen that is enlarged, he will probably be shocked by this manner of seeing. When I first came across Förg's work at the Kunsthalle in Bern in 1986, I plunged with him into the steep ravines of stairwells conceived and built in large format, observed with him – as though casually – the masterly construction of a glass-door frontage; my hand glided like his over a handrail, created with masterly simplicity, in a seemingly shabby stairwell, and in the same way I climbed with him up the steps of the Villa Malaparte on

Capri. What does "with him" mean here? It means that we look over the artist's shoulder in the photos because a hand, as though casually, brushes against the handrail, because someone is ascending the seemingly endless steps of the Villa Malaparte. I mention this exhibition because Förg's eye has not changed: we still look over his shoulder. And by enlarging this view for us, he shows us. He shows us without respite and yet casually. What he sees is the past visualized from the viewpoint of enchantment and lamentation. The talk is all about an experience, a tradition, and an innovative knowledge and search developed from this that has today lost its sense of proportions and its love of detail. Nobody is blamed, no criticism takes place. But Günther Förg's desolately amazed, in no way naive eye takes note.

One last point concerns me. The flood of pictorial information often puts us in a position to "check" what we have seen. The more original the point of view, the more we are attracted to it. The more banal it is, the more we overlook what has been seen. I too am subject to this mode of perception. Again, I repeat: what has been seen is one thing, the manner of seeing it quite another. Förg's way of seeing is not novel, but original. His gaze is not voiced. His gaze is like that of a mute, of someone who has lost any sense of aestheticizing, who wishes out of sheer desperation to force us into the viewpoint of his speechless and yet so knowing gaze. And this applies to Förg's entire creative œuvre, not just to his photography.

Jean-Christophe Ammann

Michel François

Michel François treats the photographic image rather as Rodney Graham and Tamara Grčić do. The Belgian artist allows the photo its independence. In his work, however, photography is one material among others, related in installations formally and by content to other media, which can be chiefly technical, sculptural, or spatial in nature. By virtue of being thus employed, the photo is both self-reflecting and reflective of the other media to which it is related. The work of the aforementioned artists (to cite examples from this collection) exemplifies a precondition of contemporary imaging, that is, it will ultimately arrive nowhere at all. In the latter half of the twentieth century, the idea of the masterpiece, the picture that reposes in itself as a consummate work of art, has been supplanted by the series, by the eventfulness of specific spatial situations, and by the processual thinking and acting on the part of artists.

For this reason Michel François set up a complex installation in Barcelona (Tecla Scala) and Rotterdam (Witte de With) in 1997. In it he employed photos, videos, texts, and concrete objects. They were based on the artist's experience with the prisoners in a Dutch high-security tract with whom he worked for quite some time. What is remarkable about the installation in the present connection is, on the one hand, that the documentary aspect of the work on the penal institution and the prisoners in it was confined to videos and information material in display cases. The poster-like black-and-white photographs, on the other hand, referred to the ambivalent nature of play and violence, representing the plane of general reflection on what is shown and how it is depicted.

This is again the role assigned to the photographic image in Michel François' most recent book, entitled En même temps (Brussels: Editions La lettre volée, 1998). In it "only" black-and-white photos are reproduced. There are no explanatory passages on where or when the photos were taken or on the artist himself. The photos were taken in the 1990s, mainly in Asia, Africa, and Europe. The title of the book emphasizes a fundamental of contemporary living, the synchronicity of diverse events and things. The meaning of "en même temps" (at the same time) reinforces the structural dynamism of these pictures, which is one of ostensibly balanced contrasts. This book represents the continuation of a traditional genre, beginning with Walker Evans' American Photographs (1938) and Helen Levitt's A Way of Seeing. François' book again makes clear that, in modern art, the individual picture does not matter as much as the complex relationship between it and other pictures, even if it has been staged and given significance of its own, which may seem odd when one considers just how much effort modern artists put into finding the "right" order for their photos. This is true of the group of photographs from Michel François' œuvre in the DG BANK Collection, which are all untitled. One might think they were classic travel photos unless one knew of the context which is suggested here. Up to a certain point, this is indeed classic travel photography, just as Helen Levitt's photography represents a sort of (very special) trip through her native city. In the work of Michel François or John Miller, however, the trip is being taken into much more international territory and is in fact being taken at all nowadays. Another key difference between Michel François and Levitt is François' portrait-like way of depicting individuals, many of whom are young, and that the photographer and the beholder are quite often taken into account. The picture of the boy jumping into the swimming pool represents a motif that runs through this group of works. It reveals more or less direct references to nineteenth-century iconography: beginning with Courbet's The Stone Breakers (once in Dresden but destroyed in the Second World War), the reference is also to Thomas Eakins' bathing boys. The François pictures in this group emphasize an essential characteristic of frozen images caught by film cameras: "stop motion," the effect of motion created by moving an object between frames. Virtual stopping in the midst of movement caught up in its own inner dynamic is rather like the significant moment in which a circus performer who has already let go of one trapeze is suspended in mid-air, reaching for the next. The quality of frozen suspension goes far towards giving this particular group of Michel François' photographs a symbolic character, despite, or, perhaps just because of, their subjectivity. Dealing as they do with the crisis-prone process of individuation and angst-ridden enjoyment of an archetypal experience, they also address artists' role as "performers." Bruce Nauman says that it is fraught with the tension between what they relinquish and what they hold on to.

Hubert Beck

André Gelpke

When Magical Realism and auteur photography caught on in the mid-1970s in German photography, it was obvious who had intellectually fostered the movement. Work by Heinrich Riebesehl, Wilhelm Schürmann, and André Gelpke, to name only a few of the best known of these photographers, linked up with 1930s tradition, the photography of Man Ray, André Kertész, and especially Herbert List, whose œuvre had just been rediscovered. Classical photojournalism was rejected. It was defined as being quick and easy to read and accessed reality like a sharp shock. Its aficionados were the readers of popular illustrated weeklies. Unlike the American traveling exhibition, The Family of Man, Surrealist photography, and its legitimate predecessor, Atget, furnished a suitably tradition-al referential framework. While studying under Otto Steinert at the Folkwangschule in Essen, André Gelpke had come into closer contact with these traditions. What is typical of his work is his detached view of events and a propensity for sur-real situations and encounters. This predilection for the sur-real is noticeable in Gelpke's portraits from the St. Pauli Sex Theater, his photographs of Carnival in Gürzenich, or exhibi-tion opening nights. Gelpke records the rituals of organized sexuality and partying with the practiced eye of a field eth-nologist. Through observing social behavior patterns, he de-veloped a sense of the grotesque, which arose from a feeling of being alienated from his subject matter. The use of flash has made the figures look as if they have been deep-frozen, like fragments of pictures of bodies which expose them-selves with their theatrical language of their gestures.

Taken between 1972 and 1980, the nine photographs in this collection come from the series called Fluchtgedanken, which was published in 1983 as an auteur book. Fluchtgedanken is a blend of grotesque and Surreal still life, landscape photogra-phy, portraiture, and architectural motifs. The poetic quality which informs Gelpke's work resembles Herbert List's fotografia metafisica in the choice of motif, the preference for fragments of sculpture and architecture, still life, enigmatic portraiture, and the conception of landscape as geometry. Yet Gelpke is concerned not only with the mysterious appear-ance of the objet trouvé but also with the act of seeing as such. Consequently, we perceive his Mann mit Brille (man wearing glasses) seated in a geometric cone of light not real-ly as a psychological portrait. On the contrary, what becomes important is where the man has directed his gaze from be-hind his tinted glasses, in fact whether he can see at all. A couple photographed from behind in a strand promenade in southern France (Cannes) plays in the same way with the be-holder's powers of perception. Although the couple have grown together to become one figure, the true nature of their relationship to one another really is an open question. The very next movement they make may bring something new and unexpected. Here, as in other compositions, the figures have been captured against the horizon of an endlessly wide sea as if they were on stage being shot in static poses which, in the indecisiveness of their configuration, also appear to record a condition of unconnectedness. These are (sujet trouvé) found pictures, not staged ones. "Each of these pictures is an inner picture found in reality which already existed vaguely in my imagination. These are pictures of a search, of unexpected seeing and sudden insight, of capturing, yet also not grasp-ing," as Gelpke says.

One could speak of Gelpke's pictures in the words Walter Benjamin used when confronted with Atget's Paris pictures: "a wholesome alienation of surroundings and person." Gelp-ke's situations hang in the balance. Refusing unambiguous reading of the scene, they refer to the presence of the imagi-nary and are a point of departure for stories whose outcome, however, remains uncertain. Reduced to a very few pictorial elements, the action appears in an aesthetic of fragment and reduction. It must be seen as a clear stance against the quick "fads" in fashions, advertising and television which infiltrate our consciousness daily. Gelpke's pictorial cosmos con-sciously opposes these mechanisms of shrill and rapid com-munication, expressed in the polyvalent significance of his scenes, an interplay of deception and reality which does not resolve tensions. Essentially, what the great Italian drama-tist Luigi Pirandello once said is true of Gelpke's pho-tographs: "Every reality is a deception."

Ulrich Pohlmann

Madonna with Child, 1992 122 x 122 cm

Language is the essential point of departure in the work of the Russian artists Rimma Gerlovina and Valeriy Gerlovin. Before the couple emigrated to America in 1980, they were part the Samizdat network of underground artists in Moscow. These artists were concerned with studying the usage and effect of language, which was regarded as the basis of the social construction of reality. Experimental and political writers, whose books could only be published and disseminated through Samizdat, and visual artists belonged to the association. The Gerlovins took as their premise the realization that language not only defines and orders the world according to objective criteria but can also be employed as a means of manipulation. They developed a concept of art which studies questions according to higher ontological truths, placing the individual in universal contexts. Through plays on words, through the use of signs and symbols derived from diverse philosophical, mythological, esoteric, and religious cosmologies and hierarchical systems, they probe the frontiers of language.

They call the photographic representations of themselves – in which the two stand for humanity as thought models and visual supports – Still Performances.

Lack of motion, standstill, and endless duration can all be associated with the English word "still." Its application to performance, however, is paradoxical. Performance incorporates both a beginning and an ending, indeed the passing of real time. Just as stopping to stand still is united with process to form a contradictory whole, dichotomies run through all the Gerlovins' work. Madonna with Child is part of the comprehensive Photoglyphs series. The title of the series consists of the words for "light" and "sign carved into," linking what is intangible, evanescent, and immaterial with indelible visibility and the concept of the eternal. The play in which the pair involve the spectator is not only metaphorical but also ironical, systematically subverting any approach to rational thought.

In front of a black background, which can be thought of as representing a timeless and boundless space, a face appears in bright light. Sometimes it is combined with naked shoulders, arms or legs. It is usually Rimma Gerlovina, who emerges to fill the format in the harmoniously balanced pictorial composition. Words, signs, or numbers have been written into her skin, recalling tattoos. Applied externally, they are in the flesh for life. Yet the association that what is internal emerges to be visible externally also sets in. We see symbols referring to time; we read, for example "Breathe," "Vivid," "To be or not or both or neither," "Aqua Vitae," "Absolute-Relative," or "Vintage." Or we may be confronted with a labyrinth, a drawing of Stonehenge or the representation of a serpent on a face. In these visual enigmas hair is repeatedly assigned a crucial structuring function within the picture. On the one hand it is employed as a formal element which subdivides words into new content, as in the work Be-lie-ve, in which two locks of hair isolate the syllable "lie." On the other hand, it serves to give abstract ideas visual form. In Pupa, long, braided hair enfolds a body like a cocoon which will metamorphose into new life. Similarly, Madonna with Child, subtitled Enchantment of Creation by its own means, is based on the acceptance of the cycle of birth and rebirth. By composing a picture which is in the tradition of representations of the Virgin, the Gerlovins take up the Christian mystery of the Immaculate Conception. Of course they are literally transliterating the paradoxical doctrine by giving the woman a child to hold that is formed of her own hair. The child is part of her, yet does not possess its own body in the physical sense so that it is revealed as pure idea, a simile or metaphor. Words and representation evade unambiguous interpretation, leaving room for doubt and new visualizations. "There are many forms of presentation of truth, each suited to the understanding of each of us,"[1] declare Gerlovina/Gerlovin when they explain that they are referring in their work to humanity as the measure of all things.

Beate Ermacora

1 Rimma Gerlovina, Valeriy Gerlovin, Photoglyphs (New Orleans: New Orleans Museum of Art, 1993), n. p.

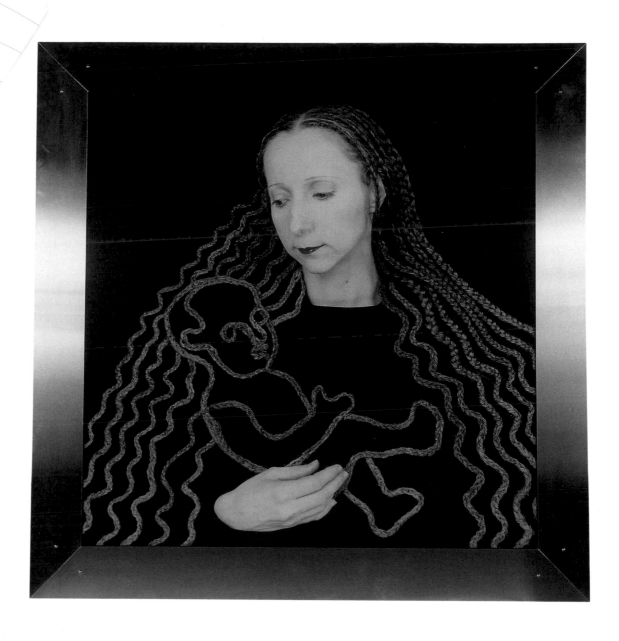

Jochen Gerz

Erase the Past, 1991
2 parts, each 18.5 x 13.7 cm; 2 parts, each 28 x 20 cm

Your Art #9 (1991) is set in the intermediate zone between various forms of expression. In this field of conflict a dialectic is produced that is a defining feature of Jochen Gerz's entire œuvre and represents one of his basic conditions. Your Art #9 combines a text with a number of black-and-white photographs, the subjects of which – street scenes, tree foliage, and the like – are not easy to identify (partly also because every other photo is printed as a negative). The sentences, which can only slowly be deciphered, deal with the artist's difficult relationship with his art, which is compared to that with a woman. At the end there is the utopian vision of a place in which there are no more artists, since art has been integrated into life. Only in this place is the unbridgeable difference between art and life erased – one of the central themes of Gerz's work. Both his campaigns of the seventies and his socio-utopian initiatives, as well as the photo/text works and memorials of the last ten years, have their roots in this underlying theme. In contrast to the works of the early seventies, which were deliberately kept quite plain, the aesthetic presence of his more recent works is evident. The black and white of photograph and text is associated in some areas with a rich red. Such a strong color contrast, which continues the Constructivist tradition, so to speak, intensifies the impact of the large format. The clarity of the construction, the extreme sharpness of focus, and the sections giving the impression of an engraving give these works a coolly intellectual slant. For Gerz, the confrontation with history plays an important role. A work such as Erase the Past (1991) also has a share in this: apart from the black or red covering parts of the picture, enough elements remain visible to be able to identify the watchtowers or the flat landscape as places of violence, of loss of freedom, as deadly frontiers.

Gerz's confrontation with the past is ultimately a recurrent confrontation with recent German history and the Holocaust as the most blatant example of humanity derailing.

It is in this context, too, that we should view his public monuments or memorials created during the last decade: the Monument gegen den Faschismus (monument against fascism: 1986 – 1993) in Harburg, consisting of a lead pillar that can be lowered, on which citizens are invited to make entries; the Mahnmal gegen Rassismus (memorial against racism), executed in Saarbrücken in 1991 – 1993 with the help of art students, with 2,146 paving stones bearing the name of a Jewish cemetery on their underside; the Monument vivant de Biron (living monument of Biron: 1995 – 1996), on which the inhabitants of the French village have attached in the form of little plaques their answers to the question what risking one's life is still worth today. All these monuments are distinguished by their open character. The artist provides an impulse that is intended to bring forth a process (thoroughly controversial, of course) of reflection and action in a particular social milieu.

In reference to the Harburg monument Gerz has said: "In the long run, nothing can raise itself against injustice in our stead." Without the living confrontation of people with the present and past a monument remains dead matter, hence Gerz's various strategies to make people participate in his works. In this way he has succeeded in reviving a genre believed dead, such as the public monument, and at the same time in making art socially effective while retaining all its artistic character. For Gerz, ever since he started out, keeping questions open has been more important than a self-contained work such as a sculpture. Certainty exists only with regard to the necessity of never-ending reflection.

Andreas Hapkemeyer

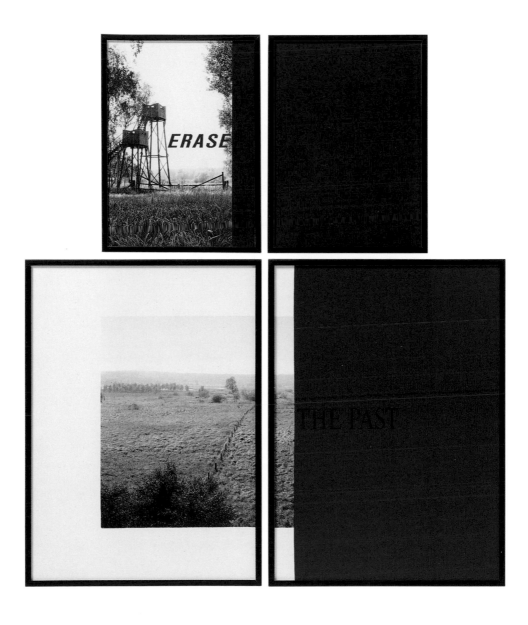

Mario Giacomelli

Io non ho mani che mi accarezzino il viso, 1962/63 30 x 40 cm

"I seek/an innocent land," explains Giuseppi Ungaretti. Mario Giacomelli, too, is searching for an untainted land. He seeks it in the hills of his home, but he also looks for it in the hearts of people, sometimes even on the threshold to death. Mario Giacomelli need not go very far to reach it. He is always finding it in the hills of his home, the province of Marche. This is land that is innocent, yet not untouched. This is farmland, whose appearance has for generations been formed, always in the same manner, by the traces left by the contadini working on it, the field hands. Under Giacomelli's gaze, the lines and planes, the light and dark parts of this landscape are put into place to form pictures, and he delights in burgeoning life. Are not these traces signs of a new beginning, of a new awakening?

He photographs from the hills. We rarely ever catch sight of a horizon. Perspective in his pictures became still flatter when he finally decided to point his camera towards the land from a plane he hired. Soon it was no longer enough for him to settle for composing his pictures with the lines, shapes, and shade as he found them. Thus, he borrowed a tractor from one of the farmers in order to etch his own forms into the harvested fields by leaving traces of the tires or the plough. Ultimately he laid his negatives (they are 6 x 9 format) on a light box and began to treat them with etching needles, scrapers, and varnish until the forms of nature and work in the fields blended with the tincture of his own abstract thought. Light and nature, the signs of landscape and his own individual, expressive will led Mario Giacomelli to create works of Land Art in nature and in his pictures years before Land Art had entered into the art of our time. He had touched the innocent land and kept it as poetry in his photographs, which he called paesaggi, landscapes.

He found a different, inner land in the hearts of the people of his home. La buona terra (the good earth) is what he called the pictures which tell of this. They tell of people who are still at one with the land which they cultivate, which they care for, the land which feeds them. Contadini are not hired field hands, they are a community. And the pictures which Mario Giacomelli took of and with them reveal people who are cheerful and have been closely bound in ties of friendship over generations. He is one of them. They are the people of Senigallia, where he comes from. Very different are the people from the south of the province of Abruzzo, in the mountainous municipality of Scanno. There he was a stranger. And we recognize in these pictures the invisible barrier separating him from these people. The innocent land of their hearts is invisible to Giacomelli. Only the people of Scanno can tell of it, yet they are silent.

Silence also touches us when we look at the often mysterious pictures to which he gave a title, no less mysterious: Verrà la morte e avrà i tuoi occhi (death will come and it will have your eyes). He had known these people, who were now close to death, all his life. Like him, they were marchigiani. But now he was encountering them in a world unknown to him. It was a dark, hopeless world, this world of dying, in which everything seemed dark and strange and in which death looked out at him from the eyes of people whom he once knew. There was no trace left of the joyful acceptance of life these people once felt after the traditional rite of dying forced them into the darkness. And this darkness moved him when he photographed its shadow, and he suggests to us what he felt and in retrospect still feels when he enlarges the negatives. The sharp focus is on the person who is waiting for death. He has given over the other parts of the picture to a strange, unreal world by bending the photographic paper upwards out of the plane of sharp focus. Thus he transmits his sense of this oppressive situation by resorting to a simple device right in the picture.

On a winter's day in 1963, he created a counterpoint to that experience. He was again working in the shadow of the church when one of the rare snows to fall in the region covered the seminary garden in joyful white. Giacomelli encouraged the young seminary priests to be caught up in this joyousness, and they remembered that they were young. For a while they were liberated from the seriousness instilled in them to again become romping, happy children. This may have been the last time in their lives that these pretini, "little priests," were really carefree.

Peter-Cornell Richter

What a sight for a poet; the robes splay out like wings. As if these people wanted to ascend to Heaven ... or to gyrate like tops.

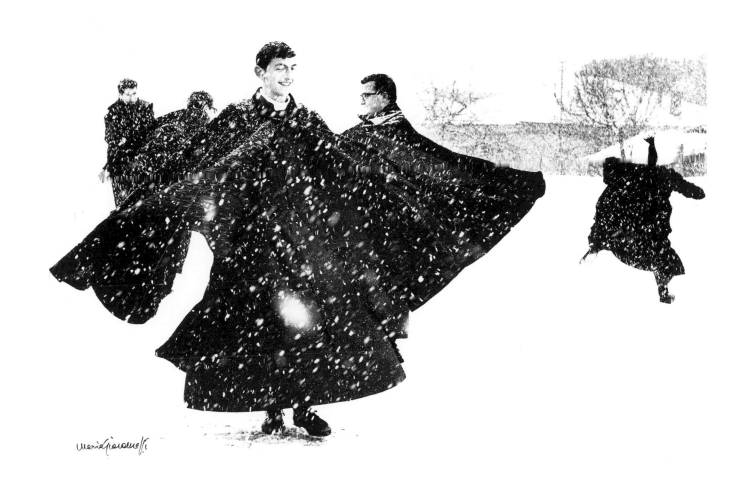

Ralph Gibson

In Situ, 1988 51 x 41 cm

The pictures are vaguely reminiscent of other pictures, but it is difficult to coax a more precise reference from memory. They give the effect of being strange and yet familiar, as though they had long ago been internalized: self-evident components of the subjective world of imagination, which is necessary for general orientation. Ralph Gibson, the creator of these pictures, goes one step further. He wants, with the help of photography, to conjure up the images from dreams and myth that lurk in the shadows of human consciousness. Surrealism influenced his artistic position. For him a Surrealist is "someone who prefers to live in his subconscious ..." In his eyes, the Surrealist attitude deepens the understanding of reality. Gibson's view is all the more astonishing since he comes from the "straight photography" school. He learned his trade in the United States Navy, subsequently attending the San Francisco Art Institute. He was then hired as an assistant to Dorothea Lange and a few years later moved to New York to help Robert Frank make a film. Gibson took over Frank's studio and founded the Lustrum Press, publishing his own books as well as those of other photographers in exemplary designs. The Somnambulist (1970) was the first Lustrum Press publication he produced. The title is an allusion to his aesthetic theories, and in order to realize them to his satisfaction, without any outside influence, he wanted complete control over his pictures – including their reproduction, final book form, and marketing.

Ralph Gibson was one of the first photographers to follow an artistic path, taking a route that many abstract artists had taken in the first half of the twentieth century. Gradually the photographer reduced his medium's pleasure in factual details to an easily comprehensible formal basic pattern. In practice, the process of continuous abstraction of the visible world was effected by concentrating on just a few objects and their subsequent fragmentation. Often he isolated a single object from among a wealth of photographic possibilities and shattered its presumed unity with the help of radical cropping. The extraordinarily suggestive Infanta (1987) shows the detail of a female face in a diagonal arrangement, projecting into the picture area from the right. But only the dominant eye with the long, finely delineated eyelashes, and the slightly curved, almost straight eyebrow awakens the appropriate association. In reality we see nothing more than an angular configuration with pronounced shading on a flat white ground. This repeats the shape of the white ground, rotated by 90 degrees, that covers a third of the picture area and contrasts with the remainder of the pictorial plane, which is a homogeneous black. Déjà Vu (1972), something of a key picture, recalls Gibson's artistic theories with an ironic twist. The concrete reality behind the shot is almost obliterated; a silhouetted fragment of a male figure moves into the picture from the left, holding a white rod in his hand. The photo's structure is based on two intersecting diagonals, one – the light one – doubled. The white rod repeats a white stripe on the floor in the photo, which is taken from a bird's-eye view. But only at second glance are we able to make out the actual subject matter of the photo, since optically the white stripe has become detached from its base and has forced the photographic image from the spatial illusion of the shot into the verifiable factual reality of the photographic, namely the two-dimensionality of the photographic paper. Gibson is playing a cryptic game with the conventions of perception, a play on the appearance and reality of the photographic claim to authenticity, a play on seeing and imagining, on recognizing and fantasizing. In his pictures the boundaries become blurred. Only irony, which sometimes develops in the correspondence between title and image, for example in the series In Situ, provides a guideline for the irritated viewer to gain insight into the aesthetic connections, which are simultaneously reflections of the connections within the world of experience in general.

Klaus Honnef

Headed, 1992 169 x 142 cm

Gilbert, the thickset South Tyrolean, and George, the somewhat taller and thinner Englishman, began their incomparably successful tour through contemporary art at the end of the sixties as living sculptures. Identical and interchangeable, according to a biographer, in suits of the same cut and color, with faces and hands painted gold-bronze, they spun around on a rectangular table like the figures on a musical clock to the catchy melody "Underneath the Arches," while singing the romantically melancholy words of the song. The music and choreography never changed, and such a performance might last for hours, going back and starting from the beginning time and time again. They conceived of themselves as "The Singing Sculpture," and countless publications explained, reinforced, and expanded into a program the artistic concepts that were suggested in their performances. To be with Art is all we ask is the title of one of these publications, which at the same time makes the aesthetic goal of their claim to be artists apparent with a slightly ironic twist. The books were illustrated with atmospheric drawings, consciously old-fashioned, not comparable with the works of contemporary artists. Some of these publications were printed on exquisite paper using select script, beautifully bound, and made up into expensive books. Later the illustrations became stand-alone, large-format picture scrolls. They showed the artists in natural scenery, apparently in contemplative mood, but subliminally they also gave the impression that the contemplation was purely a facade concealing an unseen menace. Gilbert & George met at St. Martin's School of Art, London, which once turned out the elite of the British avant-garde, and regardless of their deliberately conventional appearance, which in reality was completely false, as well as the external impression of their artworks, they were part of the last flowering of a decidedly avant-garde art. They dreamed, and still dream, the unending dream of erasing the gulf between art and life, although they themselves have probably been able to implement their design for a life of art. To the extent to which they used photographic and cinematographic methods to realize their artistic intentions, the contradictions of modern civilization have come into their field of vision. The joys of nature were lost, and the conflicts of an urban world filled the surface of their pictures. But their subjective experiences, not least their sexual disposition, also determined the focus of their artistic strategy. After initially using serial methods of visual organization, they switched to the principle of montage, which they developed to perfection. The montage principle reflects the conflicting and contradictory state of the world and moreover makes it possible to visualize the collective and the individual in their inextricable entanglement. Elements of Pop Art and advertising, the hammering rhythms of pop music, the hectic cut-and-fade technique of films, and the formal complications of electronic music mesh into a pictorial aesthetic set on a collision course. Headed (1992), with George's gigantic head in green, his bared teeth in yellow, and blue spectacles through which red eyeballs glare from a yellow retina, provides a significant example of their appellative art. Viewed from an extremely low angle, poking into the picture from above, George – in a red suit and with a yellow head – is copied on his partner's forehead at the illusionary angle of 90 degrees. It represents an abrupt change of perspective, disquieting, alarming, in glaring complementary contrast, a symbol of the ineluctable discontinuity of human existence that even sexual duplicity cannot offset.

Klaus Honnef

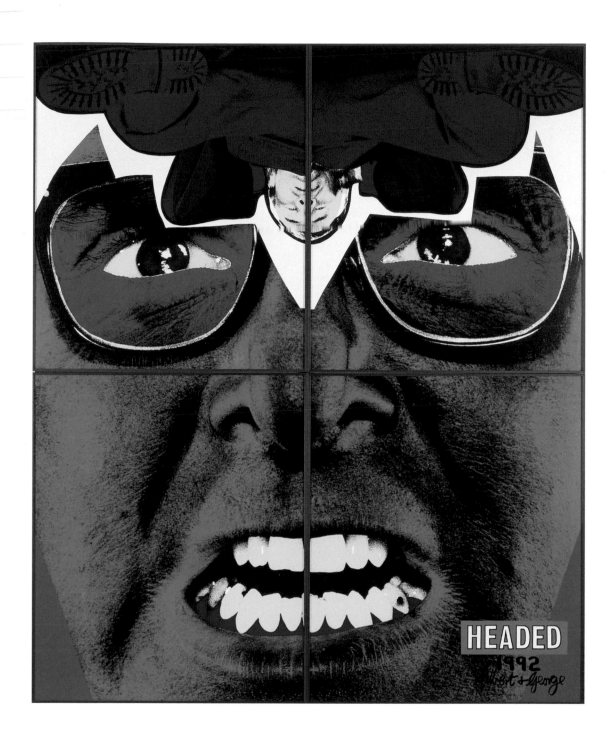

Nan Goldin

Nan Goldin has never contented herself with playing the role of the detached observer. On the contrary, she has been a player on the stage which her photographs evoke and literally quicken with life. She has often triggered off what her camera captures. Moreover, she not infrequently aims her camera at herself. She once wrote that people saw photographers as voyeurs, the last sort of people one would invite to a party, and that she herself would never be intrusive because she was the one giving the party – and anyway, she continued, it was her family and her history.

It is indeed her life that is reflected in the stream of her pictures, and these are her friends, both men and women. No generation before or since has been so hedonistic – and has all too often paid a high price. Many have died young of AIDS. For a while, freedom seemed limitless. Life was one long high. Then the lofty hopes shattered on the bleak cliffs of reality. Nan Goldin's visual diary, as the artist sometimes calls her work, glows behind a facade. It reveals the disappointments and unsatisfied yearnings, the frustration, and the consequences of physical violence which suddenly set in when all inhibitions have been removed. One portrait shows the photographer herself with a battered face. The camera lens has replaced her swollen eyes. Then there are tender and exuberant pictures, full of the joy of living. Elisabeth Sussman has called this photographer a "passionate chronicler of love." At any rate, her work does revel in the whole gamut of love, the light and dark gradations of its palette, its black moments and its rapturous ones. Its spontaneity is contagious. Yet most of her photographs are the visual proof of aesthetic judgement. The first impression is deceptive. Nan Goldin's hint at who really throws the "party" is the key to her work. A fleeting glance might lead the observer to think that these photographs are "snapshots," with a claim to documentary status. On the contrary, the photographer has acted throughout as a director, employing subtle devices that are distinctive and sophisticated. She takes advantage of everything that photography offers as a medium, explicitly playing with its ambivalence. The many enigmatic aspects of photography reflect the feelings of people caught between appearance and reality when they are being photographed.

Nan Goldin obviously enjoys playing roles, assuming guises, changing identities and, concomitantly, diffusing gender and being fascinated with fashion. Consequently, what these pictures express is not determined by the contours of empirical reality. Instead, they represent a way of seeing that has been aesthetically screened through projections from film and fashion photography. The most intimate of these photographs are a series of stills for films. Others quote, more or less directly or even subliminally, the work of photographers such as Baron de Meyer, Helmut Newton, and Guy Bourdin. The world revealed in Nan Goldin's photography is a thoroughly artificial one, violently intruded on by reality with seemingly surrealist suddenness. The battered faces and bodies are real; all at once the varnish of appearances has cracked. Right from the start, Nan Goldin was determined to publish her visual diary. Another simultaneously achieved record in writing has remained private. Her pictures deal with the drama of failed experiments in attempting to base human existence on the deceptive appearance of artificiality. The mirror is a prop often used in her photography. It reflects the picture caught by the camera. The protagonists look into a mirror while the camera is aimed at them. These are, one might say, ricochet portraits, or more accurately, refracted portraits. Some of them look as if they were viewed through a wall of colorless glass. Others are both explicitly staged and about staging. Here it is not always possible to say who directed whom: the photographer or the actors themselves may have staged these. The boundaries are blurred. Not until the more recent portraits has a deliberate style become a recurrently distinguishable feature.

Nan Goldin states that she has documented her life. She does not deny filmic experience gained through frequent visits to the cinema nor her own personal experience of filming. The mood prevailing in the late 1960s encouraged her tendency towards the artificial. She recalls that, as a teenager, she always had the feeling of being in a film and that she never thought that this was such an unusual feeling. Reality soon caught up with Nan Goldin. In her hands-on approach to photography, art has triumphed over it.

Klaus Honnef

Above: House, Outside of Pittsburgh, 1993
Below: "Neo-Colonial" Garage, Westfield, N. J., 1978
82 x 62 cm

The question of the intentions that link media producers and users lies behind the impressive media work of Dan Graham, who has appeared since the sixties in the guise of rock musician, performance artist, video and installation artist, experimental filmmaker, and photographer. Graham's work completes the transition from Minimal Art, in his case with a critical orientation, to analytical Conceptual Art. For him it is the task of the media to query formal interactions in the social environment. At the same time he turns against the thoughtlessness with which the "idea of the individual" is exaggerated to mythical dimensions in American culture. The subject, for him, is always present within a network of relationships in a space structured by society.

His installations and photographic works are essentially inventories of the structures of order and the hierarchies which manifest themselves in architecture. Since the seventies he has built small walk-in glass pavilions for which he uses opaque mirror glass and one-way mirrors. The concept consists of the public recognizing itself as active and passive parts of a visual system. Like a model the apparently transparent language of architecture, which is assumed to be public space, is exposed in these glass installations by multiple reflections.

The fact that Graham regards himself as a "photojournalist," with which he is going back to one of Marcel Duchamp's terms, has often been misinterpreted by the artistic world, especially as his paradoxical sense of humor subliminally finds expression here. In the USA and Canada in 1966 he compiled the project Homes for America from black-and-white photographs.[1] These were photos of standardized, medium-size apartment blocks erected as cheaply as possible. The striking common factors between the sterile residential blocks and the serial standards of Minimal Art, which as an "ism" from New York claims a high market value, cannot be denied.

The six photographs in the DG BANK Collection show an analytical approach to architecture as a socio-historical field. Two photos each, from 1965 to 1996, are arranged to provide a context. The subject of investigation is the architectural constructivism described as "modern," whereby the preferred materials – stone, iron, wood – are also comparable to the artistic serialism of Minimal art. The photo "Neo-Colonial" Garage, Westfield, N. J. was taken in 1978; the luminous orange industrial paint creates an association to Minimal Art in the color and the formal context. Even the motif of a corridor disappearing into the darkness in a junior high school shows a control system, strategies of limitation and enclosure. Quite clearly, these structures have the function of limiting possession from the outside via a closed security system. The same hermetic self-containment, here symbolically represented by architecture, is continued in the forms of movement of human bodies, as in People in Highway Restaurant, First Day of Opening, which shows an interior view. In other words, the modern era has produced dominant spatial arrangements and modulated structures symptomatically so that they become standardized phenomena of this space. Their noticeable, even serial distance from each other is the result of cultural factors. Here we are dealing with less varied, social forms of distancing. Similarities between private inter-structural relationships and communal urban design are revealed in Dan Graham's photo motifs. As index and pattern, his photographs show the problem of sensory deprivation in modern urban spaces, the visible tactile monotony and sterility, which may often be blamed as the cause of medial and technological distraction in urban geography.

Gislind Nabakowski

1 Cf. Ulrich Bischof, "Dan Graham," Medium Fotografie – Künstler arbeiten mit Fotos, Kunsthalle zu Kiel (1982), pp. 46 – 47.

Top: House, Outside of Pittsburgh, 1993 Bottom: 'Neo-Colonial' Garage, Westfield, N.J. 1978

Rodney Graham

Ponderosa Pine IV, 1991 210 x 180 cm

Viewed as an individual work of art, and as a unique print that is in the DG BANK Collection, the large photograph entitled Ponderosa Pine IV (1991) by the Canadian artist Rodney Graham might at first glance seem like a photographic paraphrase of the German painter Georg Baselitz's approach to art. Baselitz paints many of his (figurative) motifs as if they were upside down. A paraphrase of this kind is not possible, however, because in photography it is the "pencil of nature" that draws, and the laws of optics invert all photographic images. Graham's approach to art tends to include reflection on the medium in which a work has been executed. Moreover, the motif of the tree itself in all its strangeness is what seems to be in need of explanation. One need only think of Caspar David Friedrich's trees to realize with how much resonance and intertextual reflection the motif has been charged. This nexus, which places Graham's picture in the tradition of painting and its iconography, is a given of the motif as represented. Mondrian, for instance, arrived at abstraction via the tree motif.

Pinus ponderosa: this tree species gave its name to the Ponderosa Ranch which was the focus of the early TV series Bonanza. The series had a formative effect on the idealized image of America entertained by several generations of Central Europeans. The very title of the show revealed inadvertently the true relationship to nature behind the idyll. The conifer forests of the Pacific northwest of the North American continent (Graham lives in British Columbia) are a bonanza. The region's economy still depends on the construction and paper industries and their steadily increasing demands for fast-growing pine wood. These trees, of which there are both hardwood and softwood species, also play a material role in painting, through the solvent turpentine. Graham points out that natural idylls and land claims represent two sides of the same coin.

The upside-down tree in this "obscure" picture recalls the long history of the lens and the early photographic view of the "new" world through it, in that it brought natural wonders into focus but represented the tree as felled or being felled rather than standing. Graham's monumental gesture is, therefore, both a picture of what is "unnatural" about instrumental rationality and a symbol of the unresolved ecological dilemma facing the modern age. Further, the motif of the heroically heightened tree, which has assumed the shape of its own cones in the picture, represents the expression of an idyll which is enlightened about its own self and, therefore, desirous of righting things again by inversion. Vancouver artists, among them Rodney Graham, Ken Lum, Jeff Wall, and Ian Wallace, are linking up with the North American fine-arts (and literary) tradition of Naturalism. It differs from the European, despite obvious parallels, in that the idea of untamed nature can also convey definitive concepts for national consciousness and values. There are obviously parallels in content between Rodney Graham's landscapes and those of Jeff Wall. We find the motif of the pine especially in Wall's Pine in the Corner (1990) and his Park Drive (1994). In both the focus is on the suburban back-to-nature idyll. Wall has also described a project of Graham's, a companion piece to the Ponderosa Pine pictures, in the form of an installation in public urban space: "In Graham's Millennial Project for an Urban Plaza, from 1986, a raised yellow platform supports a large camera obscura which looks out onto a broad, inner-city square. In the square an oak tree was planted at the time the pavilion was completed. The camera obscura watches the tree grow. After fifty or a hundred years, the tree is fully-grown and tall enough to be framed precisely on the screen in the chamber's interior. Graham's project inverts the relationship between the forest and the architecture of the present-day city."[1]

Hubert Beck

1 Jeff Wall, "Traditions and Counter-Traditions in Vancouver Art: A Deeper Background for Ken Lum's Work," Càmeres indiscretes, Centre d'Art Santa Monica (Barcelona: 1992), p. 110.

Angela Grauerholz

Basel, 1986 148 x 100 cm

Angela Grauerholz has a painter's eye. Her camera lens perceives landscapes and interiors in moments of transition from photography to painting. In the photograph she succeeds in skillfully simulating an optical arrangement of outlines dissolving picturesquely. Framing and the use of sepia tones favor the impression of realistically blurred paintings, which might have their origin in a Seurat drawing and would like to achieve completion in Gerhard Richter's halftones.

Like a vision straight from the last century, St. Alban's Pond in Basel flows in a whitish-gray swirling spume past the papermill between narrow housewalls near the modern art museum. With a photo like this Angela Grauerholz seems to stir up memories of that early time when photography froze for eternity the flow of the present at a fleeting instant as a visual message to a later era. Is the smudged mood photo, totally impressionistic, intended to give the past a helping hand? Its expressive potential is at any rate not yet exhausted – and this urban wild-water scene has not changed since then.

Entering the Landscape is a series on the threshold to the incessant, although never concluded, concretization of the photographic motif: the people over whose shoulders the artist peers have not yet reached their destination. They move in the direction of buildings and bushes, groups of trees and rivers, which seem to hide something that cannot be pinpointed. Even if the passersby and intruders have gone on and are no longer visible, the places still retain their undisclosed secrets. Thus, with the series Leaving the Landscape, it remains left to the viewer's imagination, all human presence having been removed, to speculate on the happenings and manifestations that remain invisible between the groups of trees, in clearings, on railway platforms, in swamplands, and in empty farmyards. Something must have been there. Michelangelo Antonioni's Blow Up, the sixties' film

about the fallacies of photography and the tricks of enlargement, described this bizarre sensation of the concrete dissolving in an arena of time that has already passed.

In 1976 Angela Grauerholz left Germany for Canada. It is said she was made uneasy by a social climate that thwarted sensitive photographic endeavors. Camera-toting artists, especially those who openly took photographs in places where others could see nothing special, were in any case suspect at that time. In Canada Grauerholz was able to look at the landscape, at room arrangements, and at people without the unpleasant feeling of herself being observed until, under her gaze, a romantic impression in the style of the "pictorials" of Edward Steichen and Alfred Stieglitz again took shape – a Postmodern déjà vu of an impression from earlier days, long familiar but now blurred.

Angela Grauerholz develops form and landscape out of light that seems to draw back from the motif. What Gerhard Richter had to paint accrues to his colleague from the merest pressure on the shutter release: the fleeting glance registers agitation of the atmosphere; haze, dawn, and twilight favor veiled, shrouded perceptions. Only a few of the many negatives taken are considered worthy of further evaluation. The photographer, who lives in Montreal, made a great impression at "documenta 9," a year after her first European solo exhibition at the Westfälischer Kunstverein in Münster in 1991, because her photographs came closest to the painted character of a classical impression made up of black-and-white halflight zones. No painting could have competed with the picturesque effect of these photos. So sensuous were the results that thoughts about the technical process involved did not even arise. Among the ancient Greeks, Psyche was one of the deities of nature. Angela Grauerholz is the Psyche of photography.

Günter Engelhard

Tamara Grčić

Untitled, 1995 50.8 x 61 cm

The Instant is not in Time – Time is in the Instant

The five sheets (all 50.8 x 61 cm) by Tamara Grčić belong to an untitled series of twelve C-prints that the artist took in 1995 in a grocery store in New York's Chinatown. The series was first shown in 1996 in an exhibition in conjunction with a room installation by the artist in the Galerie Monika Reitz in Frankfurt, where this selection of five motifs was acquired. In this exhibition the installation – floodlit red garments and fabrics laid on camp-beds taking up the entire room – and the photography contained references to each other (red gloves and garments crop up as motifs in the photo series), but were nevertheless separate with respect to space and content. By contrast, in Grčić's installation in the art society, the Kunstverein, in Bonn a year later, they were brought into direct dialogue and understood to be parts of a single work. In this case the photos show hair photographed from behind in the streets of New York in winter, thus demonstrating a certain creative connection to the grocery store pictures. Eighty-one pieces of women's outerwear hired from a clothing manufacturer are hung, arranged according to color, between two columns opposite the photos. The photographic image in the creative work of Tamara Grčić, however autonomous the photographs are considered to be, cannot therefore totally be separated from the context of her artistic œuvre. For instance, the melon and the eggs in the photos are objects and motifs that the artist has employed in earlier installations.

These "found" still lifes, photographed with a poetic and intensely painterly eye, are marked by their exaggerated close-up view of things which therefore essentially appear as fragments. Almost every object – fleeting details of insignificant, left-over goods and tools lacking the shine of wares intended for display – is cut into by the picture frame. The meditative stillness and sublime landscape of a precarious world of things is taken in a small way from the loud comings and goings of a shop in the big city, accessible not to the busy shopper but to the aesthetizing eye of the stroller. Form follows function. Yet these qualities of form are not arranged artistically, as in the still life tradition, but are discovered purely by concentrated attentiveness on the part of the artist. Thus these photographs also participate in a documentary compilation of the photographic image. These pictures are not lit up by flash, so the depth of field is very small, unlike object photography in the field of photographic design. Interestingly, however, this brings out all the more clearly the structure-forming conflicts of form and content between organic and inorganic (plant and plastic, town and country, nature and civilization), damp and dry, rough and smooth, lasting and ephemeral, inner and outer, green and red, or blue, as vehicles of meaning in the sense of a romantic, melancholy "vanitas" motif. This is evident, for example, in the egg, broken and therefore no longer sellable, in the carton.

This world of things seems, on the one hand, to be unmistakably subject to the circulation of goods in the city that grabs everything for itself and makes it a commodity to be bought and sold; on the other hand, the gaze of this camera opens up a charged corporeality, with all its latent erotic imagery and symbolism, seeing the city as the great promise that it does in fact represent. Not only because, through the garments and tools, the human being is represented as the absent presence, but because the ability to regenerate and the power of imagination, however endangered, appear in the picture as something of the present day, particularly in the photo with the melon and its uterine symbolism. Within the present collection, the most interesting common features with and differences from Grčić's photographs are to be found in the work of Nobuyoshi Araki and Beat Streuli.

Hubert Beck

152

Andreas Gursky

When the great Italian poet Petrarch daringly climbed Mt. Ventoux in Provence with his followers on April 26, 1336, in order to look down from the summit over people and landscapes, he provided, or so legend says, the symbolic impetus for a fundamental change in the Western system of perception. The view from above did not just give an overview that could be of enormous advantage in warlike conflicts, it changed the relationship between humans. Instead of the individual in God's image, the modern collective now appeared in the field of vision. Andreas Gursky prefers the bird's-eye view. Only rarely does he photograph his subjects frontally, although the artistic result is the same. He studied under Bernd Becher – the clear visual idiom is unmistakable, the neutral lighting devoid of atmosphere, the inclination towards a typological understanding of the world – but even before that he listened to Michael Schmidt. Yet, unlike Becher and his school, it was not just the civilizatory traces of human activity, the cultivated nature and the architecture that aroused Gursky's artistic interest, but the people, the originators of these sometimes confusing manifestations. He observes and records how people present themselves, how they behave, how they associate in the swimming pool, on the beach, in the mountains, on the football field, in the office and at the railway station, at the stock exchange and the airport, at university and in high-tech industry, as well as out on a Sunday walk. Landscape and town, outer and inner, are products of the process of civilization – internal and external worlds, the difference a matter of degree, not principle, at best optically meaningful. In the view from above people do not appear as individuals, nor as models that can be molded according to patterns laid down by the modern communications industry, but as social beings whose existence takes place in changing groups under changing external conditions, with consequent changes in behavior. When Gursky gives one of his large-format photographic pictures a title

that is the name of an important politician and statesman, such as Charles de Gaulle, Paris, then he is thinking of the huge airport, not a portrait. Down the tentacles of an architectural octopus people glide across a funnel-shaped abyss on conveyor belts towards their destination. In the mezzanine floors they sit on widely spaced seats to wait for whomever or whatever. The correspondence of architecture and collective grouping, the influence of the architecture – including its complex conditions – on the behavior of humans, whose needs the architecture was on the other hand erected to satisfy, stamp the structure of the picture, including its form. Gursky does not direct in front of the camera, but rather with the camera, which he positions exactly where the connections become optically evident. The picture Singapur Börse II (Singapore stock exchange II: 1997) obeys the same aesthetic principles. Here again the architecture, thanks to precise framing, imposes order on the seething hordes of people at the stock exchange. It forces the many protagonists into a comprehensible group rhythm, and the careful distribution of volume supplements an overlaid color management, which may be accidental, but in the case of Gursky is the result of precise observation. As with the red in Singapur Börse II, so with the metallic gray in Charles de Gaulle, Paris. Does the use of colors also perhaps have symbolic value? The dominance of technical architecture in the one picture, that of human activity in the other? Gursky knows that appearances are generally deceptive. And what interests him is the balance of being and appearing. It is not just the choice of format that demonstrates the affinity to the cinema (and to painting). Like John Ford, Gursky with his bird's-eye-view pictures conjures up a concept of fate that cannot be defined more closely. And, like Alfred Hitchcock, he intensifies the sense of the threat to human existence that lies just below the surface.

Klaus Honnef

Jitka Hanzlová

The twenty-five-piece photographic cycle bewohner (inhabitants) by Jitka Hanzlová begins with the view from a heightened perspective of a city square in winter. It is characteristic of this series in several respects that it is only at second glance that one realizes this is the Alexanderplatz in Berlin, as the television tower can only be sensed through the low-lying clouds, rather than clearly identified. On the one hand this introduces a specific way of looking at the city, at places, which attempts to depict natural pictorial qualities with the aid of atmospheric and seasonal filters; on the other hand – as the title hints – it is more a question of the inhabitants than of the places they inhabit, if such a distinction is ever possible. And yet the cultural and socio-political symbolism of this particular city square is obvious: Berlin as the pivotal point between East and West may of course also have some biographical significance for the artist, who arrived in Germany from the former Czech Socialist Republic in 1983.

In several architectural motifs in the photo cycle, however, it is noticeable how closely they appear to relate to the aesthetics of the Becher school. Two photographs in particular, which show the gabled ends of multiple dwellings, seem to be based on the Häuser (houses) and Hallen (halls) typologies of Hilla and Bernd Becher. Excepting the visual parallelism of the house walls and the deeper viewpoint which is "missing" in Hanzlová's work, the main difference is that (in one case) the branches of a tree protruding into the picture bear the tender young leaves of springtime. This is exactly the type of natural pictorialism that the Bechers deliberately exclude. The comparison does not go much further, since Hanzlová's color photographs have an eminently painterly quality. The painting that most closely resembles her photo series is in fact Edward Hopper's Approaching a City (1946). Hanzlová's eye for the picturesque is particularly evident in the photo of the excursion boat against the sunset. This image is very strongly reminiscent of the color photography of William Eggleston.

If the color in Eggleston's work came more from landscape and region, in the end the "American" aspects, and less from the figures, here the color comes from things (animals, often dogs) and the clothing of the "inhabitants", the majority of whom, incidentally, are women. Color appears in these pictures not just as analytical or formal, but above all else as a subjective principle. Yet the people whom the artist captures after accidental encounters are "staged," as are the things; they sit or stand, usually alone, in corners, in niches of private, so to speak "placeless" rooms, which, however, appear to be open to social space. Connections from within and from outside take place primarily in the gaps between the motifs, to be filled by the viewer. Thus the series ends with a frontal picture of a woman in the snow and a closing image of dying sunflowers in a pot in the corner of the room, which has a melancholy and quietly ironic effect as a result of the sequence.

These pictures are evidence of an active search. This applies explicitly to the "inhabitants," but also to the artistic self. The artist's spatial movement through the city is the expression of an internal, emotional "movement" which seems to be averted for an instant by the statuesque qualities of the figures and things depicted. To dwell is to leave traces. The places in these photographs are strangely devoid of traces. It is the colors and the clothes that the figures wear which are inhabited, as though (like a uniform) they could tell their story or keep silent. The inhabitants dwell in the manifestation of their, and our, collective hopes and fears.

Hubert Beck

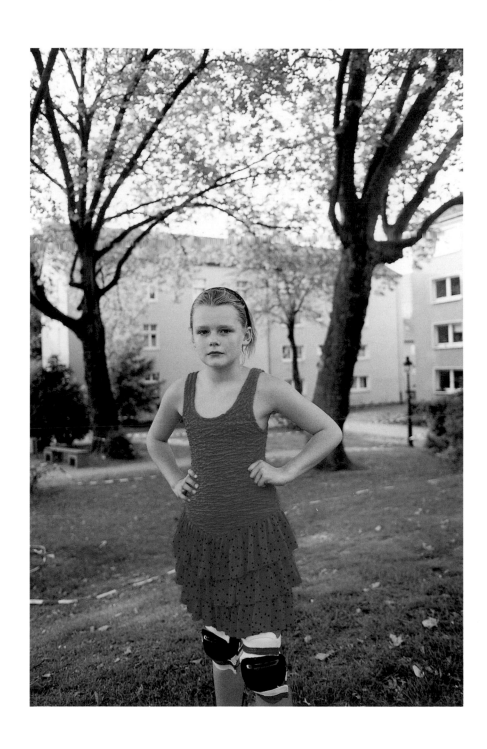

Alex Hartley

Untitled (Three Part Division), 1992 3 parts, 150 x 150 x 31 cm

Alex Hartley is no photographer in the classic sense. The Briton, born in 1963 in West Byfleet, blows up his own or existing photographs into wall objects with dimensions of up to more than two meters. In a series dating from 1993 he shows gallery rooms. The photos themselves are objets trouvés from such well-known art magazines as Artforum or Flash Art, where they illustrated reviews of exhibitions by artists such as Ellsworth Kelly at Portikus in Frankfurt or Robert Morris at Leo Castelli in New York. Hartley processes these photographs; he enlarges them, whereby the artworks that were the actual reason for the illustration are removed, and then retouches them with an airbrush. What remain are black-and-white photos of empty exhibition rooms. Hartley mounts these photos on pressboards and encases them in greenish, frosted glass. Extremely heavy three-dimensional wall objects are thus produced, which shed light on various aspects or dimensions of space. Primarily, however, Hartley takes over these gallery premises by liberating them from all other works of art. He adapts the now empty spaces for his own purposes by incorporating them into his own work. This gesture can be interpreted as an Oedipal rage against the great father-figures of modern art. Hartley calls them "icon-artists." He follows much the same process in an installation dating from 1991. Untitled (After Monet) is devoted to the presentation of pictures in a museum setting. The photograph shows a wall of the National Gallery in London on which three Impressionist paintings are displayed. The segments taken up by the pictures are however etched on the glass-plate surround. Here Hartley does not completely empty the room, but he obstructs the view of the masterpieces. Thus his photo-sculptures are not merely minimalist reflections on space and its perception, the viewer's meditations, and the strictness of the geometric composition, but they are also enlisted in the cultural activity. Hartley's works reflect the places in which they are shown, not just as rooms but as a complex blend of artwork, display structure, and artist.

Another work complex continues with the motif of emptied gallery rooms, although in a modified form. The works now consist totally of fictitious premises. Untitled (Three Part Division), from 1992, thus does not start from the basis of an actual gallery room but from an ideal one. The room depicted in the black-and-white photo exists only as a model made by Hartley. Again he surrounds the photo with a framework of frosted glass that makes it independent, three of the glass cases fitting together to form a rectangle. The lines that are thereby created divide up the unity of the room originally provided by the photo. They are not orientated towards the structures set by the photo, however, but form independent spaces. Thus two spatial systems are produced in competition with each other: the fictitious gallery room and the concrete space for the artwork provided by the glass cases. This irritant factor is intensified by the picture surface, which is not flat, as the viewer would normally expect, and does not run parallel to the wall, but rises diagonally from left to right of the work. The frosted glass also contributes to this diffused and confusing impression of spatiality: if the viewer steps closer to the picture to get a better look, he will be prevented from doing so by the glass. There is no clear view. Alex Hartley violates the usual patterns of perception of a work of art. The disruptions produced in Untitled (Three Part Division) deliberately force the viewer to think about his vision. What is real, what imaginary? How do I get close to an artwork? What do I really see?

In this work group Hartley is again investigating the conditions of a work of art. The focus here, however, lies less on considerations about cultural activity in general than on the work of art itself and the way it is viewed. Hartley is continuing along a path already trodden by such artists as Marcel Broodthaers and Daniel Buren, who in the sixties and seventies confronted the context of the work. Here, as there, it is no longer the artist and the expression of his inner being that stand at the center of art production. The emphasis is more on the conditions that create and surround the artwork; the viewer, the place in which it is displayed. A shift has taken place – from the work to its context.

Martina Weinhart

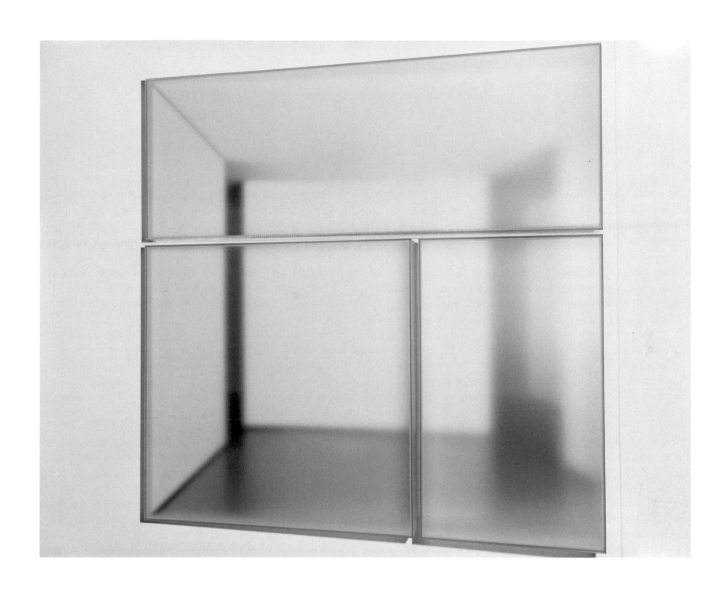

Robert Häusser

Born in Stuttgart in 1924, Robert Häusser is the outstanding personality among the photo-artists of the postwar period and had gained recognition in artistic circles by the sixties. He realized at an early stage that artistic photography in Germany was treading an isolated path, and he was therefore the first photographer who sought links with the Deutscher Künstlerbund, the German artists' association. In his artistic work, too, he moved away from photography's thematic preoccupations and created varied works which stand out for their particular manner of viewing reality. The magic of things remains a constant element through all his work phases. Through camera positioning and lighting Häusser succeeded in seeing simple things in a new way, isolating individual objects within an image, and establishing them as significant. Magical Realism was talked of in connection with his work, yet one could also characterize his art as photographic symbolism in continuation of the tradition of the nineteenth century. To this, too, belongs the romantic aspect without which a German approach to this tradition would barely be conceivable. A certain leaning towards the morbid is an element of his exaggerations, whether in his bright or his dark period, and in view of the self-portraits there is no doubt about his tendency to yearn for death.

Robert Häusser is, so to speak, a born photographer. As early as 1934 he bought his first camera obscura for 1 Mark. From 1946 to 1952 he led the life of a farmer on his parents' farm in the Mark Brandenburg region. It was there that he made his first portraits of local farming people and developed his specific relationship towards the farming milieu, which would later shape his perception of landscape. From 1950 he studied under Professor Heinrich Freytag and Professor Walter Hege at the school of applied art in Weimar. Häusser joined the German photographers' society (now the Deutsche Fotografische Akademie), the reform of which he conceived and expedited as a member of the jury and of the committee. In 1952 he moved to Mannheim, where he established a photographic studio. He was also very active in cultural politics; he was a founding member of the federation of freelance photo-designers ("BFF") in 1969, a member of the German artists' association, of the academy of fine arts in Mannheim, and of the Darmstadt secession. Throughout his life he cultivated deep friendships with painters, who had a lasting effect on his artistic direction.

Robert Häusser's artistic work can be divided into several phases. During the first phase his pictures were initially narrative, but dramatic, heavy, and somber in their expression. During the years 1952 to 1954 he switched to a bright period, producing light and delicate images that were often more like drawings than photographs. His interest in rural life was expressed in pictures of freshly ploughed fields, but particularly in a series on home-slaughtering, a photographic narrative in six pictures. He became increasingly interested in political topics and human borderline situations – loneliness, desolation, despair, and death. His work Die 21 Türen des Benito Mussolini (the 21 doors of Benito Mussolini) can be described as one of his major works; the twenty-one doors represent the twenty-one years that Mussolini was in power and were all found, just as he photographed them, in Mussolini's villa. The pictures are accompanied by a quote from Mussolini: "If a man falls together with his system, then the fall is final." In more recent works Häusser turned ever more frequently to the pictorial sequence, using it to document his interest in formal pictorial solutions, but also in conceptual works.

Reinhold Mißelbeck

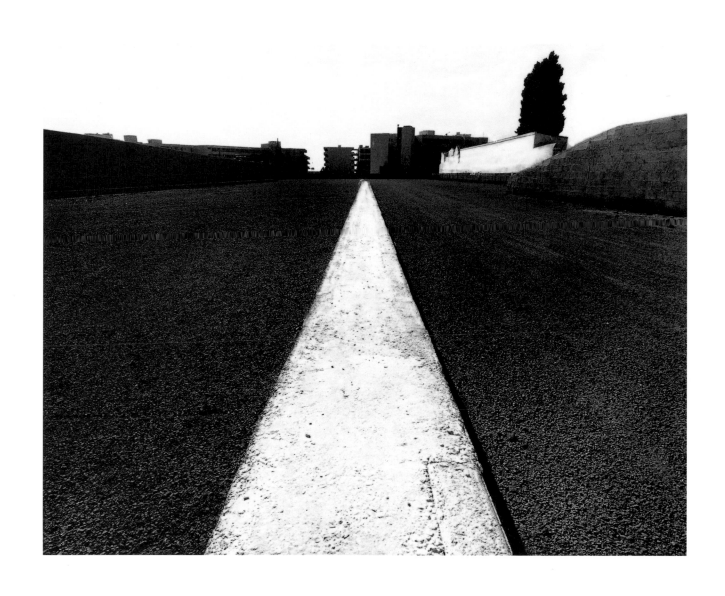

Gottfried Helnwein

Kinderhand und Kindergesichter, 1993
(View of the installation)

Kindergesicht, 1993 each 20 x 15 x 5 cm
Kindergesicht, 1993 each 20 x 15 x 5 cm

Helnwein's praxis is based on awareness of the ontological difference between photography and painting. On the one hand, he is one of the most consistent of all media artists, exploiting to the limit the specific possibilities offered by each of the various media he uses. He not only photographs and paints; he also draws and works in performance. On the other hand, his approach to his work allows the various media not only to reflect each other but also to interrelate, illuminating each other and thus enhancing the total effect. The striking result is that his watercolors possess the glowing translucence of transparencies, although the lightness of the colors is not affected. His naturalistic or realistic paintings possess the brilliancy of photo projections. All this is only possible in the medium through meticulous, craftsman-like application of photographic techniques. In turn, his photographs achieve the immediacy of paintings. His pictures always move between the poles of over-sharp and blurred focus. Each painted or photographed motif is subjected to a process of transformation. This may manifest itself in pictures in several parts, or in series, or even within a single picture. In the last case, movement seems to shift to the depths of the picture space, replacing linear progression, continuous change, or contrast. The impact the picture makes is all the more vivid for this. The American writer William S. Burroughs spoke of Helnwein's portraits being able to show the observer what he knew about what he did not know that he knew. Most of the people of whom Helnwein has made portraits, and Burroughs was one of them, are active in the media and have been photographed over and over again. Their portraits have long since been transmuted into icons: Keith Richards, Mick Jagger, Andy Warhol, Willy Brandt, Norman Mailer, and Michael Jackson. Yet in Helnwein's portraits, which he calls "faces," the sitters look as if they were being photographed for the first time. In a split second, a quality is revealed which Walter Benjamin called "aura." This means a sense of the simultaneity of the near and the distant. Everything captured in a photograph ineluctably recedes into the distance, both spatially and temporally. The artist literally effects a media cross-over, however, with his technically brilliant prints and enlargements of the photographic negatives, as well as with his own special way of presenting them behind glass in powerful lead-hued frames. The manifest result is the aura-like quality which heightens most of his pictures. They render visible the phenomenon of the simultaneity of the non-simultaneous. Helnwein also draws on film as an aesthetic experience, and it is easy to imagine that he might make films himself someday. After all, he has frequently collaborated with Johann Kresnik on stage design. In any case, Helnwein is an expert in the field. The impact of film on his work becomes even more evident in Kindergesichter und Hand (children's faces and hand) than in his photographic Gesichtslandschaften, which might be translated as "facescapes." In the former work, film technique is combined with painting and photography. A series of children's portraits, all in the same format and in blurred focus, is confronted with a child's hand, vertical and gigantic in size. Blown up in the needle-sharp style of Super, Hyper, or Photo Realism, the hand is tinted light blue. Whereas the photographs seem to be drawing on painterly effects, the painting seems to be forcing the potential of photography beyond its means. The blurred focus so tellingly exploited in the photographs is not, however, the result of a specific technique of taking pictures with an unfocussed lens. The way the picture has been installed has caused the blurred effect. The artist has used frosted glass. In this artist's œuvre, a picture is at first experienced as the object of aesthetic reflection. As such, it interrupts one's culturally mediated contact to the world of what is shown by conveying a visual shock, which enhances the urgency and immediacy of that world. Perhaps this is why Helnwein's work has provoked such vehement reactions.

Klaus Honnef

162

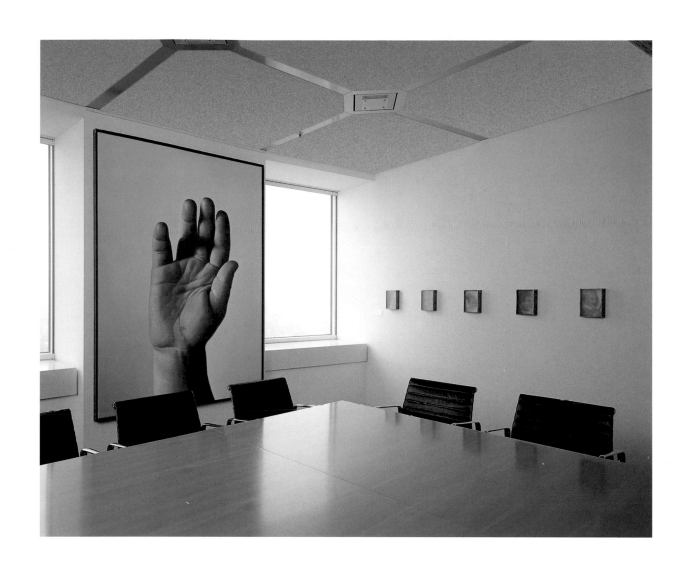

Anton Henning

Anton Henning is a painter. Starting with expressive portraits and landscapes, by the mid-1980s he had arrived at abstract collages. Not long afterwards he was working with photography. Since then he has been giving the different media, including objects and installations in various styles, equal treatment. Henning's work is usually serial.

He conducts an ongoing dialogue with earlier art – from Courbet and the Impressionists on up to Matisse and Magritte, from Marcel Duchamp's relationship with the object to Marcel Broodthaer or Manzoni's Conceptual Art – as well as with the sensory perceptions he receives from his immediate environment. Foodstuffs, particularly fish, or sexual subject matter or landscapes and portraits, mainly self-portraits, have continued to fascinate him. The first photographs he used in his work were old snapshots taken on trips with his parents, fragments of reality and experience. Henning belongs to the young generation of artists who utilize almost any imaginable material in their work. His work is distinguished by wit; he possesses alert intelligence and inexhaustible energy.

He produced the photographic work entitled Room with a View on the occasion of an exhibition held by the Brandenburg art association in the Mercure Hotel at Potsdam in 1995. In what was once a kitchen on the sixteenth floor of the hotel, Henning exhibited the kitchen pictures he had painted especially for it in the form of an installation. That did not mean that he just hung pictures with kitchen and food motifs on the walls. He related the pictures to the specific qualities of the room in which he was exhibiting them. Henning is very much at his ease in kitchens, one of his familiar haunts. He enjoys food and is a good cook. Painting is a medium of the senses and the artist sees it this way, relating it to other sensory experiences. The title refers to the James Ivory film (England, 1985) of the same name. In it a superb view from a room in Florence plays a major role. The old Mercure Hotel kitchen has no windows at all.

The pictures Henning produced for this room might at first glance be taken for windows in the wall although they do not open out on lovely views. They replicate what is actually in the kitchen: a draining board, a hose, the tiles on the wall. Reality is translated into painting, albeit in details, and viewed from a particular angle. After this ensemble has been photographed – and that is the subject matter of the large-scale photos in the DG BANK Collection – everything is again reduplicated, this time in a different "realistic" medium, that is, photography. Altogether the series consists of five photographs.

This ironical play with the media also issues a challenge to the beholder's sense of reality and appreciation of art. He will wonder what reality and art are. Naturally he will not arrive at an unequivocal answer.

Ursula Prinz

Bill Henson

Works for the Paris Opera, (#27/77), 1990/91 145 x 127 cm

Born in Melbourne, Australia in 1955, Bill Henson has been internationally known since 1975 through his participation in numerous exhibitions, among them the Sydney Biennial in 1982, Passage de l'image in the Centre Georges Pompidou (1990) in Paris, and Presence in the London Photographer's Gallery. In 1995 he officially represented Australia at the Venice Biennale. Bill Henson uses photography as a sophisticated medium for exploring modern, urban, and suburban life. A profound but unobtrusive sensitivity for psychological and sociological issues informs his choice of subject matter. Like Jeff Wall's work, Bill Henson's photography reveals an essentially different perspective on the destruction wrought by industrialization and the Fordist standardized yet fragmented environment with its rigidly hierarchical and bureaucratic structure from that evinced by the European schools of photography, which tend to show the imprint of New Objectivity. Bill Henson's consistent investigation of the alarming impact of Modernism, however, has led to a very special sort of repudiation of photographic formalism and the New Objectivist pictorial repertoire. An important background to his work, one that has been long since excluded by Modernist currents from their evolutionary pictorial strategies, might, even at the close of the twentieth century, still be dubbed "Romanticism," for want of a better term. It is always thrusting itself into Bill Henson's photographs. Bill Henson allows Romanticism to exist in the twentieth century. That this happens is noticeable in the peculiar twilight characteristic of many of these photos, for instance in the motif of bureaucratic high-rise office buildings. Henson has structured what would be serial objects with his camera while the artificial light streaming from their windows consigns the mechanical hardness of this architecture to a drastically different space. The same light articulated in color tints and reflections returns as skin tones in numerous color portraits. Henson's photos of youths motivated by social disintegration are very stirring. There are tumultuous Henson photos of youths, individuals or groups of them, in which shock and inner turmoil are revealed in their body language and facial expressions, captured in painterly blurred focus. Henson is interested in the mysteries hidden deep in the body during adolescence, the expression of sex, panic, and exhibitionism, the battles of the soul and the violent contradictions fought out in nocturnal spaces by teenagers under pressure to conform, beset with fears and fraught with alienation. He is a master of the glance at minor gestures, closeness, and intimacy. Henson captures brief familiarity, the fleeting quality inherent in transient situations. He does so particularly in the untitled work reproduced here (1990/91), from the series entitled Works for the Paris Opera. Through his use of color photography, he elevates such situations to the status of painting. This makes many of his photographs a surface open to manifold projections. Owing to Bill Henson's persistence, the concept of "soul" has been tabled again after being marginalized with severe repercussions for art and society by functionalist thinking. He writes: "In reality we are always between two times: that of the body and that of consciousness. Hence the distinction made in all other cultures between body and soul. The soul is first, and above all, the locus of another time."[1] The Australian photographer is Conceptualist in his defense of the contemporaneity of Romanticism and Symbolism in the media society of the late twentieth century. This means that he is working consciously and affirmatively on forging structural links to the pictorial repertoire of the nineteenth century. All Bill Henson's work tends to be involved in exposing how conditioned our eyes have become to mechanical and anonymous ways of seeing. The humane way he depicts irretrievable natural spectacles in his photography is shown in his cloud pictures. This outlook on the world is not sophisticated in the Central European sense. These are pictures which reveal universals in atmospheric conditions.

Gislind Nabakowski

1 Bill Henson (referring to John Berger), in: Mnemosyne oder das Theater der Erinnerung, ed. Peter Weiermair.

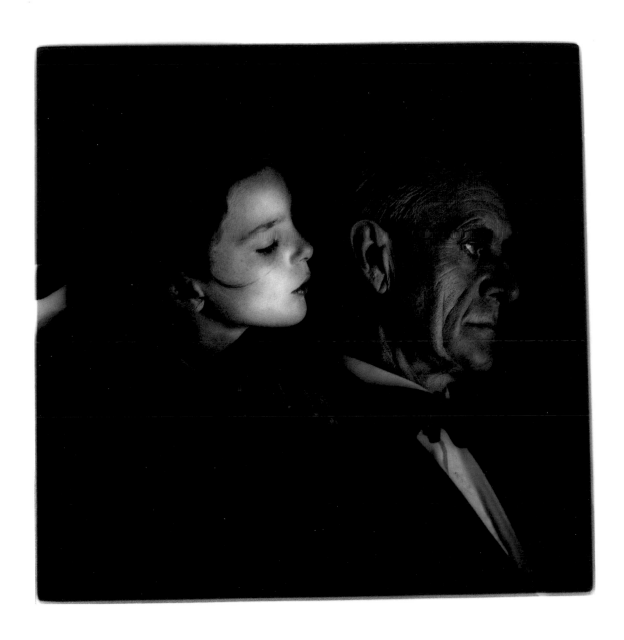

John Hilliard

Since the seventies, John Hilliard has been one of those few English artists working exclusively with the photographic medium. It all began almost by chance at the end of the sixties when he was searching for a vehicle of documentation for his performance works; he found the ideal medium for visualization in photography. From the beginning, the artist was fascinated by the difference between the image and its depiction, between that which is represented and the representation itself. The starting point for his early artistic reflections were Minimal Art and, above all, Conceptual Art, which offered Hilliard the possibility of radical visual innovations in the sense of a media-reflective approach.

In the eighties he concentrated on media-immanent processes which nonetheless took up subversive social themes. In particular the positive and negative pictures, e.g. Dark Shadow (1984) or I See a Black Light (1987), demonstrate a successful interaction of media and social reflection. These works, however, are mainly to be viewed as a conscious alternative discourse to the renaissance then taking place in painting and sculpture, which he regarded as "serving a flourishing, albeit conservative market."

The stringent and rigorous reference to optical and physical qualities of the medium of photography, which has always involved a questioning of traditional forms of representation, is becoming noticeably diversified in the nineties. John Hilliard's unease with respect to photography and its apparent transparency of reality becomes visually more opulent and narrative in technical, formal, and constituent respects, without sacrificing the (conceptual) strategies of "filtering out, reducing, and veiling," as he terms it (the 1996 work Original Study for Debate is a good example of this). In the linking of existential issues with certain formal solutions, it is not only a matter of our (photographic) desires with respect to the world and imagery, but also a question of the possibilities of a conception and constitution of the world in view of technically possible pictorial idioms.

The puzzling and the complex, as well as the different pictorial and viewing levels are similarly paramount in his works of the nineties. Distorted Vision (1991) is a notable example. From a narrative point of view, it is the story of a woman who is contemplating something which could be a picture; her red dress, the bottle and the suggestion of a bed might hint at sex and/or crime. The picture-in-the-picture (the photograph in the foreground) doubles the blurred picture in the background and is recognizable as a mirror image. Evidently, the woman is viewing a photographic self-portrait, so that the blurred face in the mirror image begins to constitute itself more distinctly. This dual nature of the picture is constitutive for many works from the nineties, such as Control (1991). "An element of unparalleled power of attraction emanates from John Hilliard's pictorial idiom," writes Marion Piffer Damiani concerning the work of the English artist, "a seduction and suspense as we know it from the context of media reality. His photographs are posed scenes, precisely formulated pictures constructed like theater staging. John Hilliard's pictures have undoubtedly a strongly aesthetic appeal; at the same time however, they always contain something enigmatic which draws our interest into their interior."[1]

In a fascinating, challenging, and complex way, this artist has developed his reflections on seeing, visibility, fiction, and photography. His reflections relate not only to the current discussion on art and pictorial concepts in general, but also to the status of photographic images in the digital age in particular. Therein lie, among other things, the necessity, topicality, and relevance of his new photographic picture image scenarios, which represent a permanent challenge to the "more discerning viewer" (Burghard Schmidt).

Carl Aigner

1 "Vexierbilder des Lichts," John Hilliard: Arbeiten 1990–1996, AR/GE Kunst, Bolzano and Kunsthalle Krems, eds. (Vienna: Triton, 1997), p. 42.

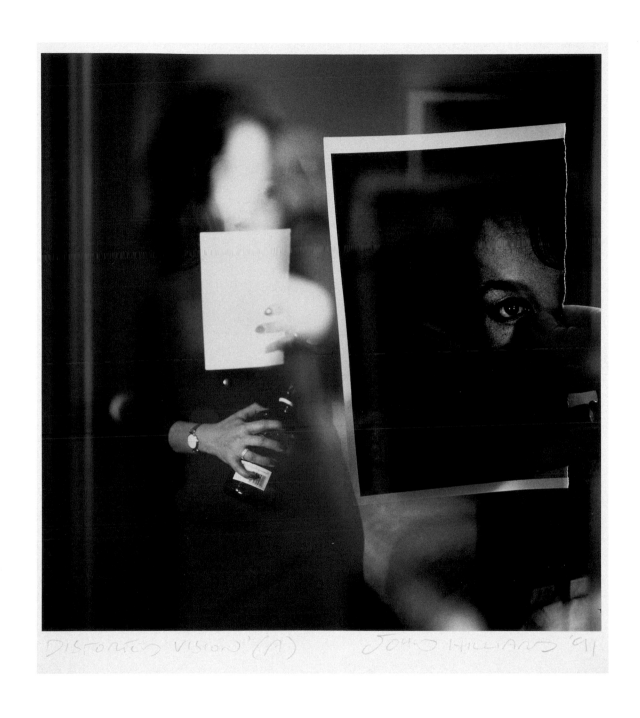

"DISTORTED VISION" (A) JOHN HILLIARD '91

David Hockney

Prehistoric Museum Near Palm Springs, Sept. 1982
214.6 x 143.5 cm

David Hockney has prescribed a general overhaul of painting by means of photography. He also abstracts reality in opulent stage design for musicals. What he is doing is broadening his field of vision as if he were standing on a revolving stage. His method rounds off the edges of the Cubist way of viewing things. The different sides of a representational motif are captured as a panorama by being surrounded photographically. The transposition of the central perspective to the photographic picture plane allows it to be repeated within a single picture. The parataxis of Chinese scroll paintings, which the viewer's eye follows as if walking through them, is another principle structuring the visual sequence.

Hockney started his first photo album in 1963. Since then, he has made 150 of them, containing about 30,000 photos. What he called "joiners" (montages of small-format and Polaroid prints) have developed into increasingly larger and more painterly "photoworks." What originally only replaced drawing as a means of converting quickly executed detail into painting became almost compulsively independent, as a photographically mounted simultaneous scene of a single motif, viewed sequentially at intervals of seconds. Diverse views of a motif are staggered and cross each other. The photographer takes hundreds of snapshots of landscapes, interiors, and people viewed from specific angles. The inorganic material is developed with regard to the glowing color range of Matisse or Picasso, whom Hockney so admires. The photograph is a simulation of a painting, and photo-collage results from painting. A single picture is made of snapshots and Polaroid prints, all of which were taken at nearly the same light values and stuck together, uniting the phases of perception to form a continuous projection.

The monumental collage entitled Prehistoric Museum near Palm Springs (1982: 214.6 x 143.5 cm) looks like a black-and-white documentary of this multi-perspective process in the midst of the colorful universe of the "photoworks." Exaggerated lengthening creates a comic effect by means of which the photographer casts his shadow over the light, porous texture of the desert floor, which is gradually composed into a topographic parquetry of countless contact prints. Behind the light-colored car on the left, the viewer is confronted by the dinosaur, which the shadowy man on the right has photographed, turning away behind a black car. Such methods of projection install Mulholland Drive, viewed on the way to Hockney's studio, or indeed the Grand Canyon, on a twelve-meter panorama. Staggered planes receding into the background turn such subject matter into painterly theater landscapes. Colored objects jutting forward in the rhythm of the individual "photo" elements are encircled, or bodies are caught in revolution. The reversal of perspective results in the deconstruction of reality. The artist's wit, his ironical view of the world, and his analytical mind make these works a parody of Realism.

In Hockney's view, photography has never constituted a threat to painting. Photography gives the painter inspiring material for an inconceivable wealth of forms of communication media. From his "paintbox," the way leads via the fax machine and the color printer to the production of painting and its dissemination on the Internet. David Hockney is preparing the digitally expanded coloring of the world, as if an electronic Baroque era were dawning.

Günter Engelhard

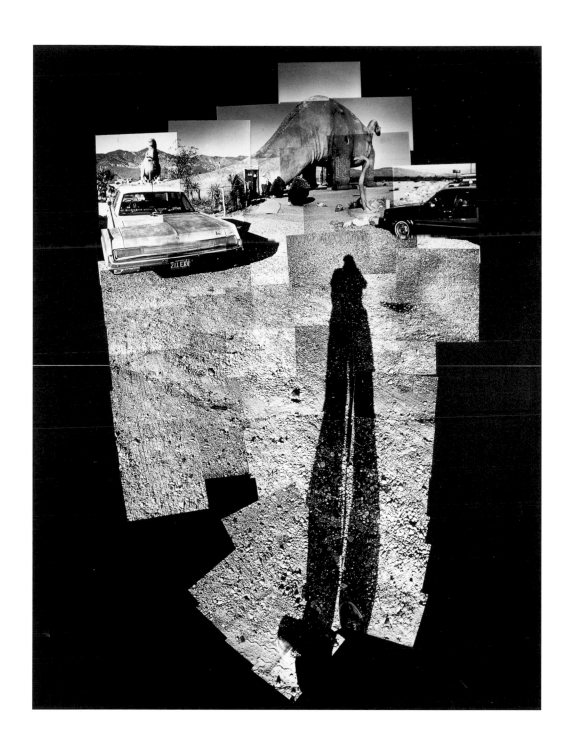

Candida Höfer

Following a period of practical training with respected Cologne photographers, study at the Werkschule in Cologne, and participation in the reconstruction of daguerreotype in Werner Bockelberg's studio in Hamburg, Candida Höfer was already a fully qualified photographer when in 1973 she attended Ole John's film class at the art academy in Düsseldorf. (Ole John was a maker of socially committed documentaries.) At that time Höfer's main theme, apart from the press work that she did not much enjoy, was the life of Turkish immigrant workers in the Rhineland. Towards the end of the seventies, however, she found her very own subject matter, which she did not interpret with the Bechers' austere black-and-white photo technique, but with a small camera at 200 ASA and in color: the interiors of public buildings, mostly museums, institutes, or societies. The importance and the past of these places are evident in the details selected by Höfer, but this is not the "official" view but a view that is more atmospheric and often apparently more casual. Seldom does she choose symmetrical visual parallelism, but more often an intuitive obliqueness; lines running at a slight diagonal accentuate the architecture, create a feeling of space. Even the early photos, like those in the Schlaglichter exhibition in Bonn based on barrooms with slot machines, are empty of people and seem more stamped by history than by the present. To some extent this is because of the daylight, which appears to be the secret underlying theme of all of Höfer's photos; she favors rooms that are flooded by daylight, its reflections bouncing back off smooth floors or walls. She does not choose this light in order to be dramatic; rather the light seems to reflect the passing of time in these rooms, which perhaps once experienced glory days but now give the impression of being deserted. The theater has emptied, but the lights are still on – for whom? This is the question that Candida Höfer makes us ask. Thus, all her works are associated with paralysis and contemplation, whether at Schloss Mannheim, in the former Russian parade rooms at Karlshorst, or in the room in the Cecilienhof in Potsdam, pregnant with history but here mute, where the decision to divide up Germany and Europe that persisted for half a century was made. Even Höfer's more recent works, such as the room in the library of the venerable University of Granada (1993), viewed slightly asymmetrically, the shrine room at St. Benediktusberg in Vaals (1993), but also the gallery of antiquities at the Hermitage in St. Petersburg, breathe out the same attitude: clarity and simplicity of documentation, interpretation of meaning through lighting, angularity of perspective. At the same time there is something magical in the emptiness of these places that were intended for people but have now been abandoned by them.

Wulf Herzogenrath

Nan Hoover

Born in New York in 1931, Nan Hoover trained as a painter, graphic artist, and sculptor. She later applied for Dutch citizenship and now lives in Amsterdam. From 1973 she expanded her field of activity to include the medium of video. In the mid-eighties she returned to drawing. For ten years she stopped working with video, but since then she has switched enthusiastically backwards and forwards between traditional and electronic media.

The successful performer, video, installation, and photo artist has cooperated several times with avant-garde choreographers. In 1992, for Lucinda Child's ballet Naama, set to the music of the Greek composer Iannis Xenakis, she designed the lighting and costumes for dancers from Charleroi, Belgium. In 1996 Hoover produced a video projection for Susanne Linke's Hamletszenen for the Hebbel Theater in Berlin and the Bremen Theater. In the videotape Desert, from 1985, Hoover allowed the camera to glide lazily across a sheet of paper, with strong lighting developing a materiality that transformed the paper suggestively. Hoover's art always shows the discourse about art as an open movement. She declares it to be an almost timeless activity, closely connected to meditation, not yet manipulated by goals stipulated in advance.

In the center of her work stands the theme of the dialectics of time versus timelessness. This corresponds to her handling of time in the social and individual sense. It is the artist's primary concern "to check the pressure of time, to withstand it, and to transform it into the state of timelessness. If she is successful in this processing of sensations – she herself compares the process to that of digestion – the artwork will be created, so to speak, intuitively."[1] Her pictures show slow, extremely protracted movements of the body through rooms. The body moves through zones of light and shadow, freezes, and pauses. It plumbs the depths of the room, but it is also a direct part of a two-dimensional pictorial system.

Yet Nan Hoover is also influenced by observation of the management of edges and light in the paintings of the great Dutch masters, and particularly by Rembrandt's color contrasts.

Her photos, which have been produced since the eighties, belong in the media context of the twentieth-century self-portrait. They give the effect of being stills extracted from video or film work, from the flow of time. The single-frame mechanism on the video recorder often produces an optical effect similar to that of slow motion. Hoover's photos take as their subject the dialogue with one's own likeness, which as a specific of video technique emerged as an electronic reflex technique. In Still/Movement, where she throws her head back in a violent movement, the blurring produced by the light and the action lies in the upper part of the head, while the sharp focus is found on the hesitant small hand gestures close to the body. This opposition results in a highly individual contrast. In Coming and Going the use of hard, very bright light partially leads to the color being bleached to an almost pure white. A very elongated motif measuring 42 x 124 cm, it was produced by taking prints from two successive negatives. The dividing line between the negatives remains totally in darkness and is therefore invisible. In the left part of the picture the camera took the hand from the front, and on the right side from the back. The negatives of Coming and Going were not subsequently processed, nor were they cropped. The photo was produced intuitively. "We all come and go. Life is movement. In this work I am translating my concerns into the language of photography."[2] Even earlier, Hoover summarized her credo in the succinct formula: "I am part of the darkness born of light."

Gislind Nabakowski

1 Renate Petzinger, in the introduction to the exhibition held in the Galerie am Ludwigsplatz, Wiesbaden, October 16, 1992.
2 Nan Hoover, in a letter to the author dated May 10, 1998.

Craigie Horsfield

Ulica Papiernicza, Kraków, February 1989, 1989 140 x 140 cm

Without knowing the title – Ulica Papiernicza, Kraków, February 1989 – which reveals the place and date of this photograph by Craigie Horsfield, one might assume this dark, deserted street scene is set in the London of Charles Dickens or the New York or Chicago of film noir. Like most of Horsfield's pictures, apart from a strikingly cinematic quality it also contains something that is markedly specific, and yet general. The specific is explained in part by the biography of the English artist, who lived in Poland for several years from 1972 (where, among other things, he studied graphics in Kraków) in order, as he later put it, to "understand the problem of Europe."[1] The general is explained firstly by Horsfield's understanding of tradition, which is orientated towards the nineteenth century, i.e. the tableau, beyond both photographic documentarism and pictorialism, and secondly by his consequent artistic understanding of time. Several years may sometimes elapse between taking the photograph and producing the picture. Also, because of what the artist considers the important close relationship between the objects photographed – people and places, street scenes and interiors from his immediate surroundings – the works initially form a personal archive on which he can draw for his exhibitions. When the pictures become public, they have already passed some kind of evaluating, critical filter on the artist's part, and some of the objects depicted no longer exist. Thus Horsfield's epic realism is not only saturated with time through his dark tonalities and dramatic chiaroscuro, but the retention of a historical perspective, the passage of time, is also laid down in the process, i.e. is built in. The physical presence of these usually large-format, square pictures demands large premises for their presentation and can hardly be evoked through reproductions. It is this presence of the objects, as well as the actuality of historical time, which makes plain Horsfield's intention of producing an art not of memory but of existence.

This type of existentialism deliberately relates back to an awareness of European picture and portrait traditions, and it reveals how Horsfield differentiates this awareness from contemporary trends in, for instance, the work of Larry Clark,

Nan Goldin, and Nobuyoshi Araki. In a critical analysis of the so-called "unconscious kitsch" in Araki's work in an article for Galleries Magazine in 1994 he describes the central problem of authenticity: "The apotheosis of each of these artists, such as it has been, has depended on the blurring of the line between their own lives and the damaged and marginal communities shown in their work. They not only looked where others would not, they were part of it, theirs was the authentic voice of the underclass, of those who could not speak. They show bruised and stunted lives clear-sightedly and they appeared to put themselves on the line. Their very lives, as shown, satisfied the perpetual bourgeois hunger for verification and vicarious experiences through the surrogate artist. In time, too, they inevitably faced the paradox that confronts all such artists: once recognized they are separated from the community of which they were (or were supposed to be) a part and, with that separation, automatically lose what may have been their only language and are destined henceforth to be outside. They can no longer act as those with the sole need of authenticity."

Even if the rhetoric ("bourgeois hunger") is reminiscent of earlier Marxists, Horsfield is here formulating a central problem of existence as an artist and of the photographic image today. Thus he shares Bruce Nauman's claim to be able to say something meaningful about the human condition, as well as his scepticism about its potential for improvement. With Jeff Wall he shares an adherence to the differentiated multiple idioms of the art of modern life, for which photography – precisely because of its problematic relationship to reality and to time – is the medium in which the tradition of a critical "realism" can be revitalized. For Craigie Horsfield, a melancholy insight into the principal limits and the corruptibility ("the surrogate artist") of these idioms always appears more appropriate to reality than that single idiom forgotten by history ("their only language") of supposedly authentic voices.

Hubert Beck

1 Cf. the discussion between Jean-François Chevrier, James Lingwood, and Craigie Horsfield in Craigie Horsfield, Kunsthalle, Zurich, 1992.

Peter Hutchinson

Peter Hutchinson expresses the wonder of the world of phenomena through the combination of language and photography with which he appeals to the viewer's power of imagination: so says the important American conceptual artist Douglas Huebler about the work of his colleague.[1]

After a brief involvement with extremely minimalist painting, in the second half of the sixties Peter Hutchinson made the switch–parallel to Michael Heizer, Robert Smithson, Richard Long, and Hamish Fulton–to carry out actions in nature, whether domesticated or untamed. Nature is generally the location but also the subject and the medium of these activities. The proceedings, which usually take place in remote locations and in isolation, are documented through photos and drawings which thus become vehicles for the idea; through them the idea becomes communicable, or it can be revived or live on even after the event.

Among Hutchinson's most important works is an "action" that took place at the Paracutin volcano in Mexico in 1970 and was documented in picture and text, followed in 1971 by a walk through the Snowmass Range that is recorded in the work Art in America. Not all of Hutchinson's photographic works have a linguistic component, however, and there are also purely literary works. Two poetic works that verge on the microcosmic are Clock Garden and Four-Part Thrown Rope. In Clock Garden flowers are to be positioned in a garden in such a way that they open at different times of day and night, so one can tell the time from them right round the clock. In Four-Part Thrown Rope, on the other hand, which Hutchinson performed in front of the American pavilion at the 1980 Venice Biennale, accidental lines are produced by throwing ropes: along these lines blue, yellow, red, and white flowers are planted on a lawn. In other, purely photographic works Hutchinson combines fragments of photos of various places and natural areas, and combines them to form new landscapes.

Hutchinson is one of the protagonists of Narrative Art, a movement close to Conceptual Art that attracted increased interest between 1972 and 1976 without ever really becoming properly established on the market. In Hutchinson's case this may have something to do with the subtlety, but also the complexity, of his œuvre. The multi-part nature of every individual work section, as well as the sometimes long texts, demand willingness and time on the part of the viewer. A work such as Working Drawing for "Year" (1978) is not easily accessible because of the large number of pictures and the quantity of text.

Hutchinson's twelve-part series Year basically evolves on two levels: the photographic/visual and the handwritten/linguistic. Whereas the visual part is always made up of several photos (one per letter of the month), the linguistic part consists on the one hand of the aforementioned handwritten text and on the other of letters in the photos themselves which together make up the name of the respective month. The photos–landscapes, streets, architecture, people in different situations–and the separate text interact in sundry ways.

For Peter Hutchinson, photography and writing are two different ways of thinking, which influence and reciprocally modify each other. Thus the relationship is not descriptive, but dialectical: "The separate mediums interact to make a total statement about art and life."[2] The photos provide visual fragments or momentary pictures of the particular occurrence, which is focussed on experience of nature but also on self-observation and self-experience. The texts provide the temporal dimension for the sequence. Each individual month, or each letter, is a cause for reflections, for observations and memories, which do not always have an obvious relationship to the pictures. The works thereby created are not tightly concentrated on a single point, but are diffuse, ramified, and show fresh avenues that can be followed up in a variety of directions.

Andreas Hapkemeyer

1 Douglas Huebler, "Foreword," The Narrative Art of Peter Hutchinson: A Retrospective (Provincetown: Provincetown Arts Press, 1994), p. 5.
2 Christopher Busa, "Curator's Introduction," ibid., p. 7.

Working Drawing for "Year"
February

Snow is melting on the green concrete patio
At night it freezes again. Michael helps
me make letters with the snow. I use
green spray paint. "F" is green on white.
"Y" is white on green. Is the green appear-
ing or disappearing?

Peter Hutchinson
February 1978

Axel Hütte

Montevarchi, 1992 98 x 120 cm

When in his Italian "landscapes" and the later "cityscapes" (of London, for example) Axel Hütte opened up through wide vistas the "seeing space," which is in fact nothing but a reflective surface, he was just stating his aesthetic strategy without essentially modifying it. This aesthetic strategy is not aimed at architecture as such, but at the complex "architecture" of the photographic image. The artist deliberately designs his pictures flat, two-dimensional. And yet he frees the gaze through precisely calculated vistas and passages into an apparently endless, or at any rate virtual, three-dimensionality. Flat picture layout and spatial virtuality are knitted together into strange formations that, on closer examination, produce sensations of dizziness.

Hütte's aesthetic program and his artistic concepts are convincingly expressed in a group of "pictorial landscapes" from Portugal, Italy, France, Greece, Spain, Switzerland, and Germany, which he gathered together under the lapidary, but nonetheless symptomatic title Landschaft (landscape). By comparison with his earlier photos of oppressive urban architecture, the "landscapes" of central and southern Europe seem almost liberating. The extremely deep line of the horizon, for example, allows the view of an almost homogeneously white sky, against the backdrop of which a trellis of telegraph poles looks like a group of dead branches and the hardy plants above the tree-line like bizarre architectural forms (a subtle allusion to Karl Blossfeldt's picture theory). The unassuming landscape is barely above the threshold of perception. The light is free from shadows, alienating in its neutrality. A detail of a functional building, always of simple form, projecting into the picture from right or left, often accelerates the gaze to such an extent that it threatens to lose its way in nothingness and begins to flit around like a will o' the wisp. This corresponds to the view from the inside of an industrial building which regularly perforates the field of vision. At times a mountain range obstructs the view, or a phalanx of birch trees makes the eye veer off. Roads and rails emphasize the dynamic pull of the pictures, and the eye glides along them at increasing speed.

The "noëma" of the photographic image in the sense of Roland Barthes is reflected in Hütte's subject matter, indeed here it is given its visual form. None of the landscapes that Hütte photographed are natural, although this might appear to be the case. These are all "cultivated" landscapes; people have manipulated them according to perspective perception. On the symbolic level, too, this was always an introduction to action. It is true that most of the pictures appear to be devoid of people, yet here and there smoke signals indicate their absent presence: they are present despite their physical absence as a result of the mark they have conferred on the landscape.

If Paul Virilio is correct in his statement that art, up until the explosion of the media age, employed an "aesthetic of appearance" in order to formulate its "view" of the world, then in Axel Hütte's photographic images the ground is being prepared for a change towards a decidedly contrary aesthetic. It would be premature to give this a name, regardless of the fact that Virilio takes the view that modern society at the end of the twentieth century has already switched to an "aesthetic of disappearance," from "permanent to impermanent forms."[1] One could still describe Hütte's photographic experiments into the various modes of perception as pictures of an "aesthetic in transit," perhaps even a transitory aesthetic. And if it is a coincidence, then it is a revealing one, since the artist covers an average of almost two thousand kilometers per motif before his artistic idea of an appropriate object is satisfied. He, too, is a traveler over the course of time.

Klaus Honnef

1 Paul Virilio and Sylvère Lotringer, Der eine Krieg (Berlin: 1984), p. 86.

Bill Jacobson

Born in Norwich, Connecticut in 1950, Bill Jacobson has attracted attention in the past few years with photographs which look as if they are out of focus. His motifs are sketchy figures, portraits, seated or standing figures bending towards each other or isolated, all of them without much appearance of substantiality. In recent years Jacobson has enlarged his thematic repertoire of portraits, nudes, and body fragments to include landscapes and water scenes. None of these pictures, however, are the result of wrong exposure or rangefinder settings. On the contrary, they represent a deliberate denial – and this means the employment of an aesthetic strategy on the metaphorical plane – of the demands made on photography as a medium to be clear and unequivocal in conveying the reality of our surroundings. Jacobson is definitely not trying to emulate turn-of-the-century pictorialism. Of course, his photographs do have a timeless quality. These pictures might just as easily have been taken in the early days of photography as now. This is because Jacobson has made a basic element of photography – focus – the center of attention. His decision to do so is based on the concept of transience and loss which informs the era of AIDS, the phenomenon of distilling the evanescence of memory into a distinctively memorable formula.

Jacobson eschews the sharp attack. The reality surrounding him, beautiful bodies, their glamour and erotic appearance, as they might be viewed with rational understanding of what bodies in space are, have yielded in his work to the idea of material dissolving or evaporating, evading one's grasp.

This work represents a metaphor for how our intellect and emotions deal with memories, which fade, and for how they are replaced by ideal substitutes. In the darker pictures especially, the finite body looks like black brush strokes, signs for feet or bodies just before they are extinguished. These are fleeting images, portraits of anonymous subjects or people losing their features to the tricks played by memory, forms intuited by the unconscious. Somewhere between fact and fiction, these photographs are both dream and reality. In them human beings are drawn with only a few strokes, which gives these subjects a timeless, archaic quality, something which makes them difficult to place even as objects. Bill Jacobson's pictures are enlivened by contrast, by the circumstance that they ignore what most observers might expect of them. Indeed, most people do tend to expect a world with firm contours, where everything has its place, even rebellion, and where the human body is youthful and beautiful. Photography, by these standards, is supposed to capture a marketable product. In Jacobson's photography, by contrast, bodies are swallowed up by the velvety black of his meticulously worked prints in which grayish-white contours dissolve into white. The saying that photography is written with light very aptly characterizes the processes of distillation and "vanishing" at work here.

Jacobson deliberately concentrates on black-and-white photography, which offers him a wide range of action and also a wealth of aesthetic qualities, particularly in the potential for differentiating gray tones against the background of a conceptual message which corresponds to that aspect of photography which characterizes it as a "medium of death" (Roland Barthes).

Peter Weiermair

Magdalena Jetelová

Through photography, Magdalena Jetelová testifies to the occupation of space in the landscape. In a series of twelve photos, Island Projekt (Iceland project: 1992) follows the laser beam that picks out a trace of geological development over millions of years; Atlantic Wall (1995) reports with text projections on the transient human battleline on Denmark's west coast, a place of constantly changing tidal currents. Photography records the course of the projections in which the sculptor, over and beyond her own sculptures and installations, incorporates a materiality influenced by earthly and cosmic powers into her visual consciousness. Thus she creates a kind of topography of origin for wooden sculptures of gigantic dimensions that have their roots in myth.

More than a thousand years ago, on the threshold of transition from the legendary world of the matriarchal age into the patriarchal society, Libussa founded a city that was expressly called Praha (Prague), literally "threshold" (thus leaving the possibility of return open). Just so Libussa's late heiress Jetelová thirty years ago – following her art studies during the Prague Spring and scholarship studies under Marino Marini in Milan – began to make monumental oak sculptures with the character of a threshold: bridges, steps, gateways, tables, and chairs, hewn from the wood with axe and power-saw with active, even aggressive movements. These sculptures often give the impression of being furnishings set in the landscape for an emerging race of giants.

Initially produced under crippling political conditions, these hulking, dynamic sculptures (chairs marching forward, for example) have been interpreted from the Western viewpoint as space-grabbing designs for freedom. Since 1985, when Jetelová moved to West Germany, the transitory individuality of her work has been applied to ever larger spaces, and to wide-open landscapes devoid of human life, in a constructive,

dramatic, and emotive manner. The "translocation" – that is, the irritating displacement of familiar perspectives through the retraction of walls, with the consequent impression that entire rooms have been rotated around their longitudinal axis – and finally the marking, sounding, and inscribing of the landscape by means of laser beams have made the necessity for artistic dissemination and reflection through photography all the more urgent, since there is no audience for Magdalena Jetelová's lonely campaigns in the remote settings in which they take place.

The black-and-white photographs of Island Projekt point back to the myth of Libussa in a legendary frontier zone of human life. On Iceland a 70,000-kilometer-long "threshold system," which encircles the earth in the form of a mountain range at the bottom of the oceans, appears above sealevel for 350 kilometers as an excrescence on the Mid Atlantic Ridge. This line of demarcation between America and Europe, initially fed into the map coordinates by computer, is transformed by the laser beam into a glowing white intersection through the lava, vaporizing in a cloud of steam over the geysers.

As an inscription for a work of mankind, Atlantic Wall is a kind of warning of the futility of resistance to the elementary forces of nature. On the fiftieth anniversary of the Allied invasion, Jetelová directed her text projections at the stones of the fortified bunkers sinking into the sand and water, tipping from the receding dunes towards the sea. The theatrical appearance of the concrete monoliths remorselessly pounded by the tides is sucked, script and all, into the boundless reaches of the heavy gray sea – an oceanic symbol for the prolongation of time. The laser writing reveals that the bunkers mark the cut-off point between human territory and the forces of nature. The bunkers, too, are furnishings for Jetelová's giants. The photograph shows their downfall.

Günter Engelhard

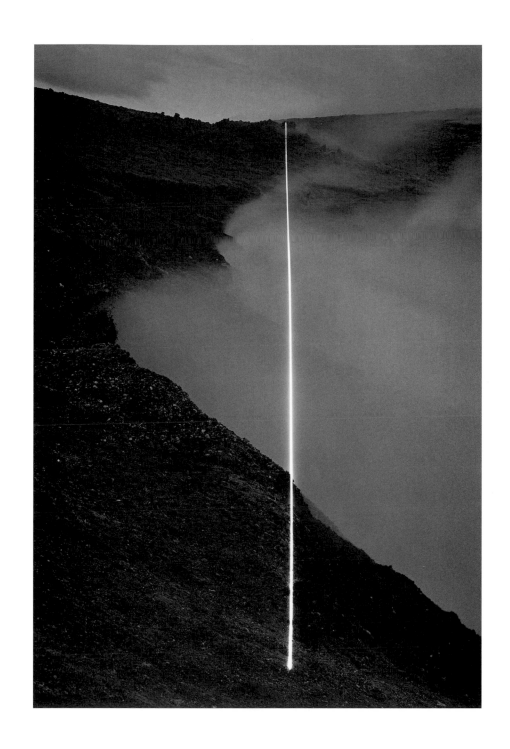

DoDo Jin Ming

Agrigento, Sicily, 1994 61 x 51 cm

Although DoDo Jin Ming's motifs in her Stone Series (1994) give no clues as to their place of origin, the subtitle, Agrigento, Sicily, tells us where the photographs were taken. This aspect of her photography is of great importance in all her work. Jin Ming spent the mid-1990s in Italy, France, and Egypt. Except for the photographs she took in Egypt, her work has little or nothing to do with travel photography as a genre. Nevertheless, travel in the figurative sense, as the archetypal romantic motif, has left its imprint on her creative approach to her medium.

These photos of stones and rocks reveal the play of carefully counterbalanced contrasts on several planes: antinomies of objective representation and formal abstraction, micro and macro perspectives, depth and flatness, black-and-white and restrained earthy tones, rich detail and surface organization, hardness and softness, dampness and dryness, heaviness and lightness, darkness and light. In the darkroom, the artist intervenes to such an extent in what she has photographed that many zones of the prints appear to have been double exposures. The palpable hardness of stones is thus presented in an aesthetic recalling the flowing forms of music and film.

This seems to be an attempt at allowing a voice to the energy captive in the stones. For all the rhetoric of abstraction distinguishing this pictorial idiom, it is clearly traceable to the nineteenth century. These photographs look as if the artist had retraced Timothy O'Sullivan's footsteps to where he photographed the Anasazi ruins in Canyon de Chelly in the southwestern United States. One can imagine how the artist really feels the heat of the stones and the earth. These are charged with significance in Jin Ming's work as if she wanted to give them the sensuousness of skin. And the reference to the Anasazi, whose gods came from the depths of the earth, is made explicit as the definitive motif in all the Stone Series pictures: the opening, the hole as the entrance to spiritual space. One of the artist's pictures in the DG BANK Collection, in fact, shows nothing but a hole in the earth.

What DoDo Jin Ming has to say about the role of place and image in her Egypt motifs applies to all her work: "It (a place) is more or less like a mirror of my desire. My original preoccupations fade away. I have found an opening.... The true image cannot be found whether I choose to look or to close my eyes."

Hubert Beck

192

Ilya Kabakov

10 Personages, Installations 1994
12 parts: 7 parts, each 50 x 70 cm; 5 parts, each 70 x 50 cm

Ilya Kabakov is the artistic undertaker of socialist bureaucracy. His Personages, paradoxically devoid of human beings, depict – in oppressively matter-of-fact photographs – installations of Kafkaesque dimensions from which the person has been eliminated. One can only still sense the elapsed time, the dispatching, the passage. In the rooms and hallways that Kabakov has staged and that he records photographically prior to their dismantling, questionnaires lie spread out and official forms are scattered around; evidence is stuck up on the walls, protocols and snapshots are stockpiled on worn out, battered furniture. "My context is Soviet and I suffer from it," the artist has confessed. The Western world greedily immerses itself in the dreary poetry of the remains of the ruined system.

Ilya Kabakov reached the West in 1987, still bearing Russia upon his shoulders: "I have brought my own hell along with me and I'd like to display it to the dwellers of paradise." While in Moscow he was always deemed an "unofficial artist." Today, as a resident of New York, he carries on a double existence as illustrator and bookkeeper of the defunct communist form of existence. The photographic records of his installations deliver their report: neatly ordered scenes of misery in the narrative tradition of Dostoyevsky, Gogol, and Mayakovsky – but the sarcastic satires of a Mikhail Zoshchenko would also be at home here. Kabakov reconstructs the places of his own personal biography as lived in the collective – and in fact it always seems as if the collective sets forth its existence in some spectral form. He encircles it in depressingly allegorical installations from which only the photos, sketches, cartographical representations, and written commentaries are destined to remain.

Kabakov discovered the relationship between art and angst at an early stage. It is no wonder then that he has made himself comfortable with the latter. Even as a student of his academy (formerly in Leningrad – today St. Petersburg – but later relocated to Samarkand during the war), he drew his inspiration from forbidden books. In the conspiratorial community of artists, his subversive work has thrived since 1957. During the seventies he became the leading theoretician of the Second Generation, which struggled to attain a critically detached standpoint to Soviet ideology. This was actually the germ cell of Moscow Conceptualism, which became known in some circles as "Soc-Art" and endowed common, everyday socialism with a second, satirical viewpoint. The cultural bureaucrats of the regime viewed this with mixed feelings. In both the private and public spheres Kabakov continued to uncover evidence of tremendous social dreariness. The vain wish to flee is the theme of the first satirical installation, The man who flew into space from his apartment. The photo shows the spot where a tenant succeeded in catapulting himself through the ceiling of a Moscow public housing apartment with the assistance of a slingshot stretched between the walls of his dwelling. This symbolic act of liberation was later reconstructed in the Centre Pompidou in Paris. The shared apartment is the birthplace of the installations. In documentary fashion, life is laid out bare in the corridor; here, nothing is private anymore. Here one finds the ultimate destitution. State totalitarianism sets forth its destructive effects even in family life – but these are constructively recorded in cynical inversion. Ilya Kabakov builds a communal home for the Russian family and its regulators. Once, in Moscow, he had visitors who wished to see one of his artistic works. He led them through the decrepit house, over filthy stairs, up to his attic filled with garbage, and from there to a studio full of useless junk. There he opened a drawer, pointed to its contents and designated it as a work of art: "It's not important what you show – important alone is the act of demonstrating." His final point: "I myself am also a piece of garbage that nobody has swept away." More fatalism is scarcely imaginable.

Kabakov lives mainly from commissions and prize money, for instance from the Frankfurt Beckman Prize, which, however, also financed his expenses for the Russian pavilion at the Venice Biennale in 1993. He carries on his work together with his partner Emilia Kanevsky, writes tens of thousands of personal documents, hammers every nail home, positions each piece of garbage where it should be – and takes keepsake photos.

Günter Engelhard

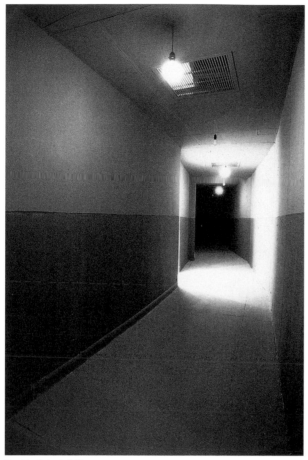

Corridor in installation

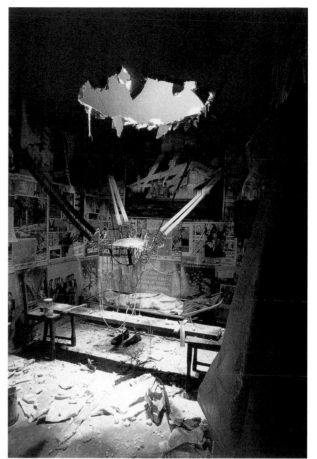

The man who flew into space from his apartment

Installation view

The short man

The collector

The man who saves Nikolai Victorovich

The composer

The man who never threw anything away

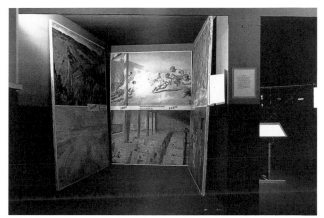

The untalented artist

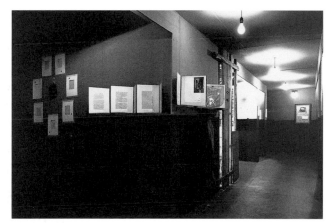

The man who collects the opinions of others

The man who flew into his picture

The person who describes his life through characters

Peter Keetman

Peter Keetman is rightly considered the influential personality among German postwar photographers. Quite distinct from the active organizer Otto Stelnhart, Keetman has neither managed nor marketed the group "fotoform," but instead has exerted an influence through the clarity of his style. Peter Keetman has given the group conceptual impetus. His photos may be regarded as the essence of that to which Subjective Photography aspired and should have attained in the postwar years. Once again there was a consensus regarding photographic principles, as they had been formulated years before in Neues Sehen (new seeing) and photographic Constructivism, and there was a desire to dispense with any connection to ideologies. The intellectual purism of the fifties, which found its expression in philosophy and literature in existentialism – and in painting in Abstract Expressionism – sought in photography its appropriate expression in its striving for the pure, abstract form, filtered from the perception of reality. Peter Keetman, the taciturn, introspective photographer, concentrated on the world of technology and fine detail. For him this was no new dawn of photography following the end of the war, but a continuation of precisely the same trend he had pursued in the thirties. His renowned close-up of a shellac record demonstrates the same interest in graphic structures as do later well-known photos, for example his 1001 Gesichter (1001 faces: 1957) – a self-portrait reflected a thousandfold in drops of water – or the solarized graphic reduction of a view of Stachus in Munich, from the same year.

Peter Keetman was born in Wuppertal in 1916. He received his first photographic impetus from his father, a passionate amateur. At nineteen he attended the Bavarian state institute for photography in Munich, where he completed his apprenticeship in 1937. After spending two years at the Atelier Gertrud Hesse in Duisburg, he worked as an industrial photographer at the firm C.H. Schmeck in Aachen. In 1944, he returned home from military service severely wounded and unable to work. Nevertheless, he continued his studies at the Bavarian state institute for photography, in the master class, subsequently becoming a pupil of Adolf Lazi in Stuttgart. At the

same time he fulfilled the requirements for his qualification in Munich. Following the legendary exhibition organized by Professor Reisewitz in Neustadt/Hardt in 1949, Keetman became one of the founding members of the group "fotoform." Along with other members of this group – Toni Schneiders, Wolfgang Reisewitz, Ludwig Eindstößer, Siegfried Lauterwasser, and Heinz Hajek-Halke – he exhibited in 1950 at the first "photokina" exhibition. After Otto Steinert joined the group, their photographic style determined Subjective Photography, a concept which Otto Steinert influenced and which went on to gain acceptance all over Europe as a generic term. It was an expression of the weariness that this generation felt concerning politics, a flight into one's inner self, and hence greatly reflected the spirit of the times. Peter Keetman's photography is subjective in its themes while remaining objective in its conception. This is why it links up so well with the notions of Bauhaus photography and Neues Sehen. His interest in technology and his feeling for its concealed aesthetic enabled him to maintain his style even when working on assignment. A series documenting the production of the Volkswagen, which was published in 1953 in a book entitled Eine Woche im Volkswagenwerk (a week in the Volkswagen plant), shows innumerable pictures testifying to his fascination for the serial as well as the sculptural aspects of technological objects. One essential element in the conception of Keetman's art is the segment. The image is so tightly cropped that the context of the photographed object is lost, while what does appear suddenly acquires the ability, in connection with the picture's composition, of standing alone. It becomes pure form. A similar trend employs a second, though opposed method: the frame is extended outward until the details are lost amid chaos and flow together to form pure structure. The abstraction from the respective content is the essential element in both procedures and goes hand in hand with the overall orientation away from the political. Peter Keetman achieves the transformation without becoming subjective, while at the same time maintaining his link to the tradition of industrial photography.

Reinhold Mißelbeck

Jürgen Klauke

Self-Performance, 1972/73 13 parts, each 57 x 42 cm

Jürgen Klauke photographs himself profusely. Whether sketching or painting, he prepares himself for representations which call forth his "inner milieu," in the representative form of hybrid role and transformation games (transformer allegories) in the staged interaction of his own person with insidious objects. Via photography, the performance is shot as a ritual sequence. The black, alternating photo shows the course of a dialogue with fetish-like props. The action, conceived and carried out on several visual levels of expression (a kind of existentialist pantomime), appears in freeze frames as an intimate and subdued connection between objects incorporated as shadows and the artist's body. As the realistic fiction of a play of meaning, Klauke's photography is in the painting tradition of Magical Realism, whereby the individual picture always suggests the appearance of an original print made in the early days of the medium; neuroses and psychoses are rooted in the past. The artist interprets his obsessive inheritance of his social environment – in the style of the theater of the absurd. The sequence Dritte Wiener Richtung (third Viennese school: 1992) shows ceremonial orders for overcoming "Sunday neuroses," which Jürgen Klauke linked to his cycle Formalisierung der Langeweile (formalization of boredom: 1981). What the viewer sees are sticks as devotional objects along with the artist in distress and in absorbed posture: one may consider them strictly comic comparative orders to the orgiastically provocative liturgy of Viennese Actionism. The protagonists of this school succeeded, among other things, in rocking Austria's Catholic educational dictates while introducing a thoroughly pleasure-oriented art mutation of Freudian flavor. Klauke, similarly under Catholic influence, opposes this tendency in his staging as well as Alfred Adler's individual psychology, which refers to human striving for power – and does so in the sense of the existential analysis of Emil Frankl, who founded the "third Viennese school of psychotherapy." Following a blasphemous, self-exposing phase in the early seventies, which reduced transubstantiation to transsexuality, he has now frozen this conflict as a photo study at the level of material symbolism. Sticks threaten him, sticks bar his world, sticks with shining knobs congregate to become a sacrificial candle altar, sticks transform themselves into bishops' staffs.

Props such as these serve the orientation of the subject Klauke and form his supportive system amid released anxieties, paralyzed sensations, and constant sexual duplicity. For his seemingly narcissistic attempts on the stage of a studio – among specially manufactured furniture to maintain a delicate equilibrium with the world by means of an easily disturbed body-object geometry which often deviates from the linear – the artist has no previous model reproductions, but instead allusionary partners.

What is obvious, for example, is the object conversation of the shadow dancer with Pierre Molinier's personages, costumed in transvestite dress and denuded; Francis Picabia's target-like bodies meeting each other androgynously; Hans Bellmer's stringed puppets; René Magritte's bowler hat; and the flying hat objects of the Dadaist filmmaker Hans Richter. In his nevertheless autonomously actionistic camouflages and veilings, in the conflict with insidious objects, Jürgen Klauke negotiates with the inner portion of his existence and relates it to society, which probably shudders at the sight of its own furtiveness. Klaus Honnef summed it up perfectly: "In the extent to which photographic technique was refined and perfected, it brought two concealed human tendencies to the fore on a wide front – the desire for brazen seeing and the desire for uninhibited exhibitionism."

Günter Engelhard

200

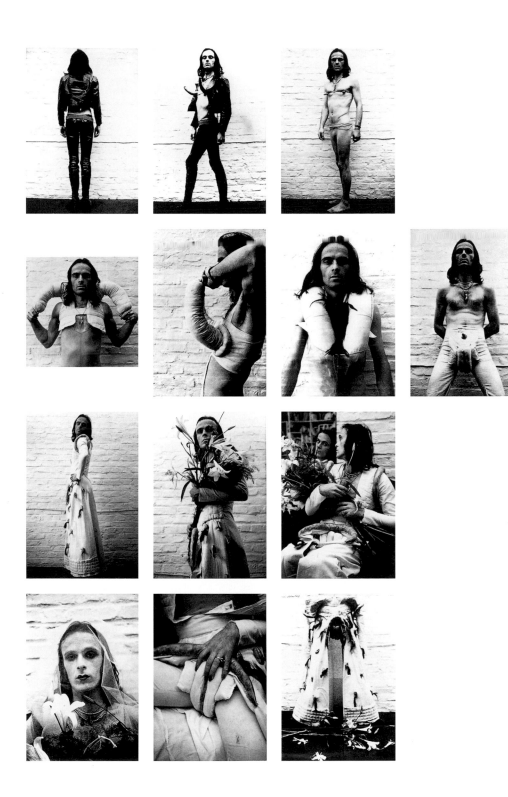

Astrid Klein

Gedankenchips, 1983 126 x 208 cm

He seems to have stolen away like the proverbial thief in the night, unrecognized yet caught. No one knows who he is. In this case, his identity does not matter. He has left traces behind him, however: the imprint of his body contour. Only the contour, as if he had touched the film which captured it. It is revealed in a detail from the negative, which implies that the body has absorbed the light waves which, at a certain time, hit the photosensitive film. The almost genderless figure's oddly stealthy movement is indeed suggestive of a thief in the night. Moreover, the place where the thief is and has been caught in the picture is also hinted at. The whole thing is rather unusual and, subliminally at least, menacing. Astrid Klein's large-format photographs, called Gedankenchips (thought chips), are the location. The sketchy figure steals away from the right half of the picture plane. The technique used turns it into a glaring figure of light, all the more striking against a dark background. At first glance, the background seems mysterious. The diagonal structure of its carpet-like pattern is striking. The standing figure is captured where the structural lines converge to form a 90 degree angle. Only a set of numbers, more or less encircled, hovers above the structured landscape on the same plane as the disappearing figure. The composition is balanced; the numbers from the left counterbalance the accentuated arrow indicating direction on the right. The title of the work is what tells us about the background of the picture. What looks like a landscape which might have been taken from an altitude usually reserved for spy satellites, is, in reality, a photograph of a chip, a piece of that hardware which already governs so much of our lives. The numbers, which form an arithmetical progression, are, however, only shown in close-up detail. They, too, are negative prints. Dominating the lefthand part of the picture plane, they recall mysterious vessels from outer space if viewed from far off. They do shed light, however, on the rational background of the chip culture. As mentioned above, a chip, or a detail of a chip, forms the background of the picture. The artist has obviously constructed a montage of photographs and details of pictures which may not have

originated as photos, like the numbers, which she has written in by hand on the originals using a specific technique. Each photographic reproduction cuts into what "was once there" (Roland Barthes) along the continuum of time and space, thus creating distance from the continuum. With each further stage of the work process, the distance increases. The traces change, some become lost. This circumstance is what Astrid Klein works with. Extinguishing what might seem like certainty as far as the photographs are concerned, she undermines any preconceived expectations and interrupts customary contact to promote the imaginative, deductive faculties of the observers of her photographic "thought chips." In addition, the way she has presented her visual effects casts observers of the work in the dual role of detective and of offender who has been caught in flagranti delicti. The traces of a contradictory reaction represent a dilemma which cannot be resolved. The figure which seems to be stealing away from the "scene of the crime" probably did not actually touch Astrid Klein's picture in the literal, physical sense. What did touch it was probably a cut-out from a photograph of a person who was presumably in a hurry. The use of cut-outs has enhanced the puzzling visual effect which has lent the work aesthetic plausibility. The cut-out was presumably a positive print. And, because this was probably the case, the observer has an identification figure as an aid to interpreting the picture.

Astrid Klein's work poses a great many questions. The questions raised always refer to empirical reality, the pragmatic context of invisible processes taking place. It is these questions that assure the status of the picture as a work of art. The artist's pictures resist collective demands for rapid communication. They reflect the preconditions for and the terms of the technically, or, more precisely, electronically generated pictorial world of the media. Astrid Klein's pictures go against the grain, aesthetically. The threatening qualities of modern civilization are manifest in her photographic universe. One may indeed read these pictures as the visualizations of nightmares.

Klaus Honnef

Barbara Klemm

For years now I have been examining Barbara Klemm's photos in the Frankfurter Allgemeine Zeitung, and not only because her name appears in the credits. I have kept a number of these photos. What is it that so fascinates me about her pictures? It eluded me for a long time. When I once had to go to Frankfurt, I decided to pay Barbara Klemm a call – the first of many. Together we looked through hundreds of photos. In making our choice for the collection, exhibition, and publication, it became clear to both of us that her famous shots had to be included as well, yet the spotlight is on those which first disclose their secret following closer examination. A comparative scrutiny made clear the reason for my fascination; Barbara Klemm's photos are composed with an uncommon precision. This is not apparent at first glance, however, and the reason is simple: her photos have not been made with an explicit compositional intent. There are pictures which give the impression that they were made with a long exposure using a tripod (as was done eighty years ago); others are reminiscent of genre pictures from the last century. Some appear based on an exact choreography of movements, gestures, and actions, while in others the moment becomes an unrepeatable tableau vivant. Many photos are distracting due to the events taking place. If one takes the time, one recognizes how meticulously, for instance, the picture has been composed, whether pushed into the surface or, through precise graduation, led into the depth.

More perceptible than visible is the way in which the different levels, event and motion factors, groupings, objects, and architectural details are linked to one other. Barbara Klemm does not discuss such matters. In retrospect, she recognizes certain regularities and constants in her œuvre, things which cannot be planned or controlled. Her father was the Karlsruhe painter Fritz Klemm. It was perhaps from him that she inherited her painter's or artistic sense – that is, the ability to perceive space and objects in their immediate spatial relationhips.

But Barbara Klemm can also relate how she happened to take a particular photo, explaining the circumstances. One listens to her words, looks at the picture and has the feeling of being at the very place where it all happened. Photography is often hard work: fighting one's way forward through the crowds, stubbornly waiting for someone's approval, maintaining attention even under great strain. But fatigue seems to be a foreign concept to her; curiosity and instinct keep her alert. Her charisma and involvement never turn her into a voyeur. Human dignity, even in extreme situations, is never abused. One of her secrets is that she never obviously takes sides. She remains true to Brecht's maxim that the theatergoer knows more than the players on stage. Thus the meaning is never represented or produced in an additive manner, nor is it mentioned casually in the sense of a delaying factor. Meaning creates the eye of a photographer; the shot itself, the construct, which is always manifest as a conclusive whole in itself. In this way Barbara Klemm succeeds in initiating the viewer to additive seeing, to perception.

Photojournalism has increasingly been superseded by television, although it is associated with some of photography's highlights. By this I am also referring to an attitude that combines such determined involvement with such great intellectual openness.

Jean-Christophe Ammann

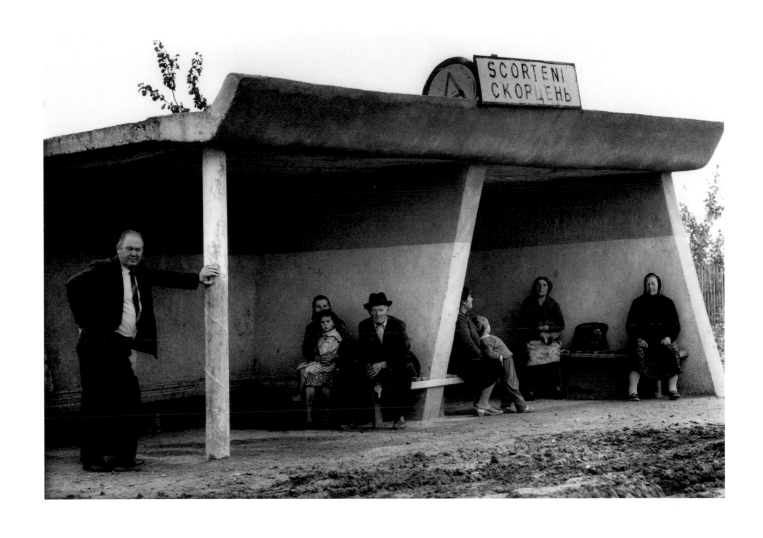

Imi Knoebel

"We gaze expectantly into space," wrote the philosopher Hans Blumenberg in his Die Vollzähligkeit der Sterne (the completeness of stars), published from his legacy, "our last and outermost 'expectation horizon,' waiting for an unexpected message of good fortune." In a series of photographs, consisting of 54 shots in full-plate (30.5 x 30.5 cm) format, Imi Knoebel has photographed the entire northern and southern skies. Knoebel is not a photographer in the usual sense; photography interests him, if at all, merely peripherally. His artistic œuvre avoids any traditional categorization. Frequently he has turned down invitations to exhibitions out of fear of such stereotyping. His nom de guerre reflects both an artistic and a biographical background. Following a transfer from the Werkkunstschule in Darmstadt to the art academy in Düsseldorf, with the intention of becoming a pupil of Joseph Beuys, he and Rainer Giese (deceased 1974) attracted the attention of the master by consistently and extravagantly referring to themselves as the two "Imis." This "performance" had the desired effect. At the same time, such provocative behavior stood in constant contrast to the aesthetic austerity of their artistic work. In fact, Knoebel developed an aesthetic program for the systematic exploration of artistic possibilities from Beuys's practice of the extended "art concept." Yet his foundation always remained artistic practice, something which may be attributed to his friendship with the painter Palermo. He did not lose himself in theoretical speculation. And so grew the project Linienbilder (linear images), which manifests itself in vertical as well as horizontal, always black-and-white lines and assembled series of between two and ten plates, making up the unimaginable bulk of 250,000 pages. His aim was to free art from any objective constraints. For Knoebel it is a matter of the elementary effect of material and color, and he frequently incorporates space as an artistic medium. But he is not content just with the presentation and reflection of the artistic material. On occasion, even picture titles will complement the purely aesthetic dimension with cues of anecdotal character. There is no doubt that the photographs of the northern and southern skies are more than a mere demonstration of photographic possibilities. In these pictures, the stars appear as brighter or fainter points of light, sometimes as part of the spiral arms of the Milky Way, sometimes densely clustered, sometimes more scattered, apparently devoid of order. Yet in every photo there is to be found a single point of light that fails to correspond to any real star; the artist has personally added it to the firmament. Is this his signature? Did he wish to write himself into the celestial heavens? Or is it a new star which was at that time still "undiscovered" and has since found its place in the heavens because its "message" could be received by radio telescopes? Even one which will be discovered at some future time? And thus a possible expression of an "expectation horizon" for unexpected messages of good fortune as mentioned by the philosopher? The artist leaves all such questions unanswered. But since the pictures condense time to a certain extent, instead of just fixing it, as is the case with normal photography, they betray an unconscious (and also unintended) affinity to the photographic art of Hiroshi Sugimoto with regard to their expressiveness. Time becomes a relative factor, and the time point of the particular shot can only be reconstructed through the signature of the artist as photographer. "A white point, indistinguishably added to fifty-four photographic sections of the entire sky, remains an exclusive self-projection of the person who did it. However, it refers the viewer to the possibility of an individual interpretation" (Katharina Schmidt).

Klaus Honnef

Barbara Kruger

Barbara Kruger makes quick-witted photos with word signals. She upsets the general public with combinations of words and pictures, the verbal content of which grabs the attention in passing against a background of aggressively enlarged details of motifs. Words and pictures appear to goad each other on or contradict each other; at any rate, on the basis of apparently familiar phrases, they suddenly act as vehicles for facts with a deeper meaning. The artist uses the magazine layout and promotional photograph for her thought-provoking actions: with effective poster-like snapshot motifs, she mobilizes a more or less thoughtless consumer society into taking a critical stand against itself. The danger zones are marked out. Briefly formulated, the words jump out at the viewer – a shocking message – from the middle of the blown-up picture motif. The devil always lurks in the detail. "Business as usual," projected onto a wolf's fangs, is a direct allusion to wolf-like competitive practices which repudiate the actual title of the poster.

The DG BANK has acquired the photo print Not Angry Enough. The central text motif over part of a male face names a shortcoming that reveals a state of latent individual passivity immediately before social paralysis. "Not angry enough," together with the corresponding statements "Not numb enough," "Not white enough," "Not dumb enough," "Not dead enough," is inserted in the border zones of the square picture measuring 2.77 x 2.77 meters. Numb, white, dumb, dead, and finally – the only active emotion – angry: all this, rather too little, characterizes our gullible contemporary who is now conscious of himself only when buying, not thinking. On another large-format photo of 3 x 3 meters, the message presented like a credit card between splayed fingers replaces the Cartesian key phrase "I think, therefore I am" with the consumer slogan "I shop therefore I am."

Initially, in the eighties, Barbara Kruger approached the anonymous hordes of passersby through her solo nocturnal bill-sticking activities on the streets of New York. Amid the explosion of advertising her succinct slogans burst directly out at people going about their everyday business. As a smart fifty-three-year-old she is still beating the advertising strategists with their own weapons. Together with Jenny Holzer, who has the aphorisms that she simplifies in banal philosophical terms projected onto facades in strips of illuminated letters, Kruger was a student of the conceptual artists Lawrence Weiner and Joseph Kosuth at the New York School of Visual Arts. As a copywriter and layouter at Condé Nast she invented her own method of subverting the field of advertising and reversing the mechanism of seduction. What appears to be a phrase turns out to be a trap: in a sort of raid, distorted mottos and altered quotes are manipulatingly attributed to the world of commerce through the text-in-photo montage.

This type of poster art, "read" in a second, also has a long-term effect because the content plainly allows the viewer to recognize the double meaning. The artist's strategy is based on a "rhetoric of intimidation," as is customary in positively programmed election and promotional campaigns. Their inventors, however, have in the meantime themselves switched the signals to booster power. For a long time now they have been drawing capital for their product promotions from the polarization of words and pictures. Barbara Kruger's campaign to increase awareness via the world of Coca-Cola and the McDonald's culture has in the meantime been dignified by museums and has therefore probably reached the end of the line.

Günter Engelhard

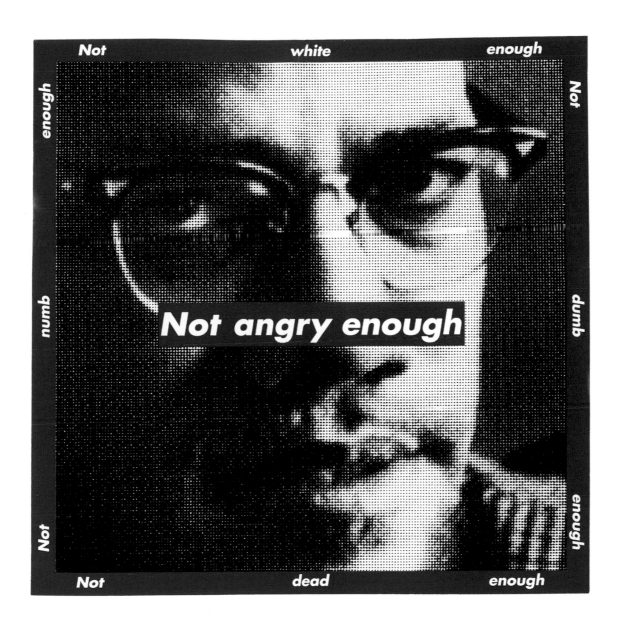

Zofia Kulik

Zofia Kulik, formerly the female half of the performance duo "KwieKulik," unifies elements of her previous œuvre with the medium of photography, thus expanding the expressive possibilities of collage. She opens up to the viewer a black-and-white photo-kaleidoscope that lives from the tension of opposites: past and present, banal and aesthetic, reality and fantasy meet each other head-on. Since 1987 she has made large-format ornamental compositions which she has assembled from a multitude of individual photographic motifs. She has maintained a simple technical standard, enlarging all the details separately and combining them as a collage, without concealing irregularities. In this way her works retain a lively, characteristic, "handwritten" style.

Just as in performance, the human being stands as a player at the center of attention; his actions are symbolic. A dramaturgy determines time and space. Objects function as attributive requisites in the allegorical symbols. In Zofia Kulik's art there exists only one theme: the dense interweaving of human relations. It deals with the relationship to the divine, to nature and to one's fellow human beings.

As the daughter of a Polish army general, she reflects in her pictures the experiences of her parents' generation and that of her own with totalitarianism. She abstracts from concrete situations and generally illuminates the manifestations of the private and official exercise of power, as well as suppression. She gathers together fragments from the art and everyday worlds, photographing and categorizing them as documents of her own life. This personal archive does not, however, stiffen into a dead inventory, but serves as a rich find for an artistic rearranging of the world. With her knowledge of design principles, as valid for cosmograms or mandalas, she weaves individual items into a "carpet of life." Her ornamental symbols are a call in equal measure to reading and meditation in order to trigger aesthetic experience. Along with the inherent strength of meaning, the individual photo motifs interweave to become energetic structures. An inner rhythm reigns within this pictorial cosmos; any continuous conception of space and time is annulled through repetitions and symmetries. Almost exclusively, Zofia Kulik uses her artist friend Zbigniew Libera as a model. Through his nakedness, the dictated poses, and a multitude of individual photos of different sizes, she succeeds in "de-individualizing" him and reduces him to a series of gestures. By contrast, she frequently appears in her pictures as an emancipated woman. In the self-portrait The Splendour of Myself (1997) she presents herself before a heraldic background in the habitude which Mannerist painters such as Clouet and Gheeraert d. J. lent to the portrait of Queen Elizabeth I. The robes of the artist consist of "festive dress," "jewelry," and "insignias," suggesting a display of power and splendor with their ornamental richness. The macrostructure of the portrait aims for a monumental effect through symmetry and statuesque characteristics. At the same time the richly detailed "patterns" vibrate and form a vital order. The reading of the symbols remains complex; subjective and handed-down meanings are overlaid. The nakedness of the man, reduced through stylization to a symbol, can be understood both as an expression of beauty, purity, or heroism, as well as of self-abandon and man as victim of his fate. Flowers and fruits symbolize fertility and transience. Additionally, the sickle and the cross in the background refer to development and passing away. Here, a fertility goddess ruling over life and death presents herself. The feminine principle is confidently represented; extending to the male counterpole, this art offers a communication pattern characterized by eroticism in the sense of platonic philosophy.

Zofia Kulik does not permit any false pathos, however; she counteracts this demonstration of power almost ironically. The banal realism of the sickle eclipses the religious realism with its political symbolism and poses the question of the respective use and misuse of symbols. Ironically, the symbol of power of the former Soviet Union is echoed in the image of the flower with five petals. A cucumber as a scepter, a withered dandelion as an imperial orb and cabbage leaves as a crown lend the portrait a caricature-like quality. At the same time, they also lend a fairytale, fantastic quality to the artist's portrait. Zofia Kulik has expanded her aesthetic œuvre to the effect that, with the aid of photography, she is able to extend her fleeting performance to lasting scenes from the world theater.

Hans Günter Golinski

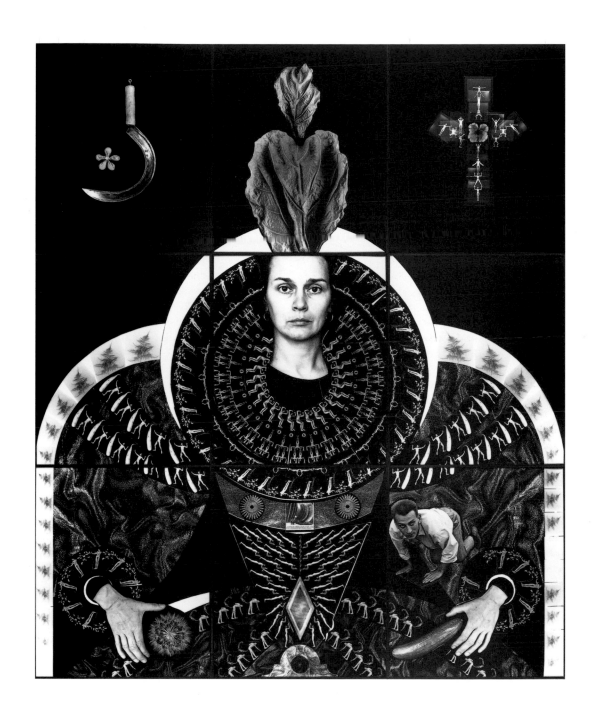

Suzanne Lafont

Passante, 1995/96 4 parts, 106 x 359.5 cm

A preoccupied young woman darts past house fronts in the windows of which the sun is reflected, as are the nearby trees. Completely absorbed in her thoughts, she is holding a strong paper bag from which the page of a newspaper projects. The title of a heading is only incompletely legible: "Sur les tra..." The bowed stance of the woman's upper body corresponds to the arc described by a river dyke. The colors of the body (pale pink skin) and of nature (blue sky, green water) stand out against the gray of the concrete buildings.

This photomontage, which bears the title Passante (passerby), is part of Suzanne Lafont's photo series Le Défilé (parade) dating from 1995/96. The Passante opens the parade, or procession, of figures with an activity of the utmost simplicity: walking.

In this work Lafont is trying to rethink the relationship between figure and background, so fundamental to the Western picture, by separating these two elements. This is why the human figure is moving whereas the background is indeterminable. As the relationship between the two can only be produced in the stable and clearly structured network of the closed space of paintings, Lafont uses the montage technique. The constructional principle of this series is based on discontinuity both of space and of perception. Even if her technique shows many similarities to the collage and photomontage aesthetic of avant-garde movements of the twenties, it does not make the different picture registers fit the right-angles of a sheet of paper or a canvas. The pictures retain their integrity and relate to each other, forming a closed unit. As these are screen prints, the pictures are rather like posters. The figures stand out against a somber, uniform background, and the backdrop is like a stage set of the urban milieu. The figures move within the decaying world of modern life.

"I did not want the positioning of the individual human in the world to take place within the figure/background continuity. I did not want any subliminal association, any communication between the people and the world.... For me the question was roughly as follows: how can the relationship of the figure to the world be represented, based on its distance, its rootlessness, its isolation?"

Exactly to the extent that the montage forms a contradiction to the naturalistic style, so the passerby who is moving through a bottomless space seems to become more like a puppet. The image of this passerby is contradictory to that of a person who is sure of his or her place in the world and who dwells in it as though at home. The political equivalent of the figures in the Le Défilé series is the image of the immigrant. "Entering, walking, moving across, moving forwards, etc., are basic activities in getting used to a room. The immigrant is loaded down, he carries the baggage of his origin around with him. In a comparable manner the figures in the Le Défilé series step into a new territory taking with them familiar, everyday elements of the world: house fronts, advertising bills, snippets of the sky, etc."

The photographic compositions of the Le Défilé series are subject to a simple logic, which, however, encompasses a variety of possible variations. The two modes in which the pictures relate to each other are juxtaposition and layering on top of one another. By contrast there is only a single construction principle, thanks to which dizziness as a result of the constant revision is averted. Only a very fine thread could bind these fragments together and produce a minimal relationship between them. It is the line which guarantees this implicit order. It makes it possible to establish connecting axes: architectural lines of house fronts, water lines of what is portrayed, body lines of figures, concrete lines of picture frames. In addition, the line is the formal tool with whose help these images, in which deracinated elements are gathered together, can be put on the wall. In an exhibition room, the Le Défilé series replaces the actual floor of the exhibition premises with the intellectual floor of the representation. These montages counteract gravity.

Paul Sztulman

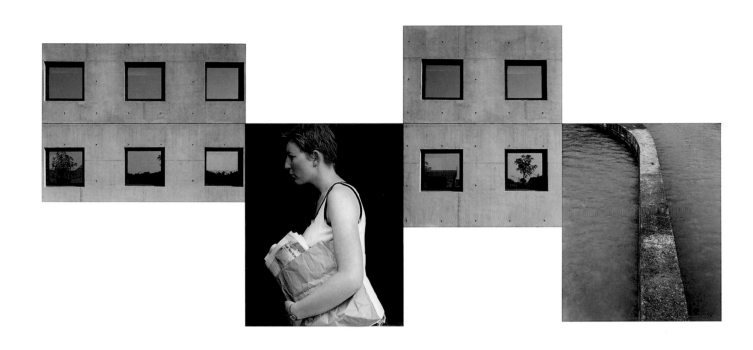

Marie-Jo Lafontaine

Der Augenblick des Überlebens
ist der Augenblick der Macht, 1989
4 parts, 160 x 320 cm

Marie-Jo Lafontaine, who since 1980 has worked with environments and video, emerged into prominence in 1987 during "documenta 8" with the video sculpture Les Larmes d'Acier (the tears of steel). The object resembled a black film backdrop and stood out like a gigantic, expressive bulwark. As an explanation for this spectacular object, Marie-Jo Lafontaine wrote at the time, "Our history is transforming itself into horrors and in this way is accelerating its own demise."[1] From her point of view, Les Larmes d'Acier was thus a metaphorical video cycle on the history of the accelerated demise. With its martial content, the installation initially aroused much attention, but also much controversy. Many interpreters repeatedly emphasized its "ambivalence," that is, the discord and the vagueness owing to the aesthetic fascinations of the work's standpoint. As a retrospective reference to the media-historical success of this sculpture for "documenta 8" in Kassel, seven smaller, tower-like video steles appeared as an edition a year later, again bearing the title of the original sculpture. In 1989 the four-part wall installation from this collection appeared, bearing the title Der Augenblick des Überlebens ist der Augenblick der Macht (the moment of survival is the moment of power) in bronze antique letters in the left portion of the picture. This wall installation with a length of 320 cm is conceived as a multimedia sequence of text, monochromatic colored field painting, photography, and heavyweight framing. The aforementioned media were fused together with the intention of creating a unified pictorial context. The photo of the male head comes from the final cycle of the video installation Les Larmes d'Acier. But here, a concentration on the facial expression of the male is intended. The significantly enlarged head was more closely cropped in the frame, which is in turn essentially more closely cropped around the face than was the case in the original video installation. The head of the athletic man is shown in full-face, in light-dark contrast, with eyes shut and mouth open, in a state of self-abandon and ecstatic delight. The gigantic, serial, and symbolic complex of the mechanical, as well as the exercises performed at the machine which the large video sculpture evinced, no longer occur. The crisis of interpretation is aggravated by the artist herself, for the erotic highpoint is unambiguously shown as a "moment of power and survival."

Attempts have frequently been made to interpret the works of Marie-Jo Lafontaine with the charge of philosophy.[2] Yet this largely resulted in the avoidance of a difficult and complex discussion concerning visual aspects of her work. This happened chiefly because the artist – by way of her picture title Savoir, retenir et fixer ce qui est sublime (know, retain, and fix that which is sublime: 1989), a work completely filling a huge room – hinted directly at the philosophical discussion of only a few years previous concerning the "sublime." This also occurred, however, as a direct consequence of her preferred stance – as an integral component of her work, as inscriptions identical to the title – of quoting individual statements by Heidegger, Baudrillard, or Pessoa.

In the case of the present wall installation, the optical and reflective procedure shows how the bronze letters of the quote conceal the original context to be suggestively ordered upon a colored background as an abstraction and as a figurative, photographic quote: a general disposition of the Postmodern era. At the same time, the architecture of the Postmodern also developed as an ideal the monumental, "cool" impact of quotations out of context.

Does the artist succeed in illuminating the relationship between sexuality and violence? Doe she dissociate herself? Why then does this opus itself require this neo-classical, outsize scale, the expansive gesture of a will to self-determination bordering on the monumental? Does the artist idealize the impact of a cynical element of male power? The enrapturing optical impact of monumental and memorial aesthetics cannot be overlooked. A deepseated conflict concerning questions of aesthetics and power in Marie-Jo Lafontaine's œuvre has not yet come to an end. There are still questions to be posed.

Gislind Nabakowski

1 M.-J. Lafontaine, documenta 8, vol. 2 (Kassel: 1987), p. 140.
2 Cf. Otto Neumaier, "Les Larmes de Lafontaine – Der große Stil entsteht, wenn das Schöne den Sieg über das Ungeheure davon trägt," Friedrich Nietzsche, Noëma, no. 35 (1991).

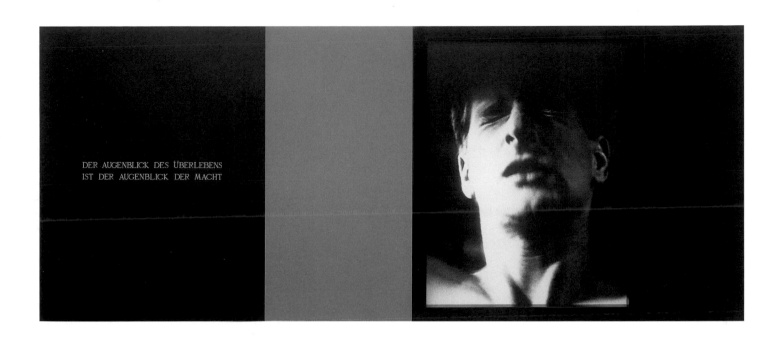

DER AUGENBLICK DES ÜBERLEBENS
IST DER AUGENBLICK DER MACHT

It could be Elvis, 1994 70.8 x 85 cm

Louise Lawler is a disappointment to expectations nurtured by a long tradition of what an artist should be. Her photographs show the work of others and they rarely show them whole. She prefers to photograph famous paintings, occasionally sculpture as well, as they are presented in the rooms of private collectors, in the lobbies of firm headquarters, in museums and exhibition rooms of galleries or auctioneers. Instead of simply reproducing the works she photographs, Lawler fragments them: cut into as color reflections on a polished parquet floor or, with little cards or colored dots attached, as a heterogeneous collection of goods.

Lawler's view of the works of art tracks down their pragmatic context which shows how the historical status of a work of art changes under the conditions imposed by the event-orientated media. For Walter Benjamin, painting in the 1930s – and this distinguishes it from the transparency of photographic illusionism – still persisted in impenetrability simply by being materially present. Lawler, however, reacts to the ease with which such views of art have broken down under the force of simulation. The conditions under which works of art can be reproduced have become a matter of course. Their seemingly resistant surface can be transformed into a transparent sign disseminated by the media. The work of art no longer stands as evidence of spontaneity or authenticity. Now it reveals an exchange of signs.

Lawler utilizes the pictorial idiom of newspaper and advertising photography as well as the matter-of-fact, contemplative detachment of documentary photography. She has photographed a Jackson Pollock "drip painting" in a provocatively impartial manner. It hangs above a sideboard on which a soup terrine is standing. Thus she gives us a glimpse of a Biedermeier drawing room, in which two works by Hodler appear to have been so neutralized that they might just as well be in a hotel lobby. Or she focusses on a detail of a wall in a Sotheby's exhibition room. Pictures up for sale at auction are hanging on it. Again in Auction II, the strange proximity of a Warhol and a Lichtenstein makes them recognizably consumer articles. Lawler's "style" eschews irony, commentary, and evaluation.

It might be Elvis. It could be. Lawler's title, It could be Elvis, deliberately misleads the spectator. If you know a little, you will notice at once that this is Warhol's portrait of Joseph Beuys, even though all objects have been cut into by the edge of the picture. The Beuys is hanging in a room where it has entered on a peculiar relationship with a Japanese folding-screen and other furnishings. It is not only noticeable that art has been degraded to the status of decoration. Further, the power of composition – which unites pictures, furniture, the armrest of a sofa, an occasional table, and a lamp to form an aesthetic whole – is equally evident. Like an ensemble of frames, the wall paneling encloses all the disparate parts. This tasteful interior, in the style of Vogue Interior, unites Beuys' mythologies with Japanese culture, a petrified mushroom and a lamp, the base of which is made out of a bronze African cult object draped with a necklace of cowrie shells. Lawler's color photography makes it possible to view things in a peculiar way. One learns how to see how everything can be changed into at least two versions of itself, the "original object" and the reproducible sign for that object.

Lawler's work shows where photography is now and where it is heading. She documents the destiny of art in public and private rooms. In so doing, she does not fail to realize that the collector's arrangement of the works reveals something of the freedom given back to objects which have escaped the marketplace. Sometimes, as Rosalind E. Krauss has pointed out, a utopian moment of astonishment seems to have been incorporated in such compositions. The impartiality with which Louise Lawler bends over the wound, caused by the plundering of the world, and the power of the collector to compose make appreciation of the marvelous possible, an awareness that can heal the wound.

Thomas Wagner

Jean Le Gac

Les jardins et le peintre, 1977
10 parts: 9 parts, each 40 x 40 cm, one text, 60 x 50 cm

Writing, painting, and photography, with some literary and cinematographic references, merge to invent an unedited narrative which is not without humor.

Jean Le Gac's work is set apart by its heterogeneity and its fictional dimension, even if it does voluntarily conduct a dialogue with other contemporary work (for instance, with Christian Boltanski's "histories"): memories of childhood as real fictions which pastel coloring places firmly among illustrations from popular children's books, installations as diptychs and triptychs challenging the material and colors of photography and painting by utilizing the same materials, photographs of old cameras mounted on their tripods. Making us look at an installation of a real camera on its tripod in front of pictures, Jean Le Gac, like other contemporary artists, speaks to us about his profession and the media he uses while pretending to devote himself to brilliant representation. It is a matter of course, therefore, that he should tell us about his profession, evoking "the coolness of the painter" in a series which has brought him acclaim as being one of the most original of his contemporaries.

In the device he has adopted – which allows him to play with the charm of letting himself be captivated by what is pretty in capturing the spectator's glance – photography occupies a place and a function which, in his hands, permanently redirect it away from the conventions of the medium. This occurs coherently in the way Le Gac turns the convention of bourgeois painting into satire. He frequently uses photography, in fact, to depict a camera. Having thus designated with precision the materials which contrast with pastel, the object, rendered obsolete by his model, appears ridiculous. Jean Le Gac places himself squarely within the contradictions wrought by the images he produces. In developing an unlikely narrative, the artist underscores his ridicule of the collective gullibility which believes in the presumed "objectivity" of photography. And, in a nimble change of direction, he reverses the situation, calling into play a manner of representation which he pretends is "faithful" to the invention of little stories. These stories are seemingly not important yet are obviously literary. One of the figures he depicts, a painter who sets about humbly copying illustrations from the children's books he had as a child, seems like a personification of photography. His chief weakness would seem to be his slavish devotion to tangible reality. On the contrary, Jean Le Gac uses this attitude to take us into a world of imagination and joyousness. The skill of the draftsman who confronts himself and others with implied ironical references to photographic images is played out maliciously on complementary planes which are both captivating and caustic, brilliant and irreverent. As if to say that nowadays creativity cannot be limited to technical prowess in a single area, Jean Le Gac's use of texts and references to the cinema tell us that, in the contemporary world of clashing images, it is necessary to give them a certain status by subjecting them to crises and jeopardizing them. Happiness, in Jean Le Gac's work, means that he does what he does good-naturedly and communicatively.

Christian Caujolle

It is in rather unromantic circumstances that I got to see "The Gardens" of the painter Ureste Maury.Sincerely believing that the place was abandoned,I walked in on a 15th of august,without a thought,a little like a child [illegible] at their cousins'.When,at a turn in a shady path,paralysed on the spot by the irruption near my knee of an enormous toad,I was hailed by Maury himself, so great was my surprise that it is doubtlessly to alleviate my terror that he addressed me,and then,taking to my company,that he proceeded on the way to give me some details on what he called his collection of gardens.

An imposing hedge of wild ailantis trimmed only to one side,that visible from the road (Maury was satisfied with that trick which skilfully deceived prying eyes - my mistake had seem to arrive from the wrong side as he pointed out to me) forwarded the idea of an inhabited residence though brambles were assaulting the deck and a torn curtain was hanging out of one of the second-floor windows.Maury however was not destitute.His art,which was looked down upon by certain people because of what he had obviously borrowed from other artists at the time and which, towards the end, was praised for such bad reasons that even the most hostile art critics had ceased their attacks, reached prices so high that he could have easily devoted some of the gain to the maintenance of his property.but it was not his idea.He reasonably thought that this type of abode today could not fall into decay and very astutely he was taking advantage of the decaying of his own.On account of the expenses its keeping implied and of its lack of comfort,he had bought it for nothing - as it were.without undertaking any maintenance task worthy of the name,with the only help .f a couple of retired gardeners,admist crumbles and plaster rubbish,he was keeping up a dagireime in search of his lost identity,who knows'Finally,I would add that I had to follow a rather long course so as to discover each thing separately,the painter wanted it that way I obviously he had conceived "his gardens" as so many successive paintings that were to appear,at long intervals,within a frame of underwood and vegetation returned to wilderness.The few acres that were meticulously kept contrasted with the miserable and forlorn state of the remaining parts of the painter's domain.

Les Levine

Consume or Perish, New York Subway, 1989 40 x 50 cm

"My work is explicitly intended for the public; in it language appears to be an absolutely intrinsic component. It is a matter of a direct dialogue with the public on topics of concern to them ... The presence of the artist as physical fact is not to be taken notice of. The public should rather be aware of the presence of ideas which it perceives as projections of its own experience."[1] Les Levine, born in England in 1935 but resident in New York since 1968, was from the very beginning an artist with social, i.e., enlightenment-oriented intentions in his œuvre. Although his works were rooted in Conceptual Art, they soon began to extend beyond primarily internal artistic issues. Following the production of disposable and utility objects or "media sculptures," he switched in 1972 to picture-text combinations, which since then have characterized the appearance of his work.

"What distinguishes art that directly utilizes language is the fact that it wishes to make a particular statement, one which can only be correctly expressed with the help of linguistic structure."[2] The integration of language into his pictures is of great importance. Text and picture are striking and can therefore be absorbed at a single glance: they exploit the insight, fundamental to advertising, that generally only simple messages attain their goal. Impulses arising from Pop Art are also taken further, however its political indifference is cast aside in favor of a critical process of reflection. For Levine it is not a matter of marketing a product, but the communication of a socially relevant idea. This idea is, in its essence, removed from the market, even directed against it (provided one refrains from the argument that the work is ultimately a form of advertising for itself and the artist).

The Cibachrome pictures prepared by the artist are in a small format. However, the form of publication typical for Levine is a presentation on huge billboards within the scope of an urban publicity: on highway exits and streetcars, at parking lots and bus stops. Not unlike the works of Barbara Kruger, which also avail themselves of the picture-text combination or the billboard, Levine seeks to find ingress into the daily reality of life.

It is not the form of a presentation in galleries or museums but the direct introduction into the context of a city, next to advertising posters, that makes the direction of Levine's art really clear. The context is a crucial component for understanding his works. It is of significance that in 1989 the artist placed his work Change Your Mind on streetcar carriages in Lodz, Poland. Next to an advertisement for a well-known cigarette brand, a poster with the slogan "Get More" begins to speak in a completely different way. Levine refers to the mechanisms implicit in advertising: advertising attempts by means of suggestion to awaken needs and thus to promote consumption – for consumption is an inalienable part of the modern affluent society. The pig-like head in the poster "Get More" promotes ironic detachment in place of seductive insinuations. (The same is true for works such as Pray for More, 1980, or Consume or Perish, New York Subway, 1989).

What is important in the case of Levine is that the message of his œuvre is seldom unambiguous, but instead opens up aesthetic possibilities for the viewer. Whether one can justify the optimism that leads many critics to believe that the placing of art in a public context simultaneously compels a coming-to-terms as it were with the works seems doubtful. And yet, if in an "age of anesthesia," certain works can still be effective, then it is those – like advertising – that seek out, or even jump out at the viewer in their lucidity and pithiness.

Andreas Hapkemeyer

1 Les Levine, "Post-larmoyante Kunst," Die Sprache der Kunst. Die Beziehung von Bild und Text in der Kunst des 20. Jahrhunderts, edited by Eleonora Louis and Toni Stooss (Ostfildern: Cantz, 1993), p. 318.
2 Ibid., p. 311.

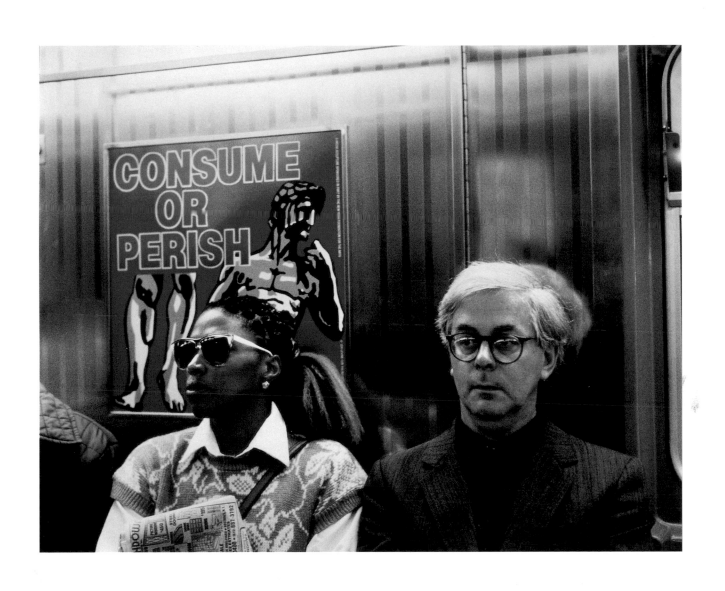

Sherrie Levine

Sherrie Levine annexes–through photography, painted and sculptural reproduction–those works of art which, by her own admission, she would have most wished to have created in their original state herself. Through her strategy of duplication, she creates such a tangible distance between the original and the copy–often changed in both format and material–that her adoption (in a reverse procedure to that of Appropriation Art) in effect assumes the character of an original action. The photographed scenes After Degas (1987), all in a 66 x 53 cm format, fulfill in the eyes of the American artist (already an original basis in the 1870s and 80s) the ideal of painting-like, candid snapshots of people in cafés, at the ironing board, at the riding arena, and in the dance studio. Sherrie Levine photographs Degas motifs as if, in the medium's early days, they were snapshots taken by a painter not so very unskilled with the camera.

A late birth is no mercy for this American. With keen melancholy, her art effects the consistent adaptation of Modernist artworks which were created much too early to offer the artist the slightest opportunity of extrapolating from them. Sherrie Levine is left with merely the option of imitating and copying those works of art that she would so gladly have made herself, and this she does, assuming the role of a grand sentimentalist gifted with declamatory means. This is not an expression of weakness. On the contrary: irresistibly, she seizes the reference figures of her intellectualized creativity with claims to copyright. For instance, in six bronze castings with a bright gold polish, she seizes the urinal titled Fountain from her mentor Marcel Duchamp, takes the billiard table from a painting by Man Ray (La Fortune, 1938) six fold replicated into the third dimension, copies Kasimir Malevich's suprematistic forms and Yves Klein's spherical colors, photographs Karl Blossfeldt's deceptive sculptural plant forms (seed capsules, shrub architecture), and the portraits of Walker Evans, commissioned by the Farm Security Administration during the Great Depression in the United States. With her photos, suggestive of black-and-white sketches, she has succeeded in directing our attention to Degas' real impressions back to a stage of an initial impression of reality. Sherrie Levine is evidently concerned with lending objectivity to the cult object "artwork" by way of photography. She even photographs her own copies of familiar subjects, which again were not painted from the original but from a reproduction: this is the autonomous achievement of "pleonastic reworking." The photo corresponds to a readymade by Marcel Duchamp: artistic content and value are dependent on circumstances outside of the picture. The viewer is invited to take up the challenge and break through the silence of the distanced pictures.

By "stealing" the aura of the original, as if it were Schlehmil's shadow, the illusionist creates a prerequisite for the replication of the artwork from the shadow of the reproduction. In short: she visualizes the distinction of that which is identical–be it Marcel Duchamp's "bachelors" from The Great Glass or George Harriman's Krazy Kat and Ignatz Mouse. Out of the delirium of repetition, the original appearance ultimately awakens once again–the reproduction inevitably becomes the one which we had lost and which appears in the serial memento of the photo as Memory Art with appellative qualities; an adroit, intellectual sleight-of-hand. "Photography," says Sherrie Levine, "is to me something magical, and photography in two stages even more so."

Günter Engelhard

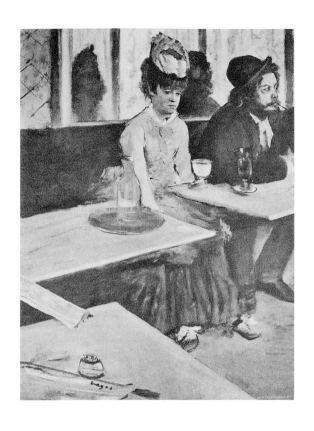

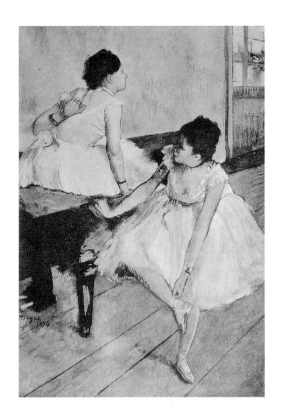

Helen Levitt

New York, 1980 35 x 42.5 cm

The presence of a camera in operation noticeably affects people's behavior in most situations, especially if that camera is pointed at them. Photographers have consequently gone to great lengths to make themselves and their tools unobtrusive, even invisible. Walker Evans actually concealed the camera he used in the late 1930s to make the surreptitious studies of New York City subway riders for his suite, Many Are Called; and his accomplice on that project, Helen Levitt, based her working method on the right-angle viewfinder, which enabled her to photograph people a quarter-turn to her left while appearing to be looking elsewhere.

The illusion of non-intrusion is of course just that, a stylistic device; no matter where she seemed to be pointing it, this white woman with her Leica could not have passed entirely unnoticed in the streets of Harlem and other run-down sections of the city, and the behavior described in many of the resulting images is an often direct and obvious response to her presence. Yet, even when one understands it as a narrative strategy, the illusion is consistently effective in the resulting imagery. What Levitt offers at her best is a vision of the street life of poor and working-class New York City neighborhoods as the urban version of an enchanted forest: a theatrically energized context ripe with magic and bursting with epiphany.

If there is a sociology to be extracted from this project, it is one that would be of no interest whatsoever to someone dependent on statistics. Neither the eventful nor the stereotypical drew Levitt; more interesting by far to her were the incidental and idiosyncratic, those interactions to which no one but the participants paid much attention, such as neighborly dialogue and children's play. From these she derived what seem like artless, self-contained slices of life owing as much to dance as to drama, constructing with them a world inhabited not by types but by particulars.

Most of the best of these black-and-white photographs were made in the years between 1938 and 1945, and were collected in a modest book titled, after its introductory essay by James Agee, A Way of Seeing, first published in 1965, ten years after Agee's death, and recently restored to print in a new edition. (It is one of two classic books on which Agee collaborated with photographers, the other being Let Us Now Praise Famous Men, co-authored with Evans.) Quotidian doses of transitory grief, joy, pride, distraction, love, introspection, anger, solitude, and wonder are freeze-framed here for our scrutiny. Certainly a part of their appeal at this juncture is nostalgia: nostalgia for this city in its earlier days, and for childhood and adolescence less contaminated by mass media and marketing, among other poisons. Yet their strength is not that wistfulness, but the sense they convey that someone unafflicted by either reformist impulses or nostalgie de la boue is describing the nuances of the public life of everyday people. It seems likely that Levitt's reputation will stand or fall on the basis of A Way of Seeing and the parallel, nonpareil short film on the same themes from the same time, In the Street, on which she collaborated with Agee and Janice Loeb. In both these projects, she displayed a consistent surgical delicacy with which she excised moods, relationships, gestures and poses in order to filter them through her own sensibility. It is the fifty-odd pictures in that book, plus another dozen or so made during the same period, that constitute Levitt's most widely recognized contribution to photography. Levitt has expanded her œuvre considerably over the intervening years, however, for several decades refreshing her vision by working mostly in color – well before that became popular among street photographers – but more recently alternating between the two, continuing to seek out traces of the transcendent in the everyday.

A. D. Coleman

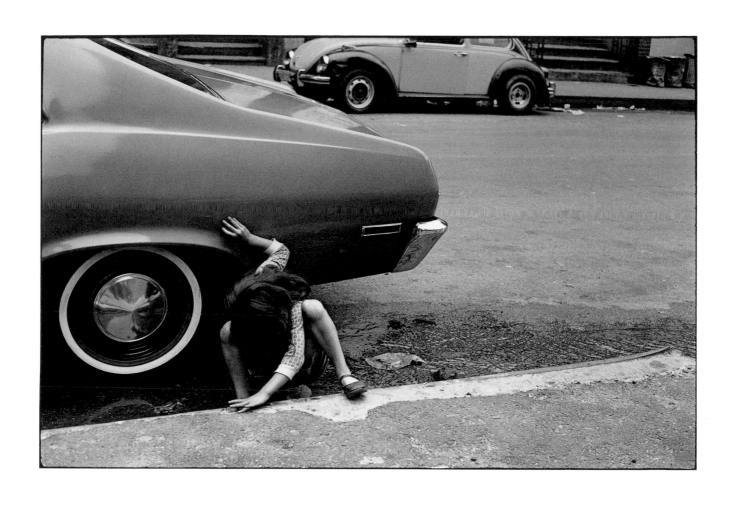

Edgar Lissel

Olympiastadion, Berlin, 1994 125 x 250 cm

Architecture is incorruptible. Like all arts it stores up, so to speak, behind the backs of its creators intentions and messages of which the latter are unaware. Art-historical examination of the so-called "Neue Deutsche Baukunst" reveals that all the modernity and even all the traditionalism of National Socialist architecture was just a porous mask from behind which the obsession with eternity and, not least, the longing for death showed through. Thus, just as the cultural critic Karl Heinz Bohrer once described the essential core of National Socialism as a "practical and mental ritual of killing," so the state buildings of the Third Reich betray themselves as being gigantic sacrificial altars, as catafalques and mausoleums, in and before which the masses were to attune themselves to the idea of their own death: a willing death, extolled by the regime as a heroic act, which transformed the reality for thousands upon thousands into an agonizing, senseless death. The altars and monuments of antiquity were – often anonymously – the models for state buildings, enriched by the mythical aura that Fritz Lang and other German film directors gave their set architecture; fake buildings such as the crystal-shimmering and yet martial Worms Castle in Lang's Nibelungen, but also the cathedrals of Speyer and Worms – effectively shot in close-up – in Rudolf Bamberger's documentary films, aroused the rapturous admiration of Hitler and his architects.

Light, the effects of which had been learned from cinema, was a major tool in transforming the subliminal necrophilia of Nazi architecture into messages of salvation. Both the oppressed and their oppressors were intoxicated by the magical radiance that was spread at night primarily by the illuminated buildings that provided the settings for mass celebrations and mass solemnities. All this culminated in a construction that was entirely imaginary and yet became the most famous architectural work of the Third Reich: Albert Speer's cathedral of light, which anti-aircraft searchlights created in the night sky, first in Nuremberg and later in Berlin. The French ambassador of the time wrote in his memoirs that he felt "solemn, as in a cathedral made from ice."

A solemn, icy coldness also emanates from the photographs of Edgar Lissel. Since he, too, works with light, he shatters the mystique of the edifices of that era – only to give them a new mystique. The camera obscura technique with which he exposes photo canvases for hours at a time gives the buildings depicted a strange radiance and surrounds them with a glowing nimbus. They exude a pale, cold shine similar to that attributed by Hieronymus Bosch to Hell more than four hundred years earlier, when he painted his Garden of Earthly Delights.

The reverse procedure, whereby the buildings as color negatives of themselves become at once alien and yet identifiable, evokes an association with Franz Murnau's film Nosferatu. The first viewers, so it is said, cried out with horror when Murnau allowed the furious coach ride to continue in the form of negative film from the instant when the frontier to the kingdom of evil was crossed. The shock of this world, which is distorted in order to reveal the ghastliness it conceals, can also be sensed in Lissel's photographs, the effect lessened by the delicacy of the angle of vision, the technique, and the colors, but still vivid in the long run.

All this, and the oppressive freeze, which at times seems more alarming than the milling masses in Murnau's ghost sequences, brings out the Third Reich. The time, the "fleeting appearances" of which Hitler spoke and which – as moving people or moved objects – are in fact the manifestation of life, become ghostly patterns in Lissel's photographs, or else they vanish completely in the glimmering eternal pathos of the edifices, as the dictators strove to freeze time for a thousand-year empire with unswerving rules. With the imperious rigidity, the lack of people and of life, and the magical shine of the edifices, Lissel's pictures come quite close to the suggestion of the real Nazi buildings and are at the same time worlds away from them. For in these photos one is aware of the rigor mortis of this regime and the phosphorescent glow of decay that lay hidden behind the claim to dignity, permanence, world domination, and universal power. Edgar Lissel's renderings give an effect as though Breughel's war fury "De dulle Griet" has just raced by and left behind the eternity of death. This is what Hitler subconsciously revealed when he spoke of his buildings which, "like the cathedrals of our past," were intended to project forward into the millennia of the future.

Dieter Bartetzko

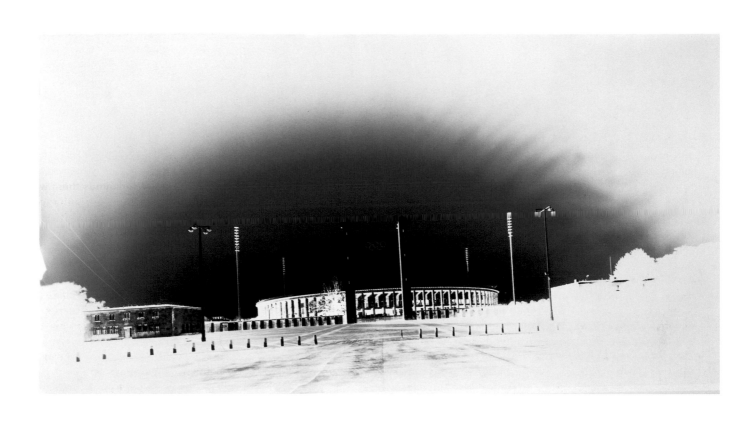

Ingeborg Lüscher

After having trained as a psychologist and actress and also having worked ten years in theater and in television, Ingeborg Lüscher decided to take over the direction of her own works. In 1993 she gave the following information in an interview, without concealing the crass breaks in her œuvre: "Continuity interests me only as a basis of human relationships; forms of loyalty; as soon as it becomes a matter of external forms of a process of visualization, I feel fettered."[1] The artist's first objects originated at the beginning of the seventies, when the effects of happenings, the materialist conception of Actionism, and mixed media made their visible marks on Object Art. At this time, Ingeborg Lüscher found her working materials in the form of cigarette stubs and butts. She used thousands of them to mark and envelop everyday objects such as window frames, a bicycle, a Thonet chair, a leather coat, and a book. Later she showed a readiness to adopt the commonplace into art by turning to the outsiders and eccentrics of society. In 1985 she presented in book form her intensive and respectful encounters with the beggar Laurence Pfautz, who was homeless and stateless.

Light and shadow are existential phenomena of human perception. Ingeborg Lüscher's love of these two extremely contrasting elements has been documented since the 1980s in her paintings, and later in her objects. At first she worked with color. Soon, however, she turned to substances of other consistencies and material natures, such as fine wood ash or dust, earth, and sulfur. Ash, a relic which is naturally left over after combustion, enables the artist to achieve many dull, monochromatic shadows and nuances between gray and black. With regard to the symbolic potential of ash, she once remarked that it is "a material that has survived catastrophe – fire." Sulfur is a wholesome natural powder, extremely fine, whose specific qualities are preferred by the artist because of its phenomenal luminosity. Fascinated by this luminous power, she transferred it to canvas, wooden sculptures, and objects, as well as to open and closed cardboard boxes. She then fixed it with glue and loaded it down with weights so that traces of her working method on the surfaces of her "luminous objects" could later be represented expressively. Thus, the leitmotif of her initial phase returns, that is, that of subjecting everyday objects to a transformation. Under closer examination, it turns out that Ingeborg Lüscher's working method is not at all inconsistent.

In her photographic series, the "light-dark" returns in a most surprising manner. The major themes of the artist, who never titles her photos, have from 1993 been the sky, and from 1994 the sea. In these photos, the color black represents that which is dark in nature: water, the deepest depths, the cosmic night. The essentially more saturated yellow is still reminiscent of sulfur as a "light-bearer." Sparkling sunlight, however, is compactly incorporated within a damp material. The far horizon is removed. One feels either warmth or threatening moods. Flashes of sunlight and drops of water become intermingled. One feels that both are brought close to the eyes. Instead of directing the glance into the expanse of nature in her photos, Ingeborg Lüscher draws the observer's gaze into the depths of the elements' intermingling. Here one feels something directly of nature as a breathing organism, senses the exchange of elements on the basis of different material constituencies and temperatures as well as the condensation processes of an uncommon cloud formation. "The photos were made on the way from home to the studio. Extreme weather conditions were necessary; the rock of the mountains had to be saturated with heat from the summer sun. It had to rain constantly for three days and nights. The sky had to be very bright but could not be blue."[2] With her intensive observation of nature and its local expression, the artist succeeds in avoiding the visual cult of the superficial, which results from the industrialized consumer culture in global markets and which dominates contemporary photography.

Gislind Nabakowski

1 Interview with Yvonne Resseler, "Ingeborg Lüscher," Aargauer Kunsthaus (1996), p. 64.
2 Letter to the author, April 3, 1998.

Urs Lüthi

Self-Portrait, 1976 3 parts, 85 x 375 cm

Originally a painter and maker of objects, the Swiss photographer Urs Lüthi has been consistently working with photography since 1968. Viewed superficially, many of his works might be conveniently classified as "Body Art," which was trendy in the 1970s. A recurrent theme in his photos – as here in Self-Portrait (1976) – is the human figure. The artist himself often poses for the camera. Appearing alone, he may be masked or disguised with varying gestures or physiognomy, bearing mute witness to disturbingly unpleasant situations. His portraits are often combined with landscapes and other settings, or filled with props which defy definition. Nevertheless, on closer scrutiny, the observer would be hard put to call this work simply "Body Art," because here the body does not represent the only frame of reference for the statement the artist is making. In his photographs, Lüthi does not document physical action or motion sequences. On the contrary, he investigates the psychological and emotional content of situations in which the human figure appears in photographic representation. In other words, he stages such situations in order to study the psychological or emotional space of the human figures he is depicting.

It would be wrong, however, to evaluate what might appear to be Lüthi's preoccupation with himself as an expression of extreme narcissism. With a few exceptions, his work does not represent "self-portraiture" in the narrower sense of the term, as we have known it in painting since the Renaissance. Traditional self-portraiture often amounts to affirmation of the artist's role as creator. Lüthi, on the other hand, seems to question the assumptions underlying this view of the artist's role. He builds up a noticeable distance between his ego and the picture. "Urs Lüthi's self-portraits put emphasis on the reality and the fictions of the ego. They proclaim 'je suis un autre' ('I am apart') by affirming with equal obviousness both his consciousness of self and its exact opposite" (Rainer Michael Mason). Viewed in this light, self-portraiture is a surrogate for situations which infringe on privacy or intimacy, thus enabling the observer to participate in a generally intelligible reflection.

The semantic ambivalence expressed in the Self-Portraits is encountered in a great deal of Lüthi's work done after 1973. His repertoire has been enlarged to embrace the confrontation of Self-Portraits with settings and landscapes, as well as Double Portraits, made in collaboration with Elka Kilga, who has taken on the woman's role in them. One of the most comprehensive of such works is They Have Lived for Many Years in Our Neighborhood and They Are Very Friendly People (1976). With it, Lüthi has abandoned private space for the experience of daily living and reflection on human situations. The confrontation of Self-Portraits and Double Portraits on the one hand, and settings, landscapes, and spaces on the other has given rise to poetically symbolic, yet critically detached representations of scenes. These are not real scenes, although they "represent" real-life situations which might conceivably arise. What counts for Lüthi, however, is not the "story" which can be empathized with but the accompanying psychological space.

"I don't represent big events, but rather the background which gives rise to such events ...," wrote Lüthi as a statement in Lea Vergine's book Il corpo come linguaggio (the body as language: 1974). It is the psychological background of the "events" which challenges both Lüthi and observers of his work to self-observation and analysis of their own circumstances and situation.

Zdenek Felix

Robert Mapplethorpe

Photography was the perfect medium for Robert Mapplethorpe. No other form of visual art represents so painfully and so clearly our repressed consciousness of the transience of all being. The act of taking a picture literally cuts into the process of living, freezing it in the moment in which the light rays reflected from the object photographed burn into the light-sensitive layers of the film. Mapplethorpe's main subject matter, however, was life. Eroticism, bursting with vitality, fills his pictures. Even flowers are transformed in the light of his art into erotic symbols. Nevertheless, he conceived of eroticism in a way totally different from the sterile glossy photos familiar from advertising. It is ancient Eros, vigorous, primal, and obscene as he is, who shows his face here – that powerful drive which bursts the bounds of human existence like Thanatos, his opposite, who ends life to lead it to new life.

Mapplethorpe was well aware that Eros and Thanatos are inseparable. He knew that even before he knew that he would die young. In his photographs, life and death appear as a unity; death is the prerequisite for and precondition of life and not vice versa. Eros and Thanatos embody our yearning to break into the monad-like "ego" that informs human existence, the longing to again plunge into the broader context of nature which birth interrupts. This is the desire to experience continuity undisturbed. Taboos have been set up around this yearning, and Mapplethorpe's pictures infringe upon them. Its sexual license is only in a superficial sense what makes his work so provocative.

Mapplethorpe's consummate mastery of form and composition enabled him to express the ambivalent character of his subject matter. He was a superb craftsman in form and light. His artistry in staging was modeled on the principles of classical art. Mapplethorpe himself frequently emphasized his predilection for symmetrical composition, preferring the painterly photography of the nineteenth century to that of his avant-garde contemporaries. Far from being mere statements of a particular aesthetic, his photographs manifest his will to stylization. Classical composition is an affirmation of human yearning for permanence. The medium of photography freezes this yearning, seemingly elevating the object photographed to the sphere of timelessness. In fact, however, by making its object remote in time, photography subverts these yearnings for permanence.

Light plays the major role in Robert Mapplethorpe's work. Light alone conveys the contradiction between lapsing back into nature and longing for eternity, between body and intellect, body and soul, and between instinctive drives and intuition filtered through spirituality. Mapplethorpe's friend and patron Sam Wagstaff has said that Mapplethorpe allowed himself only one trick, the dramatic effect of light. Light staged with great artistry lends his pictures their distinctive radiance, their "aura" in Walter Benjamin's sense of the word, the experience of being at once close and distant. In Mapplethorpe's work, light flatters faces, bodies, and flowers alike. Some look as if they came from another world, as if they transcended this one. Others are as cool as marble, yet as fragile as porcelain. Simply looking at them means jeopardizing them. The philosopher and art critic Arthur C. Danto finds these pictures fraught with a conflict that approaches paradox. On the aesthetic plane, light fuses the extremes informing Mapplethorpe's art: physical violence and cerebral lucidity, hardness and softness, beauty and transience, sexual license and immaculate purity, aggression and sublimation, naturalness and artificiality.

Coming to terms with his own death, Robert Mapplethorpe captured the process of his dying in moving self-portraits, relentlessly recording his own physical decay. These pictures have overcome death – at least long since the photographer's life ended. Incorporated in our collective visual consciousness, they renew themselves, like all great works of art, each time we look at them.

Klaus Honnef

Maix Mayer

New York, 1993 100 x 122 cm

Biographical reference is of special importance for Maix Mayer's œuvre. His central themes are space and time, movement and development. Mayer's photographs are "views of life," drawn from his journeys into his own biography and into the strange which first make possible the experience of that which is one's own as something personal. His most significant works of the nineties are now available in the form of a publication in four volumes: as an independent work and at the same time as a documentation of series and projects relating to one other by means of dialogue.

In the first volume, Anthropologische Vexierbilder oder die zerbrochene Symmetrie (anthropological picture puzzles or the shattered symmetry), he visits the places of his childhood and youth. Following the "inner journey" to his former school or to the railway station where his father worked, the second volume, Pilzsuche oder Phantome auf dem Möbiusband (mushroom hunting or phantoms on the Möbius strip), features travels to places unknown to him. In the travel images in search of the self in others, birds are the photographer's most frequently recurring motif. There are live birds before a painted backdrop as well as prepared, stuffed ones in museums: a bird installation by Mario Merz in Switzerland, bird motifs stuck onto glass panes as a warning to other birds, a white plastic swan, and live black swans in Tasmania. In this project, which he calls Gullivers Reisen (Gulliver's travels), he undertakes – influenced by events on the international art market – a trip through time and space to leading fairs and exhibitions: to Sydney, London, Paris, Brussels, or New York. There remain memories and photos, for instance of the flying cranes in the Museum of Natural History in New York, which he visited.

Working with his old Polaroid camera, Maix Mayer puts up with many inconveniences. This procedure compels him to lay down in advance the picture composition exactly and to use long exposure times. In order to modify the negatives further, he must always have a container with a special solution on hand which removes the developing fluid from the negatives. The irregular borders of his black-and-white photos – which with their apparent perforations lend an additional visual appeal – are made by tearing the print from the negative backing. Mayer's aesthetic means are as simple as they are effective.

These photos remind one of everyday things. They are in fact unpretentious shots which are confusing when viewed on their own. Irritations arise through blending the different levels of real and artificial spaces, of abstraction and construction. The conception becomes clear only within the system of successive modules. Owing to the sensory visual language of the artist's photos, the individual shots nevertheless acquire a value which lends them quality and permanence.

In the volume entitled Haus Raum (house room), Mayer concentrates mainly on his parents and seeks familiar closeness in his birthplace, Leipzig, just as he seeks foreignness in the small locality of Leipzig in Tasmania. In Bordbuch (boardbook: 1997), his most recent volume to date, the artist examines this theme further and offers information on his earliest travels and his background by "recycling" old photos of his parents. Sandman figures, teepees, electric trains, pilots, astronauts and globes appear and introduce the travels which were possible for citizens of the German Democratic Republic. These enigmatic narrative photographs from his parents' family album, with posed groups of figures on an outing, seem almost as threatening and intense as the works of Jeff Wall. Maix Mayer plays a serious game with lost dreams and realities. While the photos remain largely unchanged, everything around them has altered. Even the printing house is scarcely in a position to reproduce the ORWO-colors of the sixties and seventies.

Bettina Becker

Will McBride

"Hair"-Darsteller in Pappkartons, München, 1968 70 x 85 cm

Born in 1931 in St. Louis, Missouri, Will McBride now lives in Frankfurt and in Casoli, Italy. He first painted and drew, and then he took the decisive step of beginning to work with Willy Fleckhaus as a photographer for Twen magazine. This publication undertook to document the cultural changes that took place in postwar western Germany, focussing on the dissatisfaction young Germans felt with what they saw as the inhibitions, lies, and materialism of the Adenauer era. In 1953 McBride fled the Puritanism of America, seeking in postwar Germany the feeling of renewal that went with unrestrained body culture and a future-oriented lifestyle reminiscent of the twenties, especially in Berlin, and revived in Germany in the fifties and sixties. Photography became for him the aesthetic medium for depicting and recording this lifestyle. He did so in Berlin in the sixties and seventies, in Munich with Hair and later in both Hamburg and Frankfurt as well as Casoli, to which he returns frequently.

He states that, for him, photography is not something dead or print-like, but life itself, as it moves and sweeps him along with it.

A Humanist pathos, which sometimes seems naive to European observers, informs all his work, whether in the context of a famously enlightening book or photos taken on many trips. It is basically a hymn to youth, which he views as our only hope of continued renewal. Premonitions of death and youth cult are, after all, two sides of one coin. McBride is not celebrating youth as an American contemporary; instead, he transfigures the state of being young, elevating it to a potential for openness and untainted purity.

Klaus Honnef says that the attitude assumed by a photographer towards his subject matter expresses dismay. His dismay at what he sees is distilled in his pictures as a code for individual and social conditions. The fact that McBride, an American, has viewed Germany as a foreigner has certainly had a positive impact on the way he observes life there, which he does with detached affection.

McBride himself speaks of photographers as wanderers. He is "on the road" like the poets of the Beat Generation. A photographer is a wanderer and a learner who roams through the present thoughtfully and consciously. Will McBride has not only illustrated Hermann Hesse (Siddhartha); he shares his philosophy. What is striking about his pictures, even work done on commission, is their genuineness, their moral clarity, the photographer's powers of judgement, the sympathy he expresses, and the inclinations he voices. He has written that he does not photograph what he does not feel any more than he would what he has not experienced.

Photography is for him an act of intensive communication, a medium through which he relates to others, a medium of interpretation, instruction, and even confession. The street is his stage for these relationships, his theater of gestures and glances, a visual metaphor for life itself.

Peter Weiermair

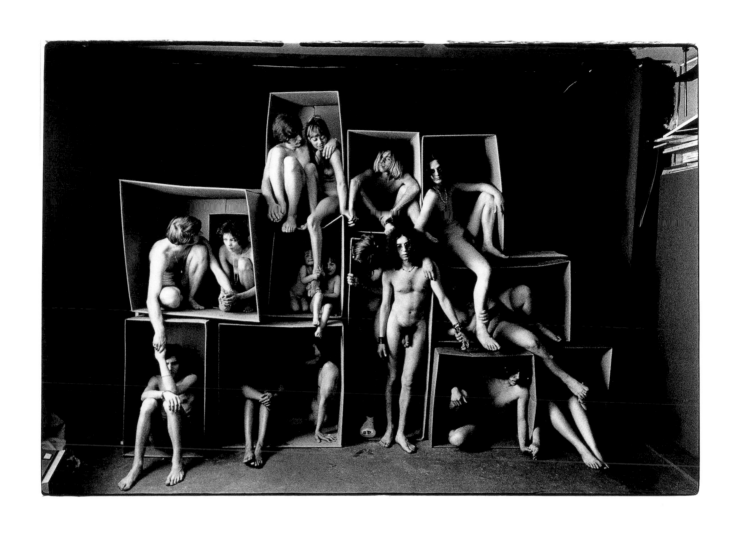

Florian Merkel

Erfahrung, 1995 138 x 105 cm

Hansel and Gretel lost in the forest: we all know the fairytale. Interpreting it is a different thing altogether. In Kinderbildnisse (children's portraits), the working group of photographs done by the Berlin artist Florian Merkel, the children are named Leo and Anna and are probably his own. Merkel is represented in this collection by two works from this series, Leo und Anna auf dem Waldweg (**Leo and Anna on the forest path**) and Leo und Anna im Winter (**Leo and Anna in winter: 1993**) as well as a somewhat larger work belonging to his group of self-portraits (Selbstbildnisse) in portrait format entitled Erfahrung (**experience: 1995**). He works like a graphic artist, using an egg-tempera wash on baryta paper (barium sulfate and gelatin emulsion) to color all his photographs by hand. The reproducibility of photographs is thus set against a "one-of-a-kind" print. Merkel, however, comes from the East German alternative music scene, and his personal aesthetic idiom has a rather "trashy" look. Its motifs still recur in reproduction on the covers of the music scene to which he belongs. A strikingly ironical artist, he allows private life, albeit not from petty-bourgeois environments, to shine through his hyperbolic treatment of mythological and symbolic themes. The cheap, trashy look still reflects the culture of poverty of his formative years. He makes his work transparent in both senses of the word. His pictures of children with motifs such as the Sunday walk, taken from amateur photography, reflect the desire to seize time by means of memory. In their pointedly allegorical handling, they achieve a different time horizon and a surplus of signification so that one almost inevitably sees in Hansel and Gretel the inequality of East and West Germany personified. This is all the more evident in other works which are stylistically close to the tableau vivant, **such as** Rückzug der Roten Armee (**retreat of the Red Army) or** Verklärung der Bourgeoisie auf dem Marktplatz zu Falkenstein (**transfiguration of the bourgeoisie in Falkenstein market square**). In these, he deals with more specific historic events. We are transplanted to the timelessness of the mythical in Erfahrung, **his picture of paradise with its Land of** Cockaigne motif. Who is this about and what experience is it? A man as a pastoral figure, the artist, lies there as Adam – without Eve – figuratively mythological before the tree of knowledge. In most traditions paradise is an enclosed garden. Here it is one in a German orchard, with fruit trees spread widely over agricultural land, open to the sky. The figure is looking up into it. Enclosed gardens also represent the female sheltering principle. The question is whether the scene is set before or after the fall? The apple behind the figure's head alludes to the Land of Cockaigne. At first glance one might think that the figure is lying there and simply letting nature pour her treasures into his mouth. Or so it seems. Perhaps experience means here resisting the temptation of Eve and not eating the fruit of the tree of knowledge. Yet an experience of that kind would only be possible after the expulsion from paradise. The man, however, is wearing shorts. Therefore, he is probably only dreaming of paradise regained through German unification, which delimits time. The bright red apples are the predominant motif in the picture. Might this be a dream of the fruits which the promised "flourishing landscapes" should have long since borne? The ambivalent treatment of the subject matter lies not least in the equivocal symbol of the apple. In Christian iconography the apple represents both the forbidden fruit of temptation and original sin and the new Adam and redemption.

In its roundness, the apple is also temporally symbolic as the orb of empire, an old symbol of political unity and hegemony. Consequently, the question of the ownership of the tree arises. A fruit which is not always easy to cultivate in our climate symbolizes the conditions after the Wall came down. And Wolf Biermann once sang: "That was in Bukow in the sweet-cherry season, the trees belong to the LPG (Collective Farm) ..."

Florian Merkel's allegories of the current state of affairs cannot be deciphered unequivocally. Instead of leading us out of the forest of temporal signs, they lead us further into it.

Hubert Beck

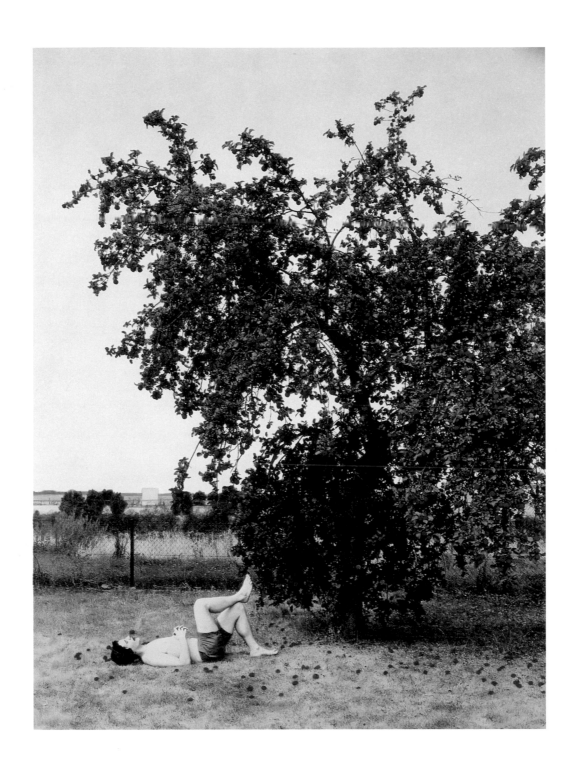

John Miller

Untitled, 1995/96 each 19 x 15 cm

Nietzsche's philosopher is a wanderer in the landscape who goes his own way. In the light specific to early or late in the day, particularly however the brightness of noon, he seeks the sources of certainty and happiness. This light promises immediate insight into reality, making tomorrow illuminate today. The image, however, is necessarily mediated.

For several years the American artist John Miller has been taking pictures across the urban landscapes of the United States, Asia, and Europe, between the hours of twelve noon and two p.m. This series is called The Middle of the Day, and thirty of the photographs in this collection are from it. As Miller himself says, what he is after is the mundane quality which he wants to look at in a documentary framework. The conflict between subjectivism and objectivism with which this project (like the history of perception in photography itself) is fraught is revealed in the two perspectives essential to him. On the one hand these photos may be read as the sociological background for the problem of work vs. leisure, the theory of the mechanization of time, and the like. On the other, they may be read as the photographic diary of an artist who views photography not so much as a medium but as a process. Miller's return to a small format corresponds with the search for the mundane since the 1960s. The artist, however, who is also a critic and instructor, knows all too well that capturing the object always entails a loss of self, just as representation invariably ennobles it. What is decisive for Miller is the form in which his work is presented. Without exhibiting strict typologies as the Bechers do, he abandons, like them, the production aesthetics of chronology of place and time. He shows, in a certain sense, typologies of synchronicity encompassing all formal and thematic coordinates, according to which pictures are classified today. What at first glance might seem to be due to the subjectivity of the wanderer subsequently proves itself to be a withdrawal, as in reception-aesthetics, from the picture. With John Miller, who belongs to a generation of artists who rhetorically question the assumptions of authorship, Conceptual – in his own words, "the system in which a picture is placed" – becomes readymade. What is paradoxical about readymades is revealed in a flash in the anecdote Robert Morris tells about Marcel Duchamp. The latter had been invited in the mid-1960s to a forum discussion in The Museum of Modern Art in New York, which Morris attended. Duchamp answered the question of how readymades came into being by saying that he, in order to achieve something artistic at all, set himself deadlines, went to ironmongers and picked out something. His answer to the question of selection criteria was that he tried to predict to which of the things there he would always be indifferent and then chose that. When Alfred Barr, then director of MoMA, intervened at this point with the question of why the works look so beautiful today, Duchamp merely answered: "Nobody's perfect."

Two works in this collection reveal particularly clearly the way John Miller views things. It was typical of him to call one of his recent exhibitions A Trail of Ambiguous Picture Postcards. One of them is of a city scene, a construction site, on a lovely day. Only on looking at it more closely does one discover in the distant background the Berlin Reichstag, wrapped by Christo in 1995. Formally speaking a postcard view, the postcard motif of Event Culture has receded into the background and the building site in the Markish sand has been introduced, on the one hand as an urban pastoral. On the other hand, the restructuring of the new-old capital has clearly been made into the actual event. Walter Benjamin once remarked on Charles Meryon's etchings of Paris before the metropolis was redesigned in the nineteenth century: "Meryon's Paris streets: canyons with clouds passing high above them." That this link to the capital of Modernism is not arbitrary is shown in the other work by Miller, featuring a Tokyo street scene. With its street canyon, visual axis, umbrellas, and street lamps, one cannot avoid reading this scene as a reference to Gustave Caillebotte's painting Rue de Paris, temps de pluie, from 1877. (Incidentally, it appears in Thomas Struth's photograph Art Institute of Chicago II, 1990.) Employing a different strategy, yet nonetheless sustaining comparison to Jeff Wall, Miller seems, in his wanderings through the brightness of noon in the global village, to be trying to revitalize the critical content of painting of modern life a century after it began.

Hubert Beck

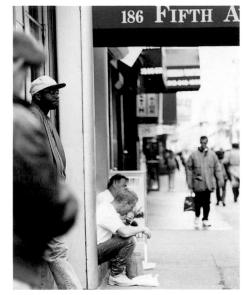

Tracey Moffatt

Following completion of her studies in Visual Communication at the Queensland College of Art, the Australian artist Tracey Moffatt worked as a filmmaker and photographer. Her short film, Night Cries, was shown as an official contribution to the Cannes Film Festival in 1990, as was her first full-length film, Bedevil, which was selected for the series Un Certain Regard (a certain look). Moffatt's photographic work also demonstrates her affinity to film. Taking a series of single shots, she always utilizes the serial principle or, in photo series, avails herself of the vocabulary of trash films of the seventies, or Hollywood melodramas of the fifties. Like many artists of her generation whose childhood was characterized to a great extent by omnipresent television, Moffatt brings these constantly available images into her works.

Setting out from her own experiences as an "outsider," being of half Aboriginal, half Irish descent, Tracey Moffatt chooses problems of cultural identity as a central theme, and not just in her first series. Subsequent works concentrate ever more on this topic. Scarred for Life (1994) describes traumatic scenes taken from the daily life of Australian children and young people during the sixties and seventies. Problems of sexual identity, feelings of being excluded and of inferiority are spotlighted in short narratives. Scarred for Life orients itself not only in its temporal context toward the childhood of the artist; some scenes have a direct autobiographical character. "During an argument her mother flung her birth certificate at her. That is how she discovered the real name of her father." Here, in a most direct manner, Moffatt depicts her childhood as an adopted daughter in a white household.

In the series Something More (1989), Moffat depicts the road ballad of a young woman in search of "something more," something not to be found in the narrowness of her provincial home. She ultimately meets her end in a ditch at the side of a road leading to the big city. The stations of this drama are embodied in a tableau of nine pictures. At the beginning, the young woman – depicted by Moffatt herself – stands before a miserable shack, her gaze half hopefully, half fearfully directed into the future. Behind her are the other persons who make up this life, one she can no longer endure: the slut and the violent drunkard, the Asian lover (dressed like a coolie), as well as two indistinct white youths. In the second picture, the latter two mock the young woman in Asian dress, referring to Moffatt's theme of social conflict between differing cultural identities. In the third picture we learn that the lover is also unable to hold back the young woman. He grasps her tightly, but she brushes him aside, seated on a box which announces her imminent departure. The next (black-and-white) photo depicts the dream of the young woman, symbolized by a lurex dress which she holds up before her body as the sign of a new life of wealth and glamour. In the tableau opposite – also in black-and-white – the nightmare: the young woman lies on the floor, her dress torn, blood at the neckline, and the hand of a woman with red nailpolished talons and a whip claws at her. Between the pictures of dream and nightmare Moffatt shows the violence in the real life of the young woman. A knife in the tabletop describes her day-to-day existence with the white couple in the cabin.

A hasty departure follows, but the highway offers no escape. The nightmare overtakes her. Once more she encounters violence, this time in the form of a "motorcycle bride" with whip and heavy boots, before which the young woman humbly throws herself into the dust of the road ditch. In the last picture, the ballad culminates in an actual murder. The young woman lies dead on the road. A sign beside her again shows hopelessness and her failure: Brisbane is still 300 miles away. "Violence, sex, and glamour. The photos must show it all." This is what Tracey Moffatt demands of her œuvre. Her staged photos, which were produced in a professional studio, fulfill this aim totally. There is no escape from violence: violence is everywhere, and sex as a dynamic is the stuff of her story. She shows glamour. The visible artificiality of the backgrounds and props lend the individual pictures the effect of glamour. Through the cancellation of the aesthetic of daily reality, Moffatt upraises her story into timelessness. It becomes a metaphor.

Martina Weinhart

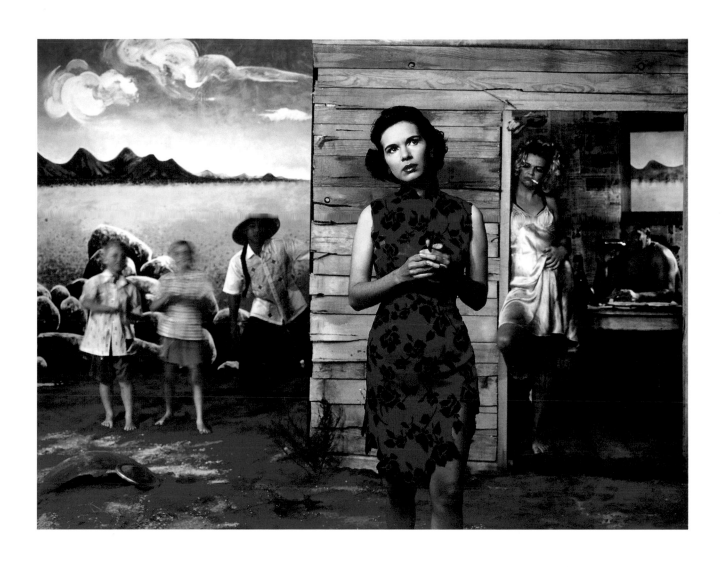

Andreas Müller-Pohle

Andreas Müller-Pohle has emerged as one of the most rigorously intellectual photographer-theorists of his generation. From the very beginning, as he demonstrated in his first monograph, Transformance (1983), Müller-Pohle was exploring visual ideas in a systematic fashion. With his close attention to the operations of what Walter Chappell called "camera vision," and his capacity for interpretive print-making, he made clear from the outset his awareness of the photographic tradition. At the same time, by working against certain tendencies of common photographic practice, he positioned himself as one of his medium's active interrogators-from-within.

Transformance involved random camera movement combined with a slow shutter speed; Müller-Pohle returned to that approach for a more recent project, Perlasca Pictures (1992). From the start, one of his primary concerns appears to have been time as a phenomenon, and the application of chance operations inherent to photography as a means for exposing time itself. Our actual perceptual experience, visually speaking, is that "blooming, buzzing confusion" of which the pragmatist William James wrote; it remains always contingent, positioning whatever it receives in relation to what it last received and whatever next crosses the visual field. What any of us, including Müller-Pohle, actually sees are not sharply defined extracts but rather smears of time.

Hence Müller-Pohle's images from those two projects in fact do approximate what he sees – but not what he (or we) hold in memory. What we remember, at least consciously, comes to mind as isolated vignettes, stills from the continuous film of our optical input.

Within the history of photography, that particular photographic method of Müller-Pohle's has its roots in the theory and praxis of Peter Henry Emerson, Antonio Bragaglia, Wynn Bullock, Ralph Eugene Meatyard, Dieter Appelt, and others. Yet the consequent imagery looks like none of theirs, but is, "stylistically" speaking, distinctly his own. In this case, however, what appears as style – a sensuous, layered, seamless, montage-like segment that appears to reveal time folding over onto itself oneirically – manifests itself not as the end-goal of a search but as the by-product of a distinctive process, a methodological consequence.

For all its conceptual formality, this approach has proven itself flexible enough to embrace not only an extended, multi-faceted address to the matter of time but, in the photographer's series Perlasca Pictures, an inquiry into the issue of history. Generated to serve as components of a film – not "film stills," but integral elements of the visual discourse – about the anti-Nazi hero Giorgio Perlasca, one of the "rescuers" of the Holocaust, this sequence in full comprises 230 images.

They take as their function the evocation of perceptual and psychological experience at a historical moment of traumatic social disintegration, a passage of moral and ethical paradigm shift during which multitudes were uprooted and shunted around the globe, the physical structure of vast territories was transformed rapidly and often violently, and the very definition of what it meant to be human was in flux. In these images Müller-Pohle seeks and finds analogues for how the eye of the hunted might have scanned the social and intimate landscape, searching the surroundings for indications of danger and sanctuary, visual signposts guiding the beholder through that dreadful no-man's-land of history and back into the calmer stream of time.

Müller-Pohle recently combined extracts from Transformance and Perlasca Pictures and titled the result Synopsis, knowing that, in the last analysis, neither of its two subjects – time and history – can truly be synopsized, reduced to schematic outlines or essences. The attempt is doomed to failure. That, I think, is the photographer's point. Thus, these pictures, as a group, turn us back to their true subject – not what they are of, which is almost incidental, but what they are about: ourselves as perceiving consciousnesses enmeshed in history and afloat in time.

A. D. Coleman

Isabel Muñoz

What is apparently the "subject matter" of photographs frequently amounts to allurements offered to us by their authors. This is noticeably true of Isabel Muñoz's work. It looks like a succession of studies in various types of dance (Tango, Flamenco, classical ballets, oriental, Cuban, Cambodian, or African) or sports (bullfights and Turkish wrestling). The theme underlying all these ostensible "subjects" in the work of the young photographer from Madrid is the body: its sensuality, its placing in space, and its physical identity. In order to develop an original way of investigating the body, she has established a sophisticated code in which she works out each element precisely, from taking the picture to the way she crops the prints to be shown.

Her compositions alternate between extremely fragmented bodies – and bodies encountering each other – to wide-angle shots of the same bodies in space and in landscapes. Space in these photographs is always (even in the case of studio shots) connoted: places which have memories or seem to have. Architecture is noticeably present as the repository of history. In recent work, in which she revisits the architecture of Baroque Rome, this has allowed her to do the same thing she does with bodily structure, emphasizing the sensuality of the stone itself and sexual allusions in many aspects of sculpture.

Platinum prints are the end result of this work in reading bodies and where they belong in space. Costly and difficult to produce, the prints intended for exhibition are realized in large formats, which she prefers (the platinum prints are made as contact prints and in some cases it is necessary to use 120 x 80 cm negatives). Exhibition is the artist's ultimate goal after so much hard work, but this form is also ideal for books and press publication.

In Isabel Muñoz's work, platinum prints are anything but sumptuously anecdotal. Only this technique can reconstitute the physical properties of the materials she is investigating and express the fascination with the texture of skin or of fabrics which she is able achieve through melting it into the grain of the film to congeal into the softness of platinum salts. Her prints, and this is her clearly stated goal, literally make one want to touch the picture physically.

Violent eroticism underlies the seductive appearance of images in which classical form is deliberately cultivated. Always palpable, the erotic quality of this work is gradually thrust upon the spectator as if it were the main subject under discussion. One has the feeling that the artist takes undisguised pleasure in demonstrating that social taboos with regard to desire are always being channeled or covered up. All one need do to realize to what extent this œuvre goes in demonstrating that what is "beautiful" is utterly disturbing, beyond the norm, in fact subversive, is to look at the violence shown by the reactions of aficionados in her work on bullfights. These pictures stringently emphasize how the costume matadors wear reveals their bodies in every detail. In her most recent work (Madrid "drag queens" who are posed in the nude and shot in color), she has abandoned all pretense. When these pictures are exhibited, they will most certainly provoke a vehement response. This is obviously the artist's aim.

Christian Caujolle

7/25

Floris M. Neusüss

Tanz, 1965 250 x 255 cm

Floris M. Neusüss is regarded as one of Germany's leading exponents of the photogram. He began in the 1960s with surreal photomontages. During that period he also developed the nudogram, life-sized silhouettes of nudes, later also of people wearing clothes. Moreover, he made a name for himself as a theoretician, not simply as a photographer, by investigating the history of photography without cameras. At the same time Floris M. Neusüss conducted the class for experimental photography at the art academy in Kassel. In Kassel he also founded the Hochschule gallery and both the "Fotoforum Kassel" collection and publication. The fraught relationship of photography to art plays a major role in his own work, exhibitions and theoretical writings. His exhibitions in 1982 and 1985, Photo Recycling Photo and Fotografie, Geduld und Langeweile (photography, patience, and boredom), dealing with environmental pollution caused by photographs, among other things, caused a furore. Tanz (dance), a work executed in 1965, is an early example of his life-sized photograms. As early as 1963, they had opened the doors of the "photokina" convention to him. There he created an entire room installation with nudes in a dark environment. Tanz is his first work in this technique involving many figures. The models lie down on the photographic paper and after it has been exposed, they leave a negative print of themselves. The working principle derives from the early days of photography – Talbot himself had presented photograms in his work The Pencil of Nature – and artists have taken it up again and again at intervals during the course of photographic history. When Floris M. Neusüss was doing his first work in this technique, he was familiar with similar work by László Moholy-Nagy, who had made portraits of himself and his wife Lucia. Robert Rauschenberg was making life-sized "blueprints" of the human body in the 1950s and Yves Klein was doing his clothed studies of people at about the same time, anticipating Neusüss' 1980s portrait studies.

Reinhold Mißelbeck

Walter Niedermayr

The theme of mountains and Alps has an astonishing presence in contemporary art, whereby the photographic medium has played a major role since the eighties.[1] The complexity of this theme can be recognized not only in the divergent artistic attitudes and standpoints, but also in the special procedures and methods.

The South Tyrolean artist Walter Niedermayr has been working on his Dolomites project, Die bleichen Berge (the pale mountains), since 1989. The main title refers to a South Tyrolean legend that tells of the origins of the characteristic color of the Dolomites (i.e., their pale, wan appearance), while the titles of the different tableaux refer to geographic designations in this region. At the same time, it is a thematic reference to the tourism-related industrialization of the Alps with all the disastrous ecological consequences. Thus, in the summer of 1995, a closing of the Dolomites Alpine Road was given serious consideration for the first time. The artist, however, is not primarily interested in an immediate ecological-political critique but rather in a subtle work of perception in the face of the current developments and state of affairs in this region.

The project is intended as an ongoing work and is realized in the form of sequences and tableaux, with which Niedermayr is able to make a more differentiated pictorial statement than he could by using single photos. Here, several levels of image and reality can be filtered out: the relationship between image and "reported" reality, the pictorial reality of the individual photographs, the relationship of the pictures to one another in sequences, as well as the interconnection of these sequences to yield photographic tableaux. Mostly, a panoramic view is constructed, a view in which nevertheless, on closer examination, one sees that the joins between the pictures have been shifted, the boundaries offset, and the perspective (in part) imperceptibly displaced. The pictorial "injuries" thus inflicted upon the panoramic view correspond to the injuries inflicted upon the alpine landscape itself: the impacts and modifications resulting from technological intrusions and unscrupulous exploitation, which the large-format prints invite us to study in detail. Michel Guerrin rightly remarked that one perceives Die bleichen Berge "like a magic show, both gentle and frightening."[2] For the artist, it is not just a matter of conveying a truth external to the picture but of intensifying the act of seeing.

In addition, the specific color aesthetic corresponds to the aforementioned compositional principles in that it puts our typical perception of the alpine region into a new light. The pictures do not convey a past, dishonest beauty, nor do they invite consideration as beautiful. Instead they attempt to portray the disappearance of beauty in this once unspoiled natural world. Walter Niedermayr's Dolomites project also makes our own perception apparent as well as the necessity of reflecting on his subtlety and degree of differentiation. The project chooses as its major theme, however, the question of the visibility of this alpine reality.

In Die bleichen Berge it is thus always a matter of views, of vision, and the relationship between views which become recognizable as intrinsic qualities in the act of perception. If we describe photographs as a form of the materialization of vision, we may recognize in the Dolomites project Niedermayr's (autobiographical) experience in seeing, extending over decades, embedded in the field of conflict between mythical permanence and radical transformation. Hence, the "pale mountains" may also be seen as a visual form of grieving for the disappearance of vistas.

Carl Aigner

1 Cf. Die Schwerkraft der Berge 1774 – 1997, trans alpin 1, Aargauer Kunsthaus, Kunsthalle Krems (Frankfurt a.M.: Stroemfeld/Roter Stern, 1997); Alpenblick. Die zeitgenössische Kunst und das Alpine, trans alpin 2, Kunsthalle Wien (Frankfurt a.M.: Stroemfeld/Roter Stern, 1997).
2 Michel Guerrin, "Walter Niedermayr. Entre tradition et disparition," Eikon – Internationale Zeitschrift für Photographie & Medienkunst, no. 16/17 (1996), p. 12.

Detlef Orlopp

In the past few months the discussion on "non-places," those anonymous topographies of modern architecture encountered at airports, industrial premises, highway rest stops, railway stations, leisure parks, banks, and other buildings has definitely assumed more importance. Just as the "inhospitable cities" (Alexander Mitscherlich) were deplored in the 1960s, the devastation and fragmentation of the natural landscape by industrial and commercial developments, as well as expansion of traffic networks, is condemned today. The American photographer Lewis Baltz was the first to realize that approaching the issue of landscape photography in an idealistically romantic way was no longer feasible, so he replaced the term "landscape" with "territory." Using this term shifted the political and social context of the (landscape) area to the center of discussion. Consequently, the photographer modified his position as a creative interpreter in favor of a detached documentary approach.

Detlef Orlopp has developed his own stance on this issue. Working systematically and with impressive consistency, he has concentrated for more than three decades on representing unspoiled natural landscape. Seemingly "archaic" landscape, revealing no obvious impacts of civilization, yet recording the processes of geological development, is his usual subject matter.

Since 1965 a teacher of design at the Niederrhein polytechnic, Orlopp was a pupil of the internationally influential educationalist Otto Steinert at the state school for art and design in Saarbrücken and the Folkwangschule for design in Essen. The founder of the "subjective school of photography," an influential movement in postwar German photography, Steinert aimed to link up with Bauhaus traditions. His studies under Steinert were formative for Orlopp's aesthetic. Like his teacher, who enticed magical visual qualities from the industrial landscapes of the Ruhr, Orlopp approaches his subject matter with analytical detachment. In his work he draws on craftsmanship of the highest standard to reproduce what is visible. His basic formal means, also definitive for

Steinert's teachings, are consummate technical skill both in taking pictures and processing them In the darkroom. His conception of composition is based on knowing exactly how to frame and compose his subject matter in the viewfinder to the best advantage and how to observe and deal with natural lighting.

Three views of mountain formations which are geologically dated with utter precision illustrate how the artist has transformed the barren mountain landscape into a system of abstract ciphers. All details reproduced are weighted equally. Further, the square format prescribes the direction in which they must be read. Orlopp has succeeded in lending plasticity to his motifs although they have been reduced to two dimensions. He is not interested in interpreting the natural landscape in the Romantic manner, a tradition which exacted of the spectator a sort of empathetic identification and attempted to conjure up the unity of humanity and nature. On the contrary, what he is after is a process of abstraction in which representing the geological formations suggests something of the eons of developmental processes they have undergone. Whether the photos are close-ups or panoramic, nature and natural matter are always translated into stringent abstraction or linear patterns. Formally speaking, Orlopp's photographs are close to Concrete Art so that in a figurative sense it is certainly possible to speak of "Concrete Photography" (Peter Weiermair).

Orlopp has captured the unspectacular and undramatic natural formations and landscape in a matter-of-fact way, eschewing narrative elements. His method of objectively purist representation negates the subjectivism of an emphatically individual signature. Instead, he records natural phenomena with almost scientific impartiality. In this sense his compositions symbolize a spatial and temporal tinge with a meditative aura that renders the essence of nature intelligible. Or to use Orlopp's own words: "With every photograph I take, I give the earth back to the earth."

Ulrich Pohlmann

Gabriel Orozco

Gabriel Orozco is a semiotician of photography. He depicts objects and situations which everyone can see well, but not necessarily recognize. He uses the camera as a card index for his recording, definition, and apparently random arrangement of leftover materials from a fragmentarily perceived environment. In this nomadic artist's field of vision, a newly arranged "sculpture of daily life" appears as a pointed fragment in every photo. Through his photographic references he attests to paltry things a remarkable ability of intensifying the visual, artistic character. Orozco's photos fix the gaze for an unforgettable moment in time: the suddenly awakened interest for things always present but mostly disregarded subsides immediately afterwards, but the sight of them has had its effect, namely to demonstrate just how many optical uncertainties there are in the world. In that Orozco's pictures and arrangements categorically refuse to accommodate the eye with "made" art, they open up the possibility of seeing everything which is not art impartially. And behold: just there, where simple things suddenly appear different, seeing and experiencing complement each other involuntarily. Nature culminates in the middle of the forest as Green Ball, mimetically located between two fork-shaped trees which have grown together. On wobbly legs set before five cheap plastic chairs, the Comedor en Tepozilan (lunchtable in Tepozilan) testifies to the once again biblical dignity of simple fare. Even amid all desolation and ordinariness, subjects designated by convention as trivial radiate a little sublimity.

The simplest of things acquire sense and significance during the border crossings of the eternal migrant. He is the Mexican brother of the German Hans im Glück (lucky devil). Every belonging has an exchange value, all the more so when placed in an object-related or photographic staging, isolated from entirety, cut off from extraneous factors. A lump of clay, for instance, clasped by two hands, the fingertips and base of the palms touching so that when they open again the form of a heart is seen: Mis manos son mi corazón (my hands are my heart: Cibachrome, 1992). Another custom is enough to invoke a changed appearance. Whatever was in the way or thoughtlessly shoved aside makes possible another quality of perception, all the more by virtue of this "delocalization" and concomitant new categorization. Home Run, shown in connection with an exhibition at The Museum of Modern Art in New York, had to be long sought as an exhibit before one discovered it on the other side of the street: oranges, outside the museum, in the windows of the apartment opposite. The oranges on tables that were hammered together from the rough boards of an abandoned Brazilian street market (one piece of fruit per table) only become recognizable through photography as the "sculptural highlighting" of an everyday impression.

Perspective changes value. A table, viewed from underneath, is lent the dimensions of a pantheon: Orozco also utilizes photography to relieve depression – that which forces to the ground. In showing how the last things volatilize, the Mexican artist draws attention to them. His exhibitions suggest absences. As a wanderer along the border of poverty, he poeticizes between exploitation and destruction the remains of poor people's fortune.

It is impossible to ignore oneself and one's own conceptualizing when there is nothing more to see on each of the four walls of the gallery – as in the artist's New York debut in 1994 – than a yogurt lid with a blue border. Something has been lost. And because nothing is present, Orozco's art denies making a judgment. From out of this desperation, his artwork creates its own meaning – and assurance.

Günter Engelhard

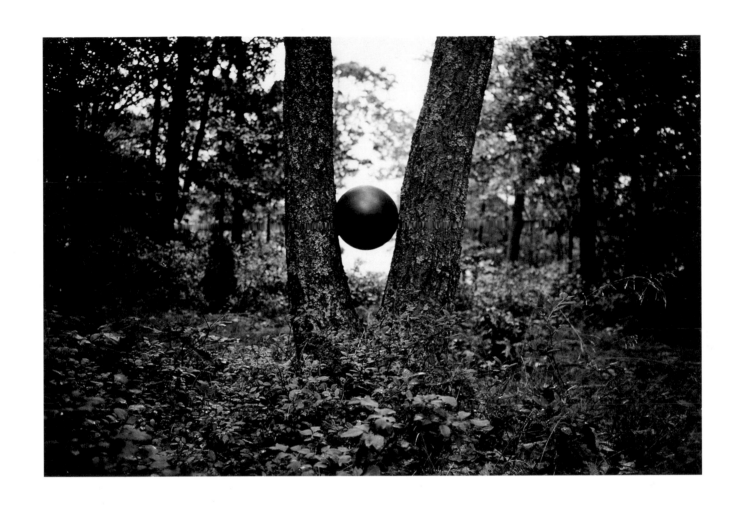

Fragility, Wounds, 1996/97 each 60 x 40 cm

Fragility, Sex, 1996/97 each 60 x 40 cm

Intensive representation of their own horizon of experiences verging on the documentary is characteristic of the overall œuvre of Anne and Patrick Poirier. Beyond the copying of once elaborate architectural and sculptural forms, their aim is the reconstruction of a cultural memory now lost to the public consciousness and of the myths disappearing with it. In many of their exhibitions since the seventies they vividly documented the ethno-archaeological field that they created with multimedia tools–models, herbaria, collections of rocks, collages, maps, poetical reflections. Among the places that they reconstruct in fragments and sections are vanished cities such as Ostia Antica or Nero's Domus Aurea. Rome as a city did not just awaken their fascination with decaying statues. What particularly charmed them about the "historic city" was the glorious lack of respect for history. There they discovered history not frozen or destined for a museum but "present everywhere, piled up in anarchical layers with a complete disregard for chronology."[1]

Associative techniques play a very broad role in the work of the Poiriers. When Harald Szeemann wrote his text Museum der Obsessionen (museum of the obsessions) as a reaction to the art of the seventies, it was his intention to establish the museum as a place for the conservation of ephemeral and fragile processes. In this clever text, "fragile" and "fragility" are central terms of epistemological theory which should find their place in art. The twelve-part photo series Fragility by Anne and Patrick Poirier shows already wilting flower petals, each photographed individually, from the flower of a white lily (Lilium candidum). These petals have a whitish, transparent structure. They are patterned with parallel veins. In botany the beauty of such growth forms is described as ovoid/lanceolate. They have been described as being like loose leaves or the enchanted pages of a book with a waxy texture. The pen, however, was dipped in bright red ink. The points at which writing is found were marked beforehand with punctures and scratches. The petals have taken up the blood-like liquid as if by intravenous injection. Sometimes they provide a background for just a single word, sometimes for longer chains of words. A few individual letters, words, or word fragments have already been obliterated or have disintegrated, particularly in the longest messages, which are illegible or were never completed. We can decipher the following: Sex – Fragility – Wounds – Membre – Hunger – Intentiones – Occultae – Ruins – Exile – Intuitio – Tears – Black Ash. Loosely associated with the petals one sees the stamens dusted with red pollen, like a "natural tool." The flower of each lily has six petals, so two lilies were used to write on. The reading of texts applied to petals follows an illogicality, a desire for chaos, the incompatible fragments of a dream, the dialectic of fragment and completion, a procedure that is found early on in the Poiriers' travel reports.[2]

Artists such as the Poiriers observe with care the cycle of time innate within the bodies of humans, buildings, statues, and plants, and their existence. Processes such as remembering and forgetting are always also existent in the physical/material and psychoanalytical senses and are therefore threatened by decline and decay. It remains for computers, whose capacity is now considered limitless, to store the values of cultural memory projected in algorithms. Anne and Patrick Poirier, however, have from the very start processed their obsession that the cultural processes of remembering and forgetting also exist beyond technology–in the body itself.

Gislind Nabakowski

1 Anne and Patrick Poirier–Die Zeit ohne Tyrannei, **Galerie der Stadt Esslingen, Villa Merkel (1987), pp. 9 – 10.**
2 **In their books** Les Réalités Incompatibles. Notes et Croquis de Voyage **(Sélinute, August 1974; Copenhagen: H. M. Forlag, 1975); and** Les Paysages Révolus **(Paris: Edition Galerie Sonnabend, 1974).**

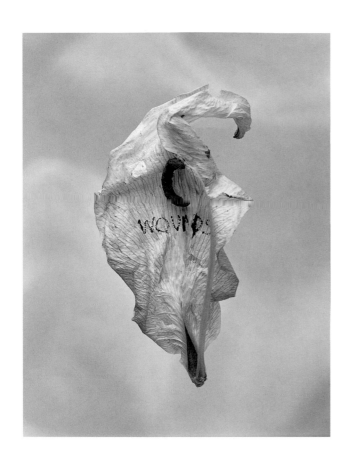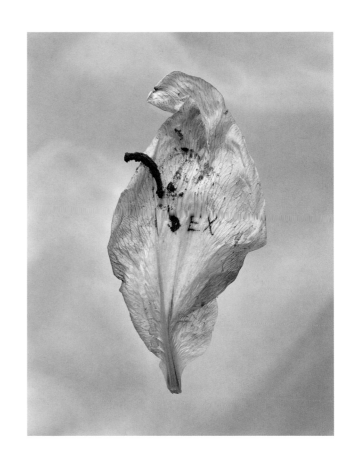

Sigmar Polke

Wiederbelebungsversuch an Bambusstangen, 1968 60 x 50 cm

In his famous installation Vitrinenstück (showcase piece: 1966), Sigmar Polke gathered together a series of objects that at first glance appeared to be completely harmless: saucers, a handful of peas, matches without tips, the shreds of his own image. Only the accompanying typescript indicated that these were all pieces of evidence; relics of obscure occurrences which evidently haunted the artist for days on end. "Once," it says in his notes, "I took two saucers in my hand and waited. Then I held them to my ears. Then I could hear how the saucers spoke to me. That's when I realized that saucers were not merely pieces of tableware." This commentary – a protocol whose aim is exactness and yet is full of irony – brought for the first time that "higher entity" into play, about which much would be heard in times to come; it was the prelude to Polke's ongoing occupation with magic. It would extend to his present works, which come to terms with alchemy, the kind of "dreamed knowledge" (Mircea Eliade) which is based on the assumption of a thoroughly animistic form of nature, be it organic or inorganic.

In retrospect, this idea may already have been of relevance for the staging of the 1968 Wiederbelebungsversuch an Bambusstangen (reanimation attempts on bamboo stalks). The artist filled a plastic bowl with water, placed a few bamboo stalks inside and exposed them to the bright light of his attic window. Magic practices and quasi-scientific experimental directives began to interact with one other. The photos of the undertaking in such a manner fulfill two purposes. On the one hand they certify that the action actually took place; under this aspect they seem consciously unpretentious, almost dilettantish. Nothing is to be palliated, nothing corrected; that which is represented must speak entirely for itself. On the other hand, magical wishing comes to the fore to the same extent, as suggested by the title, especially through the repetition of the motif. Viewing them, the shadows of living leaves link up with the shadows of the bamboo stalks on the back wall. We become witness to a process of reanimation whose outcome remains uncertain. Polke chose his apartment on Düsseldorf's Kirchenfeldstrasse at the time as the scene of post-Dadaist minimalist actions whose results he documented photographically: a pair of scissors that seems to hover over a water glass, two globe-shaped lamps

over which a cucumber is spanned like a bridge, a coffee pot from which a material, mysterious plasma, is pouring – spatial views which bear an uncanny resemblance to "ghost photographs" of the nineteenth century. The intended dilettantism of the photographic – be it over-, under-, or double-exposure, fuzziness, or shaky camera movements – confers a high degree of credibility to the scenarios: that is the way it really happened. Through the constant alternation between the occult and sheer nonsense, however, the photos expose themselves as the emanation of some lavish jest of a higher order.

The supernatural was omnipresent for Polke in the year 1968, whether in the form of "relationship madness" (Die Weide, die nur meinetwegen hohl gewachsen ist [the pasture which has only grown hollow for my sake]), or as "psycho-sculpture" in the form of his Decke, in die sich immer wieder die Konturen einer weiblichen Figur falten (a blanket in which the contours of a female figure repeatedly appear); whether in communication with deceased artists, as in Telepathische Sitzungen I & II (telepathic sittings I & II), or in Kartoffelhaus (potato house), a lattice construction with impaled potatoes on all sides, the function of which rests on the speculation that the growth forces of this member of the nightshade plant family could transfer themselves in some mysterious manner to the person entering the construction. In addition, the film Der ganze Körper fühlt sich leicht und möchte fliegen (the entire body feels light and would like to fly), which Polke realized in collaboration with Chris Kohlhöfer, reveals itself as a chain of actions as banal as they are obscure. In the photograph of the pendulum, which assumes an important role in the film, the supernatural makes itself apparent as shadowy self-duplication of the object: a projection that is more than a little reminiscent of the "phenomenal" duplication of Duchamp's Bottlerack (Bottle Dryer) in a corresponding photo of his so-called Box in a Valise (1941).

Behind the Wiederbelebungsversuch an Bambusstangen is the general question of what the artist in fact is capable of and in which manner he is able to exert influence upon a given reality: a question which, at the close of the sixties, set an entire generation in uproar.

Martin Hentschel

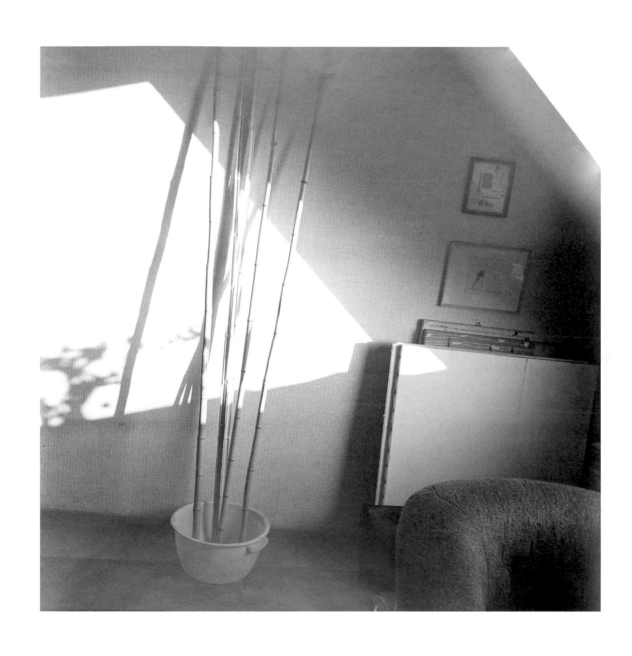

Richard Prince

Untitled, 1982 – 1984 50 x 61 cm

Untitled, 1982 – 1984 61 x 50 cm
Untitled, 1982 – 1984 61 x 50 cm

While Sherrie Levine and Louise Lawler have moved into the pictorial cosmos of high culture with their photographic reproductions of famous paintings, thus questioning the assumptions of the art scene, Richard Prince in his "rephotography" has opted for the banal aspect of mass popular culture. He tracks it down in the ubiquitous illustrated press. In 1977 Prince "stole" four advertisements from The New York Times Sunday Magazine by reproducing them and enlarging details. In his Untitled series, he fell back on consumer goods such as perfume bottles, sunglasses, watches, fountain pens, and lighters, which had been disseminated and made popular by the media. He represented the way they had originally appeared in the advertisements by repeating them and grouping them in art-director fashion. Among the eight stylistic devices used in rephotography to make what Prince calls an "eight-track photograph" were, as he put it, "the copy which is faithful to the original, rephotographed, turned, cut, focussed, blurred, black-and-white and colored." Prince was interested in pictures which might be read by the public at large as an inducement to consumption, yet were suitable for representing the American way of life. The setting of these photographs is drawn from advertising, which means that the object has been dissociated from its intended use and put into a setting which reveals it purely and simply as a fetish. In Prince's work, the appeal of beautiful, beguiling presentations of goods for the market is reproduced; conversely, the aesthetics of consumer goods are exposed as making a fetish of them. Thus playing with the delusive character of that synthetic, artificial world, which is present in the consciousness of many people as reality, works in the series called Untitled achieve something like the "'hyperreality,' of something real without an origin or reality" (Abigail Solomon-Godeau).

Richard Prince plays with the paradoxical truth-content of fiction, thus rendering visible what may be as close to many Americans as reality. His assemblage of pictures entitled Spiritual America unites, in addition to motifs from consumer goods advertising, figures which constitute the mythology of American daily life, such as his Motorcycle Girlfriends, Models, Cars, Cowboys, and Celebrities and Criminals. It also includes various representations which Prince has reproduced from elegant lifestyle advertising. These are views of male and female models. In Three Women Looking in the Same Direction or Untitled (both 1980), specific codes and the normative behavioral conventions of advertising photography are revealed, which at the same time refer to the collective consciousness.

Between 1982 and 1984, Prince produced a series of fragmentary representations of hands and faces, among them the photographs in the Untitled series (e.g., Woman, Soda, Straw). These pictures do not deny their origin as reproductions from printed advertising, as the clearly visible halftone dots show. The individual personality of the model, whose eyes are hidden behind sunglasses, has been obliterated. Physiognomy has been transmuted into the smooth superficiality of detached aloofness.

Of course elevating the images of "cheap" taste, represented by what emerges from the standard anonymity of advertising photography to the status of art is provocative, for connoisseurs of "photography as fine art." According to Douglas Crimp, consumer goods, as Prince represents them, have again assumed an "aura": "Only now this is no longer a function of presence but of absence, dissociated from an origin, from an originator, from authenticity. Nowadays aura has become mere presence, that is, a specter."

For all that, Richard Prince's pictures reject unequivocal interpretation. Regarded by Postmodernist theoreticians as representing an art form which is innovative, anti-museum, and critical of institutions, they are read by other critics as concealed self-portraits in the sense of personal mythologies. One can view Prince's work as an appreciation of the consumer quality of art in late capitalism and also as a deconstruction of macho ideals. Yet Prince's work is not simply critical deconstruction of consumer aesthetics nor illustrations of Baudrillard's theories of aesthetic simulation. Prince is primarily interested in the factual presence of the objects: "I'm interested in what we produce and what we consume. What we own and what we think we control…. My work is not about illustration, allegory, irony. I'm interested in what some of these images imagine…. I'm interested in wishful thinking."

Ulrich Pohlmann

Bernhard Prinz

Bernhard Prinz is one of the rare artists to have consistently set sculpture and photography in an allegorical framework. He concentrates on full-length portraits and still life, genres looking back on a long tradition. In photography it goes back to the allegorical work of Camille Silvy, Adolphe Braun, and August Kotzsch, when the medium was a new art.

Since the seventeenth century, still life has been regarded in Germany as occupying the lowest rank in the hierarchy of genres. This surprisingly deprecatory attitude to the still life rests on a distinction between the representation of bodies quickened by the divine and the reproduction of "inanimate nature." Yet, as the theological interpretation would have it, the objects depicted in still lifes have always had, in addition to their function, diverse layers of religious signification, emblematically and allegorically referential within the framework of Christian belief, morality, and eschatology.

What metaphysical meaning might Bernhard Prinz's still-life cycle Sieben Gefässe (seven vessels) harbor? Prinz is a master of illusion and deception. He makes harmonious and beautiful pictures by using devices familiar from advertising photography, which seeks to seduce and mislead the observer: emphasis on the material and superficial, and perfect staging of seductive elegance. Commercial still-life photography presents the consumer value and the lovely exterior of things to enhance their attractiveness to buyers. Prinz, however, takes this smooth staginess with a pinch of salt. In List, a carafe reposes on draped material exuding expensive luxury. The perception of clarity and purity of form are distracted by the asymmetry accorded the horizontal. Formally speaking, Alba, Memento, Fata, and Gotha recall decorative mortuary sculpture. Läuterung (purification) is the representation of a jug full of holes without the slightest consumer value which would involve potential users, Sisyphus-like, in endless repetition. Does this mean that purification is equivalent to the knowledge that human endeavor is in vain? The number seven, which constantly recurs in Prinz's work, is symbolically loaded. It is regarded as a sacred universal number. In the iconography of Christianity, Judaism, and Buddhism it symbolizes perfect creation, cosmic order, and wisdom. Yet this number is not only significant in mythology and fairy-tales. Product designers and managers also rely on its magic, as trade names like Seven-up, Boeing 747, and 4711 show.

It has been remarked elsewhere that Bernhard Prinz's still life arrangements awaken associations of department store window displays. In department stores, however, every object is a sample representative of a non-quantifiable set of wares that can be bought. Prinz's still lifes, on the other hand, function as intellectual representations in which art historical tradition – especially Baroque, (National) Socialist Realism, and 1930s Agitprop – as well as contemporary philosophy and ethics – are reflected. Superficially, the still lifes may indeed look like advertising photos. At the same time they are the translation of aesthetic theories about art into something resembling a stage set. The construct of artificiality and the staging of appearances are rendered visible and not concealed, as they are in advertising. The allegory proves brittle, hardly viable as a vehicle for meaning or explanation.

In these pictures the reception of pathos and the sublime is refracted through richly allusive irony and wit, achieved in the heterogeneous juxtaposition of the trivial and the valuable. Titles and captions do not explain the content of the pictures. On the contrary, text and picture content are fraught with tensions which, however, open up scope for association. The pictures remain enigmatic; they do not lend themselves to unambiguous interpretation. Comprehending Bernhard Prinz's theater of illusions as hermetic or even the distillation of allusive theory would mean misunderstanding it. Playing on recipients' expectations, it makes his work visually enigmatic. It deals with the expressive power of the photographic image.

Ulrich Pohlmann

Gewitter, 1993 54 x 58 cm

Countless reworked photos document Arnulf Rainer's artistic confrontation with his own body's poses and gestures. At the end of the sixties he began to make grimaces in front of the camera as a consequence of his "over-painting" series on famous Austrians. These forced, extreme facial contortions, which initially were recorded in an automatic photo booth at Vienna's Westbahnhof, developed against the background of his intensive preoccupation with the extraordinary manifestations of psychotic body language. The Face Farces were followed in the early seventies by the so-called Body Poses, taken in the studio.

"With these shows," the artist reported in 1973, "I am in a state of tension, of nervous excitement. Later, the stiff photos disappoint me ... I feel the urge to paint onto the pictures the dynamic force and tension that filled me while I was taking the photo." As a memento of his direct, psycho-physical experience he afterwards draws and paints over sundry photos in his exploratory "search for the many possible and impossible people who hide in all of us."

The reworkings accentuate the particular poses and sometimes seem like a kind of graphic analysis of his atypical, untranslatable expressions. Other graphic interventions comment on his own appearance in a playful way and give him a fictitious sense of building an associative bridge to the title. Although the continued processing leaves parts of the underlying photo visible, the interplay between the layers of reworking and what has been reworked is dominant, permitting the appearance of a reflective component in what has been created.

From the outset Rainer uses the possibility of reproducing photographs so that he can rework a motif in several versions and in very different ways. And, like the medium of photography, printed graphic techniques are suitable for the creative principles of extension – always in series – and the processional compression of his œuvre. An indirect merging of photography and gravure printing, among other things, allows the use of a zinc block, which transports the photo as a printing plate and moreover can be processed in a linear manner by scratching it with a needle, like drypoint work. This technique, which gives the reworked motif a different kind of print-graphic quality, uniform in its result, was first used by Rainer around the mid-seventies; he compiled selected works in the portfolios Darbringbietung (offering) and Schreckversteck (hidden horror), published in 1978. He is not, however, making any claim to definitive formulation with these. For one thing, the artist uses identical prints of a duplicated printed graphic work as the starting material to further draw and paint on directly. For another, he changes many of the conditions of the plate and thus gradually develops new prints for duplication. Both these aspects can be followed through the decades taking his usual engravings as an example.

The four printed graphic works from the collection published in 1993 are also the result of continuations of previous reworkings. Thus Gewitter (thunderstorm: 1979) was developed from Zentrum (center: 1975), a drypoint work on a zinc block from the portfolio Darbringbietung (1978). A cloud compressed almost to a flat surface made up of slightly undulating lines lies over beams radiating out from the center, which only cover the underlying photo motif there. Upright and frontal, with both arms bent and raised, the artist stands with a bare torso in a strained pose, exemplified by the elastic band stretched tight over his face.

Like the earlier stage of the drawing, which is attached to the surface by transparent blue plate clay, even the photographically recorded pose can only be isolated through the power of imagination or reconstructed by way of recollection and memory. Nevertheless, it can basically be acknowledged that these printed graphic works represent qualitatively new creations within an artistic œuvre whose development always includes the reflective utilization of existing material.

Jutta Schütt

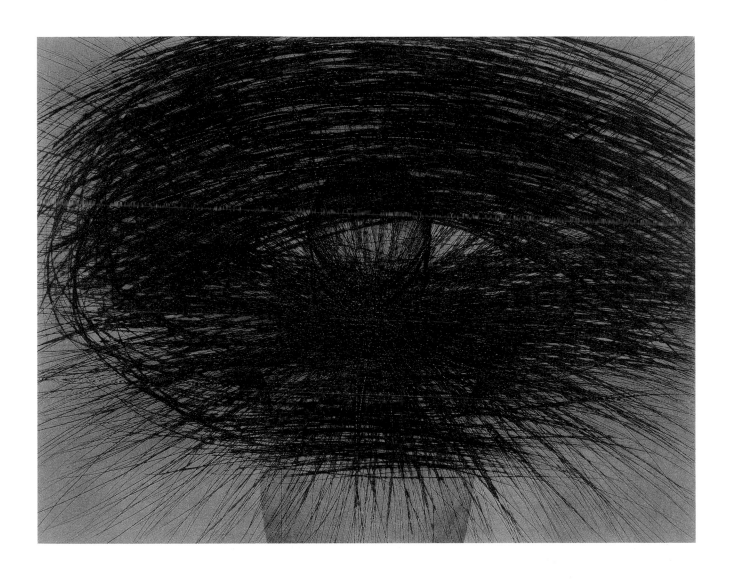

Inge Rambow

Wüstungen bei Knautheim, Sachsen, 1991 103 x 119 cm

"For the German Democratic Republic, the brown-coal indus-try was just about the only, and hence by far the most impor-tant source of energy.

Using open-cast mining, brown coal was extracted down to a depth of 200 meters. Especially in the sixties and seventies however, there was a particularly great lack of recultivation measures, which were repeatedly postponed.

The environmental problems caused by coal-mining under massive economic pressure in the former GDR are among the most difficult of those that must be solved in the 'new feder-al states.'

According to conservative estimates, an area of approxi-mately 380 square kilometers must be rehabilitated. Some 70,000 hectares of landscape have been greatly modified or utterly devastated; more than one half of this area, 38,500 hectares, remains as wasteland or dump sites.

An especially great problem is that of the some 400 dump sites in the remaining pits of exhausted open-cast mines which are not sealed off from the groundwater. In addition to household refuse, these pits were filled with highly toxic chemical wastes from factories, including those in the so-called 'Chemical Triangle.' Thus, residual brown-coal wastes also constitute residual chemical wastes and vice versa. A complete, environmentally sound disposal of these wastes is, according to expert opinion, neither financially nor techni-cally feasible.

Each year, the draining of open-cast mining areas necessitat-ed pumping 1.2 billion cubic meters of water from the Lausitz. Owing to this constant pumping, some 13 billion cu-bic meters of water are lacking from an area of 30,000 hectares. This is more than three times the amount of water stored in all German reservoirs. A sudden 'turning off' of this water regime to drain the remaining pits would result in the unsealed dumps coming into direct contact with the ground-water. Moreover, the groundwater supply for all of Berlin and Brandenburg would be endangered since this is obtained from the ultrafiltrate of the Spree River, which might then run dry.

The time needed to complete the rehabilitation works – as-suming success is at all possible – is estimated to be fifty years. The costs of these works, according to conservative estimates and at present monetary value, are expected to amount to at least 30 billion German marks."

Inge Rambow in her own words. She calls the group of photos that we are talking about Wüstungen (devastations).

The question is: how does she see these "devastations"? I would like to describe her approach as "touristic." By this, I mean a way of looking at things which includes the viewer, one which calls upon him to step inside the picture as it were, as if he himself were present amid these "devasta-tions"; as if he had made his way through these "dead" land-scapes, as if they were his own recollections. In this respect, the landscapes are composed like paintings. The viewpoint appears familiar to us. We associate what we have seen and experienced.

The breadth and the depth of focus of the large format pho-tos makes possible the identification of every single detail. This is important, because the scale of the landscapes is of-ten difficult to grasp. There are photos which seem like aerial shots, but a rusted pipe brings us back to earth again. Deep-cut canyons appear to recede to a vanishing point on the horizon, but the stones in the foreground soon correct our perception. A muddy landscape appears with inlets, hills, and streets like some resort area seen from afar – one devas-tated by a rain of ash.

The colors add a tinge of the pathetic to the "devastation" in the sense of natural occurrences. One is reminded of icy winds and volcanic landscapes in Iceland, or of the enchant-ing Lake Powell, at the edge of Arizona's Grand Canyon.

Inge Rambow plays with light and color, not to prettify the drama, but rather intentionally to make conscious the nature and extent of the dramaturgy.

Just as Ansel Adams once did, Inge Rambow, too, was com-pelled to wait for light. Without light, there are no colors, and above all, no shadows. Inge Rambow's photos are a testi-mony to her patience. Again the question: how does one go about photographing such "devastations"? The GDR govern-ment coined the term "devastation" for the sake of objectivi-ty but overlooked the French origin of the catastrophe of "devastations."

Inge Rambow had to find a standpoint and a viewpoint in order to lend form to the sheer immeasurable scale of these human impacts. She turns the aesthetic around in our stom-achs. The objection often heard, that such photos can be shot wherever open-cast mining is practiced, may have its justifi-cation; however, these "dead" landscapes are witness to de-cay, apocalyptic mood, abandonment, and desolation: the absence of humanity and labor lends the disaster a timeless quality.

Jean-Christophe Ammann

268

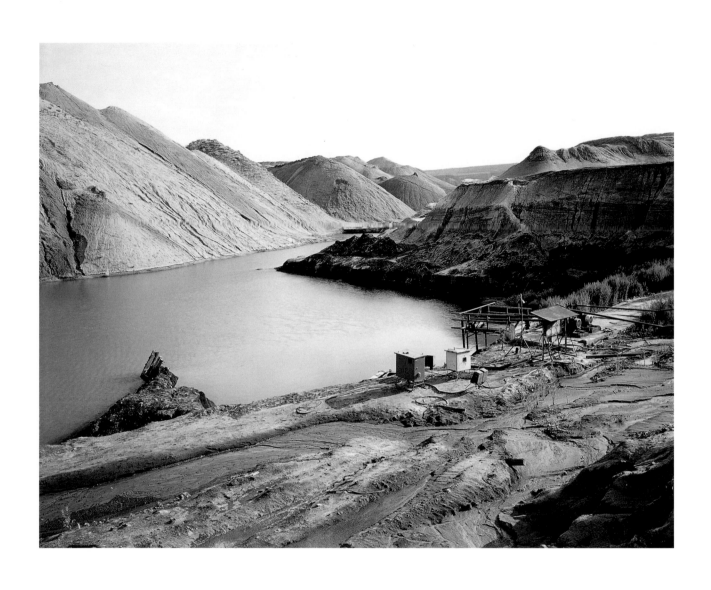

Robert Rauschenberg

Photem Series I (4), 1981 138.4 x 119.4 cm

In and Out City Limits, 1981 32 x 48 cm
In and Out City Limits, 1981 48 x 32 cm

Robert Rauschenberg's work is impulsive, full of energy, and powerfully rhythmic. Emerging from the fireworks of Abstract Expressionism, by the end of the 1950s Robert Rauschenberg was seeking close links with the everyday world in his work.

Since studying at Black Mountain College in North Carolina, he had been friends with the composer John Cage. The latter's idea, first realized about 1955, of deliberately removing the mathematical rigidity of tones in serial compositions by aleatoric means (that is, by adding tones "organized by chance" and according them equal treatment), began to fascinate Rauschenberg. This new "aesthetics of chance" could certainly be translatable to the visual arts. According to John Cage, music which had become "freer" was to help make art closer to life. And that was exactly what Rauschenberg was trying to do in his own work.

He overlaid the undiminished vehemence of his brushwork with unusual things: newspaper photographs, scraps of material, pages from comic books were glued onto them and in turn just as forcefully painted over. Surpassing that, he integrated electric doorbells, radios, signs, chairs, car tires, Coke bottles, stuffed animals, and garbage in his enormous pictures. He went from painting via Combine Painting to Junk Art. Even garbage had become art-worthy. And one should not make the mistake of misconstruing this as mere criticism of the consumer society. All Rauschenberg was trying to do in his art was to identify it with everyday things. He rescued art from Mt. Olympus and dragged it into the streets. He turned on New York visitors to exhibitions and future Pop artists by administering an initial stimulus.

Robert Rauschenberg's visual rage began to abate in the early 1970s. After achieving plasticity through the objects he had affixed to them, his pictures were now becoming flatter. Their vehemence and refreshing spontaneity, however, remained unchanged. By then Andy Warhol had discovered the silkscreen process, which at that time was still being used for purely industrial purposes, of projecting photos onto canvases in large formats. Rauschenberg took up this process in 1962. Then there were vastly blown-up reproductions of old paintings as well as photos of U.S. presidents, aircraft, and dollar bills in his pictures. They were joined by reproductions of astronauts and classical statues, stop signs, and bald eagles. "Controlled chance" had brought them all together. None of them retained their discrete representational value. Everything was fused into works of art, each of them highly personal, seemingly abstract poetry for all the apparently representational quality of individual elements.

It is no wonder that Robert Rauschenberg picked up a camera one day. Photography is, after all, a medium which takes its subject matter from exactly the same place where this artist had made fast his work, the everyday world. Ever since his first Combine paintings, Rauschenberg never stopped trying to paint a picture of his native New York. His photographs confirm this with great urgency and immediacy. Street signs and company plaques, flags, people, wires, cables, scaffolding, panels, materials, stone and concrete walls, windows, furniture, scrap, and garbage: all these things unite in his photographs to shape his own distinctive visual world, in which it looks as if a cyclone had whirled all these disparate things together. This is chance operating in the everyday life of this city. What is new is Rauschenberg's preference for representing windows. Like a picture within a picture, they add a spatial depth to his work. Here, too, however, the discrete constituents lose their identity for the sake of the photographic visual whole. Each of his photos is a composition of things and scenes which have been swept together by chance somewhere in this city. When he found them and composed them into a picture in the viewfinder of his camera, Robert Rauschenberg transformed them into poetry, just as he had done in his large panel paintings. New York, that vast assemblage, may well have found her most faithful interpreter in this artist, who is convinced that "a picture is more truthful if it has been made of pieces of the real world."

Peter-Cornell Richter

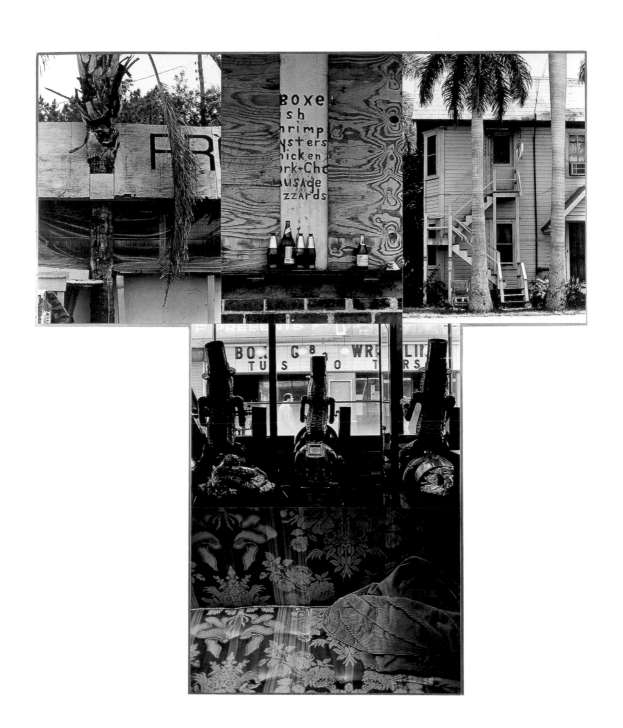

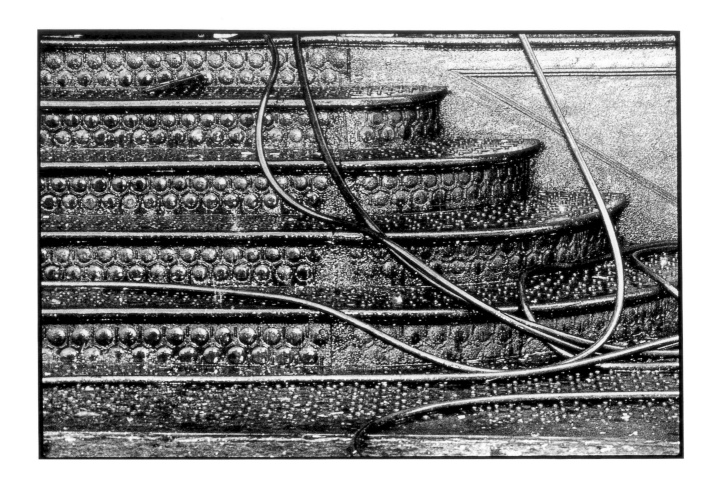

Bettina Rheims

Bettina Rheims is disturbing – for many reasons, not least because her work is widely acclaimed and undeniably successful on the commercial market, both in the press and in advertising. And this arouses envy – even more so because this young woman of good family has never had financial worries, so that she can throw herself whole-heartedly into projects which others would find vitriolic. One must say that, from whatever standpoint one may look at these pictures, she has no qualms about questioning taboos which have become increasingly established in Western society: androgyny, sexual identity, and exhibitionism, to name a few. Moreover, she calmly launches aesthetically smooth images at issues which have become controversial. With consummate technical skill which bears comparison with Robert Mapplethorpe or Helmut Newton, she has been able, it would seem, to read profoundly in their work to develop uncompromising projects.

Remarkably well versed in the history of the medium, she practices photography to confront us with flawless representations of anything which might seemingly infringe norms. Thus her androgynous beings gaze at us serenely, without doing anything more provocative than affirming and accepting what makes them different and doing so calmly. What is disturbing about this is that we are compelled to recognize their beauty, whatever the sex of the being looking at us or, for that matter, of the photographer. The feeling of uneasiness which overcomes those with fixed ideas is exacerbated by a series in color, the subject of a book for which she asked pretty young women she accosted in the street to pose for her in dingy hotel rooms in a provocative state of semi-nudity. Somewhere between the flattery of visual wallpaper and poses for the nastier sort of pornographic magazines, these pictures are disturbing in their voluntary ambiguity. They call norms into question just as they do things which are usually left unsaid, voyeurism as well as the unacceptable secrets of immediate desire. They ask questions about the relevance of the limits to kitsch or vulgarity. Vitriolic and polemical, this body of work by a woman on how women are seen constitutes a healthy dose of mocking provocation. The effect is certain but the reaction is delayed. The same is likely to hold for the work she is currently finishing, a renewal of Christian iconography from the perspective of the third millennium. Somewhat removed from the above direct questioning of social and sexual identity, an important ensemble dedicated to portraits of stuffed animals reveals technical mastery, formal classicism, an astonishingly apt touch with portraiture, and a gentleness which is perhaps even rather touchingly sad, at any rate moving and genuine. It is rather as if these straw-stuffed creatures deserved more than the bravado, suppressed anger, and demonstrations of brilliance which inform the other series dedicated to unusual human beings and intended to shatter "ordinary" human certainties. Bettina Rheims' approach to photography remains disturbing, and this is not the least of its merits.

Christian Caujolle

Olivier Richon

Olivier Richon uses his camera symbolically as a metaphorical demonstration of photography. He allows the camera to incorporate itself in scenes he has arranged and to format itself into characters. The four photos in the DG BANK Collection belong to the context of Et in Arcadia Ego, which comprises a total of seven photos. They are constructed ensembles of glossy cloth or heavy velvet which are, variously, deep red, salmon pink, blue, gray, or other dark colors. Single vegetables or fruits repose on the cloth. The scenes represented are almost entirely filled with the dramatically and intricately arranged folds and the smoothness of the cloths. On the wall, a caption in large letters gives the context. Olivier Richon feels that the still life has been treated as a low genre. In the history of genres, the still life has been subordinate to the self-portrait and, therefore, has been considered a subgenre of it. Self-portraiture, landscape painting, and mythological painting has enjoyed a higher status. Richon's artistic photography frees the still life from the stigma attached to it. Liberating it from being a representation of a vessel or table, he has heightened it to a large spatial situation. His arrangements are economical. To the glance, which is considered dominant and paramount in our culture, he has not merely added captions as an associative and anecdotal logo – "allegory of virtue," "Madeleine in ecstasy," "homo bulla," and "spiritual exercises." Through expansive, accumulative pictorial arrangements, he also appeals to taste and sensory perceptions related to it. The allusion is to the senses of touch and taste through the eye, and to the temporal extension needed for incorporating them. Madeleine's transcendence of the sensual, her ecstasy, is associated with a lemon which has been cut open. Before being enjoyed, the fruit of "spiritual exercises" must first be released from its spiny hard shell. Arranged like scales, the individual flower carpels of artichokes can only be enjoyed in small bites. Richon's photos speak with the pathos of contradiction. They oppose the aesthetic of lavish consumption with an ethic of dearth.

Talking with Parveen Adams, Olivier Richon commented on the role played by his texts: "But I would say the caption opens a whole, an emptiness … that would be like a series of metaphors … to increase meaning in all directions…. It seems to me that, when one has read the caption, one sees the picture in a different way."[1] Richon threads our glance into a discourse on art history. He breaks through and enlarges the scope of pictorial modalities by divesting them of their opulence. He decodes them, only to transpose them into the iconic system of photography as an extended frame of reference. The beholder's way of seeing things is thus divested of its authority, so that he or she is free to reflect on taste and oral pretensions. This is another dimension of sensory perception, and it is incorporated into the system of representation that is photography. As far as the sense of taste is concerned, the object would come into contact with one's hand, mouth, and palate instead of with the eye. The theme underlying these photos is, to put it briefly: "our oral relationship to the picture" and the way it widens our view of things, allowing it to find its own path between the picture, text, and sensory perception. Another theme is the difference in scope which allows for diverse systems of signs. Thus Olivier Richon emphasizes "the frozen quality" of photography as its basic characteristic; for "the photograph mends the disparate things into a representation."[2]

Gislind Nabakowski

1 "Upon an Account of Death Caused by Holding One's Breath – A Conversation with Parveen Adams," After D. L., Forum Stadtpark (Graz: Edition Camera Austria, 1995), p. 8.
2 Ibid., p. 11.

HOMO BULLA

Evelyn Richter

Kunstausstellung des VBK, Dresden, 1983 40 x 30 cm

The works of Evelyn Richter arose in the specific climate of political repression and intellectual narrowness of society in the former German Democratic Republic. In 1956 she founded the group "action fotografie" along with other artists in Leipzig, in order to offer a forum to artists whose works did not correspond to the stylistic and ideological dogmas of Socialist Realism. Evelyn Richter's photography, which she generally presents in the form of thematic series – visitors to an exhibition, people in the public transportation system, portraits of musicians and composers – is subjectively observant and narrative. The rather emotional relationship with reality found in her respective working method linked the group together, which was last able to exhibit publicly in 1958.

During a visit to the world festival in Moscow in 1957, Evelyn Richter took the first photos of her central cycle Ausstellungsbesucher (exhibition visitors), which to this day has not been completed. She began in the Moscow Tretjakov gallery, her aim being to use the camera to capture the sensitive reactions and elementary personality traits of visitors. In subsequent decades, predominantly in museums of the former GDR, she took photos portraying people in deep contemplation or showing alert awareness, bored disinterest, or disbelieving amazement. The peculiar nature of the political system resonates in many of these pictures, which were made in the sense of live "shots." They document the inner strife of the people, caught between emotional extremes and the accompanying psychological strains. On occasion, Evelyn Richter waits for hours, even days, for these psychological phenomena, which suddenly become apparent in the correspondence between artwork and viewer.

In 1997, she continued her ongoing, long-term study in Roman museums with the help of a stipendium from the Villa Massimo, in order to characterize there, too, exhibition visitors in unstaged and unmanipulated photographs.

August Sander, Henri Cartier-Bresson, and Dorothea Lange are important points of reference for Evelyn Richter's artistic orientation. A comparison with the work of Richard Avedon and Chargesheimer is also appropriate, however, for they too have concentrated on the personalities of those photographed with great intensity. It is true that, at first glance, Thomas Struth's large-format color photos of groups of people in museums from the 1980s seem related, but they are essentially different to Evelyn Richter's work in their conception. She reveals, in apparently incidental occurrences, moments of truth, messages between resignation and vision which never appear intentional in Thomas Struth's work. Her photography combines emotion, intellect, and recent history in an unmistakable symbiosis. Evelyn Richter's greatest concern, one which forms the basis of her entire œuvre, was formulated in an interview that she gave in 1992: "I wish to create contacts; contacts in the sense of intellectuality and dismay."

Bettina Becker

Gerhard Richter

Since the early sixties the medium of photography has been noticeably present in Gerhard Richter's work, a constant challenge for his artistic œuvre, which reflects the existing model. Thus his paintings are based on "found" photographs or on his own photos, and photographs also form the starting point for his printed graphic works. For the series 2.5.89 – 7.5.89, published in 1991 in the form of a portfolio, the artist chose photography in order to document and illustrate a dialogue with himself by utilizing the specific possibilities of the medium.

On examination this series shows itself to be a dense, highly calculated, even manipulative form of portrayal. And whereas the low intensity of the form allows the underlying theme to appear gradually, the convincing quality of this work is revealed through the mutually dependent relationship of form and content.

Six times the eye falls on a dimly-lit room. A bare wall forming a boundary is visible in the weak light of a searchlight installed in the right foreground. It leads into indeterminate depths, where only a slight, pillar-like, narrow outline offers the eye any further help with orientation. Black edges at the sides of the picture give rise to the impression that the camera was set up outside the narrowing, desolate room. The construction of a "light tent" produces an artificial distance from the room that makes the photographer, and the viewer too, unnoticed observers of barely discernible figures.

With an unchanged camera position and in a fixed sequence, a solitary person moving upright through the room is the first to be made out. His bare back appears in the half-light, and his uncertain, almost stumbling movement can be sensed. We then come across two stooping figures in the middle ground, presumably carrying out some joint action for a specific purpose. But even here the fuzziness of the photo only permits assumptions and leads to an increasing feeling of uncertainty.

It is almost a relief to distinguish a person moving out of the darkness into the light in three phases; he is crouched facing the front in the extreme foreground. With this photo the artist not only identifies himself and draws express attention to the multiple exposure and the use of an automatic release,

but at the same time the photos become self-questionings; the room whose boundaries seem to hold the earnestly upward-gazing person prisoner becomes his room, his studio. Yet this visual identification is followed immediately by a renewed retreat into the background and into secretive, completely obscure doings. In the further course of the series, the newly revealed proximity offers only the blurred motif of a figural group which evokes oppressive associations. Until the concluding photo, of an isolated figure crouched on the floor in the middle of the room, the indistinct photos suggest sequences of an action but at the same time withhold any clarification.

The experience of seeing finds an additional source of irritation in the inscriptions of dates. Whereas each of the six photos is attributed to a particular day as though this were an official record, details of the enlargements visible at the sides make May 4th, 1989, follow the 6th, the 5th the 3rd, and the 7th the 2nd.

From February to April 1989, Gerhard Richter showed his cycle of paintings 18. Oktober 1977 of 1988 (The Museum of Modern Art, New York) in public for the first time, in Krefeld. This, as he himself noted, "almost helpless attempt to give a form to feelings of sympathy, grief, and horror," which was intended neither to make a political statement about the deaths of the Red Army Faction members incarcerated in Stammheim nor to seek the historical truth, provoked strong reactions from the public. When the fifteen paintings in the cycle were exhibited in Frankfurt in late April 1989, not just the works but also the artist himself were subjected to a considerable degree of accusation and speculation.

Against this background, we are better able to understand the dated photographic sequence in its proximity to the painted over and smeared paintings, worked exclusively in gray tones on the basis of photos. If the unquantifiable and the disconcerting throw the viewer back on himself, and if he discovers that questions are evoked but remain unanswered, in the end he will recognize in this work by Gerhard Richter the efforts of an artist necessary in order to evoke in vivid terms the theme of the artist's own powerlessness and self-doubt.

Jutta Schütt

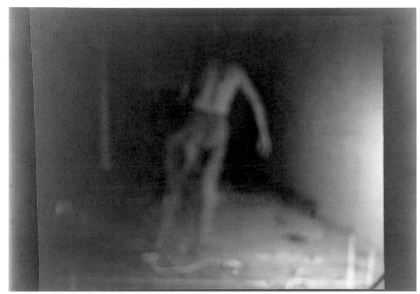

2.5.89

3.5.89

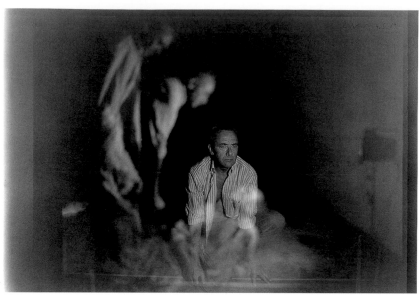

4.5.89

5.5.89

282

6.5.89

7.5.89

Klaus Rinke

Klaus Rinke uses photography to "measure" the body demonstratively. By changing his standpoint in landscapes and artificial settings, through a symmetrical language of gestures and a controlled relationship with his anatomy, the artist has succeeded in creating a physically orientated "measurement" system in a process-orientated fashion. Because the body must by definition always be in motion, photography can be used to depict and "freeze" the sculptural forms which movement leaves behind. It is a substitute for sculpture. The "primary demonstrations" which have been made since the beginning of the seventies show precisely delineated, site-related postures against a completely white backdrop. The photos serve as a lasting documentation of "units" from the body's own arrangement, but suggest themselves, primarily due to enlargement and the serial sequence of the work, to be the actual artwork originating from action, and "fixed" in the photographic end phase. Thus, Erdgebunden (earthbound), a work conceived in 1973 for the Biennale de São Paulo in collaboration with Monica Baumgartl, shows the body of the artist viewed from a wide-angle perspective as a sculpture developed out of the picture's foreground and founded upon an elliptical horizon line. At the same time, Klaus Rinke visualizes energies which come from the coordinated relationship with physical prowess. In the minimalist expression of such "body art," a will of order is articulated, the collective appearance of which earned for the artist the honorable title of "German Buddha" at a performance in Tokyo in 1974.

Rinke became the subject of public interest for the first time in 1968 when he began to define his "energy fields" out of water, in order to contain a fluid element in a sculpture of arrested movement. On that occasion he pumped the small Oos stream right through the Baden-Baden art center and filled twelve metal containers at twelve different locations along the entire length of the Rhine. In the physically organized "measurement measures," the strategic channeling of the fluid element flows toward a static order. What Leonardo once sketched in his diagrams finds practical application: Rinke uses his own body as a compass, as a spirit level, as a ruler, as a protractor. His actions are not "body language" but rather "body structure."

As a "measurement artist" rather than as a Constructivist, he develops his measure directly before the eyes of the viewer from circulation and coordination of the limbs. Gestures and poses define a relational system between man and space. After having oriented himself initially toward Pop Art, and then in France having landed between the fronts of Tachism and Informal, Surrealism and Nouveau Réalisme, the trained poster artist from Wattenscheid in the Ruhr has, since 1966, perfected body geometry. He practices it in front of white walls, in empty rooms, and in landscapes. Anyone who takes an interest in Rinke's projects – with the help of photography for optical comprehension – will see, for example, how the artist's back appears superimposed on itself after he has changed his location nineteen times on his way through the same park vista, an infinite perspective arising from the striding figure. From this physical-geometric "performance," a coordinate system arises for the controlled relationship with and anchoring of physical existence. The growing consciousness of his own energetics and their exactly calculated release has over the years led to the realization of a spanned structure rooted in the landscape which has extended to the design of technological connection systems (aqueducts in France). The artist Rinke became an engineer sui generis on the basis of his challenges to the mechanical possibilities of the body developed from rational consideration and meditative postures. While he literally sets these right, he creates for himself the fundamental basis of an "art-ificial" space through a landscape toward the horizon. The appearance of Klaus Rinke's artistic body in photography conveys assuredness.

Günter Engelhard

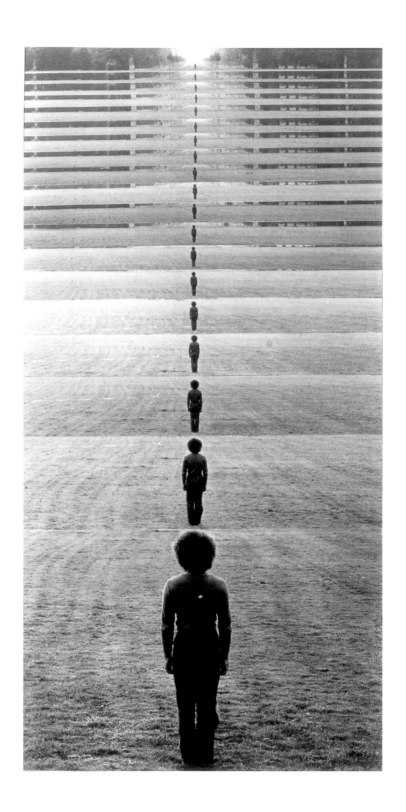

Miguel Rio Branco

Untitled, 1995 110 x 110 cm

"Celidônia, lovely Yoruba girl/Stray flesh/Exhausted night/ Dark brown rose/First sorceress," as Jorge de Lima puts it. Miguel Rio Branco's photographs have something of the same intimacy. On first encountering them, you involuntarily take a step backwards because you have the feeling of having got too close to someone, of having stumbled into some place where you have no business being. They are strangely haunting, these photographs, in colors which are often so unreal in their intensity that you think they will stick to your fingers. They put off the beholder, yet irresistibly draw him on. The barrier is poverty. The lure is what is strange to us, mysterious.

The things Rio Branco is telling us were strange to him, too. Like the Brazilian poet Jorge de Lima, he too had to be introduced to the magic that belongs to that enigmatic world in which you never tire of conjuring death and the spirits which, albeit invisible, are always there: the Loas, the "mysterious ones" of the Yoruba and the Dahome and the Bantu. Spirits which here, in a strange land, have been forced to ally themselves with the Christian saints, who many a time have had to shelter them under their cloaks from the persecution of the church.

Miguel Rio Branco gives us a hint of them in his photographs: in the gesture of a hand, the glance of a prostitute, a dark brown rose with the face of a queen of Benin from the old kingdom of the Yoruba. He shows us the unfathomable juxtaposition of bloody animal carcasses and the enchantingly lovely back of a young woman. It is the very real surrealism of that country which is expressed in many of his pictures, in

pictures cleft by chasms of contrast. The beautiful and the repellent blend seamlessly, like life and death. Transience could not be demonstrated more crassly. Thus many of his photographs turn into a time-lapse image of all being. And you stand in front of them and feel profoundly moved. The world grows small and the pictures crowd up close to you when you grasp that they tell of something that is omnipresent.

And his "still" photos? The pictures in which we do not encounter people and bloody meat and dancing enchantment? Those pictures, which at first glance seem to radiate such a profound tranquillity? There, too, life and death are indistinguishable, so enigmatically that you are overwhelmed; even if a dubious life is involved, like life in an egg that may already have rotted next to a bird carcass, trampled almost beyond recognition.

To whom were the red flower petals sacrificed which Rio Branco found behind the grille of a glory, protected from the wind by a scrap of paper on a plastic dish? Perhaps some of them have fallen down on to that peculiar shape (is it stone or bronze?) which we encounter in the last of the three pictures. A hideous grimacing mask shimmers up out of it. Have sarcophagi been kept behind the glory since ancient times? Whatever it may be, a bleak and unlit other world seeps from these photographs. Having it before you all your life diverts your senses automatically towards the things of this world, which are still preferable to it, even if they are set in the most squalid poverty. Here you still have, to fall back on, an alliance with the "mysterious ones," the spirits.

Peter-Cornell Richter

Peter Roehr

Peter Roehr's projects from between 1964 and 1966 (FO) are not directly photographic prints as such, but rather montages produced from printed advertising brochures. The brief, concentrated work of the prematurely deceased Frankfurt artist is devoted entirely to the investigation of the serial, the repetition of identical, found elements in grids, and this at the beginning of a far-reaching change of paradigms which was apparent above all in the art of the sixties. This meant a shift away from "hot" Abstract Expressionism to "cool" Pop Art, from Existentialism to Postmodern, from symbol to fact, from author to structure, from emotion to tangibility (which is to a great extent photographic), from gestural to medial, from the heroic-ingenious artist-creator to the artist as ironically detached arranger of already existent visual worlds. For Roehr, a work is finished when the repetition of things is perfect. The work group of the photomontages is only one, however, in addition to montages of objects, typeface, texts, and film created by the artist in 1966 for the sake of a return to object montage (labels and stickers) – interestingly enough because it all seemed too "literary" to him. This was perhaps because he had been given Volkswagen advertising materials by his friend and patron Paul Maenz, then in the advertising field, along with other such materials (e.g., coffee and cosmetics ads). Roehr went on to elevate the motif of the Volkswagen Beetle to become a historically significant and symbolic German icon. Thus the presence of the Beetle in many photos by Hilla and Bernd Becher is more than just coincidental. And because for other motifs the single image of the model reveals a complex curvilinearity, the mounted grid develops a nearly gestural dynamic and picturesque characteristics which the artist seeks to repress, explicitly striving as he does for the exact midpoint between the perceivable object and independent aesthetic structure.

With the works in this collection FO-56 and FP-101, examples are represented which, in their degree of abstraction and graphic clarity, represent Roehr's "midpoint" in exemplary fashion.

The models in a 5 x 8 grid are from a Volkswagen advertising brochure which highlights the quality of workmanship of the Beetle model of the time. Roehr acquired 100 copies of these brochures in 1965. For both of the aforementioned works he chose illustrations of the front and back seats respectively, whereby in the case of FO-56 the seat back has been laid flat to demonstrate the enlarged trunk capacity. In comparison with the other picture in the brochure, these pictures are the least "iconic" in the sense of Beetle iconography, as we know it from the slogan: "It runs and runs..." Even without being familiar with the original however, everyone will recognize in Roehr's works which car the pictures come from. It is not without a certain irony when the page of the brochure where they appear features the words: "Because every detail is right at VW, the whole car is, too." This could also be said of Roehr's technique; his "grids," exactly as they are, allow no variations, no intermediate spaces between the objects; the structure demands perfect execution. The pictures must be laid together like a parquet floor so that no "non-forms" arise.

Unlike Thomas Bayrle, Peter Roehr, like Charlotte Posenenske (three artists who, viewed from a contemporary standpoint, represent the Frankfurt Development) – in the ecstasy of productivity of those years and in the hope that art would one day rise up in society – have shown less feeling for the ironies and contradictions both in the new materials (advertising included), and artistic self-evidence. Roehr's works (including his films) thus appear "perfectly" contemporary, which, ambivalent as ever, characterize then as now our modern times.

Hubert Beck

Ulrike Rosenbach

Ulrike Rosenbach has defined photography and video as a "mirror of the self." This means she has used these visual media for the politics of her own historical experience. The artist developed her theories of identity and emancipation through mises en scène that she recorded on video, a medium that was still little burdened by tradition in the seventies. Her solo performances served to clarify her social and cultural role. In order to prevent them becoming routine, they were rarely repeated. All these images, as "the presentation of thought processes," were also philosophical experiments. As a sequence of autobiographical experiences, Rosenbach's performances became increasingly complicated. In retrospect it can be said that they fostered the process of artistic self-assurance in the context of emancipation, because they helped the artist herself to obtain "mental feedback," as she frequently emphasized in interviews. They should also be viewed as documents of contemporary history and the history of emancipation, as well as, in a complex fashion, documents of art history – all of which leads to the decisive question of what role art played in this. Ulrike Rosenbach has answered that art presents her with possibilities of showing a process or a topic in a more concentrated way than is possible in pragmatic, everyday life.

When in 1979 the artist found unacceptable working conditions (that she had not anticipated) at the Centre Pompidou in Paris – a cinema theater fitted out with black fabric – she had to feel her way in darkness through the entire forty-five minutes of her Keine Madame Pompadour (no Madame Pompadour). She had to move along the walls, carrying her small videocamera on her body. To express her anger, she showed the audience, on a monitor set up in the room, her hand banging brass knuckles against the wall. The sounds this made, sometimes quietly interrogative, sometimes decidedly loud, were the direct expression of her emotional state of mind. In 1975 during the Paris Biennial, clad in a white jersey, she shot an entire quiverful of arrows at a photographic reproduction of Stefan Lochner's charming Madonna im Rosenhag (Madonna in the rosebush). In this action, entitled

Denken Sie nicht, dass ich eine Amazone bin (don't think I'm an Amazon), it was a question of deconstructing a cliché of femininity. In the video monitor the image of the Madonna shot full of arrows was overlaid by the portrait of the artist herself, concentrating on shooting arrows with her bow.

The present photographic cycle, Wachshörnerhaube (wax horn bonnet), dating from 1972, is a reference to research carried out by the artist into exemplary women of the Middle Ages. In books about the Middle Ages, Rosenbach was struck by portraits of women wearing unusual bonnets or caps. These were very far from being fashionable accessories or hats. It was impossible to understand them as decorative headgear. Rather, it was their precise symbolic function to accentuate women's heads in order to give them a more prominent, visible role in the social environment. The artist copied some of these bonnets, which had horns on either side, using a wire framework covered with transparent gauze. The photo cycle Hauben für eine verheiratete Frau (bonnets for a married woman), from 1969, was the first to document this process, and the present photo cycle was produced in close association with it. These five photos were created in the artist's studio using a delayed-action shutter release. The performance shows free play with the plastic forms which Ulrike Rosenbach found in depictions of the Middle Ages. She shaped the horns by hand from wax and fitted them to the right and left of her head. The photographed action takes place in small stages and demonstrates the meticulous philosophical adjustment of the process. Step by step, the artist draws across her face a sculptural wax form, a symmetrical formation consisting of four horns. As the horned form has threads at the sides, it has a direct association with a mask, but it corresponds to the shapes on the artist's hair. The photo cycle, built up with strong black-and-white contrasts, shows an obviously concentrated process of self-reflection. The interplay between planning and surprising plastic formalization shows a very early and typical example of Ulrike Rosenbach's overall œuvre. This mise en scène marks the beginning of the artist's later history of emancipation.

Gislind Nabakowski

Georges Rousse

Pliny the Elder is famous for the legend of the important Greek painter, Zeuxis, who was able to paint grapes so naturalistically that birds pecked at his work. Zeuxis was in turn surpassed by Parrhasios' skill at creating optical illusion when he tried to draw aside the picture of a curtain that his colleague had painted.

Georges Rousse is just as enthusiastic about trompe l'œil when he translates three-dimensional spaces into a plane in his photographs, only to create the illusion of a new three-dimensional space. Since the early 1980s, the French artist has intervened in architecture by means of monumental painting and drawings. At first he placed figurative compositions which were close to Art brut or the painting done by the Jungen Wilden (young savages) in derelict houses, cellars or ruins. Then he drew geometrical figures and cubes in interiors. His figurative drawings and paintings of abstract signs spread out across floors, ceilings, and walls, crossing architectural boundaries to redefine perspectives in spatial composition. His painted figures and sculptures are reproduced on the anamorphotic principle, according to which the original structure of a room shimmers through a transparent color wash. Usually his rooms are not conceived as walk-in environments, nor can they be experienced as such. Thus photography, attesting to the aesthetic result of such interventions, lends durability and permanence to such ephemeral venues and actions. But photography not only represents a document, it also realizes conceptual and aesthetic directives. A walk-in installation takes into consideration that the spectator will experience it from many different vantage points and thus from many different angles. Photography, however, defines a specific perspective for staging a room. It also makes the phenomena of light and color into objects. Photography renders the manual process of creating a space abstract. Moreover, it offers the possibility of translating three-dimensional space into a two-dimensional surface.

Since 1991, what occasionally bordered on the diffuse and even chaotic in Georges Rousse's work has yielded to stringent organization of space. Simple words such as "Eros," "air," "eau," "vox," "Gaia," as well as entire sentences are painted or drawn on the walls. At first glance the layman might wonder whether these installations owe their form to computer ray tracing or further manipulation in the darkroom. CAD has certainly become a matter of course in architectural simulation as a means of rendering spatial volumes. This confusing play of reality and simulation is probably not unwelcome to the artist. After all, as a former industrial and commercial photographer once active in advertising, he is familiar with illusions and staging. Is the work entitled Oberhausen a photograph of an architectural model, an architectural drawing, or an installation? Here the purist architecture of a stairwell, presumably built after 1945 in the aftermath of the Bauhaus, is tinted blue-black. The abstract pattern formed by the railing and stair treads is heightened by a filigree of white lines. In the left half of the picture a transparent, crimson rectangle, visible behind the structure of the stairwell, recalls the Constructivist painting of Kasimir Malevich. According to Rousse, the dark color incorporates something of the "darkness of death." Its antithesis is the color red, the symbol of sunlight.

In Tsukamaro, Japan, executed in 1995, an empty office building is the setting for a far-reaching aesthetic transformation. Here, too, we encounter the basic colors blue-black and red. In the left half of the picture, symmetrically divided from the right, there is a circular basic form rather like the pictogram for an epicenter. The right half is completely colored red. A certain spiritual presence – in the artist's own words, the "presence of God" – is the motivating force which impels Rousse again and again into derelict buildings. In them he is hoping to find questions being asked on the nature of man, death, and the afterlife. His aim is to transform these anonymous places into meditation rooms so that such questions can be contemplated in more depth. His photographs are, in the last analysis, optical illusions "of our own solitude and unrest" (Alain Sayag).

Ulrich Pohlmann

Thomas Ruff

Nacht 11 II, 1992 189 x 189 cm

Anderes Porträt Nr. 50/29, 1994/95 200 x 150 cm
Anderes Porträt Nr. 109/55, 1994/95 200 x 150 cm

Thomas Ruff surprises with ever-new pictures, created respectively in large groups; but in view of his œuvre the context of these initially contrary picture sequences becomes apparent as an interrogation of photography as a visual medium, comparable to the apparently contradictory picture groups of the painter Gerhard Richter.

From 1979 he made some thirty, small-format, colored "interiors": details of apartments which had remained unaltered since the fifties. These interior views are in fact peculiar details of a normality that, thanks to Thomas Ruff, become apparent as something special. They simultaneously become the "exteriors" of a specifically German character.

Since 1984, around sixty "portraits" have followed, first in small, then in giant formats. Ruff chose his subjects from his family and circle of acquaintances. Each picture is a frontal view cropped almost like a passport photo, with a self-chosen monochromatic background color, matter-of-fact, devoid of any artificiality or staging. This results in a portrait series depicting a specific generation with which Ruff is connected, parallel to the expressive images of the Jungen Wilden (young savages) at the beginning of the eighties. Ruff endeavors "always to get as close as possible to reality, to the model." The giant-format Sterne (stars, taken from professional scientific photos) and the Zeitungsfotos (newspaper photos) appeared more or less at the same time at the beginning of the nineties. Ruff uses unfamiliar models which have already acquired their own level of reality. Here he fathoms the question of the reality inherent in a picture, the role of the artist, and photographic technique in two extremes. He produces brilliant pictures of a technically high-quality black-and-white negative printed in color, which in the enlargement triggers content-related associations – rough, almost washed out photos of cheap tabloid halftone photos, the simplification of which is akin to clichés in the truest sense, not only on the level of the picture content but also of the medium. To the viewer, the series Nachtbilder (night shots: 1992) appears uncommonly colorful and blurred owing to the use of a night vision device. The greenish highlights create a peculiar mood, and the harmless scenes appear to contradict the association of this technique with spying, war, or at least intelligence photos, since the banal objects reveal nothing with any clarity of content in themselves. The photographic technique, that is the implementation of the media, determines the interpretation, not the depiction of the objects themselves. This is a typical stance of Ruff's, one which distinguishes him from many other artists who work with photography.

Wulf Herzogenrath

Sebastião Salgado

As a "reporter without frontiers," Sebastião Salgado expands photojournalism into a mythical dimension. As geographical divisions present no obstacle for the fifty-four-year-old Brazilian domiciled in Paris, he operates fearlessly with his Leica beyond the frontiers of suffering and poverty – there where humanity in distress and despair, in time of war and natural catastrophe still, under the gaze of the camera, retains a last, dying expression of dignity. Placed by nameless miseries into a state of consciousness somewhere between fear and trance, people stay rooted as though spellbound within the nightmare of their reality, the only bond remaining between them being that of awaiting deliverance through death. This gives many photos the aura of a fatalistic religiosity.

Salgado's photographic passions rapidly become sinister: even the merest snapshot records an irrevocable fate. Before the existence of photography, Callot and Goya carried out equivalent reportage with their graphic cycles on the horrors of war. As Salgado's lens, too, strives towards an existential iconography, it traces a last spark of self-assertion amid the consequences of violence and in scenes of utter wretchedness. The observation of the struggle for life is stamped by an aesthetic with a leaning towards death.

The artistically expanded perspective of Salgado as a reporter leads involuntarily back to the early line of socially committed portraiture, from Jean-François Millet (1814 – 1875) to the early work of poor Vincent van Gogh (1853 – 1890). Photos of gatherings of Peruvian campesinos, who first became organized in 1977, display a striking affinity to Van Gogh's group portraits of Potato Eaters. First communicants and religiously organized peasant families concentrating on their first and last hopes in the Brazilian state of Ceará in barren fields under a cloudy sky, some with expectant, others with downcast eyes, share the devotional stance of Millet's field laborers and women gleaners as the clock strikes midday. The arranging eye of the photographer dignifies the binding faith within the collective of the surviving community. In portraits of starving refugees from the Korem camp in the Sahel region, on the other hand, every single individual has to bear his or her own destiny; as in an Old Testament myth of devastation, the faces already appear to have distanced themselves from their bodily needs in lethargy and in feverish expectation of death. The belief in salvation through a higher power is, however, lost completely when faced with the animal swarm of goldmine workers in the Serra Pelada, where the fate of thousands of human ants is sealed column by column in a faceless cycle. The individual expression of rage and despair flickers up only for an instant of revolt against the mine police before being again at once extinguished in the slave-like rotation.

In such moments the committed journalist Sebastião Salgado appears from behind the aesthete of death, but he can do nothing except shoot misery upon misery with his Leica: Salgado among the amputee victims of landmines in the villages of Cambodia; Salgado in the huge Rwandan refugee camps; Salgado among 15,000 people from the Croatian enclave of Bihać. And then suddenly, on a tuna-fishing trip off Sicily, a group of fishermen appear in his sights like Jesus and his disciples on the Sea of Galilee. And children in northeastern Brazil build the world they long for from the bones of animals that have died of thirst. The messenger of misery Sebastião Salgado cannot relinquish a belief in salvation.

Günter Engelhard

Jörg Sasse

Jörg Sasse became known at the beginning of the nineties through his photos of ordinary interiors. He presented unprepossessing interior layouts and architectural details as reduced, often almost abstract compositions. Since 1994 he has radically changed his working method. He no longer takes photographs himself but utilizes the possibilities offered by digital image processing to create with "found" material, that is, photos taken by amateur photographers.

In 1994, at the invitation of the DG BANK, Sasse developed a project with the aim of involving the employees of one of the bank's departments, in other words the future viewers, in creating a work. Interested employees were asked to allow Sasse free access to their private photo albums. From this reservoir he selected a total of seventeen photographs with the objective of processing them by computer.

What was done with the photos? At first glance most of the snapshot and holiday memento motifs look familiar: a beach scene with somebody walking along it, a waterfall in the mountains, a forest landscape with rocks. The lack of focus of many of the pictures is not an irritation initially. This may be due to the various shortcomings of amateur photography, or it may remind us of the particularly authentic-looking photos in illustrated magazines depicting, for example, the secret hideaways of the rich and famous.

If we examine the photos more closely, however, they start to appear astonishingly strange. The feeling of familiarity with the subjects disappears. In place of the presumed reality, artificiality suddenly breaks in: in the blurred pictures some of the outlines are nevertheless clear and sharp, the features of the people depicted cannot be distinguished, and the color displays odd breaks. As a result of digital processing, the apparent association with reality is called into question, and a changeable relationship between representation and fiction is created. The photograph itself and its perception become the themes. The works present the viewer with a question about the relative status of photography, painting, and the immaterial/digital picture.

The formal certitude of Sasse's photographic works pushes the original content of the "found" photographs into the background. For computer processing he primarily chooses unintentional, accidental components of the basic material, often only using details, or he may concentrate on a detail in the background. These motifs are then compressed in their composition so that entire people or parts of buildings disappear. The pictures produced in this manner possess their own, idiosyncratic suggestivity.

For example, the work entitled 5744, 1995 takes as its subject a decidedly nondescript scene. A crash-barrier, striped red and white, runs along the edge of the road though a monotonous landscape. As a result of the sequence of the horizontal division and the differentiated color relationships arising from the brilliant red and white in the center of the picture, a dynamic power is produced that is reminiscent of painting. At the same time the remains of the original photo, which can still be sensed, prevent a purely formal view and involuntarily provoke a question about the narrative content. What is the crash-barrier meant to protect against? What is going on in these gleaming white buildings? Between supposed portrayal and simulation there is thus created a tense relationship that cannot be stilled, that challenges our perception time and again.

Iris Cramer

Michael Schmidt

What the scorching region with the Indian name Yoknap-atawpha was for William Faulkner, is for Michael Schmidt the aloof city of Berlin. Yet whereas the county in America's Deep South was exclusively the product of an extravagant fantasy, the old and new political center of Germany is a historical and factual reality. To top it all, Faulkner was a writer while Schmidt is a photographer. Is the comparison here some-what lacking, as usual? For both artists, the subject was real-ity, nevertheless not in a narrow, empirical sense, but rather a far more complex one, beyond that merely seen and exam-inable. Although Schmidt himself feels obliged to a docu-mentary stance in photography, and his pictorial idiom is direct, clear, and gripping – in short eminently photographic – his images nonetheless convey as much artistic imagination as a novelist conveys livable reality. And are not literature and photography more akin to one another than are photog-raphy and painting? Walker Evans, the great American pho-tographer, preferred to compare himself to writers such as Faulkner and Hemingway than to the photographers of his time. And many experts have noted that the respective ways of perceiving photographic pictures and literary texts are similar. Roland Barthe's clear notion of the "punctum," the moment when the viewer "registers," is also along these lines.

Not least, the photography of the American "neo-documen-tarians" (Ute Eskildsen) exerted its influence on Schmidt during the genesis of his characteristic visual style, and many of their representatives are members of Evans' aes-thetic kin. He is self-taught and had tried various professions before finding his way to his aesthetic stance via ambitious amateur photography. Photography oriented toward artistic premises was never of interest to him. In 1978 he summarized his photographic philosophy when he said: "I am completely subservient to the things being photographed. Only by means of the self-depiction of the objects can one recognize their sense and purpose." That a decisive subjectivity with re-spect to the realization of the objects photographed first cre-ated this basis for achieving the goal, or initially to find its limits at all, is an insight which he attained along the way of goal-directed theory and extensive photographic practice, a way fraught with solutions, crass contradictions, and weary-ing uncertainties.

His photos of Berlin and its inhabitants are indeed invested with documentary spirit, but at the same time Schmidt un-derlines the specifically photographic character of what he photographs, thus precluding the illusionary trait inherent in the medium.

He accentuates the "vignette" nature of every photographic image; his works presume neither to mirror nor to duplicate the visible. Schmidt conceives of photography as an inde-pendent reality – nothing less than the motifs and objects of his images. This is particularly clear in his portraits. Strictly speaking, they are not portraits, not likenesses in the tradi-tional sense in which the human individual expresses his subjectivity. The subjects of his pictures do not gaze into the camera, regarding the viewer as it were, but rather give the impression that the photographer has cut the individuals out of some group shot. They seem immersed in conversation with others, while avoiding any dialogue with the viewer. The city shots, too, are representative of the same photo-graphic style. Here constructions appear as backdrops on the horizon, as the borders of the picture space into which the big-city ambience extends as a void. "The history of urban spaces has been overgrown by weeds, the areas serving primarily as space for transport routes. The special consideration given to voids, the still recognizable traces of the war such as ruins, but also the new concepts in con-crete have introduced a historical factor into Schmidt's work" (Ute Eskildsen).

A diffuse gray dominates the pictures, soft transitions in place of sharp contrasts separate the motifs from one other. A leaden atmosphere hangs over the city. The same atmos-phere also characterizes his landscapes. The themes of Schmidt's work are his own experiences. The subjective per-spective uncovers the exemplary in his photographic objects and lends them profile. The notion of "author photographer" is applicable to him. Berlin, a German metropolis at the close of the twentieth century: Michael Schmidt is its portraitist.

Klaus Honnef

Sean Scully

Sean Scully photographs materials which determine his use of color. He uses photography to arouse awareness of terracotta facades, tarred wood, or rusty corrugated iron, recording ageing and the concomitant changes in color under the influence of wind and weather, heat and cold. In his New York studio Scully proceeds to create what nature, before him, has done with time: painting as discoloration. Scully has photographed shacks and hovels on the islands of Harris and Lewis in the Hebrides and in the Atlas Mountains of Morocco. Weathering has enriched their discolored facades with patina as a faded yellow grid of ground color which evokes geometric impressions. At the same time, these facades look like painterly patchwork: collages of nailed, glued, walled, and painted details.

Sean Scully's choice of detail lends these secular facades a degree of ceremonious solemnity; they look like diptychs and triptychs. The poorest shacks, the most dilapidated tool sheds, and houses abandoned to rack and ruin are presented like the fraught social material of a makeshift altarpiece on the lowest levels of society. In Scully's view, closed off and decaying places of human habitation are just as dignified as the blurred contours and fading motifs of Italian Early Renaissance frescoes. From the purely practical standpoint, these photographs with their stripes and bands, squares and rectangles, can be classified as Scully's inspiration for his painting. They are part of an aesthetic system, each brick on top of the other, and somewhere on the picture plane a window or a door has been reserved. Joints and seams enhance the melancholy and pathos of the surrounding color. What one sees in Scully's photographs is the result of photographic reconnaissance: what activates color? One answer might be the painter's defining it in terms of clay, dirt, tree bark, or corroded metal to make an existential statement. A photograph of a closed door has been admitted to the architecture of the painting Empty Heart. Thus the painter gives walls a voice.

Discussing his approach to art, Scully says that he sees it as a sort of emotional glue. Just as bricks are held together by mortar, Scully's compositions are cemented by stripes and bands in irregular courses. The dull glow of earthy tonality creates color harmony. His opaque brushwork alludes to the secrets concealed in deeper layers, just as the brilliant interaction of colored zones does in the paintings of Mark Rothko. With Piet Mondrian and Henri Matisse, the American mystic has set standards which are also definitive for Scully's painting: Mondrian the supporting planar construction, Matisse the atmospheric color, Rothko the deeper ground and degree of emotion.

Perhaps Scully owes his ability to sing and poeticize with perfectly allotted fields of color to his being Irish. Informed by steadiness, Scully's pictures are never shallow; he is, to paraphrase his own words, building a work that causes the earth to quake. His poetry is the surface. Scully divides it up into striped lines and geometric strophes. The color is not merely to be looked at but is meant to induce emotional captivation. The painter's camera, too, has "captured" what moved the artist in his wanderings over the empty, shuttered haunts of Scottish shepherds and Moroccan farmers. It is in such pictures that one can see how a deliberately selective approach to photography which aims at natural color values can induce the painterly use of form and color.

Sean Scully, poet of Minimalism, has laid out his color fields to abut on the deeply layered, stringently ordered linearity of the territory he shares with fellow American artists for whom he feels an elective affinity (Ad Reinhardt, the early Frank Stella, Sol LeWitt, Agnes Martin). Photography has made them grow.

Günter Engelhard

Cindy Sherman

Sherman, Cindy/Prince, Richard:
Double Portrait, 1980 2 parts, each 50 x 80 cm

Untitled, #69, 1980 50 x 60 cm
Untitled, #75, 1980 50 x 60 cm

Cindy Sherman's pictures lie. Whatever they show us does not exist in reality. It may have been there at the moment she directed her camera at it, but this was solely for the purpose of creating a photograph. Sherman's studio is a laboratory of camouflage.

For a decade, these composed arrangements were linked to the physical presence of the artist, who claimed she was playing the leading role. The painstaking precision with which these scenes have been staged legitimizes their name, Film Stills (1976 – 1980). Cindy Sherman did not slip into the sixty-nine different, socially and individually definable female roles, as some interpreters claimed; rather, her empathy was directed far more at the fictional director of these scenes. All the efforts made – from the stage scenery to the costuming, from the wigs to the poses, from the make-up to the finest mimetic nuance and the atmospheric lighting – existed for the sake of the imaginary male presence, the male viewpoint. In this manner she succeeded in creating a parabolic quasi-documentation of that dictatorial practice with which the media stereotyping of the (by no means only female) human image is promoted in Hollywood films.

The sets of the subsequent, colored action shots lost legibility, as did the participants' suggested psychophysical expression. A dramatic "before and after" effect is therefore hardly attainable; the narrative character of the scenes remains reduced to a minimum. Schematically projected backgrounds and gestures, which are never brought into the clarity of a pose, hinder clarity. In a double portrait with Richard Prince, the location is completely undefined; an identification of the subject as ostensibly transsexual is contradicted in both cases by the accessories employed: the same wig and suit with shirt and tie. Moreover, the indifferent demeanor of both evokes an impression of introverted androgyny. In subsequent work series Sherman spells out a variety of projections (using her own body) which have been taken as welcome demonstrations in debates on gender, i.e., how women "mutate" to medially determined artworks, possibly even when the evocation of intimacy and purity is the main point. Sherman's studio was temporarily the location of a purgatory of art history. The History Portraits (1988 – 1990) call out to us, "This is not Caravaggio's callboy! This is not Raffael's Fornarina!" ("Ceci n'est pas...") They are photos of model sculptures built with demonic abandon which, grinning, demonstrate what kind of a medially conveyed image the pictures have in our memories.

Camouflage as a revealing trick remains Sherman's principle. She can be sure that we will fall into her trap even when the identification aid of the artist as model is absent and her works are created with the help of trash, feces, organic or inorganic materials (Disgust Pictures, 1986 – 1989); or dismembered marionettes, reassembled to become sexually charged monsters (Sex Pictures, 1992); or diverse fragments of puppet bodies put into surreal contexts of scarcely definable materials (Horror Pictures, 1995).

Sherman's pictures lie. Yet what they do show us brings to our awareness that which exists by way of focussed, caricatured, or even perverted exaggeration until it becomes recognizable; conventionalized projections of sexuality, beauty, power, and violence which serve as medial strategies to suppress reality, and fakes that aid in the implementation of their claim to reality.

Barbara M. Henke

Stephen Shore

Broad Street, Regina, Saskatchewan, August 17, 1974
19.5 x 24.5 cm

Born in New York in 1947, Stephen Shore became well known for the black-and-white photography he did between 1965 and 1966, when he was able to observe Andy Warhol's Factory as an insider. These are pictures which have been rediscovered, especially in recent years, because the cultural significance of the New York underground has finally been recognized. What has secured Shore's standing as a photographer, his main achievement, has been the way he has developed color photography into a medium of genuine aesthetic expression. In this respect, his work parallels that done by his contemporaries William Eggleston and Joel Meyerowitz in 1970. With his early pictures, Shore soon became a classic. In 1971, he was the first living photographer to have had his work exhibited by New York's Metropolitan Museum of Art. In 1976 he had a solo exhibition at The Museum of Modern Art. Being exhibited in this New York "temple" of the arts represented a first for color photography.

Shore hardly ever left New York until he was twenty-three. During the 1970s, however, he explored North America, its landscapes and urban diversity. After Walker Evans, no other photographer has captured what makes American life so distinctive as Shore has. Shore's interest in architecture, cars, road intersections, motels, and commercial art reveals his affinity for modern art, especially Pop Art. His diverse interests are what lend his pictures their unique quality. In the afterword to his book Uncommon Places (1982), Shore describes how he set out to discover the "new" world. With a friend, he left for Texas by car. What he saw of America was framed by the car window. "It was a shock. I would be in a flat nowhere place of the earth, and every now and then I would walk outside or be driving down a road and the light would hit something and for a few minutes the place would be transformed." Shore's photographs are fraught with the conflict between movement and extreme concentration.

A phenomenon he first perceived out of the corner of his eye is translated into permanency by means of large cameras (Shore works with negatives in large, full-plate formats: 8 x 10 inches). The translation is indebted to the photographer's drive for composition. Each of his photos shows a moment of daily, seemingly familiar reality. All links with chance have been severed, however. His unflinching concentration on making the picture autonomous is what makes Shore's work art.

Stephen Shore works with light in the literal sense of the word. He differs from the early traditionalists of his medium in wanting to show that he views color as a phenomenon of light. What he is doing is tracking it down as it appears from place to place and changes hourly. Shore's pursuit of light as color gives each picture its distinctiveness. Light as color enlivens the picture space to unite with the material quality of the things depicted. These pictures owe their magical quality to the way the infrastructure of the mundane, the seemingly familiar, is heightened in its potential to the extraordinary. The fact that everything is connected is rendered transparent for a moment to reveal an underlying principle of order. This is evident as well in Shore's later pictures made in the landscapes of the American southwest, Scotland, and Mexico.

Heinz Liesbrock

Katharina Sieverding

Nachtmensch, 1982 300 x 500 cm

Steigbild I/1 – 3, 1997 300 x 375 cm
Steigbild III/1 – 3, 1997 300 x 375 cm

Since the beginning of the seventies, Katharina Sieverding has utilized the photographic medium as a mirror for intimate desires and dispositions. She created her photos, which she ordered in rows, sequences, and series, with reference to the additive technique of film as an explicit and committed plea for voyeurism which, as an inheritance of the fifties (which were dominated by prudery), was still a cultural taboo. Thus, using the medium of photography, she enthusiastically investigated the dimensions of her own self and believed that "the conquest of the other sex initially takes place within oneself." In photographs of her face, as well as in scenic representations, she staged her own feminine and androgynous characteristics with make-up and costumes, as well as her physical and sexual narcissism – something unusual for an artist at that time. This work phase also includes photos which show her with her partner, the artist Klaus Mettig, each with make-up and long hair. The grosso modo favored by Katharina Sieverding – the frontal portrait – is in our culture, however, not just the means of expression for the widespread narcissistic cult, as criticized in Richard Sennett's cultural-anthropological study, of a dangerous "tyranny of intimacy" in public urban places and thus in the pictorial realm of the twentieth century.[1] It is also a current cliché for the stylization and camouflage of the subject, a mask which protects as much as neutralizes it. These photos defy. They address the viewer with an act of reference which expresses that the portrait is to be seen in a detached way, as something objectivized.

Katharina Sieverding has touched on diverse political terrain by triggering secondary effects from enlarged pictures from the mass media or research documents. For instance, she reacted to extreme right-wing tendencies and xenophobia in her 1993 cycle Deutschland wird deutscher (Germany is becoming more German).

Steigbilder (climbing pictures) was her title for nine large pictures with current political themes and medical-physical phenomena exhibited at the German pavilion of the 1997 Venice Biennale. Her interest in medical diagnosis played as much a role in these pictures as did her fascination with the visualization of organic formative powers. In these pictures Katharina Sieverding combines in one pictorial unity two parallel design worlds, the artistic and the scientific, which are normally separated from one another. In previous years, she experimentally enlarged in her Kristallisationsbilder I – XII (crystallization images I – XII) the structural phenomena of blood counts and photograms of blood plasma in black-and-white photos, thus revealing arcane hieroglyphics of nature. She combined these symmetrically with parts of her face and carried out a form of vivisection on her self-portrait. For the Steigbild in this collection the artist made use of X-ray pictures of human skulls and real paper chromatographs. She used chromatographic images of organic substances in a copper chloride solution. The dissolved substances "climb up" a piece of absorbent filter paper immersed in the solution, such pictures being used in early diagnoses. These chromatic "records" on paper filters are permeated by a "polar principle" for the diagnosis. Sieverding linked back the image of the skulls to art-historical "vanitas" pictures, divided it into a triptych and expanded it so that the inside of the head appears as a macro- and microcosmic image that can be deciphered only by the analytically versed contemporary. The pictures hold their secret in a 300 x 375 cm format. These are not analog pictures but rather computer generations. Picture I/1 – 3 releases exalted cosmic saturations of color, like magma. The viewer is drawn to the picture threshold where he recognizes the skull as a virtual form. Without being able to guide his perception, he is confronted by a delimitation and an extreme process of dissolution of the motif in the field of conflict between diffusion and clarity. The fact that, in the three-part division, the extent of the depiction mode of the skull does not exactly match that of the neighboring parts may be understood as a comment on the incising intrusions which science as institution and instrument inflicts on the organs of the body.

Gislind Nabakowski

1 **Richard Sennett,** Verfall und Ende des öffentlichen Lebens. Die Tyrannei der Intimität **(Frankfurt a. M.: S. Fischer Verlag, 1994).**

Lorna Simpson

As an African American woman, Lorna Simpson concentrates on issues of race and gender. Much of her work grounds itself in such matters as the characteristic body language of urban Black males and the look and texture of the hair of their female counterparts. And familiarity with African American vernacular is helpful, sometimes even necessary to fully grasp the nuances of her work. Yet, though it arises from the specifics of her own experience, it speaks ultimately to the broader concerns of stereotyping and prejudice to which everyone is subject from one direction or another.

For example, Two Frames, from 1990, juxtaposes an image of a long, cut-off braid of (presumably) woman's hair surrounding the word "undo" with a close-up study of the back of a close-cropped (presumably) female head. The combination automatically evokes the unspoken complementary word "do," which implies action but is also commonly used among African Americans to describe chemical methods for straightening kinky hair. However, we also speak of a woman "undoing" her braids, or "letting her hair down," which has erotic overtones. Meanwhile, the clipping of a woman's braid carries rich and contradictory connotations: self-abasement, punishment, transition from girlhood to womanhood, liberation from conventional gender constraints.

Simpson prefers to allow the possibilities to float freely, rather than to anchor or pin them down. This seems a logical outgrowth of her working method. "Generally," Simpson has said, "the imagery and the text go hand in hand. It's much easier when the text comes first, but I sometimes need visual stimulation in order to find the words. I get an idea of what I want when I begin to shoot, and the text is usually the last thing to be completely resolved. I tend to leave the text open, and I refine the words up until the last minute. As for the image, I can resolve that and get that done fairly quickly."

Even when the pieces are completed, their implications characteristically remain open. The correlations between texts and images are never exact or delimited; Simpson's choices of words ("bio," "five day forecast"), phrases ("shoe lover," "twenty questions – a sampler"), or compact mini-narratives (in such works as Gestures/Reenactments) qualify her images but do not caption them. Sometimes she plays with the expectations that prefixes – not unlike stereotypes – set up, offering the viewer a choice between, say, "backlash," "backbone," "background," "backache," and "back pay."

Historian Naomi Rosenblum has written, "Lorna Simpson's almost identical serial images along with their disjointed texts make the point that misconceptions about race, gender, and class do not change much over time." Most of her work is set in the present, the images stylistically of our time: crisp, glossy black-and-white or full-color prints of sharp-focussed, studio-lit still lifes and studies of sections of human subjects, their faces rarely visible. But in one project, Details (1996), a set of twenty-one small photogravures, Simpson appropriates small sections of anonymous studio portraits of Black people from early in this century, extracting from them only the hand gestures of the unknown photographers' subjects (a recurrent motif in her own images). To each of these manual gestures of self-presentation to the lens she appends an ostensibly descriptive, biographical word or phrase – "soulful," "carried a gun" – that, though clearly arbitrary, nonetheless resonates, proposing an enticing imaginary storyline that has little or nothing to do with the life actually lived by the whole person to which that hand belongs.

We make our worlds with words. That is what Simpson does, too, using our habits of speech and sight to help us deconstruct our programmed, automatic responses. "I'm hoping," she told curator and historian Deborah Willis, "to stretch the viewer's perceptions beyond thoughts of race and gender."

A. D. Coleman

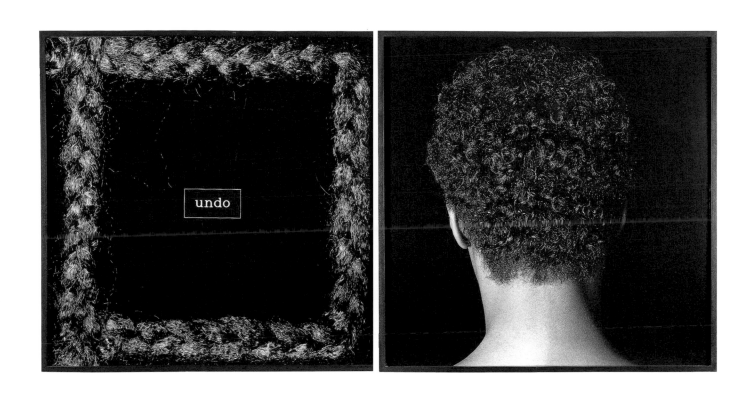

Annelies Štrba

Hiroshima mon amour, 1994 100 x 150 cm

The sun is covered by clouds, which lie in a dense, impenetrable mass over a park landscape and give only a pallid light. We believe we are faced with an unspectacular situation, as ordinary as it is beautiful: a couple, let's assume they are lovers, sit on a bench at the edge of the park. The scene is quiet, a girl and a young man, deep in contemplation of one another. Were it not for the motorbike parked at the curb nearby, indicating their youth, we might be tempted to take them purely as conceptualizing the image of lovers, ageless, communicating wordlessly. Here, we might go on to assume, a degree of mutual understanding has been reached that has for a long time made expressive gestures superfluous. The complete concealment of being together after many years, at an advanced age. A couple, somewhere in this world, in a park, while three benches away a solitary person rests after a stroll. It is winter. Or spring is nearly at hand. Nature, too, seems to be resting.

And then we discover the title of Annelies Štrba's picture – Hiroshima mon amour. Our gaze is, in a split second, robbed of all certainty about the incessant return of the eternal, all those couples, the continual reaffirmation of love, the annual unfolding of nature. Our gaze is suddenly redirected from the general to the particular in the realization: even fifty years after their nation was disciplined by others in a way that precluded all contradiction, for the people of Hiroshima normal conditions, thinking without formulas and forcible reminders of history, or simply the present, must still be a constant struggle. If, up until this point, imagination has provided the impetus for our thoughts and inventions, the title imposes on us the force of history and reality based on the script by Marguerite Duras (Alain Resnais' film appeared in 1958, thirteen years after the catastrophe). Yet out of the

polarity between the power of our imagination and the might of history, Štrba's composition, which initially strikes us as a banal observation, produces its own tension. A tension not least between image – perception – feeling, on the one hand, and between specific – knowledge – logic, on the other.

The great project of the postwar period, which has been given particular support by artists, is to return things back to their nature, to give life back the warmth that was taken from it by the heat of the atomic retaliation in the Far East and in the crematoriums of Eastern Europe. If, as with Walter Benjamin, the look is the residue of the human, then consequently the look at Hiroshima is the residue of humanity. The photographer-artist collects our looks, their residue, and their limitations. The fact that something is incomprehensible does not stop it from existing. Many of the horrors that humans do to other humans are so inconceivable that we can do nothing except confront them. A poster in Hiroshima bears the written message: "It is however regrettable that the political intelligence of the human being is a hundred times less well developed than his scientific intelligence."

Common to almost all of Annelies Štrba's works is that they track down the intimate in urban space, the social force field in the private domain. They are a delicate peeling away of layers in the accidental togetherness of the family – between kitchen and living room, between waking and dreaming: a never-ending photographic work radiating out like the annual rings of a tree. Ephemeral layers of houses, buildings, street panoramas, veiled landscapes: everything is penetrated by a gaze that does not wish to draw any distinction between the political and the personal, that defines us as much in the domestic environment as out in the wider world.

Jeannine Fiedler

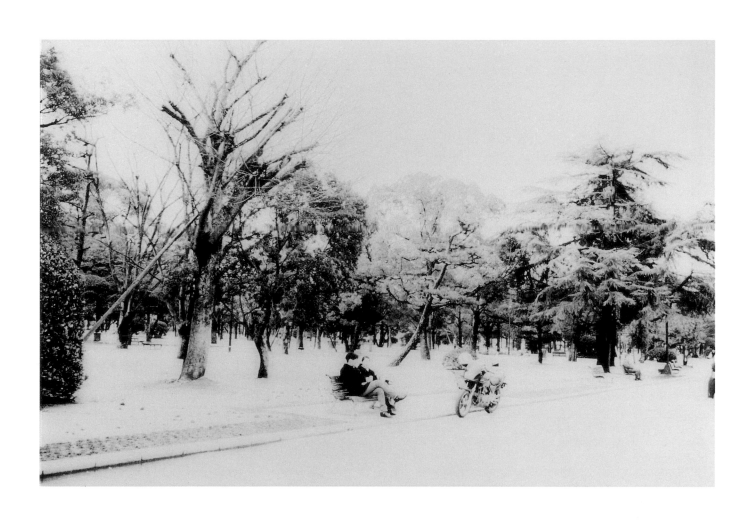

Untitled (USA 95), 1995 95 x 124 cm

Beat Streuli does the exact opposite of what a photojournalist does: he photographs beyond the motif. He behaves like the eleventh daughter of Reinhard Lettau, who says of her, "If she drops something, it can happen that she will ignore the object and follow the hand reaching down to it with eyes full of amazement, completely forgetting the object she was on her way towards, just as a bird can forget the purpose of flight – never clear at the best of times – and simply revel in the act of flying."[1]

To photograph beyond the motif as it were has nothing to do with an intention, but with a certain attitude. Ultimately, television has done away with the "interesting" motifs. A flood of images has driven the moment into oblivion. Beat Streuli swims against the current. He photographs what he finds in the water, against the current. And what he finds is more influenced by the flow than by his character. When I sit in a train or airplane, I am being transported. The state of being transported is fundamentally stronger than my perception of the people in the compartment or flight cabin. Beat Streuli does not swim against the current just for the sake of it, but because he remains "stationary." When one stands still, among people for instance, one sees things that one otherwise misses. Beat Streuli looks as if he would not take photographs. When one views his photos, one sees directly as he does, with one who sees but does not photograph; Beat Streuli's photographs are evidence of the absence of photography by means of photography. He distances himself from the picture and enhances it through the back door, so to speak.

We are speaking of the incidental. In flux, everything is incidental. The incidental is distinguished from the arbitrary by the fact that I do not recognize something as arbitrary – any which way – but rather incidentally, by virtue of my standpoint, my attitude, to integrate the periphery into the scope of my attention. In order to recognize the incidental as such, the focus – the recognizing eye – is a prerequisite. The incidental is never in vogue; there are daily peripheral phenomena which I perceive in myself and others and then immediately forget again (fade out). I recognize them because they are a part of my being, without interpreting them: gestures of expression, of disposition, as well as gestures in the social

sphere. In this way change is articulated: in thinking, in taking action, and in one's behavior. We are speaking of remembering. Remembering the incidental. And creating a form of consciousness for it. But is that so important? Are there not more important things? The incidental can also be unutterable because it cannot be expressed, can never be spoken aloud. The unutterable embodies a lack of conception because the notions acquire a transitory significance in the current. Perhaps we must accept the fact that notions do not embody one thing today and another tomorrow, and thus create reality; or perhaps we must accept today that they mean this and that simultaneously.

We are speaking of the processual. Processes are the epitome of the transitory, and notions (perceptions) always yield themselves in retrospect. But how can I conceive of the transitory when the notions in retrospect are again outdated? This the focus of Beat Streuli's œuvre. The constant is the incidental. "Deheroizing" turns humans into humans, architecture into real estate, migrants into tourists, while blueprints contain their own plans for demolition.

We are speaking of a charismatic vision. In the incidental we find articulated suddenness, needs, anxieties, curiosity, longing, and desire. Beat Streuli speaks of our daily experiences, of people and things, of the peripheral which has long since become central, using such precise and incidental pictures that he succeeds in infecting our routine consciousness, directed as it is toward priority and the so-called "new." I personally find it incredibly exciting the way Beat Streuli succeeds, from the cool distance of "stationary," in "returning the flesh to the word, of making knowledge corporeal again, not deductively but immediately via perception or the senses; the corporeal senses."[2]

Beat Streuli's charismatic vision shows young people in a self-assured disposition, occupied with themselves, in a moment of reflection or introspection. They know nothing of the photographer's seeing eye.

Jean-Christophe Ammann

1 Flucht von Gästen (Munich: 1994), p. 63.
2 William Blake, Annotations to Berkeley's Siris. Cited according to Norman O. Brown, Love's Body, with a critique by Herbert Marcuse (Munich: 1997; Frankfurt a. M./Berlin/Vienna: 1979).

Thomas Struth

Musée du Louvre III, Paris, 1989 152 x 168 cm

Thomas Struth is that former Becher pupil from the Düsseldorf art academy who was closest to the fine arts right from the start and has remained so. His experience with free art, during a long practice as a painter and graphic artist, is reflected in his photographic work. At that time, as he remarked to me in 1992, "I've tried just about every form of (picture) technique that there is. Thoroughly." Thus the choice of the painter Gerhard Richter as his first teacher seems logical, as well the transfer in 1976 to the class of Bernd Becher, the newly-appointed instructor and the first to establish photography as a fully recognized art form within the venerable academy.

In 1975 Thomas Struth hung up in the academy circuit a block of seven groups of seven photographs showing views of Düsseldorf street scenes, and with that took his leave of the painting class. In 1989-90 he created large format and color works depicting interior scenes of large museums in which masterpieces of Classical art are presented as painted pictures along with their viewers. Photography as a mirror of painting's achievements – this could be considered the theme of Struth's œuvre: a coming to terms with the tradition of painting as a visual form using the means of photography.

His first group of works from 1978 shows views of empty street scenes in New York, taken at eye-level from the middle of the deserted streets. These are "photographs which are typical of the individual cities and which therefore, in context, make visible the structure of the respective separate districts," as he wrote in 1980.[1] The system initially observed disintegrates, however, when Struth also introduces colors for characterization of a city. We see public areas, squares, facades, and streets of Düsseldorf, Munich, Tokyo, New York, Edinburgh, Rome, and Paris. These works were brought together and titled Unbewußte Orte (unconscious loci: 1987).

His "portraits" also arose at this time, initially out of gratitude to friends, then generally as portraits of entire families, less often of married couples. Yet in the representation of human beings, Struth likewise exercises extreme restraint: the people position themselves on their own; they gaze at us, serene and relaxed. In standing poses seen from below, in sitting from somewhat above eye-level, always from a central position, well-lit, sometimes almost over-lit, nevertheless, with a long exposure – usually for one second – the subjects wait as if in a portrait sitting before a painter in previous centuries. As observers, we are fascinated: we look these strangers in the eye, initiate communication and begin to relate those in the photo with each other and with ourselves. Every person is different, and yet we always find something that can in turn be associated with the familiar. Thus the "portraits" of the city streets are the surroundings, the environs, the social sphere in which the subjects of the family and group portraits exist. Here, both thematic groups seem to enhance and enrich each other in a mutual fashion. A particular linkage of the above themes is represented in the "museum photographs," which were begun in 1989. These are large-format photos of museum halls decked with large paintings, each with different viewers. The person depicted is at once the viewer of the pictures on the walls, and we become the viewers of the viewers and these depicted pictures. Hans Belting has written an insightful essay on these pictures, whose theme is the linking of art-historical lines of perspective and media-specific phenomena.[2]

In Musée du Louvre III, shown here, we see an entire series of visitors to the gallery, yet all of them have turned their backs on the Titian works facing us; only the person seated on the far left seems to be interested in art, offered to us to view in full expanse. One senses Struth's interest in the representational character of art and the relationship between viewer and work – yet in the selection of his painting motifs we also sense a real relationship to painting, to the power of the images of the great masters. Thus, his personal preferences (Giovanni Bellini, Giorgio de Chirico, Gerhard Richter) can also be seen as a line of true painting which at the same time embraces for the viewer the reflex of questioning the reality of the truth of the picture.

Wulf Herzogenrath

1 Schlaglichter, Landesmuseum Bonn (1980).
2 Thomas Struth (Munich: Schirmer/Mosel, 1983).

Hiroshi Sugimoto

Black Sea, Ozuluce, 1991 58 x 64 cm

Europeans who write about Japanese photography are treading on uncertain ground. Yet adventurous travel photographers from Europe introduced photography into Japan, along with a world view which must have seemed utterly foreign to the inhabitants of that country owing to their completely different conceptions. European rationalistic structure had no correspondence in the Far Eastern culture of timelessness. Still more difficult is the undertaking when a Japanese photographer refers to the teaching of Zen, as does Hiroshi Sugimoto. Can the quintessence of this influential teaching be at all reconciled with photography's expressed love of detail? European materialism on the one hand, and Asian transcendentalism on the other? Sugimoto has studied both in Tokyo and Los Angeles, and has made his home in the most European of American cities, New York. In terms of culture the metropolis has always been considered a "melting pot." And in fact the photographs of the Japanese artist combine Eastern and Western influences to produce suggestive effects. He has banished rapidity from the medium. What has only just taken place is not what matters, but what "was" is subsumed within the "is." In other words: the permanence of the past in the present. Instead of photography in the aesthetic notion of the "snapshot," Sugimoto indulges in a photography of contemplation and celebrates the perpetual return of the "same." His pictures are correspondingly unspectacular, regardless of the subject: for example, the figures of a frieze upon a famous temple in Kyoto or the unchanging views out to the ocean. The photographer does use different sites, but in view of what he shows and what is important to him, the alternation is only relevant considered from the standpoint that perception remains principally unchanged. The images deny the sensationalist views of the visually addicted; his pictures demand neither the absent-minded glance of the passerby, nor the flickering glance of the long-since jaded. Rather, they demand a radical change in the viewer's attitude with respect to the pictures and the world that they depict. They demand what one may describe as empathy, both sympathetic understanding and critical reflection. Particularly sustained and intensive is the long series of sea pictures. A straight horizon divides them in the middle, yet the line is only seemingly sharp as if drawn with a ruler. In reality the dividing line between sea and sky, between the lighter and darker halves of the picture, is blurred. Now and then the heavens seem to triumph over the water, enlarging the lighter portion, but appearances are deceptive, for this is due to a mirror image. In the highlights, a single development is taking place, in fine nuances. The bright and dark fields pulse slightly, the darker approaches the lighter, though without merging. The course of the development is clear and transparent; no atmospheric mood arises. Hiroshi Sugimoto has melted time in his pictures. The long exposure of the middle-sized formats, which veritably invite the viewer to immerse himself, lend a meditative character to the pictures. In the normal photographs the optically present is in a factual sense irrefutably absent and the pictures unremittingly testify to loss. In Sugimoto's forceful shots it is precisely absence itself which remains constant and present long after the time of exposure, thanks to his artistic concept and realization. Death is only another form of life.

Klaus Honnef

Wolfgang Tillmans

Smokin' Jo, window, 1995 60 x 50 cm

Like most artists of the 1990s, Wolfgang Tillmans views the assumptions underlying the past three decades, during which the power of stating, shaping, and changing the world was attributed to art, as idealistic and utopian. They are no longer concerned with creating inverted or counter-worlds. The commercial visual media have by now infiltrated too far into how things are perceived; Baudrillard's theories on simulation and Virilio's on vanishing have become too firmly anchored in thought and feeling. The claim to generally valid truth and truthfulness has become obsolete. The world can no longer be grasped as a whole, let alone be represented as such. Taking the subjective as one's point of departure without the intention of creating overarching designs for bettering the world and pursuing the stylistic problems inherent in art are increasingly informing the practice of art. Artists are doing this in order to find out where they stand both as artists and people in a multi-perspective society.

Wolfgang Tillmans, whose photos are present both in exhibitions and catalogues as well as music and zeitgeist magazines, is often viewed as the populist photochronicler of contemporary youth culture. The picture of his own generation is at the center of his work. Since he himself is part of the scene, his view of it is outwardly directed from within it. He gives us lightning insights into the daily lives of young people which usually remain arcane to outsiders, encumbered as they are with stereotyped notions and prejudices against Techno and Club culture or the homosexual scene, as well as the status which conspicuous consumption, fashion, and brand names occupy in this culture. He usually portrays friends, acquaintances, lovers, models and scene stars, either singly or in groups. Sometimes they seem to be posing for his pictures, conscious of the camera trained on them. Most of these photos, however, seem like snapshots which have captured momentary situations by chance. "Kids" sitting on a staircase, a boy in an anorak and jeans next to a tree, another wearing make-up and his shirt open in a room, a girl staring out of a window, lost in thought; these are interspersed with photos of hetero- and homosexual couples in erotic situations or pictures of parents with their children. Juxtaposed with still lifes of naked, usually male, genitals, we encounter fruit, flower, or kitchen still lifes, the folds made by clothing that has been taken off, city scenes, and natural landscapes. The conception of these subjects is as low-key as the titles, the names, and places mentioned. Things are simply called what they are. Tillmans' photos at first seem like snapshots from a private album, ranging as they do between real feeling and kitsch, spontaneity and play, between sadness, contemplation, and a zest for living. On closer scrutiny, however, one notices that these pictures are calculated, staged, and arranged. Yet Wolfgang Tillmans does not hold with such categorization. "What interested me was how I can photograph people and things so that what I see in and behind them afterwards still looks in the pictures the way I perceived it."[1] He constantly emphasizes in interviews that the portraits reflect not only his individual view but also the ideas his subjects have of the self-image they carry with them. This seems to oscillate between an image that one embodies in society which is worn as a protective second skin and externalizes the social and personal self-image and the unconscious representation of a vulnerable ego composed of many different facets and perceptions. This heterogeneous configuration of meaning also explains the diversity of motifs in this artist's œuvre. He reveals them in ever different combinations, on different scales and in different contexts. Networks and cross-linkage arise so that the individual picture can always be viewed from a new perspective. Thus Wolfgang Tillmans reveals himself as a tracker stalking the questions posed by the complexity of the self, the immediacy of experience in a context that has already been crowded with synthetic images and disabled by alienation.

Beate Ermacora

1 Wolfgang Tillmans talking to Martin Pesch, Kunstforum International, vol. 133, 1996, p. 260.

James Turrell

James Turrell marks the conceptual starting phase for spatially concentrated phenomena of light by means of photography. He has acquired part of the money needed for his expensive crater project in the Painted Desert near Flagstaff, Arizona, through sightseeing flights over the volcano. The two photographic prints, each measuring 1.03 x 2 meters, in the DG BANK Collection record the nuances of light in the Roden Crater in delicate, subtly contrasting colors intensified with silver pen. This is the basic photographic material for painting with natural light determined by the physical qualities of color.

Turrell has owned the extinct volcano in the Hopi Indian reservation since 1977. He has divided up the entire interior – which is wider than Manhattan – into tunnels and passages. They act as receptacles for the changing colors of day and night, between the celestial bodies above the desert and the intrinsic color values of the geological matter. From this Turrell extracts the material form in order to obtain a quasi "transparent," mystically hallucinatory materialization, similar to the suggestion of light painted by Mark Rothko and Barnett Newman. His explanation: "I try to take the light and materialize it in its physical quality so that the viewer really feels it to be material: feels the reaction to the temperature and its presence in the room, not on a wall." It is, in other words, nothing less than the act of seeing itself which is intended to be seen in these rooms made of light.

The one who is seeing becomes the integral subject of a spherical progression, beyond all reality. The power of attraction is so strong that the viewer may even lose his or her inherent equilibrium in the haze of immaterially condensed emptiness and end up in a suspended state, hypnotized by color. Some years ago a visitor to an exhibition at the Whitney Museum in New York had a strange borderline experience when she jumped into what seemed to be a soft substance and, falling into emptiness, broke her leg: a painful consequence of stepping beyond a familiar sensory frontier of perception into a spatial zone permeated by pure color energy. The fluctuation of manipulated light and thus the removal of the limits of the field of vision into a universal feeling of existence simultaneously expanded on all sides began in 1966 with the aid of a quartz halogen projector. Imaginary walls were created in front of real walls. Conversely, hollow spaces illuminated by fluorescent lighting behind dividing walls with slits in them transformed real matter into an apparently transparent dark zone similar to black holes (Shallow Space Constructions). As a result of their fusion, light tones produce the impression of a pane of glass through which the viewer thinks he or she is looking into a white room (Wedgework Series). Rooms painted titanium white reflect the color of the light streaming in from natural and artificial external sources (Sensing Spaces). In Ganzfeld Pieces the activity of light, apparently within the surface of the wall, controls and regulates the extension of the room beyond its actual dimensions. External light accompanies the passerby into the total darkness of Dark Spaces, vanishes there, and then after about ten minutes is manifested as internal radiation. In Sky Spaces, spherical vaults appear to continue under water. The Roden Crater is a gigantic vessel for the transformation of actual topography into apparently unlimited perceptive spaces of the third kind.

As one familiar with the celestial bodies, a researcher of light and the sky, James Turrell certifies the cleansing power and capacity for physical expansion of his color pictures. Even on earth, the viewer is with him in the sky. Thus the light installation planned for 1998 in the Sky Lobby of the DG BANK will open up celestial views even to the world of finance.

Günter Engelhard

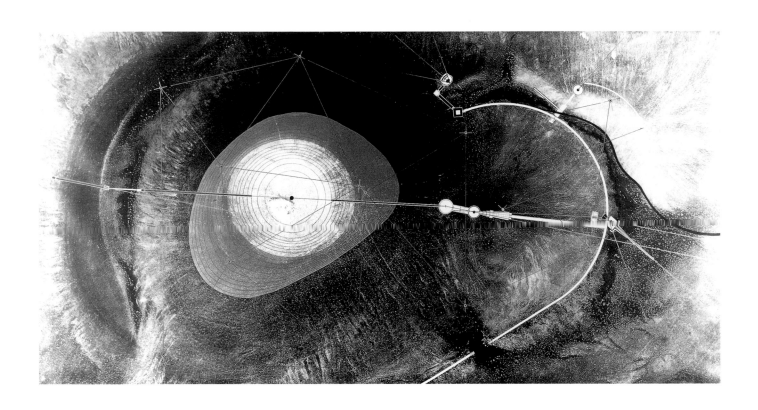

Günther Uecker/Rolf Schroeter

Günther Uecker endows his material treatments, via the staged dialogue with photo artists, with a dramatic dimension imbued with ritual. In the twenty-two action phases of Entwicklung eines Werkes (development of a work), whose concentrated dynamic moments have been derived from the context of the picture's emergence as detailed photos from the camera of the Zurich photographer Rolf Schroeter, we find material, action, and molded light effects combined. By the addition of color coordinated with the working movements, the completed photo is transformed into painting. Twenty-two photos, which have appeared in an edition of exactly twenty-two copies, preserved through Uecker's intervention (subtitle: Formumwandlungen; photo transformations) the character of the original; the artist has "injured" his photos with nails and knives, then reacted spontaneously to the injuries with white paint. Through this subsequent treatment in the tradition of Action Painting, Uecker brought once again the rhythm and tumult of his own sequence of action to the fore – the moment acquires permanence of painting.

In this manner, the development of a work becomes the protocol of a working mode which has remained relevant for the entire developmental process of the artist. In the handwritten prologue to the cycle, Uecker traces the proportions of the works directly back to a radius of movement derived from his own bodily dimensions. He designates the footprints, the arching curves of his arms (which are immersed in color), the painting tools of the hands, and the musical traces of his fingerprints as a choreographic trace on the ritual place of the maltreated surface. In this way, he confirms the uniqueness of an action which began in the late fifties with the hammering of a nail on the scene of the "Zero" movement.

Between the plays of light and fire of Heinz Mack and Otto Piene, Günther Uecker anchored his nails and stakes in the ground, in wood or metal. He made the "Zero" movement defensive, occasionally even aggressive, for instance, attracting attention by nailing over of pieces of furniture, musical instruments, and decorative objects of the fifties. What reached an international peak in Transgression – Überflutung der Welt (transgression – deluge of the world, the title of an exhibition in Rochus Kowallek's Frankfurt gallery d) at the beginning of the sixties, all with help of the nail – subsequently sought symbolic expression for extreme existentialist situations in other materials as well – sometimes ingeniously, sometimes brutally. Uecker's strategic work is enticingly formulated in its appearance, but often carries with it a political or social undercurrent. As poet and "solidifier" (German: "Ver-dichter") the artist makes a lasting contribution to "concrete" poetry.

The structural course lies rooted in childhood. The system of work in the fields with harrow, roller, and seeding machine on the arable land of Mecklenburg left a lasting impression. The groynes in the water off the Wustrow Peninsula opened the imagination to the possibility of holding that which flows fast. From the ineradicable nature of such impressions it is possible to explain the obsession of the artist's life-long attempts to record nature and its elementary phenomena, in both harmonic and disquieted rhythms in synchronous manner to human biotopes. With considerable physical effort, Günther Uecker makes his rhymes of the world – with rural experience, craftsman's tools, and artistically directed powers of perception. He takes his inspiration from ambitious travels to foreign lands, exploring the very limits of civilization. In deserts of sand or icy wastes, he has expanded his repertoire of those naturally occurring structures which, during the subsequent creative process, extend as traces of action within the objects and image area to reach civilized realms and there to become art.

Günter Engelhard

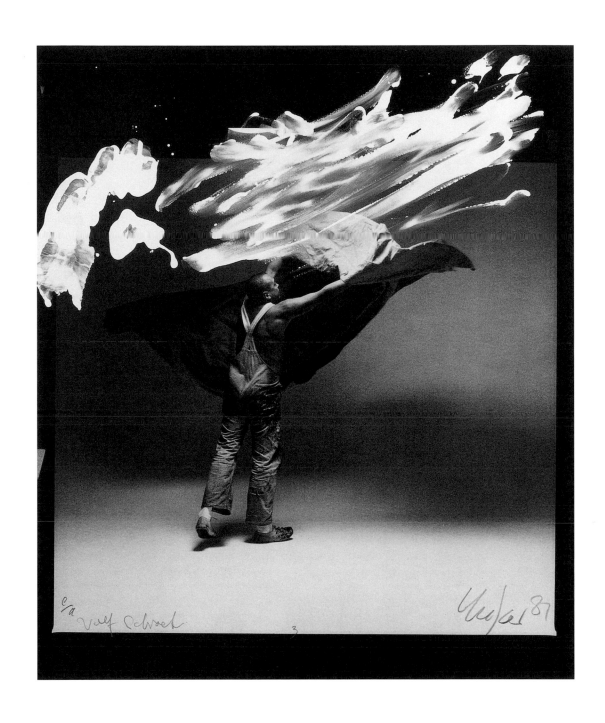

Wolf Vostell

Wolf Vostell's photomontages are part of a political aesthetic. As documentaries of real events, they have assumed the role of the prosecution within his critically oriented utopian œuvre. The German master of the Happening used photography intensively during the late 1960s to characterize the state of affairs which was being eroded by demonstrations and wars (Vietnam). He symbolically arraigned the political forces behind the scenes and the merchants of death. Phantom Savings Bank, for instance, is a photo of a combat fighter plane. Between its tail and the parachute which is braking it, the face of a war victim is discernible, held as if in a vise. The very title of the photograph suggests a bitterly sarcastic allusion to the financing of the war. The films of the original prints, mounted behind Plexiglas, lend the documentary collage its allegorical urgency and immediacy.

Vostell's œuvre, with the overarching social statement made by his repertoire of political and social references to reality, also begins with an aircraft. It crashed in 1954, while taking off from Shannon Airport in Ireland. At the time of the crash, the German artist was a twenty-two-year-old student at the Ecole Nationale Supérieure des Beaux-Arts in Paris. He heard and understood the word "décollage" (meaning "take-off"), shouted by a newspaper boy, as "d-coll/age." It took the artist quite some time to grasp that what was meant was the take-off of the airplane, literally, its coming unstuck from the ground. He found the concept so fascinating that he elevated it to the status of a guiding principle to act on when visualizing snapshots and highlights of a series of interrelated and usually disastrous events. Vostell's French Nouveaux Réalistes contemporaries François Dufrène, Raymond Hains, and Mimmo Rotella were using décollage, tearing posters down to create new frames of reference and meaning from strips and scraps of paper. Going beyond them, Vostell was not long in enlarging the scope of décollage to include material destruction and the Happening. Becoming Europe's best known practitioner of the eventful tearing up of realistically ordered scenes, he always achieved the most original effects and was very popular. He stirred up so much trouble that he even made headlines. He made trouble where trouble meant revitalizing urban life (Rathenau-Platz in Berlin: his celebrated monument with cars in concrete). By 1964 he was carting participants in the most famous German Happening from place to place making In Ulm, um Ulm und um Ulm herum (in Ulm, around Ulm, and all around Ulm) happen. The Happening was staged in twenty-four different places, changing its locale hourly. In actively participating, the public walked through urban German life to poke around in the detritus of civilized consciousness.

A guiding light of the movement known as Fluxus, Vostell was much more broad-based in his approach to art – viewing it as a blend of various disciplines which included music, theater, and literature – than his colleagues Joseph Beuys and Nam June Paik, who specialized in sculpture and theory. Vostell's fields of activity were not removed from reality. Anything which could be recorded by means of photography and the electronic media was incorporated into Vostell's scenic visual spaces as long as it served the purpose of aesthetic agitation. Overdrawn photos, some of which have been mounted in or behind a third, aesthetic plane of reality, represent Wolf Vostell's reflections on the counterfeit reality generated by television, by photos in illustrated magazines, and by advertising. Deutscher Ausblick (German view: 1958) is a panel picture in which the devil is embraced by painting in the form of a TV set. In 1979 Vostell even developed a media concept for a Hamlet in which the actors' bodies were linked over a wide space by handycam. Thus doubled by reduplication, the action of the murder was subjected to a different plane of perception by being simultaneously shown on many monitors. It has always been possible to feel that one has been actively experiencing what is going on by participating in Vostell's work. In the process, one may be sure that one is gaining critical insights.

Günter Engelhard

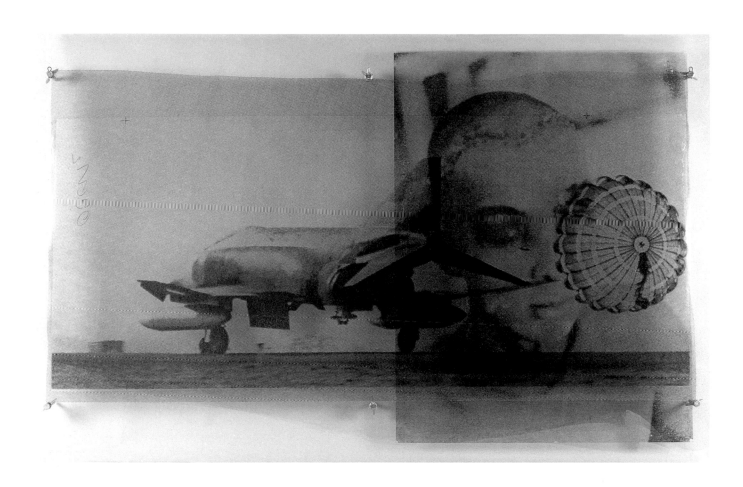

Andy Warhol

What in the art world was once considered vulgar, compromising, and utterly uninspired, he made not only respectable but also the ultimate in artistic volition at the turn of the approaching new millennium: commerce, movies, and carnival. The change is so far-reaching that it has penetrated to the very core of art. Very probably, we will look back upon this turning point in artistic self-conception and compare it with the Western notion of "Renaissance," i.e., that with which the modern age ostensibly began. All the same, Andy Warhol was more of an observer and stroller in the complicated workings of the cultural upheaval than a driving force, more a human burning-glass in which the energies to split the artistic atom were bundled, with still more uncontrollable consequences. The volatile world of the media was his elixir; in a certain sense Warhol himself was a medium. The stars in the firmament of the media world determined his life. As a child he collected postcards of film idols. He was "mesmerized" by Hollywood, as is written in a book that posthumously sheds light on his artistic horizon, which formed the triad "fashion, style, and Hollywood." The aura of the American film metropolis attracted him greatly, illuminating body and spirit, and instead of style he sought the opposite – the virtual appearance, in gesture and attitude, of the "beauties" on and of celluloid. One photographic self-portrait, not typical of the majority of self-portraits which he had created, yet all the more significant for that reason, shows him in the pose of a gangster caught in the act, his face almost completely hidden behind his right hand which is hiding a pistol, all in the somber black-and-white of film noir; and yet in addition to his right eye (the pupil of which is half-obscured by the upper edge of his glasses), the lens of the camera on his knees also seems to catch the viewer's attention. His was an existence between, before, and behind the cameras; he was a person who was always gladly someone else. A few days before his death, he appeared as a model in a Yamamoto fashion show. Although it was film that had been formative in shaping his aesthetic approach, it was photography that had made him turn to art – not artistic photography, but rather photography from the world of advertising and society magazines. Warhol leveled artistic hierarchies: the main differences between commercial and non-commercial art, "art and entertainment," advanced and trivial. His aesthetic interest was directed at the pure interface where real and apparent become indistinct; real turns out to be apparent and vice versa. The goal of his art was absolute artificiality. And no medium preserves the real as the apparent better than photography, located somewhere between the illusionism of commercial cinema and the eventful virtuality of the electronic media. Only photography has the magic of an icon. Warhol's famous "paintings" of Marilyn, Liz, Jackie, and tutti quanti were all entirely based on commercial photographs. Just as he excluded stories and characters from his films, he obliterated the quality of artistic pretensions from his photographs. He discovered that a staging was long since unnecessary in order to represent the world as such. His magazine, Interview, gave him the key to this world. The influential Diana Vreeland opened the door to the glittering cosmos of fashion. The fashion designers became his artistic stars, and the superstars of his films from the former "underground" acted on the catwalk of public vanities. The voyeur encountered the exhibitionists, and the beautiful, rich, and pompous revealed themselves before his camera as role players, as – true to his maxim – celebrities for "fifteen minutes." He hardly needed to persuade Bianca Jagger to shave her armpits in the home of the fashion designer Philip Halston, nor did he need to persuade the latter to hold artificial female nipples in front of his breast and one of Warhol's designed plastic lips in front of his mouth.

Warhol's photographic images belong within the context of his entire artistic œuvre, which continues to extend its influence on the "art scene," the aesthetic criteria of which develop from his artistic authority.

Klaus Honnef

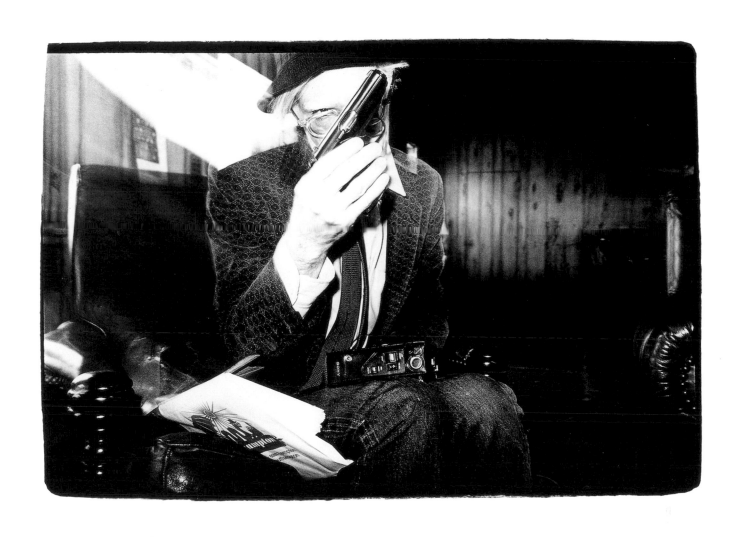

336

John Waters

Peyton Place – The Movie, 1993

Peyton Place – The Documentary, 1994
each 19 x 210 cm

From the debut of his cult classic, Pink Flamingos, through to his breakthrough film, Polyester, and down to more current efforts such as Hairspray and Serial Mom, filmmaker John Waters has simultaneously mocked and celebrated the trash culture of the U. S.

As a movie director and motion-picture aficionado, Waters has devoted much of his critical attention to matters cinematic; his own films are full of references, direct and oblique, to other famous and obscure films, celebrity gossip, and everything that composes what experimental filmmaker Kenneth Anger long ago labeled "Hollywood Babylon." Beginning in the early 1990s, however, Waters turned to another of the lens-based media, still photography, as a vehicle for critical analysis of film.

Working neither with studio-supplied images made on the set nor with staged simulations thereof à la Cindy Sherman, Waters instead makes his own "director's cut" of the films he examines by shooting color images off the TV screen while a film's video version is running. The initial impulse, he has written, came from a desire to have something resembling an actual movie still from a scene in a film of his own starring the transvestite Divine. To generate this image, "I took hundreds of shots off the TV monitor," he recalls, "blundering my way into photography the same way I blundered into films, until I finally produced the still I wanted," in 1992. "It's about editing," not about photography, he says of his process, "and I always have final cut."

Some of the films he has "re-directed" since then are vintage Tinseltown junk, like Susan Slade; some are film classics like The Bad Seed and Victor Fleming's Joan of Arc; and some continue to be his own, including a little-known early work called Eat Your Make-Up that includes what may be Waters' own pinnacle of tastelessness: a parodic recreation of the home movie of the assassination of John F. Kennedy, starring Divine as Jackie, which Waters has now mined for a sequence of stills he calls Zapruder, after the amateur who casually filmed the historic event, accidentally producing what Waters calls "the most famous movie of all time."

Sometimes Waters pulls together images from different films around a common theme, such as Liz Taylor's Hair and Feet, Movie Star Jesus (crucifixion scenes from eighteen different films, arranged in cross form), or Twelve Assholes and a Dirty Foot, drawing attention to otherwise unnoticed details in everything from star vehicles to gay porn videos. For instance, one of these, Dorothy Malone's Collar, pinpoints what apparently was that actress' personal signature in her costuming: the collar of her blouse, dress, or jacket is turned up stylishly in film after film.

Alternatively, he isolates a group of selected moments from a single film, either maintaining their original sequence or else reorganizing them into a new narrative structure.

The method Waters uses has its roots in strategies that go back to Tristan Tzara and the Dadaists, who applied such methods to poetry, and William Burroughs, who made related experiments in prose. In all these cases, the process that Burroughs called "cut-up" serves to deconstruct the cultural programming embedded in the original material, thereby highlighting its tropes, allowing its underlying meanings to show through, and often releasing unexpected, anarchic energies lurking just below the work's surface.

"Usually," Waters claims, "at least one second (twenty-four different frames) in every film can be memorable." For that reason, he suggests provocatively, "There's no such thing as a bad motion picture ... I used to be embarrassed by the lousy cinematography of my early movies, but when I started 're-directing' them decades later, I realized all my past mistakes seem to pay off artistically. Over-exposure, lousy framing, bad zooms, out-of-focus shots – hey, we're talking the foundation of modern photography."

A. D. Coleman

William Wegman

The American artist William Wegman has worked in a great many different media. He has, on occasion, created mixed-media genres. Looking back over Wegman's œuvre, Craig Owens emphasizes Wegman's deliberately unarty approach to his work, his refusal to flaunt technical mastery and espousal of informality. Wegman eschews artiness as "not simply a matter of technique; rather (it) is often the explicit theme of his works."

Wegman's early photographic work is simple. Some of it resembles photographic cartoons or illustrations which can be grasped at a glance. Wegman himself says that pictures as such are to be avoided; what matters is content. Like much of the work done by artists in the 1960s, these photographs possess the immediacy of documentary. John Baldessari's work springs to mind in this connection, and Wegman was a friend of his. This is photography that simply records something which was staged to be photographed. Wegman produced the individual pictures, diptychs, or series in the heyday of Minimal, Conceptual, and Process Art, for which photography was an important vehicle of temporal and spatial events. No importance was attached to style, composition, or other aesthetic qualities inherent in art photography. On the one hand, Wegman's work emerged from Material and Conceptual Art; on the other, it consistently mocks both the ideology of reproduction and the lack of humor of such art movements. Wegman's 1960s work does not, however, merely content itself with parody. On the contrary, it shows links with Serra, Sol LeWitt, Carl Andre, and Robert Morris. Dennis Oppenheim, an artist of Wegman's generation, is right in commenting that Wegman's great achievement has been his opting for humor. The term "humor" has been mentioned too often whenever Wegman's work is discussed. Of course he uses forms and linguistic structures derived from colloquial humor and even wit. Nevertheless, it is difficult to apply concepts such as parody, burlesque, grotesque, wit, or humor to Wegman's photography. It certainly cannot be fitted neatly into any of the above categories. His earlier work involved the representation of customs which had nothing personal or autobiographical about them. A characteristic feature of this early work – and this, by the way, is true of all Wegman's work – is that it does not convey explicit messages, although it consciously makes stringent use of succinct illustration techniques, as the photographs in the exhibition amply demonstrate. The wit informing this work is displayed on different planes, on both the levels of content (action, dialogue, objects) and mediation, which are interrelated in affecting our response to the work.

Wegman assumes that the medium of photography, as a system of signs, is one of the major determinants of our consciousness and that we have internalized this medium. Photography is often thought of as a medium that never lies, one in which photographic reality is identical with truth. Numerous artists were preoccupied with this very issue during the 1960s and 1970s, using the medium to question its underlying assumptions.

Wegman's earlier and more recent concepts – if one means by more recent work his Polaroid photography and, in particular, the photos with his dog, which are more pictorial – are similar in that they both focus on the idea of similarity and indissoluble superimposition of disparate elements to form hybrids. What he is doing is comparing related, structurally similar situations.

He employs the diptych as a visual adjunct to the creation of fake narrative situations. Then he subverts the narrative situation he has thus created. Behind the superficially slapstick humor of even the most seemingly sentimental dog pictures lurks a moralist. His Weimaraner, "Man Ray," is the impenetrable, "inscrutable" animal, the world's "id," which we, at best, can train yet not understand.

Peter Weiermair

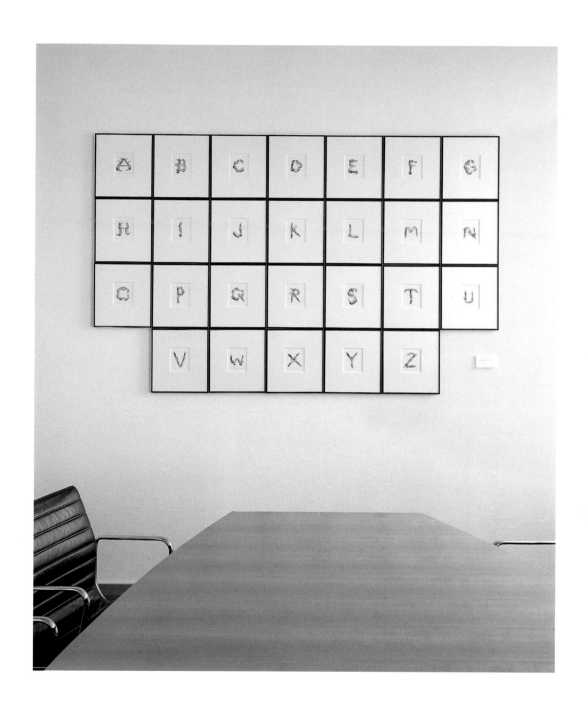

Rainer Wittenborn

Architettura Spontanea I, Detail, 1986/97 each 30 x 40 cm

Architettura Influenzata II, Detail, 1986/97 each 30 x 40 cm

Rainer Wittenborn's artistic œuvre, which can be traced back over some twenty-five years, is distinguished from the outset by his confrontation with complex themes and subjects that cannot be captured in pictures alone. In that his art relates directly to life, it attempts to retrieve an important task, one that is oriented toward our existence, one that has long since been lost in the aesthetic ghetto of fleeting artistic fashions.

After working on projects in the early seventies with a procedure that drew its material from the media (books, magazines, films), combining it with documentary photos, texts, and illustrations, and dealing with the political and ecological problems of Vietnam or the Canadian and Brazilian Indians, he concentrated in the documentary environment De Finibus Terrae (1986–1989) on the south of Italy. This is an area which in the rich, northern part of the country can seem like the end of the earth ("finis terrae"), and this in a double sense, both geographically and socio-politically. It is consequently a matter of a geographic focus which runs parallel with an absorption of Wittenborn's own biography and the sum of his experience. The environment is divided into seven individual parts, all of which, however, are interconnected. The opening chapter of the work realizes visually and in a tactile sense the situation at the southernmost tip of Puglia. The stones, originating from various geological ages and forming the word "terra," and the map of Puglia, painted with ferric oxide, are parts of an ensemble which is supplemented by a similarly red-colored cassette. This contains an exhibit book with photos of the places from which the stones of the floor sculpture have been taken. There are, however, also repeated photos of constructions made from such materials, that is, of a traditional architecture typical for the region. The subsequent chapters are concerned with the region's political history (World War I, social unrest) and cultural history (for example, peasant culture and olive cultivation, although photos of graffiti are also shown). In the sixth chapter, Wittenborn interprets the fates of several men – from the generally anonymous to particular individuals – who have lived abroad for a long time, mainly in Switzerland or Germany.

The photos in the DG BANK Collection are from the closing chapter, Le Case, which is devoted to a comparable pictorial-documentary procedure of architecture. While the cassette Architettura Spontanea contains an exhibit book with photos of various traditional constructional forms taken in 1986, as well as the trulli of the Puglian peninsula Salentina, the other, entitled Architettura Influenzata, contains a concurrent series of photos of new constructions from the same region. The combination of past and present gives the viewer a clear verdict which is also evinced by the material relics of demolished houses from the nineteenth century – building-stones, tiles, paving-stones, and so on. A few decades ago, there was a universal "culture of taste" which became lost the moment people succumbed to the consumer and "taste terror" of the construction industry of the north. What could be observed in Puglia since antiquity is carried on today, although on other premises; the locally specific is displaced, in part destroyed, and transformed into something else. But today, owing to such processes of estrangement – as Wittenborn demonstrates – it is not the endemic and the unmistakable that prevail, but rather a ubiquitous restlessness. The destruction of social links between people, as Wittenborn documents in De Finibus Terrae, is, in contrast to the views of certain Postmodernist social theorists, not viewed by him as an extension of the freedom of the individual, but as a loss of a comprehensive pattern of orientation.

Armin Zweite

Appendix

List of Works
Biographies

List of Works

Adams, Dennis
Patricia Hearst, A thru Z
1979 – 1989
Silkscreen
consisting of 26 parts
each 50.8 x 40.6 cm
Edition of 30
Inv. No. 089-001/(001-026)

Appelt, Dieter
Die Schatten erinnern an nichts
1991
Black-and-white photograph,
gelatine silver print
consisting of 6 parts
each 150 x 114 cm
Edition of 3
Inv. No. 001-001/(001-006)

Araki, Nobuyoshi
Untitled
1991
From the series
Laments: From Close-Range
1991
Black-and-white photograph
114 x 92 cm
Inv. No. 213-001-000

Araki, Nobuyoshi
Untitled
1963
From the series
Saatchin and his Brother Mabo
1963
Black-and-white photograph,
gelatine silver print
43 x 35.5 cm
Inv. No. 213-007-001

Araki, Nobuyoshi
Untitled
1963
From the series
Saatchin and his Brother Mabo
1963
Black-and-white photograph,
gelatine silver print
43 x 35.5 cm
Inv. No. 213-007-002

Arden, Roy
Pneumatic Hammer (#2),
Vancouver, B.C.
1992
Color photograph, C-print
105 x 140 cm
Unique print
Inv. No. 226-002-000

Baldessari, John
Six Color Coded Note Pads
1994
Six Color Coded Lamps
1994
Installation
consisting of 8 parts
Black-and-white photograph,
gelatine silver print, colored
with acrylic paint and oil tint
2 parts, each 110 x 160 cm
6 parts, 110 x 68.4 cm,
110 x 53.2 cm, 110 x 71cm,
110 x 52.4 cm, 110 x 78 cm,
110 x 79.8 cm
Unique work
Inv. No. 076-005/(001-008)

Baltz, Lewis
Rule Without Exception
1990
Color photograph, Cibachrome
126 x 188 cm
Edition of 3
Inv. No. 237-006-000

Barry, Robert
Untitled, (DG BANK piece #8)
1997
Black-and-white photograph,
reworked with acrylic paint
100 x 100 cm
Unique print
Inv. No. 312-002-000

Barry, Robert
Untitled, (DG BANK piece #4)
1997
Black-and-white photograph,
reworked with acrylic paint
100 x 100 cm
Unique print
Inv. No. 312-006-000

Barry, Robert
Untitled, (DG BANK piece #6)
1997
Black-and-white photograph,
reworked with acrylic paint
100 x 100 cm
Unique print
Inv. No. 312-008-000

Basilico, Gabriele
Dunkerque
1984
Black-and-white photograph
50.5 x 61 cm
Edition of 15
Inv. No. 077-003-000

Bayrle, Thomas
Guitar: Elvis Presley
From the 13-part series
GRID
1996
Computer print
24 x 32.2 cm
Unique print
Inv. No. 045-010-000

Becher, Bernd and Hilla
Wassertürme
1972
Typology, consisting of 9 parts
Black-and-white photograph,
gelatine silver print
each 24 x 18 cm
Unique print
Inv. No. 144-001/(001-009)

Beckley, Bill
Roses Are, Violets Are,
Sugar Are …
1974
Color photograph, Cibachrome
consisting of 5 parts
226 x 353.5 cm
Unique print
Inv. No. 066-001-005

Bergemann, Sibylle
Untitled
1986
From the series
Das Denkmal
1975 – 1986
Black-and-white photograph,
gelatine silver print
each 46 x 56 cm
Edition of 15
Inv. No. 236-001-000

Beuys, Joseph
Freie internationale Hoch-
schule für Kreativität und in-
terdisziplinäre Forschung e.V.
Honigpumpe am Arbeitsplatz
1974 – 1977
(documenta 6, Kassel 1977)
Detail Maschinenraum
Color photograph
34.5 x 22.7 cm
Photoedition 1979
consisting of 8 parts
Edition of 250 + 10
Inv. No. 003-020-001

Beuys, Joseph
Freie internationale Hoch-
schule für Kreativität und in-
terdisziplinäre Forschung e.V.
Honigpumpe am Arbeitsplatz
1974 – 1977
(documenta 6, Kassel 1977)
Detail FIU-Raum
Color photograph
34.5 x 22.7 cm
Photoedition 1979
consisting of 8 parts
Edition of 250 + 10
Inv. No. 003-020-002

Blume, Anna and Bernhard
Untitled
1992 – 1994
From the series
Transzendentaler
Konstruktivismus
1992 – 1994
Black-and-white photograph,
gelatine silver print
Sequence,
consisting of 2 parts
each 126 x 81 cm
Edition of 3
Inv. No. 092-001-002

Boltanski, Christian
Grandpa's Memories
1974
Black-and-white photograph,
gelatine silver print
54.5 x 119 cm
Unique print
Inv. No. 289-002-000

Bonvie, Rudolf
Gelb, Rot, Schwarz
1991
Color photograph, C-print
consisting of 3 parts
185 x 252 cm
Unique print
Inv. No. 006-002-000

Brus, Johannes
Blaues Pferd
1979/85
Black-and-white photograph,
photo linen
128 x 180 cm
Unique print
Inv. No. 240-011-000

Bustamante, Jean-Marc
Suspension I (Lumière)
1997
Silkscreen on Plexiglas
134.7 x 185.2 cm
Edition of 3
Inv. No. 325-001-000

Chamberlain, John
An Aside
1989
Color photograph, Cibachrome
50.8 x 61 cm
Edition of 9
Inv. No. 078-005-000

Chamberlain, John
Studio Lite XV
1990
Color photograph, Cibachrome
50.8 x 61 cm
Edition of 9
Inv. No. 078-011-000

Chamberlain, John
Barbihu
1989
Color photograph, Cibachrome
50.8 x 61 cm
Edition of 9
Inv. No. 078-001-000

Clegg & Guttmann
Museum for the Workplace II
1995
From the 4-part installation
Museum for the Workplace
Color photograph,
Ilfochrome/diasec
122 x 265 cm
Unique prints
Inv. No. 065-002-002

Close, Chuck
Roy II
1996
Computer print on
Somerset paper
131.5 x 99.5 cm
Edition of 10
Inv. No. 331-001-000

Collins, Hannah
Loss
1996
Black-and-white photograph
on canvas
220 x 160 cm
Unique print
Inv. No. 340-001-000

Cooper, Thomas Joshua
Mythic Stone – Message to
Timothy H. O., Sullivan Gullfoss,
Iceland
1987
Black-and-white photograph,
gelatine silver print
43 x 60 cm
Edition of 3
Inv. No. 254-009-000

Corbijn, Anton
Adam, Edge, Larry & Bono (U2),
Dublin
1991
Color photograph, C-print
125 x 125 cm
Edition of 3
Inv. No. 271-001-000

Cravo Neto, Mario
Odé
1989
Black-and-white photograph,
gelatine silver print
47.9 x 47.9 cm
Edition of 25
Inv. No. 152-006-000

Defraoui, Silvie & Chérif
Untitled
1988
Black-and-white photograph,
gelatine silver print with wax
218 x 218 cm
Unique print
Inv. No. 287-001-000

Demand, Thomas
Büro
1995
Color photograph,
C-print/diasec
183.5 x 243 cm
Edition of 5
Inv. No. 756-001-000

diCorcia, Philip-Lorca
Tokyo
1994
Color photograph, C-print
76 x 101 cm
Edition of 15
Inv. No. 321-001-000

Dine, Jim
Black, Back View
1997
Iris print
76.2 x 101.6 cm
Edition of 3
Inv. No. 339-001-000

Donzelli, Pietro
Cinema a Pila
1954/94
From the Series
Terra senz' ombra
1954/94
Black-and-white photograph,
gelatine silver print
50.4 x 40.7 cm
Edition of 15
Inv. No. 111-012-000

Eggleston, William
Sumner, Mississippi,
Cassidy Bayou
before 1975
Color photograph, dye transfer
53 x 67 cm
Edition of 12
Inv. No. 288-012-000

Eggleston, William
Near Minter City & Glendora,
Mississippi
approx. 1970
Color photograph, dye transfer
46.4 x 57.2 cm
Edition of 12
Inv. No. 288-011-000

Eggleston, William
Untitled, 1981
From the portfolio
Southern Suite
1981
Color photograph, dye transfer
40.5 x 50.5 cm
Edition of 12
Inv. No. 288-002-000

Export, Valie
Zeitgedicht
(24 hours, 24 photographs)
1970
Black-and-white photograph,
collage
consisting of 4 parts
each 40 x 40 cm
Unique print
Inv. No. 318-001/(001-004)

Faucon, Bernard
Un jour nous aurons connu le
bonheur
1991 – 1993
Color photograph,
Fresson print
61 x 61 cm
Edition of 10
Inv. No. 293-002-000

Fischer, Arno
West Berlin
1957
Black-and-white photograph,
gelatine silver print
40 x 50 cm
Inv. No. 297-005-000

Florschuetz, Thomas
Triptychon Nr. 1
1988
Color photograph, C-print
consisting of 3 parts
each 100 x 150 cm
Edition of 3
Inv. No. 208-007-000

Fontcuberta, Joan
Cala rasca
1982
From the series
Herbarium
1982
Black-and-white photograph
40 x 30 cm
Edition of 15
Inv. No. 145-010-000

Fontcuberta, Joan
Braohypoda frustrata
1982
From the series
Herbarium
1982
Black-and-white photograph
40 x 30 cm
Edition of 15
Inv. No. 145-008-000

Förg, Günther
IG-Farben-Haus VII
1996
Color photograph, C-print
242 x 162 cm
Unique print
Inv. No. 079-026-000

François, Michel
Untitled
1997
Black-and-white photograph
120 x 180 cm
Edition of 5
Inv. No. 234-012-000

Gelpke, André
Untitled
1980
From the series
Fluchtgedanken
1980
Black-and-white photograph
40 x 50 cm
Edition of 5 + 1
Inv. No. 187-005-000

Gerlovina/Gerlovin
Madonna with Child
1992
Color photograph, C-print
122 x 122 cm
Edition of 15
Inv. No. 217-001-000

Gerz, Jochen
Erase the Past
1991
Black-and-white photograph,
mixed media
consisting of 4 parts
2 parts, each 18.5 x 13.7 cm
2 parts, each 28 x 20 cm
Unique print
Inv. No. 014-001/(001-004)

Giacomelli, Mario
Untitled
1962/63
From the series
Io non ho mani che mi
accarezzino il viso
1962/63
Black-and-white photograph
30 x 40 cm
Inv. No. 013-001-000

Gibson, Ralph
In Situ
1988
Black-and-white photograph,
gelatine silver print
51 x 41 cm
Edition of 25
Inv. No. 269-010-000

Gilbert & George
Headed
1992
Color photograph, C-print
169 x 142 cm
Unique print
Inv. No. 185-002-000

Goldin, Nan
Self-portrait in the blue bathroom
at Storckwinkel, Berlin
1991
Color photograph, Ilfochrome
50 x 60 cm
Edition of 25
Inv. No. 210-007-000

Graham, Dan
Above: House, Outside of
Pittsburgh
1993
Below: "Neo-Colonial" Garage,
Westfield, N. J.
1978
Color photograph, C-print
82 x 62 cm
Unique print
Inv. No. 318-002-000

Graham, Rodney
Ponderosa Pine IV
1991
Color photograph, C-print
210 x 180 cm
Edition of 2
Inv. No. 346-001-000

Grauerholz, Angela
Basel
1986
Black-and-white photograph,
gelatine silver print
148 x 100 cm
Edition of 3
Inv. No. 012-001-000

Grčić, Tamara
Untitled
1995
From the series
New York
1995
Color photograph, C-print
50.8 x 61 cm
Edition of 6
Inv. No. 291-001-000

Gursky, Andreas
Charles de Gaulle, Paris
1992
Color photograph, C-print
165 x 200 cm
Edition of 4
Inv. No. 303-001-000

Hanzlová, Jitka
Untitled
1995/96
From the series
bewohner
1995/96
Color photograph, C-print
40 x 30 cm
Edition of 8
Inv. No. 303-001-000

Hartley, Alex
Untitled (Three Part Division)
1992
Black-and-white photograph,
etched glass
consisting of 3 parts
150 x 150 x 31 cm
Unique work
Inv. No. 017-001-003

Häusser, Robert
Platz am Stadtrand
1980
Black-and-white photograph
60 x 80 cm
Inv. No. 279-003-000

Helnwein, Gottfried
Kinderhand
1993
From the 41-part installation
Kinderhand und Kindergesichter
1993
Oil on canvas
210 x 150 cm
Original
Inv. No. 070-031-041

Helnwein, Gottfried
Kindergesicht
1993
From the 41-part installation
Kinderhand und Kindergesichter
1993
Color photograph, C-print,
Plexiglas, iron
20 x 15 x 5 cm
Unique print
Inv. No. 070-031-001/002

Helnwein, Gottfried
Kindergesicht
1993
From the 41-part installation
Kinderhand und Kindergesichter
1993
Color photograph, C-print,
Plexiglas, iron
20 x 15 x 5 cm
Unique print
Inv. No. 070-031-003/004

Henning, Anton
Room with a View
1995
Color photograph, Ilfochrome
100 x 120 cm
Edition of 5
Inv. No. 229-001-000

Henson, Bill
Untitled, (#27/77)
1990/91
From the series
Works for the Paris Opera
1990/91
Color photograph, C-print
145 x 127 cm
Edition of 10
Inv. No. 074-001-000

Hershman, Lynn
Phantom Limb #16
1990
From the series
Phantom Limb
1990
Black-and-white photograph,
gelatine silver print
80 x 110 cm
Edition of 20
Inv. No. 209-002-002

Hilliard, John
Distorted Vision (A)
1991
Color photograph, Ilfochrome
140 x 123 cm
Unique print
Inv. No. 242-001-000

Hockney, David
Prehistoric Museum Near
Palm Springs
Sept. 1982
Black-and-white photograph,
collage
214.6 x 143.5 cm
Edition of 10
Inv. No. 355-001-000

Höfer, Candida
Abteiberg St. Benediktusberg
Vaals I
1993
Color photograph, C-print
35 x 36 cm
Edition of 6
Inv. No. 080-007-000

Hoover, Nan
Coming and Going
1980
Color photograph, C-print
42 x 124 cm
Edition of 15
Inv. No. 345-002-000

Horsfield, Craigie
Ulica Papiernicza, Kraków,
February 1989
1989
Black-and-white photograph,
gelatine silver print
140 x 140 cm
Unique print
Inv. No. 311-001-000

Hutchinson, Peter
February, 1978
From the series
Working Drawing for "Year"
1978
Color photograph, collage,
consisting of 12 parts
50 x 38.5 cm
Unique print
Inv. No. 068-002-000

Hütte, Axel
Montevarchi
1992
Color photograph, C-print
98 x 120 cm
Edition of 10
Inv. No. 044-007-000

Iturbide, Graciela
Cementerio, Juchitan
1988
Black-and-white photograph
32.2 x 21.4 cm
Inv. No. 358-001-000

Jacobson, Bill
Song of Sentient Beings (#1588)
1995
Black-and-white photograph,
gelatine silver print
92 x 72 cm
Edition of 5
Inv. No. 244-002-000

Jetelová, Magdalena
Untitled
1992
From the series
Island Projekt
1992
Black-and-white photograph
45 x 30 cm
Edition of 10
Inv. No. 235-013-000

Jin Ming, DoDo
Agrigento, Sicily
1991
From
Stone Series (1–20)
Black-and-white photograph,
colored
61 x 51 cm
Edition of 15
Inv. No. 345-002-000

Kabakov, Ilya
10 Personages, Installations
1994
Corridor in installation
The man who flew into space
from his apartment
Installation view
The short man
The collector
The man who saves Nikolai
Victorovich
The composer
The man who never threw
anything away
The untalented artist
The man who collects the
opinions of others
The man who flew into his
picture
The person who describes his
life through characters
Silkscreen
consisting of 12 parts
7 parts, each 50 x 70 cm
5 parts, each 70 x 50 cm
Edition of 25
Inv. No. 133-001-010

Keetman, Peter
1001 Gesichter
1957
Black-and-white photograph,
gelatine silver print
50 x 40 cm
Inv. No. 195-002-000

Klauke, Jürgen
Self-Performance
1972/73
Black-and-white photograph
consisting of 13 parts
each 57 x 42 cm
Edition of 50
Inv. No. 020-026-000

Klein, Astrid
Gedankenchips
1983
Black-and-white photograph,
gelatine silver print
126 x 208 cm
Edition of 2
Inv. No. 064-002-000

Klemm, Barbara
Scorteni, Moldavia
1991
From the series
Blick nach Osten
1970 – 1995
Black-and-white photograph,
gelatine silver print
53 x 63 cm
Inv. No. 245-011-000

Knoebel, Imi
Für Olga Lina
1974
Black-and-white photograph
consisting of 54 parts
each 30.5 x 30.5 cm
Edition of 17
Inv. No. 139-001/(001-054)

Kruger, Barbara
Not Angry Enough
1997
Silkscreen on vinyl
277 x 277 cm
Unique print
Inv. No. 353-001-000

Kulik, Zofia
The Splendour of Myself (I)
1997
Black-and-white photograph,
multiple exposure
182 x 152 cm
Edition of 2
Inv. No. 356-001-000

Lafont, Suzanne
Passante
1995/96
From the series
Le Défilé
1995/96
Serigraph
consisting of 4 parts
106 x 359.5 cm
Edition of 3
Inv. No. 357-001-000

Lafontaine, Marie-Jo
Der Augenblick des Überlebens
ist der Augenblick der Macht
1989
Black-and-white photograph,
gelatine silver print,
varnished woodpanel
consisting of 4 parts
160 x 320 cm
Unique work
Inv. No. 021-001/(001-004)

Lawler, Louise
It could be Elvis, MP # 353
1994
Color photograph, C-print
70.8 x 85 cm
Inv. No. 336-001-000

Le Gac, Jean
Les jardins et le peintre
1977
Mixed media
consisting of 10 parts
9 parts, each 40 x 40 cm
one text, 60 x 50 cm
Edition of 3
Inv. No. 337-013-010

Levine, Les
Consume or Perish,
New York Subway
1989
Color photograph, Cibachrome
40 x 50 cm
Unique print
Inv. No. 050-004-000

Levine, Sherrie
After Degas
1987
From the series
After Degas
1987
Duotone lithograph
each 66 x 53 cm
Edition of 35
Inv. No. 104-001-005

Levitt, Helen
New York
1980
Color photograph, dye transfer
35 x 42.5 cm
Inv. No. 304-002-000

Lissel, Edgar
Olympiastadion, Berlin,
1994
Color photograph,
color negative
125 x 250 cm
Unique print
Inv. No. 177-001-000

Lüscher, Ingeborg
Untitled (IF–II)
1993
Color photograph, Ilfochrome
54.3 x 73.3 cm
Edition of 3
Inv. No. 323-001-000

Lüthi, Urs
Self-Portrait
1976
Black-and-white photograph
on photo linen
consisting of 3 parts
85 x 375 cm
Unique print
Inv. No. 328-001-003

Mapplethorpe, Robert
Self-Portrait
1988
Black-and-white photograph,
gelatine silver print
50.8 x 61 cm
Edition of 10
Inv. No. 214-011-000

Mayer, Maix
New York
1993
From the project
Gullivers Reisen
1993
Black-and-white photograph,
gelatine silver print
100 x 122 cm
Edition of 3
Inv. No. 212-001-000

McBride, Will
"Hair"-Darsteller in Pappkartons,
München
1968
Black-and-white photograph,
gelatine silver print
70 x 85
Inv. No. 168-061-000

Merkel, Florian
Erfahrung
1995
Black-and-white photograph,
gelatine silver print,
hand-colored
138 x 105 cm
Edition of 2
Inv. No. 228-003-000

Miller, John
Untitled
1995/96
4 motifs from the series
The Middle of the Day
1995/96
Color photograph, C-print
each 19 x 15 cm
Unique print
Inv. No. 335-001-000

Moffatt, Tracey
Untitled
1989
From the series
Something More
1989
Color photograph, Cibachrome
105 x 150 cm
Edition of 30 + 1
Inv. No. 304-027-004

Müller-Pohle, Andreas
Berlin/Kreuzberg
1992
From the series
Perlasca Pictures
1992/97
Black-and-white photograph,
gelatine silver print
40 x 50 cm
Inv. No. 347-005-000

Muñoz, Isabel
Untitled
1993
From the series
Flamenco
1993
Black-and-white photograph,
60 x 80 cm
Edition of 25
Inv. No. 305-001-009

Neusüss, Floris M.
Tanz
1965
Photogram on linen
consisting of 3 parts
250 x 255 cm
Unique print
Inv. No. 281-002-003

Niedermayr, Walter
Punta roca IV
1994
Color photograph, C-print
consisting of 2 parts
each 80 x 100 cm
Edition of 6
Inv. No. 230-038-002

Orlopp, Detlef
Untitled
1987
Black-and-white photograph,
gelatine silver print
57 x 50.5 cm
Unique print
Inv. No. 218-001-000

Orozco, Gabriel
Green Ball
1995
Color photograph, Ilfochrome
40 x 50 cm
Edition of 5
Inv. No. 224-001-000

Poirier, Anne and Patrick
Wounds
1996/97
From the 12-part series
Fragility
1996/97
Color photograph, Ilfochrome
each 60 x 40 cm
Edition of 7
Inv. No. 315-002-012

Poirier, Anne and Patrick
Sex
1996/97
From the 12-part series
Fragility
1996/97
Color photograph, Ilfochrome
each 60 x 40 cm
Edition of 7
Inv. No. 315-001-012

Polke, Sigmar
Wiederbelebungsversuch an
Bambusstangen
1968
Black-and-white photograph
60 x 50 cm
Unique print
Inv. No. 320-001-000

Prince, Richard
Untitled
1982 – 1984
Color photograph, C-print
50 x 61cm
Edition of 2
Inv. No. 130-001-000

Prince, Richard
Untitled
1982 – 1984
Color photograph, C-print
61 x 50 cm
Edition of 2
Inv. No. 130-002-000

Prince, Richard
Untitled
1982 – 1984
Color photograph, C-print
61 x 50 cm
Edition of 2
Inv. No. 130-003-000

Prinz, Bernhard
Alba
1991
From the portfolio
Sieben Gefässe
1991
Color photograph, Ilfochrome
40 x 30 cm
Edition of 12 + III
Inv. No. 025-004-000

Rainer, Arnulf
Gewitter
1993
Drypoint engraving on
heliogravure
54 x 58 cm
Edition of 35
Inv. No. 059-005-000

Rambow, Inge
Wüstungen bei Knautheim,
Sachsen
1991
Color photograph, Ilfochrome
103 x 119 cm
Edition of 5
Inv. No. 232-014-000

Rauschenberg, Robert
Photem Series I (4)
1981
Black-and-white photograph,
gelatine silver print, collage
138.4 x 119.4 cm
Unique print
Inv. No. 029-015-000

Rauschenberg, Robert
9-81-Q-13 (NYC)
1981
From the series
In and Out City Limits:
New York/Boston
1981
Black-and-white photograph,
gelatine silver print
48 x 32 cm
Edition of 50
Inv. No. 029-005-000

Rauschenberg, Robert
9-81-L-32 (NYC)
1981
From the series
In and Out City Limits:
New York/Boston
1981
Black-and-white photograph,
gelatine silver print
32 x 48 cm
Edition of 50
Inv. No. 029-008-000

Rheims, Bettina
9 Octobre, Paris
no date
From the series
Chambre Close
no date
Color photograph, Cibachrome
86 x 86 cm
Edition of 3
Inv. No. 333-001-000

Richon, Olivier
Homo Bulla
1991
Color photograph, Ilfochrome
120 x 80 cm
Edition of 5
Inv. No. 238-004-000

Richter, Evelyn
Kunstausstellung des VBK,
Dresden
1983
From the series
Ausstellungsbesucher
Black-and-white photograph
40 x 30 cm
Inv. No. 221-007-000

Richter, Gerhard
2.5.89 – 7.5.89
1991
Portfolio
consisting of 6 photographs
Black-and-white photograph,
gelatine silver print
each 35 x 50.8 cm
Edition of 50
Inv. No. 040-003-006

Rinke, Klaus
Documenta Kassel
1972
Black-and-white photograph
130 x 70 cm
Inv. No. 222-003-000

Rio Branco, Miguel
Untitled
1995
Color photograph, Ilfochrome
110 x 110 cm
Edition of 3
Inv. No. 161-003-000

Roehr, Peter
Untitled, (FO-56)
1966
Paper sealed in plastic
42 x 43.5 cm
Unique print
Inv. No. 296-003-000

Rosenbach, Ulrike
Wachshörnerhaube
1972
Black-and-white photograph
consisting of 5 parts
each 51 x 61 cm
Unique print
Inv. No. 024-005-001

Rousse, Georges
Tsukamaro, Japan
1995
Color photograph, Ilfochrome
120 x 160 cm
Edition of 3
Inv. No. 223-009-000

Ruff, Thomas
Nacht 11 II
1992
Color photograph, Ilfochrome
189 x 189 cm
Edition of 2
Inv. No. 028-001-000

Ruff, Thomas
Anderes Porträt Nr. 50/29
1994/95
Silkscreen
200 x 150 cm
Edition of 3
Inv. No. 028-004-000

Ruff, Thomas
Anderes Porträt Nr. 109/55
1994/95
Silkscreen
200 x 150 cm
Edition of 3
Inv. No. 028-005-000

Salgado, Sebastião
Serra Pelada: The Number Eight
1986
From the series
Workers
Black-and-white photograph,
gelatine silver print
120 x 80 cm
Inv. No. 309-013-000

Sasse, Jörg
5744, 1995
Color photograph, C-print
62 x 87 cm
Edition of 6
Inv. No. 083-013-000

Schmidt, Michael
Untitled
1980
From the series
Innenaufnahmen
1979 – 1980
Black-and-white photograph,
gelatine silver print
99.8 x 71.5 cm
Edition of 3
Inv. No. 182-001-000

Scully, Sean
Untitled
1990 – 1997
From the series
Harris and Lewis Shacks
1990 – 1997
Color photograph, C-print
50.8 x 61 cm
Edition of 24 + 5
Inv. No. 319-001-024

Sherman, Cindy/
Prince, Richard
Double Portrait
1980
Color photograph, C-print
consisting of 2 pieces
each 50 x 80 cm
Edition of 10
Inv. No. 184-005-002

Sherman, Cindy
Untitled, #69
1980
Color photograph, C-print
50 x 60 cm
Edition of 5
Inv. No. 184-001-000

Sherman, Cindy
Untitled, #75
1980
Color photograph, C-print
50 x 60 cm
Edition of 5
Inv. No. 184-002-000

Shore, Stephen
Broad Street, Regina,
Saskatchewan
August 17, 1974
Color photograph, C-print
19.5 x 24.5 cm
Inv. No. 253-001-000

Sieverding, Katharina
Nachtmensch
1982
Color photograph, C-print
300 x 500 cm
Unique print
Inv. No. 030-004-000

Sieverding, Katharina
Steigbild I/1–3
1997
Color photograph, D-print
300 x 375 cm
Unique print
Inv. No. 030-002-000

Sieverding, Katharina
Steigbild III/1–3
1997
Color photograph, D-print
300 x 375 cm
Unique print
Inv. No. 030-003-000

Simpson, Lorna
Two Frames
1990
Black-and-white photograph,
gelatine silver print,
plastic label
consisting of 2 parts
89 x 178 cm
Edition of 4
Inv. No. 290-007-002

Štrba, Annelies
Hiroshima mon amour
1994
Color photograph, C-print
100 x 150 cm
Edition of 3
Inv. No. 341-003-000

Streuli, Beat
Untitled (USA 95)
1995
Color photograph, C-print
95 x 124 cm
Edition of 3
Inv. No. 203-051-000

Struth, Thomas
Musée du Louvre III, Paris
1989
Color photograph, C-print
152 x 168 cm
Edition of 10
Inv. No. 084-002-000

Sugimoto, Hiroshi
Black Sea, Ozuluce
1991
Black-and-white photograph
58 x 64 cm
Edition of 25
Inv. No. 031-005-000

Tillmans, Wolfgang
Smokin' Jo, window
1995
Color photograph
60 x 50 cm
Edition of 3 + 1
Inv. No. 206-002-000

Turrell, James
Overall Site,
Plan with White Bowl
1992
Mixed media, photo emulsion,
wax, acrylic, and ink on Mylar
103 x 200 cm
Unique work
Inv. No. 143-001-000

Uecker, Günther/
Schroeter, Rolf
Untitled
1991
From the 22-part series
Entwicklung eines Werkes,
Fotoumwandlungen
1991
Black-and-white photograph,
acrylic applied by hand
61 x 51 cm
Unique work
Inv. No. 127-006-022

Vostell, Wolf
Phantom Savings Bank
1968 – 1971
Original printer's film behind
Plexiglas
106 x 188 cm
Unique print
Inv. No. 322-001-000

Warhol, Andy
Andy Warhol, Self-Portrait,
Montauk, Long Island
1976 – 1979
From the series
Social Disease – Photographs,
'76 – '79
Black-and-white photograph
30.5 x 43.2 cm
Edition of 250
Inv. No. 063-010-000

Warhol, Andy
His Holiness Pope John Paul II,
St. Peter's Square, Rome
1976 – 1979
From the series
Social Disease – Photographs,
'76 – '79
Black-and-white photograph
43.2 x 30.5 cm
Edition of 250
Inv. No. 063-002-000

Warhol, Andy
Bianca Jagger at Halston's
House, New York
1976 – 1979
From the series
Social Disease – Photographs,
'76 – '79
Black-and-white photograph
43.2 x 30.5 cm
Edition of 250
Inv. No. 063-001-000

Waters, John
Peyton Place – The Movie
1993
Peyton Place – The Documentary
1994
Color photograph, C-print
each 19 x 210 cm
Edition of 7
Inv. No. 227-001-002

Wegman, William
Details
From the piece
Letters, Numbers and
Punctuation
1993
Black-and-white photographs,
gelatine silver print
consisting of 44 parts
each 27.7 x 21.4 cm
Edition of 26
Inv. No. 082-001/(001-044)

Wittenborn, Rainer
Detail
From the series
Architettura Spontanea I
1986/97
Black-and-white photographs
each 30 x 40 cm
From the portfolio
Architettura Spontanea I
1986/97
Architettura Influenzata II
1986/97
Black-and-white photographs,
color photographs
each 30 x 40 cm
Edition of 2
Inv. No. 348-001/(001-053)

Wittenborn, Rainer
Detail
From the series
Architettura Influenzata II
1986/97
Black-and-white photographs
each 30 x 40 cm
From the portfolio
Architettura Spontanea I
1986/97
Architettura Influenzata II
1986/97
Black-and-white photographs,
color photographs
each 30 x 40 cm
Edition of 2
Inv. No. 348-001/(001-053)

Biographies

Dennis Adams

1948	Born in Des Moines, Iowa
since 1978	Public works
	Lives in New York

Solo Exhibitions

1979	Artists Space, New York
1990	Hirshhorn Museum and Sculpture Center, Washington, D.C.
1991	The Museum of Modern Art, New York
1993	Portikus, Frankfurt a.M.
1994	Museum van Hedendaagse Kunst, Antwerp
1995	Contemporary Arts Museum, Houston

Group Exhibitions

1985	The Artist as Social Designer, **Los Angeles County Museum of Art**
1989	**International Photo Triennial, Esslingen**
1990	Rhetorical Image, **New Museum of Contemporary Art, New York**
1992	C'est pas la fin du monde, **Galerie du Théâtre National de Bretagne, Rennes**
1993	Licht-Räume, **Museum Folkwang, Essen**
1998	Do All Oceans Have Walls? **Gesellschaft für aktuelle Kunst, Bremen**

Further Reading

"Dennis Adams, Patricia Hearst: A thru Z," So & So, **Summer/Fall 1980, title page.** The Architecture of Amnesia, **Kent Fine Art, New York, 1990** Passages de l'image, **Centre Georges Pompidou, Paris; Centro Cultural de la Fundació Caixa de Pensiones, Barcelona, 1990** Images in Transition: Photographic Representation in the Eighties, **National Museum of Modern Art, Tokyo, 1990** Blake Stimson, "Slow Provocation: An Interview with Dennis Adams," Views – The Journal of Photography in New England, **Winter 1992**

Dieter Appelt

1935	Born in Niemegk near Potsdam, Germany
1958	Studies singing and photography in Berlin
1961–79	Baritone at the Deutsche Oper, Berlin
1982	Professor of Fine Arts at the Hochschule der Künste, Berlin
	Lives in Berlin

Solo Exhibitions

1981	Galerie Springer, Berlin
1986	Stedelijk Museum, Amsterdam
1988	Neuer Berliner Kunstverein, Berlin
1995	Guggenheim Museum, SoHo, New York
1994–96	The Art Institute of Chicago; Staatliche Museen zu Berlin et al.
1998	Galerie Chobot, Vienna

Group Exhibitions

1990	Gegenwart – Ewigkeit: Spuren des Transzendenten in der Kunst unserer Zeit, **Martin-Gropius-Bau, Berlin**
1991	**Venice Biennial**
1992	**International Photo Triennial, Esslingen**
1996	**Prospect '96, Frankfurt a.M.**
1997	Deutsche Fotografie: Macht eines Mediums 1870 – 1970, **Bundeskunsthalle, Bonn**
1998	Blumen für Anita, **Galerie Neugebauer, Basel**

Further Reading

Dieter Appelt: Die Symmetrie des Schädels, **Galerie Georg Nothelfer, Berlin, 1977** Dieter Appelt: Die Präsenz der Dinge in der Zeit, **Galerie Hermeyer, Munich, 1985** Skulpturen und Fragmente, Internationale Fotoarbeiten der 90er Jahre, **Wiener Secession, Vienna, 1992** Dieter Appelt, **The Art Institute of Chicago et al., 1994 – 1996** Dieter Appelt, **The Art Institute of Chicago, Kunstbibliothek, Berlin, 1996**

Nobuyoshi Araki

1940	Born in Tokyo
1959–63	Studies photography and film at Chiba University, Tokyo
since 1970	Freelance artistic photography
1976	Founds and teaches at an independent school of photography
	Lives in Tokyo

Solo Exhibitions

1965	Shinjuku Train Station, Tokyo
1970	**First** Kitchen Ramen Ero-realism **exhibitions** in a noodle parlor in Ginza, Tokyo
1992	Forum Stadtpark, Graz et al.
1995	Fondation Cartier, Paris; Kunstmuseum Wolfsburg
1997	Wiener Secession, Vienna et al.

Group Exhibitions

1977	Neue Fotografie aus Japan, **Kulturhaus Graz**
1979	Japan: A Self-Portrait, **Center of Photography, New York**
1990	**Photography Biennial, Rotterdam**
1993	Das Bild des Körpers, **Frankfurter Kunstverein, Frankfurt a.M.**
1995	Sites of Being, **Institute of Contemporary Art, Boston**
1996	Szenenwechsel X, **Museum für Moderne Kunst, Frankfurt a.M.**

Further Reading

Nobuyoshi Araki – Akt-Tokyo 1971 – 1991, **Graz, Edition Camera Austria, 1992** Nobuyoshi Araki – Tokyo Novelle, **Kunstmuseum Wolfsburg, 1995** Nobuyoshi Araki: Shijyo – Tokyo – Markt der Gefühle, **Zdenek Felix (ed.) Deichtorhallen, Hamburg, 1998**

Roy Arden

1957	Born in Vancouver
1982	Degree from the Emily Carr College of Art and Design
1990	M.A., University of British Columbia, Vancouver
	Lives in Vancouver

Solo Exhibitions

1983	OR Gallery, Vancouver
1985	Halle Süd, Geneva
1989	Hippolyte, Helsinki
1990	Galerie Giovanna Minelli, Paris
1997	Art Gallery of York University, Ontario
1998	Morris & Helen Belkin Art Gallery, University of British Columbia, Vancouver

Group Exhibitions

1988	Behind the Sign, **Artspeak, Vancouver**
1989	Foto-Kunst, **Staatsgalerie, Stuttgart**
1990	150 Ans de Photographie, **Musée des Beaux-Arts, Nantes; Photography Biennial, Rotterdam**
1995	The Friendly Village, **Milwaukee Institute of Art and Design**
1998	UBC Photo Collection – Recent Acquisitions, **Vancouver**

Further Reading

Tom Folland, The Discursive Field of Recent Photography, **Artculture Resource Center, Toronto, 1989** Monika Gagnon, "Ruptures in the Landscape of the Photograph," Thirteen Essays on Photography, **Canadian Museum of Contemporary Photography, Ottawa, 1990** Antonio Guzman, "Roy Arden – Archives Instables," Artpress, **no. 155, February 1991** Jeff Wall, "Roy Arden: An Artist and His Models," Parachute, **April 1994**

John Baldessari

1931 Born in National City, California
1949–57 Studies at San Diego State College
1953/54 Director of the Fine Arts Gallery, San Diego
1962–71 Instructor at the University of California, San Diego, and at Hunter College, New York (1971)
Lives in Santa Monica

Solo Exhibitions

1971 Galerie Konrad Fischer, Düsseldorf
1981 Museum Folkwang, Essen
1988 Kestner Gesellschaft, Hanover
1990 Museum of Contemporary Art, Los Angeles
1994 The Museum of Modern Art, New York
1998 Museum für Gegenwartskunst, Basel

Group Exhibitions

1972 documenta 5, Kassel
1978 Art about Art, Whitney Museum, New York
1993 The Mediated Image, University Art Museum, New Mexico Art Museum, Albuquerque
1994 In the Field: Landscape in Recent Photography, Margo Leavin Gallery, Los Angeles; Sonnabend Gallery, New York
1996 Prospect '96, Frankfurt a. M.
1998 Elusive Paradise, Museum of Contemporary Art, Los Angeles

Further Reading

John Baldessari, The New Museum, New York, 1981
John Baldessari: California Viewpoints, Santa Barbara Museum of Art, Santa Barbara, California, 1986
On the Art of Fixing a Shadow, National Gallery of Art, Washington, D. C., 1989
Coosje van Bruggen, John Baldessari, The Museum of Contemporary Art, Los Angeles and New York, 1990
"Collaboration: John Baldessari & Cindy Sherman," Parkett, no. 29, 1991

Lewis Baltz

1945 Born in Newport Beach, California
1969 B. F. A., San Francisco Art Institute
1970 M. F. A., Claremont Graduate School
1980 Exchange Fellowship within the framework of the United States – United Kingdom Bicentennial
Lives in California and Europe

Solo Exhibitions

1975 Leo Castelli Gallery, New York
1985 Victoria and Albert Museum, London
1992 Centre Georges Pompidou, Paris; Stedelijk Museum, Amsterdam
1993 Musée d'Art Moderne de la Ville de Paris; Fotomuseum Winterthur
1995 Louisiana Museum of Modern Art, Humlebaek
1998 Museum of Contemporary Art, Los Angeles

Group Exhibitions

1980 Fotografie als Kunst: Kunst als Fotografie, Museum Moderner Kunst, Vienna
1985 American Images, Barbican Art Gallery, London
1993 Critical Landscapes, Tokyo Museum of Photography
1996 Prospect '96, Frankfurt a. M.
1997 Photography after Photography, Institute of Contemporary Art, Philadelphia et al.
1998 Fünf Komma Fünf, Fotomuseum Winterthur

Further Reading

Colin Westerbeck, "Photography Now," Artforum, January 1979
Marina Vesey, "The Camera in America," The Sunday Times, London, May 12, 1985
Rule Without Exceptions, Fotomuseum Winterthur, Zurich, New York, 1993
"Extracts From 3 Videos 1992 – 1994," EIKON, no. 112/13, 1995

Robert Barry

1936 Born in the Bronx, New York
1957 B. F. A., Hunter College, New York
1963 M.A.
Lives in Teaneck, New Jersey

Solo Exhibitions

1964 Westerly Gallery, New York
1972 Tate Gallery, London
1978 Museum Folkwang, Essen
1987 Galleria Christian Stein, Turin (with Lawrence Weiner)
1990 Haags Gemeentemuseum, The Hague
1995 Galerie Bugdahn und Kaimer, Düsseldorf
1997 Indianapolis Museum of Art
1998 Galerie Yvon Lambert, Paris

Group Exhibitions

1969 When Attitudes Become Form, Stedelijk Museum, Amsterdam et al.
1971 Artist, Theory, and Work, Kunsthalle Nürnberg, Nuremberg
1972 documenta 5, Kassel
1974 Concept Art, Kunstverein Braunschweig, Brunswick
1995 Attitudes Sculptures, Musée d'Art Contemporain, Bordeaux
1998 Sans Titre à Dix Ans, Musée d'Art Moderne de Lille Métropole, Lille

Further Reading

Robert Pincus-Witten, "Systematic Painting," Artforum, November 1966
Lucy R. Lippard, 6 Years: The Dematerialization of the Art Object from 1966 to 1972, New York, 1973
Robert Barry – Ein Künstlerbuch, Erich Franz (ed.), Bielefeld, 1986
Robert Barry – Going Through, Lille, 1996

Gabriele Basilico

1944 Born in Milan
1973 Completes his study of architecture at the polytechnic in Milan; starts working as a professional photographer
Lives in Milan

Solo Exhibitions

1977 Galleria Civica, Modena
1982 The Architectural League, New York
1983 Padiglione d'Arte Contemporanea, Milan
1987 XVIII Rencontres Internationales de la Photographie, Arles
1988 Philippe Daverio Gallery, New York
1992 Musée de l'Elysée, Lausanne et al.
1997 Storefront for Art and Architecture, New York
1998 Retrospective, Chapter the Photogallery, London

Group Exhibitions

1984 Paysages Photographiques, Mission Photographique de la D. A. T. A. R., French national project on contemporary French landscape
1986 Urban Landscapes, Galleria Perspektief, Rotterdam
1991 Beirut, Palais de Tokyo, Paris
1997 Kwangju Biennial, South Korea; Points de Vue Européenne, Maison Européenne de la Photographie, Paris; Zürich – Ein Fotoportrait, Kunsthaus Zürich, Zurich

Further Reading

L'Italie aujourd'hui, Omar Calabrese (ed.), Centre National d'Art Contemporain, Villa Arson, Nice, 1985
La ciudad fantasma, Marta Gili (ed.), Fundació Joan Miró, Barcelona, 1985
Italo Zannier, Storia della fotografia italiana, Bari, 1987
Roberta Valtorta, "Gabriele Basilico," Camera Austria, no. 27, 1988

Thomas Bayrle

1937 Born in Berlin
1958–61 Studies at the Werk-
kunstschule Offenbach
1961–65 Founds Gulliver-Presse
publishers with
Bernhard Jäger,
Bad Homburg
since 1975 Teacher at the Städel-
schule, Hochschule für
Bildende Künste,
Frankfurt a. M.
Lives and works in
Frankfurt a. M.

Solo Exhibitions

1980 UNAC, Tokyo
1984 Museum am Ostwall,
Dortmund
1988 Kunsthalle Innsbruck
1989 Pinsel durchgespielt,
Kunstverein Freiburg
1990 Portikus, Frankfurt a. M.
1997 Museum für Moderne
Kunst, Frankfurt a. M.
1998 Galerie Ute Parduhn,
Düsseldorf

Group Exhibitions

1964 documenta 3, Kassel
1967 Serielle Formationen,
Studio Galerie, Univer-
sität Frankfurt a. M.
1975 Der Einzelne und die
Masse, Kunsthalle
Recklinghausen
1977 documenta 6, Kassel
1984 von hier aus, Conven-
tion Center, Düsseldorf
1994 Vision Urbaines, Centre
Georges Pompidou,
Paris

Further Reading

Egoist, vol. 16, no. 1, 1969
Thomas Bayrle – Rasterfahndung,
Frankfurt a. M., 1981
Thomas Bayrle – Druckgrafik
1960 – 1983, Städtische Galerie
Wolfsburg, 1983
Bayrle – Big Book, Cologne, 1992
Thomas Bayrle, Schriften zur
Sammlung des Museums
für Moderne Kunst,
Frankfurt a. M., 1994
Thomas Bayrle – Grafik von
1967 – 72 und animierte Grafik
von 1979 – 94, Cologne, 1995

Bernd Becher

1931 Born in Siegen,
Germany
1953–56 Studies at the Kunst-
akademie Stuttgart
since 1976 Professor of photogra-
phy at the Kunst-
akademie Düsseldorf

Hilla Becher

1934 Born in Berlin
Photographic training
in Potsdam
1958–61 Studies and establishes
a photography depart-
ment at the Kunst-
akademie Düsseldorf

since 1959 Collaboration

Live and work in
Düsseldorf

Solo Exhibitions

1963 Galerie Ruth Nohl,
Siegen
1985 Museum Folkwang,
Essen et al.
1989 Palais des Beaux-Arts,
Brussels
1991 Cleveland Center for
Contemporary Art,
Cleveland, Ohio
1994 Kunstsammlungen der
Ruhr-Universität,
Bochum

Group Exhibitions

1982 documenta 7, Kassel
1990 Venice Biennial
1991 Museum für Moderne
Kunst, Frankfurt a. M.
1998 Positionen künstlerischer
Fotografie in Deutsch-
land seit 1945, Martin-
Gropius-Bau, Berlin

Further Reading

Anonyme Skulpturen: Form-
vergleiche industrieller Bauten,
Städtische Kunsthalle
Düsseldorf, 1969
Bernd und Hilla Becher –
Wassertürme, Munich, 1988
Bernd und Hilla Becher –
Hochöfen, Munich, 1990

Bill Beckley

1946 Born in Hamburg,
Pennsylvania
Lives in New York

Solo Exhibitions

1972 Holly Solomon Gallery,
New York
1978 The Museum of Modern
Art, New York
1981 International Center of
Photography, New York
1984 Retrospective,
Städtisches Museum,
Mönchengladbach
1998 Galerie Hans Mayer,
Düsseldorf

Group Exhibitions

1976 Venice Biennial
1977 documenta 6, Kassel
1989 Image World: Art Media
and Culture, Whitney
Museum of American
Art, New York
1994 Building a Collection,
Museum of Fine Arts,
Boston

Further Reading

Les Levine, Camera Art, Lunds
Konsthall, Sweden, 1975
Davis Douglas, "After Photog-
raphy," Village Voice, April 1981
Donald B. Kuspit (review), Art
in America, October 1984
Bill Beckley, Galleria Milano,
Milan, 1989
C.S. Roberts, "Rigeur et la
rupture," Kanal Europe,
January 1993

Sibylle Bergemann

1941 Born in Berlin
Trains as a business
clerk;
studies photography
under Arno Fischer;
member of the indepen-
dent photo agency
"Ostkreuz"
since 1994 Member of the Akade-
mie der Künste in Berlin
Lives and works as a
freelance photographer
in Berlin

Solo Exhibitions

1978 Galerie Berlin (Staat-
licher Kunsthandel)
1987 Klub der Kultur-
schaffenden, Berlin
1990 PPS Galerie, Hamburg
1992 Museum für Kunst- und
Kulturgeschichte,
Dortmund
1994 Kulturbrauerei, Berlin
1998 Haus der Land
Brandenburg Lotto
GmbH, Potsdam

Group Exhibitions

1989 Ausgeblendete Realität:
Modephotographie der
DDR, Völkerkunde-
museum, Vienna
1990 Die verwunderte Wirk-
lichkeit, Werkbund
Galerie, Berlin
1993 OSTKREUZ, Deutsches
Historisches Museum,
Berlin
1996/97 Ein Gespenst verlässt
Europa, Goethe
Institute, Nancy
1997 OSTKREUZ, Willy-
Brandt-Haus, Berlin
1998 Deutsche Reportage-
Fotografie, Galerie
Zimmer, Düsseldorf

Further Reading

Sibylle Bergemann – Berlin:
Ein Reise(ver)führer,
Rudolstadt, 1980
Sibylle Bergemann – Ein
Gespenst verlässt Europa,
Cologne, 1990
Sibylle Bergemann – Mode Foto
Mode, Heidelberg, 1992
Sibylle Bergemann – Das
Chinesische Teehaus in Potsdam-
Sanssoucci, Berlin, 1993

Joseph Beuys

1921	Born in Krefeld, Germany
1947–51	Studies under Ewald Mataré and others at the Kunstakademie Düsseldorf
1961–72	Professor at the Kunstakademie Düsseldorf
1963	First Fluxus Action
1986	Wilhelm Lehmbruck Prize from the city of Duisburg
1986	Dies in Düsseldorf

Solo Exhibitions

1967	Städtisches Museum Abteiberg, Mönchengladbach
1970	Hessisches Landesmuseum, Darmstadt
1974	Galerie René Block, New York; Museum of Modern Art, Oxford et al.
1979	Retrospective, Solomon R. Guggenheim Museum, New York
1993	Kunsthaus Zürich, Zurich

Group Exhibitions

1964–82	documenta 3 – 7, Kassel
1980	Venice Biennial
1981	Westkunst, Convention Center, Cologne
1982	Zeitgeist, Martin-Gropius-Bau, Berlin
1983	Der Hang zum Gesamtkunstwerk, Kunsthalle and Kunstverein, Düsseldorf

Further Reading

Joseph Beuys: Richtkräfte, **Nationalgalerie Berlin, 1977** **Caroline Tisdall**, Joseph Beuys, **New York, 1979** **Heiner Stachelhaus**, Joseph Beuys, **Düsseldorf, 1987** Joseph Beuys: Der erweiterte Kunstbegriff, **Matthias Bleyl (ed.), Darmstadt, 1989** Joseph Beuys, **Kunsthaus Zürich, Zurich, 1993** Joseph Beuys: Die Aktionen, **Uwe M. Schneede (ed.), Ostfildern, 1994** Beuys in America, **Klaus Staeck (ed.), Heidelberg, 1997**

Anna Blume

1937	Born in Bork, Germany
1960–65	Studies art at the Kunstakademie Düsseldorf
since 1964	Art teacher at various German high schools

Bernhard Blume

1937	Born in Dortmund
1960–66	Studies art at the Kunstakademie Düsseldorf
1967–71	Studies philosophy at the Universität Köln, Cologne Teaches for approx. 15 years at a high school in Cologne
since 1980	Intensive collaboration with Anna Blume on a "lifelong photo novel"

Live and work in Cologne and Hamburg

Solo Exhibitions

1988	Rheinisches Landesmuseum, Bonn
1991	Kunstverein Ruhr, Essen et al.
1995	Kunsthalle Bremen
1996	Kestner Gesellschaft, Hanover

Group Exhibitions

1980	Venice Biennial
1984	von hier aus, Convention Center, Düsseldorf
1998	Szenenwechsel XIV, Museum für Moderne Kunst, Frankfurt a. M.

Further Reading

Peter Weibel, Anna und Bernhard Blume – Vasen-Extasen, **MMK, Frankfurt a. M., 1991** Anna and Bernhard Blume, Grossfotoserien 1985 – 1990, **Klaus Honnef (ed.), Cologne, 1992** Transzendentaler Konstruktivismus/Im Wald, **Cologne, 1995** Transsubstanz und Küchenkoller, **Carl Haenlein (ed.), Kestner Gesellschaft, Hanover, 1996**

Christian Boltanski

1944	Born in Paris
1968	First short film: La vie impossible de Christian Boltanski
since 1973	Staging of fictitious existences Lives in Malakoff near Paris

Solo Exhibitions

1976	Centre Georges Pompidou, Paris
1990	Reconstitution, Whitechapel Art Gallery, London
1991	Hamburger Kunsthalle, Hamburg
1995	Kunsthalle Wien, Vienna
1996	Hessisches Landesmuseum, Darmstadt
1998	Musée d'Art Moderne de la Ville de Paris

Group Exhibitions

1986	Venice Biennial
1987	documenta 8, Kassel
1988	Zeitlos, Hamburger Bahnhof, Berlin
1993	Widerstand – Denkbilder für die Zukunft, Haus der Kunst, Munich
1997	Die Epoche der Moderne, Martin-Gropius-Bau, Berlin
1998	Die Rache der Veronika: Die Sammlung Lambert, Deichtorhallen, Hamburg

Further Reading

Nancy Marmer, "Boltanski: The Uses of Contradiction," Art in America, **October 1989** **Günter Metken,** Christian Boltanski – Les Suisses morts, **Schriften zur Sammlung des Museums für Moderne Kunst, Frankfurt a. M., 1991** **Lynn Gumpert,** Christian Boltanski, **Paris, 1992** Gedächtnisbilder – Vergessen und Erinnerung in der Gegenwartskunst, **Kai Uwe Henken (ed.), Leipzig, 1996**

Rudolf Bonvie

1947	Born in Hoffnungsthal, Germany
1973	Studies at the Kölner Werkschulen, Cologne
1978	Studies philosophy, Universität Köln, Cologne
1993	Instructor at the Universität-Gesamthochschule Essen Lives in Hoffnungsthal and Cologne

Solo Exhibitions

1985	Kunsthalle Bielefeld (with Astrid Klein)
1992	Galerie Schneider, Freiburg
1994	Fotohof, Salzburg
1995	Städtische Galerie Villa Zanders, Bergisch Gladbach
1997	Bibliothèque Municipale de Lyon (with Astrid Klein)
1998	Klaus Hinrichs-Kunstraum, Trier

Group Exhibitions

1982	Württembergischer Kunstverein, Stuttgart
1983	Ansatzpunkte kritischer Kunst heute, Kunstverein Bonn and NGBK, Berlin
1989	Das Foto als autonomes Bild, Kunsthalle Bielefeld
1992	International Photo Triennial, Esslingen
1995	Realität – Anspruch – Medium, Badischer Kunstverein, Karlsruhe et al.
1997	Deutschlandbilder, Martin-Gropius-Bau, Berlin
1998	Fast Forward, Kunstverein Hamburg

Further Reading

Rhapsodie nucléaire II, **Museum Folkwang, Essen, 1988** **S. Wedewer, "Bilder als Projektionen des Betrachters,"** Kritisches Lexikon der Gegenwartskunst, **vol. 22, Munich, 1993** Rudolf Bonvie – Fotoarbeiten, **Städtische Galerie Villa Zanders, Bergisch Gladbach, 1995** RAM – Realität – Anspruch – Medium, **Kunstfonds e.V., Bonn (ed.), Cologne, 1995**

Johannes Brus

1942 Born in Gelsenkirchen, Germany
1964–71 Studies at the Staatliche Kunstakademie in Düsseldorf
1979 Villa Romana, Florence
1986 Professor at the Hochschule für Bildende Künste in Brunswick
Lives in Essen

Solo Exhibitions

1984 Neue Fotoarbeiten, **Galerie Defet, Nuremberg**
1988 Galerie Gmyrek, **Düsseldorf**
1989/90 Fotoarbeiten, **Städtische Galerie Erlangen et al.**
1997 Kunsthalle Recklinghausen
1998 Kunstverein and Kulturamt, Göttingen

Group Exhibitions

1984 Die Gute der Gewohnheit, **CCD-Galerie, Düsseldorf**
1985 PPS Galerie, Hamburg
1986 Momente – Zum Thema Urbanität, **Kunstverein Braunschweig, Brunswick**
1997 Animaux et animaux, **Kunstverein Schaffhausen**
1998 Im Reich der Phantome – Fotografie des Unsichtbaren, **Städtisches Museum Abteiberg et al.**

Further Reading

Johannes Brus – Arbeiten von 1971–1978, **Galerie Defet, Nuremberg, 1979**
Johannes Brus, **Städtische Galerie im Museum Folkwang, Essen, 1983**
Gottfried Jäger, Bildgebende Fotografie, **Cologne, 1988**
Johannes Brus: Fotoarbeiten, **Städtische Galerie, Erlangen, 1990**

Jean-Marc Bustamante

1952 Born in Toulouse
1983–87 Collaborates with Bernard Bazile under the name BAZILEBUSTAMANTE
since 1990 Teaches at the Rijksakademie in Amsterdam
Lives in Paris

Solo Exhibitions

1982 Galerie Baudoin Lebon, Paris
1990 Musée d'Art Moderne de la Ville de Paris; Stichting de Appel, Amsterdam
1992 Stedelijk van Abbe Museum, Eindhoven
1994 Kunstmuseum Wolfsburg
1996 Galerie Nationale du Jeu de Paume, Paris
1997 Villa Arson, Nice
1998 Galerie Xavier Hufkens, Brussels; Galerie Karlheinz Meyer, Karlsruhe

Group Exhibitions

1986 Venice Biennial (Aperto)
1987 L'epoque, la mode, la morale, la passion, **Centre Georges Pompidou, Paris**; Die grosse Oper oder die Sehnsucht nach dem Erhabenen, **Bonner Kunstverein, Bonn**
1987–97 documenta 8–10, **Kassel**
1991 Metropolis, **Martin-Gropius-Bau, Berlin**
1998 Wounds, **Moderna Museet, Stockholm**

Further Reading

Jean-Marc Bustamante – Stationnaires, **Galerie Philip Nelson, Lyon, 1991**
Jean-Marc Bustamante, **Stedelijk van Abbe Museum, Eindhoven, 1992**
Alain Cueff, Der Ort des Werkes, **Kunsthalle Bern, 1992**
Jean-Marc Bustamante – Tableaux 1978–1982, **Kunsthalle Bern et al., 1994**
Jean-Marc Bustamante – A World at a Time, **Kunstmuseum Wolfsburg, 1994**

John Chamberlain

1927 Born in Rochester, Indiana
1951–56 Studies at Black Mountain College in North Carolina
1966 Guggenheim Fellowship
1977 Starts photographing with a panorama camera
Lives in New York and Florida

Solo Exhibitions

1962 Leo Castelli Gallery, New York
1971 Solomon R. Guggenheim Museum, New York
1986 Retrospective, Museum of Contemporary Art, Los Angeles
1991 Staatliche Kunsthalle, Baden-Baden
1996 Stedelijk Museum, Amsterdam
1998 Pace Wildenstein, New York

Group Exhibitions

1964 Venice Biennial
1966 The Art of Assemblage, **The Museum of Modern Art, New York**
1982 documenta 7, Kassel
1991 Seoul Art Festival
1997 Die Entdeckung des Anderen: Ein Europäischer Blick auf die amerikanische Kunst 2, **Museum Moderner Kunst, Frankfurt a. M.**
1998 Die Kunst des Zerreissens, **Bahnhof Rolandseck**

Further Reading

Phyllis Tuchman, "Interview with John Chamberlain," Artforum, **January 1972**
Gary Indiana, "John Chamberlain's Irregular Set," Art in America, **November 1983**
John Chamberlain – A Catalogue Raisonné of the Sculpture 1954–1985, **New York, 1986**
Paul Gardner, "Do Titles Really Matter?" Art News, **February 1992**
John Chamberlain – Current Work and Fond Memories: Sculptures and Photographs 1967–1995, **Stedelijk Museum, Amsterdam, 1996**

Clegg & Guttmann

Michael Clegg and Martin Guttmann were born in 1957 and live in New York and San Francisco. They have been collaborating since 1980.

Solo Exhibitions and Projects

1993 Die offene Bibliothek, **Hamburg and Kunstverein Hamburg**; The Firminy Music Library, **Unité, Firminy, France**
1994 The Museum for the Workplace, **DG BANK, Frankfurt a. M.**; Breaking Down the Boundaries to Life, **New School of Social Research, New York**
1997 The Open Public Speakers' Platform, **Grieskirchen, Austria**; 100 Jahre Erster Zionistenkongress Basel 1897/1997, **Kunsthalle Basel**

Group Exhibitions

1993 Kontext Kunst, **Neue Galerie am Landesmuseum Johanneum, Graz**; Back Stage, **Kunstverein Hamburg**
1994 / + the Other, **Stock Exchange, Amsterdam**
1995 This is Not a Picture, **Emi Fontana, Milan**; Identitá – Alteritá, **Venice Biennial**
1997 Composite Persona, **San Diego State University Art Gallery**
1998 Foundation for the Arts, Sigmund Freud-Museum, Vienna

Further Reading

Clegg & Guttmann, Collected Portraits, **Württembergischer Kunstverein, Stuttgart and Milan, 1988**
Urs Stahel, "Clegg & Guttmann," Kunstforum International, **no. 107, April/May 1990**
Clegg & Guttmann, Die offene Bibliothek, **Achim Könneke (ed.), Ostfildern 1994**

Chuck Close

1940	Born in Monroe, Washington
1962	B.A., University of Washington, Seattle
1962–64	Studies art at Yale University, New Haven, Connecticut
1964–65	Akademie der Bildenden Künste, Vienna
1965–73	Teaches at the School of Visual Arts in New York
1992	Member of the American Academy and Institute of Arts and Letters Lives in New York

Solo Exhibitions

1967	Art Gallery University of Massachusetts, Amherst
1979	Kunstraum München, Munich
1980	Walker Art Center, Minneapolis
1981	Whitney Museum of American Art, New York
1996	The Art Institute of Chicago
1998	The Museum of Modern Art, New York et al.

Group Exhibitions

1972	documenta 5, Kassel; Amerikanischer Fotorealismus, Württembergischer Kunstverein, Stuttgart et al.
1974	Tokyo Biennial
1977	documenta 6, Kassel; Paris – New York, Centre Georges Pompidou, Paris; Whitney Biennial, New York
1995	Identitá – Alteritá, Venice Biennial
1998	The Artist's Eye, National Academy Museum, New York

Further Reading

Chuck Close – Retrospektive, **Stuttgart, 1994**
John Guare, Chuck Close – Life and Work, 1988 – 1995, **London, 1995**
Chuck Close/Paul Cadmus – In Dialogue, **Philadelphia Museum of Art, Philadelphia, 1997**

Hannah Collins

1956	Born in London
1974–78	Slade School of Fine Art, London
1991	European Photography Prize Lives in Barcelona

Solo Exhibitions

1986	Matt's Gallery, London
1988	Galerie 'T Venster, Rotterdam
1993	Tate Gallery, London
1994	Leo Castelli Gallery, New York
1996	Irish Museum of Modern Art, Dublin
1997	Centre National de la Photographie, Paris

Group Exhibitions

1987	Towards a Bigger Picture, Victoria and Albert Museum, London
1988	Venice Biennial (Aperto)
1990	Images in Transition, Museum of Modern Art, Tokyo et al.
1996	Prospect '96, Frankfurt a. M.
1997	Surroundings, Tel Aviv Museum
1998	The City and the Stars, Galeria Comicos, Lisbon

Further Reading

Desa Philippi, "From the Southern Cross," Sydney Biennial Catalogue, **Sydney, 1988**
Hannah Collins, **Centro d'Arte Santa Monica, Barcelona, 1993**
Dan Cameron, "Hannah Collins," Artforum, October 1994
Dimensions: Fünf Künstler aus Grossbritannien, **Städtische Kunsthalle Mannheim, Mannheim, 1996**

Thomas Joshua Cooper

1946	Born in San Francisco
1972	M.A., University of New Mexico, Albuquerque
since 1982	Head of the Department of Photography, School of Fine Art, Glasgow, Scotland Lives in Glasgow

Solo Exhibitions

1986	The Orchard Gallery, Londonderry, Northern Ireland
1993	Galerie Stadtpark, Krems, Austria
1995	New Mexico Museum of Fine Arts, Santa Fe
1996	Galerie Frank und Schulte, Berlin
1998	Galerie Bugdahn und Kaimer, Düsseldorf

Group Exhibitions

1985	American Photography: 1945 – 1980, **The Barbican Art Gallery, London**
1990	The Forces of Nature: Landscape as Metaphor, **Manchester City Art Galleries**
1991	From Art to Archeology, **South Bank Centre, Hayward Gallery, London**
1995	Light from the Darkroom – A Celebration of Scottish Photography, **National Gallery of Scotland, Edinburgh**
1996	Prospect '96, Frankfurt a. M.

Further Reading

Poiésis – Aspects of Contemporary Poetic Activity, **Edinburgh, Fruitmarket Gallery Press, 1992**
Dear Stieglitz, **Eindhoven, 1994**
Shadows on the Water, **Fotofeis, Edinburgh, 1995**
Simply Counting Waves, **Gulbenkian Foundation, Center of Modern Art, Lisbon, 1995**
Le Printemps de Cahors – Photographie & Arts Visuels 1996, **Regis Durand (ed.), Paris, 1996**

Anton Corbijn

1955	Born in Strijen, Netherlands
1974–76	Studies at the Technical University of Photography (MTS), The Hague
1979	Moves to London
until 1985	Photographer for New Musical Express
1994	Dutch Photography Prize LP/CD covers for U2, REM, The Rolling Stones, and others Lives in London

Solo Exhibitions

1982	Untitled Gallery, Sheffield
1989	Photographic Research Center, Boston; Galerie Gawlik & Schorm, Vienna
1994	Stedelijk Museum, Amsterdam; Kunsthal Rotterdam
1996	Deichtorhallen, Hamburg
1997	Galerie Beckers, Darmstadt

Group Exhibitions

1980	Dutch Photography, **Canon Gallerie, Amsterdam**
1992	**International Photo Triennial, Esslingen**
1993	**Hugo-Erfurth-Preis, Museum Schloss Morsbroich, Leverkusen**
1997	Smart Show, **Torch Galerie, Amsterdam**
1998	Pop in beeld, **Noordbrabants Museum, 's Hertogenbosch**

Further Reading

Anton Corbijn – Famouz, **Munich, 1989**
Anton Corbijn – Allegro, **Munich, 1991**
Anton Corbijn – Herbert Grönemeyer, **Munich, 1995**
Anton Corbijn – Star Trak, **Munich, 1996**

Mario Cravo Neto

1947 Born in Bahia, Brazil
1964–66 In West Berlin
1968–70 Art Students League, New York
since 1971 Works as a sculptor, photographer, and filmmaker
Lives in Bahia

Solo Exhibitions

1971 Museu de Arte Moderno, Bahia
1980 Galleria Il Diaframma, Milan
1981 Kunsthaus Zürich, Zurich
1989 Canon Image Center, Amsterdam
1993 Vision Gallery, San Francisco
1994 Frankfurter Kunstverein, Frankfurt a. M.
1996 Museum für Fotografie, Brunswick
1998 Real Jardín Botánico, Madrid

Group Exhibitions

1971 São Paulo Biennial
1981 Fotografie Lateinamerika, Kunsthaus Zürich, Zurich et al.
1982 Brésil des Brésiliens, Centre Georges Pompidou, Paris
1990 Von der Natur in der Kunst, Messepalast Wien, Vienna
1992 Arte Amazonas, Museu de Arte Moderna, Rio de Janeiro et al.
1995 The Eyes Have It, Museum of Fine Arts, Houston
1998 Der Vogel Selbsterkenntnis, Tiroler Volkskunstmuseum, Innsbruck; Male, Wessel + O'Connor Gallery, New York

Further Reading

Carol Naggar, Mario Cravo Neto, Encyclopédie International des Photographes, Paris, 1982
Mario Cravo Neto, Milan, 1987
Mario Cravo Neto, Zurich, 1994
Mario Cravo Neto, Photo – Spécial Brésil, April 1996

Silvie & Chérif Defraoui

Born in St. Gallen in 1935 and in Geneva in 1932. Chérif Defraoui dies in 1994.

Solo Exhibitions

1987 Kunsthalle, St. Gallen
1989 Orient/Occident, Centre d'Art Contemporain/ Musée Rath, Geneva et al.
1990 Villa Arson, Nice
1991 Übergang, Kunstmuseum, St. Gallen
1993 Centre National d'Art Contemporain, Grenoble
1997 Galerie Brigitte March, Stuttgart

Group Exhibitions

1989 Triennial, Fellbach
1990 Unikat und Edition, Helmhaus, Zurich, and Kunstmuseum des Kantons Thurgau
1991 Swiss Dialectic, The Renaissance Society, Chicago
1992 documenta 9, Kassel
1993 Die Sprache der Kunst, Kunsthalle Wien, Vienna, and Frankfurter Kunstverein, Frankfurt a. M.
1998 Die Schärfe der Unschärfe, Kunstmuseum, Solothurn; Freie Sicht aufs Mittelmeer, Schirn Kunsthalle, Frankfurt a. M. et al.

Further Reading

Chérif & Silvie Defraoui, "Lettre à Ulrich Loock," Von Bildern, Kunsthalle Bern, 1986
Denys Zacharopoulos, Aux limites de l'ordre, Musée Rath, Geneva, 1989
Erika Billeter, Chérif & Silvie Defraoui, Chefs-d'œuvres du Musée cantonal des Beaux-Arts, Lausanne, 1989
Roland Wäspe, "Zur Fotografie im Werk von Silvie & Chérif Defraoui," Übergang, Kunstmuseum St. Gallen, 1991

Thomas Demand

1964 Born in Munich
1987–92 Studies at the art academies in Munich and Düsseldorf
1992 Cité des Arts, Paris
1994 M.A., Goldsmith's College, London
1997 DG BANK Grant, Frankfurt a. M.
Lives in New York

Solo Exhibitions

1991 Galerie Guy Ledune, Brussels
1992 Galerie Tanit, Munich
1993 Galerie Michel Vidal, Paris
1995 Victoria Miró Gallery, London; Galerie Guy Ledune, Brussels
1996 Galerie Tanit, Cologne
1998 Kunsthalle Zürich, Zurich; Kunsthalle Bielefeld

Group Exhibitions

1993 Het intellectuelle Geweeten van de Kunst, Galerie d'Eendt, Amsterdam
1994 Scharf im Schauen, Haus der Kunst, Munich
1995 Ars Viva '95, Frankfurter Kunstverein, Frankfurt a. M.; Le paysage retrouvé, Galerie Renos Xippas, Paris
1996 Prospect '96, Frankfurt a. M.
1998 Sydney Biennial; ARTIFICIAL, Museu d'Art Contemporani, Barcelona

Further Reading

Heinz-Norbert Jocks, "Die zerstörte und wiedergerettete Aura aus Papier," Kunstforum International, vol. 123, 1993
John Hilliard, "Thomas Demand," Camera Austria, July/August 1995
Florian Illics, "Farbe und Ordnung, Kühnheit und Chaos," Frankfurter Allgemeine Zeitung, February 4, 1995

Philip-Lorca diCorcia

1953 Born in Hartford, Connecticut
1979 M. F. A., Yale University, New Haven, Connecticut
1989 Fellow, National Endowment for the Arts
Lives in New York

Solo Exhibitions

1985 Zeus Arte, Milan
1991 Photographer's Gallery, London
1993 Galeria Palmira Suso, Lisbon
1994 Nikon Salon, Tokyo et al.
1995 The Museum of Modern Art, New York
1998 Galerie Tanja Grunert, Cologne

Group Exhibitions

1987 New Photography II, The Museum of Modern Art, New York
1993 Prospect '93, Frankfurter Kunstverein, Frankfurt a. M.; Under Age, San Francisco Museum of Modern Art
1994 Flesh & Blood, Fotofeis, Edinburgh et al.
1996 After Art: Rethinking 150 Years of Photography, Henry Art Gallery, University of Washington et al.
1998 Emotions & Relations, Hamburger Kunsthalle, Hamburg

Further Reading

Peter Galassi, Pleasures and Terrors of Domestic Comfort, The Museum of Modern Art, New York, 1991
Gary Indiana, "Five Nights of a Dreamer," Artforum, vol. 31, no. 3, January 1993
Philip-Lorca diCorcia, The Museum of Modern Art, New York, 1995

Jim Dine

1935	Born in Cincinnati, Ohio
1957	B. F. A., Ohio State University, Columbus
1960–65	Visiting Professor at Yale University, New Haven, and Oberlin College, Ohio
1985	Lives in various places in America, England, Denmark, Israel, Italy, and Austria

Solo Exhibitions

1960	Reuben Gallery, New York
1967	The Museum of Modern Art, New York
1969	Kunstverein München, Munich
1977	Centre Georges Pompidou, Paris
1988–90	Drawings 1973–87, The Contemporary Arts Center, Cincinnati, Ohio et al.
1994	Residenzgalerie, Salzburg
1996	Pace Wildenstein, New York
1997	Maison Européenne de la Photographie, Paris (with Lee Friedländer)

Group Exhibitions

1963	The Popular Image, Washington Gallery of Modern Art, Washington, D. C.
1964	Venice Biennial
1968	documenta 4, Kassel
1977	documenta 6, Kassel
1982	The New York School, Solomon R. Guggenheim Museum, New York
1992	Hand-Painted Pop: American Art in Transition 1955–62, Museum of Contemporary Art, Los Angeles
1998	Mois de la Photo, Maison Européenne de la Photographie, Paris

Further Reading

Jim Dine and Lee Friedländer: Photographs and Etchings, **London, 1969**
Jim Dine, **Kestner Gesellschaft, Hanover, 1970**
Jim Dine, **Nationalgalerie Berlin, 1971**
Jim Dine – Malen, was man ist, **Stuttgart, 1984**

Pietro Donzelli

1915	Born in Monte Carlo
1918	Moves to Milan
1931	Training as a draftsman
1946	Begins taking photographs Member of the Circolo Fotografico Milanese
1998	Dies

Solo Exhibitions

1948	Circulo Fotografico Milanese, Milan
1983	Teatro Massimo, Caorle
1994	German & British Institute, Milan
1997	Kunstmuseum Wolfsburg; Schirn Kunsthalle, Frankfurt a. M.

Group Exhibitions

1951	Mostra della Fotografia Europea, **Museo di Brera, Milan**
1953	Postwar European Photography, **The Museum of Modern Art, New York**
1955	Fotografie als Uitdrukkingsmiddel, **Stedelijk van Abbe Museum, Eindhoven**
1995	Die italienische Metamorphose 1943–1968, **Kunstmuseum Wolfsburg**

Further Reading

G. Turroni, Nuova fotografia Italiana, **Milan, 1959**
Italo Zannier, Leggere la fotografia, **Rome, 1993**
Pietro Donzelli – Fotografo dell'anno, **FIAF, Turin, 1995**
Ennery Taramelli, Viaggio nell'Italia del Neorealismo, **Turin, 1995**
Pietro Donzelli – Das Licht der Einsamkeit, **Kunstmuseum Wolfsburg, 1997**

William Eggleston

1939	Born in Memphis, Tennessee
since 1963	Freelance photographer
1967	Starts experimenting with color negative film
1974	Guggenheim Fellowship Instructor at Harvard University Lives in Memphis

Solo Exhibitions

1976	The Museum of Modern Art, New York
1985	Victoria and Albert Museum, London
1992	Retrospective, Barbican Art Gallery, London; Louisiana Museum of Modern Art, Humlebaek
1993	Museum Folkwang, Essen; Fotomuseum Winterthur
1994	Räume für Neue Kunst, Wuppertal
1998	Westfälischer Kunstverein, Münster

Group Exhibitions

1978	Mirrors and Windows, **The Museum of Modern Art, New York**
1979	Farbwerke – Eine neue Generation, **Kunsthaus Zürich, Zurich**
1980	American Images, **Corcoran Gallery, Washington, D. C.**
1995	Heimat, **Jüdisches Museum, Vienna; International Photo Triennial, Esslingen**
1997	Hope Photographs, **National Arts Club, New York**

Further Reading

William Eggleston's Guide, **The Museum of Modern Art, New York, 1976**
William Eggleston – Election Eve, **New York, 1977**
Charles Hagen, "An Interview with William Eggleston," Aperture, **no. 115, Summer 1989**
William Eggleston – The Democratic Forest, **London, New York, 1989**
William Eggleston – Ancient and Modern, **New York, 1992**

Valie Export

1940	Born in Linz, Austria
1965–68	Works as a scriptgirl, film editor, walk-on; writes first script Founding member of the Austrian Filmmakers' Cooperative
since 1989	Professor at the University of Wisconsin
since 1993	Professor at the Kunsthochschule für Medien, Cologne
1994/95	Vice president of the Hochschule der Künste, Berlin Lives in Vienna and the USA

Solo Exhibitions

1988	Collective of Living Cinema, **New York;** Hardley Martin Gallery, San Francisco
1989	Art Gallery of Toronto; Institute of Contemporary Art, Boston
1992	OÖ-Landesmuseum, Linz
1994	Galerie Krinzinger, Vienna
1997	20er Haus, Vienna
1998	Neuer Aachener Kunstverein, Aachen

Group Exhibitions

1973	Körpersprache, **Steirischer Herbst, Graz**
1975	MAGNA. Feminismus: Kunst und Kreativität, **Galerie nächst St. Stephan, Vienna**
1977	documenta 6, Kassel
1979	Sydney Biennial
1980	Venice Biennial
1981	Autoportrait, **Centre Georges Pompidou, Paris**
1998	Figur – Skulptur – Weiblich, **OÖ-Landesgalerie, Linz**

Further Reading

Valie Export – Körpersplitter, **vol. 1,** Konfigurationen, Fotografien 1968–77, **Heimrad Becker (ed.), Vienna, 1980**
Split: Reality – Valie Export, **Museum Moderner Kunst, Stiftung Ludwig Wien, 20er Haus, Vienna, 1997**
Valie Export, Peter Weibel – Wien, **Vienna, New York, 1998**

Bernard Faucon

1950	Born in Apt, Provence
1966–76	Works in the field of painting
1974	M. A. in philosophy
since 1977	Photographic stagings
	Lives in Paris

Solo Exhibitions

1987	Institute of Contemporary Arts, London; Walker Art Center, Minneapolis
1991	Picture Photo Space, Osaka
1996	Photographer's Gallery, London
1997	L. A. Galerie, Frankfurt a. M.

Group Exhibitions

1989	Das konstruierte Bild, **Kunstverein München, Munich**
1995	Beyond Recognition, **National Gallery of Australia, Sydney**
1996	Double vie – double vue, **Fondation Cartier, Paris**
1997	foto text text foto, **Frankfurter Kunstverein, Frankfurt a. M.**; Made in France, **Centre Georges Pompidou, Paris**; Collection découverte, **Musée d'Art Contemporain, Bordeaux**

Further Reading

Bernard Faucon, Chambres d'amour, **William Blake and Co., Bordeaux, 1987**
Contemporary French Photography, **International Center of Photography Midtown, New York, 1991**
À quois jouent-ils?, **Espace Van Gogh, Arles, 1995**
Tout doit disparaître, **Bibliothèque municipale, Grenoble, 1997**

Arno Fischer

1927	Born in Berlin
1948–53	Studies sculpture at the Kunsthochschule Berlin-Weissensee and the Hochschule der Künste, Berlin-Charlottenburg
1956–71	Assistant to Klaus Wittkugel and instructor at the Kunsthochschule Berlin-Weissensee
1985–93	Professor at the Hochschule für Graphik und Buchkunst, Leipzig
1990	Instructor of photography at the Fachhochschule Dortmund
	Lives in Gransee near Berlin

Solo Exhibitions

1985	Retrospective, Fotogalerie, **Berlin-Friedrichshain**
1993	**Lawrence Miller Gallery, New York**
1997	**Staatliche Galerie Moritzburg, Halle**
1998	Fotografien 1943 – 1990, **Galerie Zimmer, Düsseldorf**

Group Exhibitions

1986	Fotografie in der Kunst der DDR, **Staatliche Kunstsammlungen Cottbus**
1987	**Rencontres International de la Photographie, Arles**
1992	Nichts ist so einfach wie es scheint – Ostdeutsche Fotografie 1945 – 1989, **Berlinische Galerie, Berlin**
1993	**Omes da Fotografia, Lisbon**
1998	Deutsche Reportage-Fotografie, **Galerie Zimmer, Düsseldorf**

Further Reading

Erlebnis Bild Persönlichkeit, **Berthold Beiler and Heinz Föppel (eds.), Leipzig, 1973**
Frühe Bilder – Eine Ausstellung zur Geschichte der Fotografie in der DDR, **Leipzig, 1985**
Arno Fischer und Heiner Müller: New York Ansichten – 150 Fotografien von Arno Fischer, **with a text by Heiner Müller, Berlin, 1988**

Thomas Florschuetz

1957	Born in Zwickau, East Germany
1987	First prize in the Junge Europäische Fotografie competition
1988	Emigrates to West Berlin
1993	In New York
1995	In Brazil
	Lives in Berlin

Solo Exhibitions

1987	Museum Folkwang, Essen
1989	Aschenbach Galerie, Amsterdam
1990	Galerie du Jour, Paris
1996	Kunstverein Göttingen
1998	Städtische Kunstsammlung, Zwickau

Group Exhibitions

1989	New Photography V, **The Museum of Modern Art, New York**
1991	Bremer Kunstpreis '91, **Kunsthalle Bremen**
1997	Allemagne: Années 80, **Maison Européenne de la Photographie, Paris et al.**; Object & Abstraction, **The Museum of Modern Art, New York**
1998	Admissions of Identity, **City Museum, Sheffield et al.**; Positionen künstlerischer Fotografie in Deutschland seit 1945, **Martin-Gropius-Bau, Berlin**

Further Reading

Out of Eastern Europe: Private Photography, **Cambridge, Massachusetts, 1987**
Donald Kuspit, "The Repressed Face," Aperture, **no. 114, 1989**
Annemarie Hürlimann, "Vexierbilder aus Haut," Camera Austria, **no. 36, 1991**

Joan Fontcuberta

1955	Born in Barcelona
1973–76	Studies communications in Barcelona
1980–86	Instructor of photography at the Centro de Esenanzas de la Imagen in Barcelona
1981	Founding member and editor of Photo Vision
1990	Professor at the School of The Art Institute of Chicago
	Lives in Barcelona

Solo Exhibitions

1985	Hochschule der Künste, Berlin
1988	The Museum of Modern Art, New York
1989	Galería Juana Mordó, Madrid
1991	L. A. Galerie, Frankfurt a. M.
1992	Parco Gallery, Tokyo
1995	Rupertinum, Salzburg
1998	Yonago Photo Festival, Japan

Group Exhibitions

1985	La Fotografía en el Museo, **Museo Español de Arte Contemporáneo, Madrid**
1989	Photography Until Now, **The Museum of Modern Art, New York**
1992	La Ménagerie du Palais, **Centre National de la Photographie, Paris**
1994	Lessons in Life, **The Art Institute of Chicago**
1998	Concerning Truth, **Randolph Street Gallery, Chicago**

Further Reading

Joan Fontcuberta: Herbarium, **European Photography, Göttingen, 1985**
El Jardí de les delíces, **Centre d'Art Santa Mònica, Barcelona, 1990**
Joan Fontcuberta: Wundergarten der Natur, **Österreichische Fotogalerie im Rupertinum, Salzburg, 1995**
Joan Fontcuberta: Sputnik, **Fundación Arte y Tecnologia, Madrid, 1997**

Günther Förg

1952 Born in Füssen, Germany
1973–79 Studies under Fred Dahmen at the Akademie der Bildenden Künste, Munich
1992 Professor at the Hochschule für Gestaltung, Karlsruhe
Lives in Switzerland

Solo Exhibitions

1980 Galerie Schöttle, Munich
1985 Stedelijk Museum, Amsterdam (with Jeff Wall)
1987 Museum Haus Lange, Krefeld
1993 Werkbund, Frankfurt a. M.; Galerie der Stadt Stuttgart
1995 Luhring Augustine Gallery, New York
1997 Haus für konstruktive und konkrete Kunst, Zurich
1998 Stadtgalerie, Sundern

Group Exhibitions

1986 Momente – Zum Thema Urbanität, **Kunstverein Braunschweig, Brunswick**
1989 Wittgenstein, **Wiener Secession and Haus Wittgenstein, Vienna**
1993 Fotografie in der deutschen Gegenwartskunst, **Museum Ludwig, Cologne et al.**
1995 Künstler-Räume, **Kunstmuseum Bonn**
1997 Die Epoche der Moderne, **Martin-Gropius-Bau, Berlin**

Further Reading

Christoph Schenker, "Im Grunde ist mir der Betrachter egal" (interview), Noëma, no. 23, April/May 1989
Allegories in Modernism, Contemporary Drawing, **The Museum of Modern Art, New York, 1992**
Gestaltete Räume, **Büro Orange, Kulturkreis im BDI, Siemens Kulturprogramm, Munich, 1992**
Wall Works, **Cologne, 1993**
Max Wechsler, Günther Förg, Kritisches Lexikon der Gegenwartskunst, **Munich, 1995**

Michel François

1956 Born in Brussels
Lives in Brussels

Solo Exhibitions

1990 Galerie des Beaux-Arts, Brussels
1994 Curt Marcus Gallery, New York
1995 Galerie Gebauer + Günther, Berlin
1997 Witte de With, Rotterdam
1998 L'Espace Départemental d'Art Contemporain d'Albi

Group Exhibitions

1992 documenta 9, Kassel
1993 L'Art en Belgique depuis 1980, **Musée d'Art Moderne, Brussels**
1994 Beeld Beeld, **Museum van Hedendaagse Kunst, Gent**
1996 Prospect '96, Frankfurt a. M.
1997 Istanbul Biennial

Further Reading

Jutta Schenk-Sorge, "Michel François – fall nicht hin!," Kunstforum, **no. 1, 1996**
Joerg Bader, "Michel François – Espace Tecla Scala," Art Press, **no. 2, January 1998**
En même temps – Un livre de Michel François, **Brussels, 1998**

André Gelpke

1947 Born in Beienrode/Gifhorn, Germany
1969–74 Studies photography under Otto Steinert at the Folkwangschule in Essen
1980–90 In Düsseldorf
1990 Director of the photography class at the Hochschule für Gestaltung in Zurich
Lives in Zurich

Solo Exhibitions

1982 Galerie Forum Stadtpark, Graz
1984 Centre Georges Pompidou, Paris
1988 Fotofest, Houston
1989 Fotomuseum, Brunswick
1990 Sprengel Museum, Hanover

Group Exhibitions

1979 Deutsche Fotografie nach 1945, **Kunstverein Kassel**
1982 Künstler verwenden Fotografie – Heute, **Kunstverein Köln, Cologne**
1990 Otto Steinert und Schüler, **Museum Folkwang, Essen**
1992 Zustandsberichte: Deutsche Fotografie der fünfziger bis achtziger Jahre, **ifa-Galerie, Berlin**
1994 8 Fotografen zum gleichen Thema, Siemens Fotoprojekte, **Städtische Galerie, Nordhorn**

Further Reading

André Gelpke, Sex-Theater, **Munich, 1981**
André Gelpke, Karneval im Gürzenich, **Münchner Stadtmuseum, Munich, 1981**
Die Bundesrepublik – Zeitgenössische deutsche Fotografen sehen ihr Land, **Spectrum/Kunstmuseum Hannover, Hanover, 1982**
André Gelpke, Fluchtgedanken, **Munich, 1983**
André Gelpke, Der schiefe Turm von Pisa, **Museum für Fotografie, Brunswick, 1986**

Rimma Gerlovina

1951 Born in Moscow

Valeriy Gerlovin

1945 Born in Vladivostok, USSR

Live and work in New York

Solo Exhibitions

1993 University of Colorado Gallery, Boulder
1994 Fy Gold Gallery, Atlanta
1995 Steinbaum Krauss Gallery, New York
1996 Galerie Ribbentrop, Eltville
1997 McDonough Museum of Art, Youngstown, Ohio

Group Exhibitions

1993 The Figure as Fiction, **Contemporary Arts Center, Cincinnati, Ohio**
1994 Europa, Europa, **Kunst- und Ausstellungshalle der Bundesrepublik Deutschland, Bonn**
1995 Polaroid: Russia, **Tretjakov Gallery, Moscow**
1996 De Rode Poort, **Museum van Hedendaagse Kunst, Gent; Doppelte Haut, Kunsthalle Kiel**

Further Reading

Lucy Lippard, "Forbidden Fruits," The Village Voice, **March 30, 1982**
Still Performances: Rimma Gerlovina and Valeriy Gerlovin, **MIT List Visual Arts Center, Cambridge, Massachusetts, 1990**
Rimma Gerlovina and Valeriy Gerlovin: Photoglyphs, **The New Orleans Museum, New Orleans, 1993**
Linda Weintraub, Art on the Edge, **American Showcase, New York, 1996**

Jochen Gerz

1940	Born in Berlin
1959–66	Studies German, English, sinology, and ancient history in Cologne and Basel
1967	Moves to Paris; founded the author's publishing company Agentzia
since 1972	Objects, videos, installations Lives in Paris and Saarbrücken

Solo Exhibitions

1977	Whitney Museum of American Art, New York
1986	Musée des Beaux-Arts, Calais
1988	Kunstsammlung Nordrhein-Westfalen, Düsseldorf et al.
1995	Zacheta Gallery of Contemporary Art, Warsaw
1997	Kunstmuseum Düsseldorf

Group Exhibitions

1987	documenta 8, Kassel
1989	Viewpoints on German Art, **Musée d'Art Contemporain, Montreal**
1990	Um 1968 – Konkrete Utopien in Kunst und Gesellschaft, **Kunsthalle Düsseldorf**
1997	Made in France, **Centre Georges Pompidou, Paris**
1998	Positionen künstlerischer Fotografie in Deutschland seit 1945, **Martin-Gropius-Bau, Berlin;** Geistes Gegenwart, **Diözesanmuseum, Freising**

Further Reading

Walter Grasskamp, "Welcome Home," Kunstforum International, **no. 14, 1975**
Gerz: Œuvres sur Papier Photographique 1983 – 1986, **Musée des Beaux-Arts, Calais, 1986**
Eva Wolf, Jochen Gerz – Die Arbeit am Mythos, **Brunswick, 1991**
Jochen Gerz, Self-Portrait, **Tel Aviv University Gallery, Tel Aviv, 1995**

Mario Giacomelli

1925	Born in Senigallia near Ancona, Italy
1954	First photographs Member of the group "Misa"
1995	Culture Prize from the Deutsche Gesellschaft für Fotografie Lives in Senigallia

Solo Exhibitions

1964	The Museum of Modern Art, New York
1984	Photographer's Gallery, London; Pushkin State Museum of Fine Arts, Moscow
1988	Palais de Tokyo, Paris
1995	Museum Ludwig, Cologne
1998	Photology, London

Group Exhibitions

1958	Subjektive Fotografie 3, photokina, Cologne
1973	Five Masters of European Photography, **Photographer's Gallery, London**
1983	Personal Choice, **Victoria and Albert Museum, London**
1988	Paesaggio Italiano, **Instituto de Cultura, Rio de Janeiro**
1994	L'image de l'artiste, **Musée de l'Elysée, Lausanne**
1995	I capolavori della fotografia – gli anni 50, 60 e 70, **Forte Belvedere, Florence**
1997	Galerie am Fischmarkt, Erfurth

Further Reading

Mario Giacomelli – Storie di Terra, **Giorgio Gabriele Negri (ed.), Milan, 1992**
Ennery Taramelli, Mario Giacomelli, **Paris, 1993**
Mario Giacomelli – Fotografien 1952 – 1995, **Karl Steinorth (ed.), Museum Ludwig, Cologne and Ostfildern, 1995**

Ralph Gibson

1939	Born in Los Angeles
1956–60	Studies photography and serves in the U. S. Navy
1960–62	San Francisco Art Institute
1961/62	Assistant to Dorothea Lange
1967/68	Assistant to Robert Frank Lives in New York

Solo Exhibitions

1972	Pasadena Art Museum, California
1981	Sprengel Museum, Hanover
1987	Fotografie Forum, Frankfurt a. M.
1990	Musée Nicéphore Niepce, Chalon-sur-Saône, France
1996	Whitney Museum of American Art, New York

Group Exhibitions

1981	Self-Portraits, **Centre Georges Pompidou, Paris**
1982	Lichtbildnisse, **Rheinisches Landesmuseum, Bonn**
1990	Expo '90, **Osaka Museum, Japan**
1997	Rooms, **The Museum of Modern Art, New York**
1998	Szenenwechsel XIII, **Museum für Moderne Kunst, Frankfurt a. M.**

Further Reading

Ralph Gibson: A Propos de Mary Jane, **Cahier d'images, Paris, 1990**
Ralph Gibson, **Whitney Museum of American Art, New York, 1996**
Ralph Gibson, Lichtjahre, **Frankfurter Kunstverein, Kilchberg/Zurich, 1996**

Gilbert & George

Met in 1967 at the St. Martin's School of Art, London, where they live and work.

Gilbert

1943	Born in the Dolomites, Italy

George

1942	Born in Devon, England

Solo Exhibitions

1985	Solomon R. Guggenheim Museum, New York
1991	Palazzo delle Esposizioni, Rome et al.
1994	Kunstmuseum Wolfsburg
1995	Stedelijk Museum, Amsterdam
1997	Musée d'Art Moderne de la Ville de Paris
1998	Stockholm Konsthall

Group Exhibitions

1972–82	documenta 5 – 7, Kassel
1977	Europe in the 70s, **The Art Institute of Chicago et al.**
1982	Zeitgeist, **Berlin**
1984	**Sydney Biennial**
1996	Prospect '96, **Frankfurt a. M.**
1998	Conceptual Photography from the 60s and 70s, **David Zwirner, New York**

Further Reading

Dark Shadow: Gilbert & George the Sculptors, **London, 1974**
For Aids Exhibition, **Anthony d'Offay Gallery, London, 1989**
Carter Ratcliff, Gilbert & George: Postcard Sculptures and Ephemera 1969 – 1981, **New York, 1990**
The Naked Shit Pictures, **Stedelijk Museum, Amsterdam, 1996**

Nan Goldin

1953 Born in Washington, D.C. School of the Museum of Fine Arts, Boston B.F.A., Tufts University, Boston
since 1979 Multimedia presentations
1991/92 DAAD Grant, Berlin Lives in New York

Solo Exhibitions

1991 Forum Stadtpark, Graz
1992 DAAD Galerie, Berlin
1993 Contemporary Art Gallery, Vancouver
1996 Whitney Museum of American Art et al.
1998 Kunsthalle Wien, Vienna; Kunstmuseum Wolfsburg

Group Exhibitions

1985 Self-Portrait Show, **The Museum of Modern Art, New York**; **Whitney Biennial**
1987 American Dreams, **Centro de Arte Reina Sofia, Madrid**
1994 Tokyo Love, **The Ginza Art Space, Tokyo (with Araki)**
1995 Feminin – Masculin: Le sexe de l'art, **Centre Georges Pompidou, Paris**
1996 **Sydney Biennial**
1998 Emotions & Relations, **Hamburger Kunsthalle, Hamburg**

Further Reading

Nan Goldin – The Ballad of Sexual Dependency, **New York, 1986**
Nan Goldin – The Other Side, **Manchester, 1993**
Nan Goldin/David Armstrong – Ein doppeltes Leben, **Zurich, 1994**
Nan Goldin – I'll Be Your Mirror, **Whitney Museum of American Art, New York, 1996**

Dan Graham

1942 Born in Urbana, Illinois Lives in New York

Solo Exhibitions

1969 John Daniels Gallery, New York
1976 Kunsthalle Basel
1977 Museum van Hedendaagse Kunst, Gent
1980 The Museum of Modern Art, New York
1987 Centro de Arte Reina Sofia, Madrid
1997 Museum für Gegenwartskunst, Basel
1998 DIA Center for the Arts, New York; Fundació Antoni Tàpies, Barcelona

Group Exhibitions

1972 documenta 5, Kassel
1988 Skulptur Projekte Münster, **Landesmuseum Münster**
1989 L'art conceptuel – Une perspective, **Musée d'Art Moderne de la Ville de Paris**; Image World: Arts and Media Culture, **Whitney Museum of American Art, New York**
1991 A Dialogue about Recent American and European Photography, **Museum of Contemporary Art, Los Angeles**
1992 documenta 9, Kassel
1998 Conceptual Photography from the 60s and 70s, **David Zwirner, New York**

Further Reading

Benjamin Buchloh, Video-Architecture-Television, **New York, 1979**
Dan Graham – Pavilions, **Kunsthalle Bern, 1983**
Robert Smithson, "Interview with Dan Graham," Noëma, no. 29, March/April, 1990
Dan Graham – Interviews, **Hans Dieter Huber (ed.), Ostfildern, 1997**

Rodney Graham

1949 Born in Canada
1968-71 Studies art history at the University of British Columbia, Vancouver Lives and works in Vancouver

Solo Exhibitions

1979 Simon Fraser University, Burnaby, British Columbia
1989 Galerie Micheline Szwajcer, Antwerp
1991 Ponderosa Pines, **Galerie Rüdiger Schöttle, Paris**
1994 Art Gallery of York University, Toronto
1998 Wexner Center for the Arts, Columbus, Ohio

Group Exhibitions

1985 49th Parallel, **Center for Contemporary Canadian Art, New York (with Ken Lum, Jeff Wall, Ian Wallace)**
1990 Real Allegories, **Lisson Gallery, London**
1992 documenta 9, Kassel
1993 303 Gallery, New York (with Hans-Peter Feldman and Allen Ruppersberg)
1996 Lesen, **Kunsthalle St. Gallen**

Further Reading

Rodney Graham, **Vancouver Art Gallery, Vancouver, 1988**
Weitersehen, **Museum Haus Esters and Museum Haus Lange, Krefeld, 1990**
Càmeres indiscretes, **Centre d'Art Santa Monica, Barcelona, 1992**
Rodney Graham – Works from 1976 – 1994, **Art Gallery of York University, Ontario et al., 1994**
Dan Cameron, "47th Venice Biennial," Artforum, **no. 36, September 1997**

Angela Grauerholz

1952 Born in Hamburg
1974-76 Studies literature and linguistics at the Universität Hamburg
1976-80 M.F.A. in photography, Concordia University, Montreal Lives and teaches in Montreal

Solo Exhibitions

1988 Photographer's Gallery, Saskatoon
1990 Mercer Union, Toronto
1993 MIT List Visual Arts Center, Cambridge, Massachusetts
1995 Kunstverein, Hanover
1996 Kunsthaus, Zug
1997 Gallery Stephen Friedman, London
1998 Galerie Franck + Schulte, Berlin; Art 48, Montreal

Group Exhibitions

1985 Lynne Cohen, Angela Grauerholz, Louise Lawler, **Coburg Gallery, Vancouver**
1990 **Sydney Biennial**
1992 documenta 9, Kassel
1995 Sala Parpallo, Valencia; **Carnegie International, Pittsburgh (with Astrid Klein)**
1997 La photographie contemporaine en France – Dix ans d'acquisitions, **Centre Georges Pompidou, Paris**

Further Reading

New Image: Contemporary Quebec Photography, **49th Parallel, Center for Contemporary Canadian Art, New York, 1983**
Un-Natural Traces: Contemporary Art from Canada, **Barbican Art Gallery, London, 1991**
Angela Grauerholz: Recent Photographs, **Helaine Posner (ed.), MIT List Visual Center, Cambridge, Massachusetts, 1993**
Christina Feller, "Angela Grauerholz," Camera Austria International, **no. 38.**
Aporia – A Book of Landscapes: Angela Grauerholz, **Oakville Galleries, Oakville, Ontario, 1995**

Tamara Grčić

1964 Born in Munich
1983–86 Studies art history at the Universität Wien, Vienna
1986–88 Studies cultural anthropology in Frankfurt a. M.
1988–93 Studies under Peter Kubelka at the Hochschule der Bildenden Künste, Städelschule, Frankfurt a. M.
1997 Work scholarship from Kunstfonds e.V., Bonn
Lives in Frankfurt a. M. and New York

Solo Exhibitions

1994 Galerie Voges + Deisen, Frankfurt a. M.; Portikus, Frankfurt a. M.
1995 Galerie Labyrinth, Lublin
1996 Galerie Monika Reitz, Frankfurt a. M.
1997 Bonner Kunstverein, Bonn
1998 Kunsthalle St. Gallen; Goethe Institute, Rotterdam

Group Exhibitions

1993 The Lure of the Object, **Goethe Institute, London**
1994 A Life of Secrets, **Goethe House, New York**
1995 Scharfer Blick, **Bundeskunsthalle, Bonn**
1996 Manifesta 1, Rotterdam; Modernity Project 2000, **Palazzo Brickerasio, Turin**
1998 Das Mass der Dinge, **Ursula Blickle Stiftung, Kraichtal; Galerie im Traklhaus, Salzburg;** 8x8x8, **Frankfurter Kunstverein, Frankfurt a. M.**

Further Reading

Tamara Grčić, **Goethe House New York/German Cultural Center, New York, 1994**
Tamara Grčić. Duchamps Urenkel, **Bonner Kunstverein, Bonn, 1997**
Martin Pesch, "Spuren der Vergänglichkeit – Zu den Arbeiten von Tamara Grčić," Artis, **February/March 1997**

Andreas Gursky

1955 Born in Leipzig
1978–81 Studies visual communications, Folkwangschule, Essen
1981–87 Studies photography (master student) under Bernd Becher at the Kunstakademie Düsseldorf
Lives in Düsseldorf

Solo Exhibitions

1989 Museum Haus Lange, Krefeld
1991 Galerie Rüdiger Schöttle, Munich; 303 Gallery, New York
1992 Kunsthalle Zürich, Zurich
1994 Deichtorhallen, Hamburg
1995 Portikus, Frankfurt a. M.

Group Exhibitions

1989 International Photo Triennial, Esslingen
1990 Venice Biennial (Aperto)
1991 Aus der Distanz, **Kunstsammlung Nordrhein-Westfalen, Düsseldorf**
1992 Doubletake, **Hayward Gallery and The South Bank Centre, London; Kunsthalle Wien, Vienna;** Qui, quoi, où? Un regard sur l'art en allemagne en 1992, **Musée d'Art Moderne de la Ville de Paris**
1998 Landschaften, **Kunstverein Düsseldorf**

Further Reading

Andreas Gursky, **Museum Haus Lange, Krefelder Kunstmuseen, Krefeld, 1989**
Michael Stockebrand, Andreas Gursky: Renta-Preis 1991, **Kunsthalle Nürnberg, Nuremberg, 1991**
Andreas Gursky, **Kunsthalle Zürich, Zurich, 1992**
Andreas Gursky, Fotografien 1984–1993, **Zdenek Felix (ed.), Deichtorhallen, Hamburg; Stichting de Appel, Amsterdam, 1994**

Jitka Hanzlová

1958 Born in Nachod, Czechoslovakia
1978–82 Director of photography for state television station in Prague
1982 Defects to Germany
1987–94 Studies visual communications and photography at the Universität Gesamthochschule Essen
1993 Otto Steinert Prize
1995 DG BANK Grant for artistic photography
Lives in Essen

Solo Exhibitions

1994 Galerie Lichtblick, Cologne
1995 Galerie DB-S, Antwerp; Maison de la Photographie, Lectoure
1996 Frankfurter Kunstverein, Frankfurt a. M.
1997 Museum Schloss Hardenberg, Velbert
1998 Goethe Institute, Budapest (with Lorenz Gaiser)

Group Exhibitions

1993 Kunsthaus Essen
1995 Europäischer Fotopreis 1995, **Englische Kirche, Bad Homburg**
1996 Galerie Poirel, Nancy; **Fotografie Forum, Frankfurt a. M.; Museum Chabot, Rotterdam**

Further Reading

Jitka Hanzlová – bewohner, **Frankfurter Kunstverein, Frankfurt a. M., Düsseldorf, 1996**
Jitka Hanzlová – Rokítnik, **Museum Schloss Hardenberg, Velbert, 1997**

Alex Hartley

1963 Born in West Byfleet, England
1983–87 Studies sculpture at Chamberwell School of Arts and Crafts
1990 M. A. from the Royal College of Art
Lives in London

Solo Exhibitions

1992 Anderson O'Day Gallery, London
1993 Victoria Miró Gallery, London; James van Damme, Antwerp
1995 Galerie Gilles Peyroulet, Paris
1998 Victoria Miró Gallery, London

Group Exhibitions

1990 International Departures, **Kavalere Kazerne, Amsterdam**
1991 Whitechapel Open, **Whitechapel Art Gallery, London;** Show Hide Show, **Anderson O'Day Gallery, London**
1994 Photo '94, **Business Design Centre, London**
1996 Abstrakt/Real, **Museum Moderner Kunst Stiftung Ludwig, Vienna**
1997 Sensation, **Royal Academy, London;** Private Face – Urban Space, **Gasworks, Athens**
1998 Fotografie als Handlung, **International Photo Triennial, Esslingen**

Further Reading

David Batchelor, Alex Hartley, **Anderson O'Day Gallery, London, 1992**
Young British Artists, **Saatchi Collection Catalogue, London, 1993**
Spacious: Alex Hartley – Willy de Sauter, **Kurt Vanbelleghem (ed.), Battersea Arts Centre et al., London, 1996**

Robert Häusser

1924 Born in Stuttgart
Trains as a photographer and photojournalist
1950 Studies under Professor Walter Hege at the Kunstschule Weimar
1960 Badges and stickers for photokina, Cologne
1996 Villa Massimo, Deutsche Akademie Rome
Lives in Mannheim and on Ibiza

Solo Exhibitions

1972 Städtische Kunsthalle, Mannheim
1983 Nationalgalerie, Berlin
1985 Kunsthalle Nürnberg, Nuremberg
1988 Museum für Kunst und Gewerbe, Hamburg
1997 Forum d'Art Franco-allemand, Château de Vaudremont

Group Exhibitions

1969 Vision and Expression, **George Eastman House, Rochester et al.**
1978 Deutsche Fotografie nach 1945, **Kunstverein Kassel et al.**
1984 4 Aspekte deutscher Fotografie, **Goethe Institute, New York**
1985 Das Aktfoto – Ansichten vom Körper im fotografischen Zeitalter, **Frankfurter Kunstverein, Frankfurt a. M.**
1997 Deutsche Fotografie. Macht eines Mediums 1870 – 1970, **Bundeskunsthalle, Bonn**

Further Reading

Heiner Stachelhaus, Auf den Punkt gebracht: Robert Häusser – Sinnbilder existentieller Not, **Recklinghausen, 1985**
J. A. Schmoll a. k. a. Eisenwerth, "Robert Häusser: Klassiker der modernen Fotografie," Leica-Fotografie, **no. 2, 1987**
Robert Häusser: Photographische Bilder – Werkübersicht der Jahre 1941 – 1987, **Württembergischer Kunstverein, Stuttgart et al., 1988**
Robert Häusser – The Hasselblad Award 1995, **Erna and Victor Hasselblad Foundation, Göteborg, 1995**

Gottfried Helnwein

1948 Born in Vienna
1965-69 Höhere Graphischen Lehr- u. Versuchsanstalt, Vienna
1969-73 Akademie der Bildenden Künste, Vienna
1974 Theodor Körner Prize
Lives in Zurich, near Cologne, and in Ireland

Solo Exhibitions

1970 Nachtgalerie im Atrium, Vienna
1979 Albertina, Vienna
1985 The Museum of Modern Art, New York
1987 Villa Stuck, Munich
1992 Münchner Stadtmuseum, Munich
1997 Ludwig Museum in the Russian Museum, St. Petersburg

Group Exhibitions

1981 International Biennial of Graphic Art, Ljubljana
1983 Köpfe und Gesichter, Kunsthalle Darmstadt
1984 Orwell und die Gegenwart, **Museum Moderner Kunst, Vienna**
1987 Krieg und Frieden, **Hamburger Kunsthalle, Hamburg et al.;**
Europalia: Die lädierte Welt – Realismus und Realismen in Österreich, **Kunstforum Länderbank, Vienna**
1988 Selection 4, **Victoria and Albert Museum, London;**
photokina, Cologne
1997 Versuche zu trauern – Meisterwerke aus der Sammlung Ludwig, **Haus Ludwig für Kunstausstellungen, Saarlouis, Germany**

Further Reading

Peter Gorsen, "Der Künstler als Agressor und vermaledeiter Moralist," Helnwein, **Albertina, Vienna, 1985**
Gottfried Helnwein – Der Untermensch. Selbstbildnisse 1970 – 1987, **Heidelberg, 1988**
Peter Feyerabend (ed.), Helnwein, **Cologne, 1992**

Anton Henning

1964 Born in Berlin
Lives in Berlin and Manker

Solo Exhibitions

1988 Galerie Holtmann, Cologne
1990 Vrej Baghoomian Gallery, New York
1995 Bild-Malerei, Galerie Wohnmaschine, Berlin; White Columns, New York
1998 Kasseler Kunstverein, Kassel

Group Exhibitions

1990 Korrespondenzen, **Berlinische Galerie, Martin-Gropius-Bau, Berlin**
1992 Works on Paper, **Anina Nosei, New York**
1994 Trois Photographes Berlinois, **Espace des Arts, Chalon-sur-Saône, France**
1995 Room with a View I, **Brandenburgischer Kunstverein, Potsdam**
1996 Surfing Systems, **Kasseler Kunstverein, Kassel**
1998 Transmission, **Espace des Arts, Chalon-sur-Saône, France**

Further Reading

Ursula Prinz, "Die Einheit des Bildes," Anton Henning, **Galerie Hilger, Vienna, Frankfurt a. M., 1989**
Charles Merewether, Signs of Dissonant Modernism, **Vrej Baghoomian Gallery, New York, 1991**
Wolf-Günter Thiel, Anton Henning – Soup, **White Columns, New York, 1995**

Bill Henson

1955 Born in Melbourne, Australia
Lives in Melbourne

Solo Exhibitions

1975 National Gallery of Victoria, Melbourne
1981 Photographer's Gallery, London
1987 Institute of Modern Art, Brisbane
1989 Museum Moderner Kunst, Stiftung Ludwig, Vienna
1993 Tel Aviv Museum of Art
1998 Roslyn Oxley9 Gallery, Sydney

Group Exhibitions

1982 Sydney Biennial
1983 D'un Autre Continent: l'Australie. Le Rêve et le Réel; **Musée d'Art Moderne de la Ville de Paris**
1984 Australian Visions: 1984, **Solomon R. Guggenheim Museum, New York**
1995 Venice Biennial;
Passion Privée, **Musée d'Art Moderne de la Ville de Paris**
1997 Body, **Art Gallery of New South Wales, Sydney**

Further Reading

Bill Henson – Untitled 1983 – 84, **Australian National Gallery, Canberra, 1986**
Bill Henson – Paris Opera Project, **Tel Aviv Museum of Art, Tel Aviv, 1993**
Bill Henson – Through a Glass Darkly, **Art Gallery of New South Wales, Sydney, 1995**
Christopher Allen, Art in Australia – From Colonization to Postmodernism, **London, 1997**

Lynn Hershman

1941 Born in Cleveland, Ohio
Studies at Case Western Reserve University, Cleveland and at San Francisco State University
1972–76 Heads the project Running Fence by Christo
since 1993 Professor of electronic and digital arts, University of California, Davis
Lives in San Francisco

Solo Exhibitions

1991 The Museum of Modern Art, New York
1993 Seattle Art Museum
1995 Artists Space, New York; National Gallery of Canada, Ottawa
1996 Center for Contemporary Art, Warsaw
1998 Robert Koch Gallery, San Francisco; Lutz Teutloff Galerie, Bielefeld

Group Exhibitions

1990 Copenhagen Film & Video Workshop Festival
1991 Images Futur '91, La Cité des Arts, Montreal
1993 Artificial Games, Medien Labor, Munich;
1994 Arts Electroniques, Museum of Contemporary Arts, Montreal
1997 Das neue Gesicht, Kunstverein, Constance; Photography after Photography, Institute of Contemporary Art, Philadelphia et al.

Further Reading

Lynn Hershman, "Die Phantasie ausser Kontrolle," Kunstforum International, vol. 103, 1989
Frank Popper, Art of the Electronic Age, New York, 1993
Florian Rötzer, The Viewer is the Voyeur, Siemens Medien Kunstpreis, Munich, 1995
Lynn Hershman, "Romanticizing the Anti-Body: Lust and Longing in (Cyber)space," Clicking In: Hot Links to a Digital Culture, Lynn Hershman (ed.), Seattle, 1996

John Hilliard

1945 Born in Lancaster
1962–64 Lancaster College of Art
1964–67 St. Martin's School of Art, London
1965 Scholarship to study in the USA
Lives and teaches in London (Slade School of Fine Art)

Solo Exhibitions

1970 Lisson Gallery, London
1988 Bess Cutler Gallery, New York
1990 Württembergischer Kunstverein, Stuttgart
1996 L. A. Galerie, Frankfurt a. M.
1997 Kunsthalle Krems, Austria; Kunstverein Hannover, Hanover et al.
1998 Universidad de Salamanca; Arnolfini Gallery, Bristol

Group Exhibitions

1992 Whitechapel Open, Whitechapel Art Gallery, London
1993 Out of Sight, Out of Mind, Lisson Gallery, London
1994 Fondation Cartier: A Collection, National Museum of Contemporary Art, Seoul; Fine Arts Museum, Taipei
1996 Prospect '96, Frankfurt a. M.
1998 Les Visiteurs du Soir, Musée des Beaux-Arts, Dôle

Further Reading

Analytical Photography, Badischer Kunstverein, Karlsruhe, 1977
John Hilliard, Kunstverein Köln, Cologne, Frankfurter Kunstverein, Frankfurt a. M., Kunsthalle Bremen, 1983
Vanitas, Kunstverein Stuttgart, 1990
John Hilliard: Arbeiten 1990–1996, AR/GE Kunst (ed.), Bolzano, Kunsthalle Krems and Vienna, 1997

David Hockney

1937 Born in Bradford, England
1953–57 Bradford College of Art
1957–62 Royal College of Art, London
1969 Visiting Professor at the Hochschule für Bildende Kunst, Hamburg
1982 First Polaroid montages
1984 Kodak photography book award
since 1989 Fax and computer color laser prints
1996 Honorary doctorate from Oxford University
1998 Culture Prize from the Deutsche Gesellschaft für Fotografie
Lives in Los Angeles

Solo Exhibitions

1970 Whitechapel Art Gallery, London et al.
1982 Centre Georges Pompidou, Paris
1983 Walker Art Center, Minneapolis et al.
1988 Los Angeles County Museum of Art
1994 Takashimaya Art Gallery, Tokyo
1998 Museum Ludwig, Cologne; Twenty Photographic Pictures, Sprengel Museum, Hanover

Group Exhibitions

1968 documenta 4, Kassel
1981 A New Spirit in Painting, Royal Academy, London
1989 São Paulo Biennial
1997 Die Epoche der Moderne, Martin-Gropius-Bau, Berlin
1998 Waterproof, Expo '98, Lisbon

Further Reading

David Hockney – On Photography: A Lecture at the Victoria and Albert Museum, November 1983, New York, 1983
Hockney's Photographs, Hayward Gallery, London, 1983
Hockney on Photography: Conversations with Paul Joyce, London, 1988
Lawrence Wescher, Cameraworks: David Hockney, London, New York, 1984
David Hockney – 20 Photographs, Los Angeles, 1996

Candida Höfer

1944 Born in Eberswalde, Germany
1973–76 Studies at the Staatliche Kunstakademie Düsseldorf
1976–82 Studies photography under Bernd Becher
Lives in Cologne

Solo Exhibitions

1975 Galerie Konrad Fischer, Düsseldorf
1991 Galerie Walcheturm, Zurich
1992 Portikus, Frankfurt a. M.
1993 Hamburger Kunsthalle, Hamburg
1994 Neuer Aachener Kunstverein, Aachen
1997 Salzburger Kunstverein, Salzburg (with Elke Denda)
1998 Kunstverein Wolfsburg

Group Exhibitions

1979 Schlaglichter, Rheinisches Landesmuseum, Bonn
1991 Aus der Distanz, Kunstsammlung Nordrhein-Westfalen, Düsseldorf
1993 Fotografie in der deutschen Gegenwartskunst, Museum Ludwig, Cologne; Distanz und Nähe, Nationalgalerie Berlin
1997 Erziehungskomplex, Generali Foundation, Vienna

Further Reading

Candida Höfer, Parkett, March 1992
Candida Höfer – Räume/Spaces, Cologne, 1992
Candida Höfer/Shirley Wiitasalo, Kunsthalle Bern, 1993

Nan Hoover

1931 Born in New York
1949–54 Studies painting at the Corcoran Gallery Art School, Washington, D. C.
1973 Starts working with video
since 1976 Performances (among others in 1987 at documenta 8 in Kassel)
1986–96 Professor of video and film at the Kunstakademie Düsseldorf Lives in Amsterdam

Solo Exhibitions

1977 The Museum of Modern Art, New York
1984 MonteVideo, Amsterdam
1988 Kunsthaus Zürich, Zurich
1991 Stedelijk Museum, Amsterdam; Retrospektive Video: Fotocollagen der Performances 1974–1988, Neue Pinakothek, Munich
1998 Mexico, Salon, San Miguel de Allende

Group Exhibitions

1977 documenta 6, Kassel
1984 Venice Biennial
1985 Spatial Relationships in Video, The Museum of Modern Art, New York
1987 documenta 8, Kassel
1988 Sydney Video Festival
1990 Künstlerinnen des 20. Jahrhunderts, Museum Wiesbaden
1998 Zeichnung und Raum, Kunsthaus Nürnberg, Nuremberg

Further Reading

Nan Hoover – Photo, Video, Performance, 1980–1982, Musée d'Art Contemporain, Montreal, 1982
Installations, Tate Gallery, London, 1984
M. Hoffmann, "Über die Realität von Körpergefühlen," Künstler. Kritisches Lexikon der Gegenwartskunst, vol. 42, Munich, 1998
Friedemann Malsch (interview), Kunstforum International, no. 98, 1989

Craigie Horsfield

1949 Born in Cambridge Lives in London

Solo Exhibitions

1991 Barbara Gladstone Gallery, New York
1993 Walker Art Center, Minneapolis
1994 Carnegie Museum, Pittsburgh
1995 Frith Street Gallery, London
1996 Fundació Antoni Tàpies, Barcelona (with Manuel Borja-Villel and Jean-François Chevrier)
1998 Galleria Monica De Cardenas, Milan

Group Exhibitions

1989 Foto-Kunst, Staatsgalerie, Stuttgart
1990 Craigie Horsfield, Robert Gober, Lawrence Weiner, Barbara Gladstone Gallery, New York
1995 Call it Sleep, Witte de With, Rotterdam
1996 Face à l'Histoire, Centre Georges Pompidou, Paris
1997 Museum van Hedendaagse Kunst, Gent

Further Reading

Jean-François Chevrier, De afstand, Witte de With, Rotterdam, 1990
Craigie Horsfield, Institute of Contemporary Arts, London, 1992
Craigie Horsfield, "Araki: Unconscious Kitsch," Galleries Magazine, no. 61, October 1994

Peter Hutchinson

1930 Born in London
1988 DAAD Grant, Berlin Lives in Provincetown, Massachusetts

Solo Exhibitions

1969 The Museum of Modern Art, New York
1972 Galerie Block, Berlin
1982 Retrospective, John Gibson Gallery, New York
1994 Retrospective, Provincetown Art Association and Museum, Provincetown
1996 Landscapes, Retrospective, Mayor Gallery, London
1998 Kunstverein Düsseldorf (with Hamish Fulton); Kunstverein Ulm

Group Exhibitions

1976 Bicentennial Exhibition of Immigrant Artists, Hirshhorn Museum and Sculpture Garden, Washington, D. C.
1979 Concept, Narrative, Document, Museum of Contemporary Art, Chicago
1989 Fantasies, Fables, and Fabrications: Photo Work from the 1980s, Herter Gallery, University of Massachusetts, Amherst
1997 The Artist's Garden, Boston Center for the Arts, Boston; Lyon Biennial

Further Reading

Peter Hutchinson, Dissolving Clouds: Writings of Peter Hutchinson, 1994
The Narrative Art of Peter Hutchinson: A Retrospective, Provincetown Art Association and Museum, Provincetown, 1994
Text Foto – Foto Text, Bolzano, Frankfurt a. M. Winterthur, 1996

Axel Hütte

1951 Born in Essen
1973–81 Studies at the Kunstakademie Düsseldorf Lives in Düsseldorf

Solo Exhibitions

1984 Galerie Konrad Fischer, Düsseldorf
1989 Rotterdamse Kunststichting, Rotterdam
1990 Glenn & Dash Gallery, Los Angeles
1992 Galerie Kicken, Cologne
1993 Hamburger Kunsthalle, Hamburg and Kunstraum München, Munich
1997 Fotomuseum Winterthur
1998 Musée Château d'Annecy

Group Exhibitions

1979 In Deutschland, Rheinisches Landesmuseum, Bonn
1982 Lichtbildnisse, Rheinisches Landesmuseum, Bonn
1988 BiNationale, Kunsthalle, Düsseldorf
1990 Der klare Blick, Kunstverein München, Munich
1991 Aus der Distanz, Kunstsammlung Nordrhein-Westfalen, Düsseldorf
1992 Distanz und Nähe, Institut für Auslandsbeziehungen, Stuttgart
1998 Landschaften, Kunstverein Düsseldorf

Further Reading

Klaus Heinrich Kohr, "Altre prese da i Luoghi altre ideate," Axel Hütte, Karl Schmidt-Rottluff Förderstiftung, Berlin (ed.), Kunsthalle Düsseldorf, Düsseldorf, 1989
Axel Hütte – Italien, Hamburger Kunsthalle, Kunstraum München, Munich, 1993
Axel Hütte – London, Fotografien 1982–1984, Museum Künstlerkolonie Darmstadt, Munich, 1993

Graciela Iturbide

1942 **Born in Mexico**
1969–72 **Studies film at UNAM, Mexico City**
since 1970 **Freelance photography; Assistant to Manuel Alvarez Bravo**
1978 **Founding member of the Foro de Arte Contemporáneo, Mexico City**
1988 **First prize at the Mois de la Photo, Paris**
1989 **Guggenheim Fellowship**
 Lives in Mexico City

Solo Exhibitions

1983 **Casa de las Americas, Havana, Cuba**
1987 **Musée Cantonal de Beaux-Arts, Lausanne**
1990 **Museum of Modern Art, San Francisco**
1993 **Museo del Palacio de Bellas Artes, Mexico**
1997 **Castel dell'Ovo, Naples**
1998 **Philadelphia Museum of Art**

Group Exhibitions

1976 Three Mexicans, **Midtown Gallery, New York**
1979 Siete Mujeres Fotógrafas, **Foro de Arte Contemporáneo, Mexico City**
1981 Latinoamericana, **Kunsthaus Zürich, Zurich**
1997 Photography in Latin America: A Spiritual Journey, **Brooklyn Museum, New York**
1998 Five Decades of Mexican Photography, **Mexican Museum, San Francisco**

Further Reading

Contemporary Photography in Mexico: 9 Photographers, **Tucson, Arizona, 1978**
Hugo-Erfurth-Preis 1989, **Städtisches Museum Schloss Morsbroich, Leverkusen, 1989**
Graciela Iturbide – La forma y la memoria, **Museo de Arte Contemporáneo de Monterrey, Mexico, 1996**
Images of the Spirit – Photographs by Graciela Iturbide, **Philadelphia Museum of Art, Philadelphia, 1998**

Bill Jacobson

1955 **Born in Norwich, Connecticut**
1977 **B. F. A., Brown University**
1981 **M. F. A., San Francisco Art Institute**
 Lives in New York

Solo Exhibitions

1993 **Grey Art Gallery, New York University**
1994 **Dickinson College, Carlisle, Pennsylvania**
1995 **Photographer's Gallery, London; Robert Koch Gallery, San Francisco**
1996 **Julie Saul Gallery, New York**
1997 **Galerie Steinek, Vienna**
1998 **Rupertinum, Salzburg; Frankfurter Kunstverein, Frankfurt a. M.**

Group Exhibitions

1994 Don't Leave Me This Way, **Art in the Age of AIDS, National Gallery of Australia, Canberra**
1995 Desire, **Louisiana Museum of Modern Art, Humlebaek et al.;** Large Bodies, **Pace/MacGill Gallery, New York;** Spirit & Loss, **Fotofeis, Glasgow**
1996 Prospect '96, **Frankfurt a. M.**
1998 Versus 2000, **Museo d'Arte Moderna, Bolzano**

Further Reading

Emmanuel Cooper, Fully Exposed: The Male Nude in Photography, **London, 1995**
Anastasia Aukeman, "Bill Jacobson – Coming Together and Letting Go, On the Edge," Artnews, **October 1995**
Charles Hagen, "Large Bodies, Pace/McGill Gallery, New York," The New York Times, **July 28, 1995**
Bill Jacobson, Creative Camera, **December 1995/January 1996**

Magdalena Jetelová

1946 **Born in Semily, Czechoslovakia**
1965–71 **Studies sculpture in Prague and under Marino Marini at the Accademia di Brera in Milan**
1990 **Professor at the Staatliche Kunstakademie Düsseldorf**
 Lives in Düsseldorf and Bergheim

Solo Exhibitions

1984 **Galerie Walter Storms, Munich**
1986 **Staatliche Kunsthalle, Baden-Baden**
1988 **Hamburger Kunsthalle, Hamburg**
1991 **Moderna Galerija, Ljubljana**
1992 **Museum für Angewandte Kunst, Vienna**
1997 **Badisches Landesmuseum, Karlsruhe; Ursula-Blickle-Stiftung, Kraichtal**

Group Exhibitions

1986 **Sydney Biennial**
1987 **documenta 8, Kassel**
1996 Freed Sculpture, **Ludwig Forum, Aachen**
1997 Ungehalten, **Galerie der Stadt Esslingen**
1998 Der Vogel Selbsterkenntnis, **Tiroler Volkskunstmuseum, Innsbruck**

Further Reading

Kunst mit Eigen-Sinn, **Aktuelle Kunst von Frauen, Sylvia Eiblmayr, V. Export, M. Prischl-Maier (eds.), Museum des 20. Jahrhunderts, Vienna, 1985**
W. Beckett, Contemporary Women Artists, **Oxford, 1988**
Rolf Wedewer, 11 Künstler 11 Räume, **Städtisches Museum Schloss Morsbroich, Leverkusen, 1989**
Anne Maier, "Besetzen und Gefangensein," Kritisches Lexikon der Gegenwartskunst, **vol. 20, Munich, 1992**

DoDo Jin Ming

1955 **Born in Beijing**
 Trains as a violinist
1978 **Moves to Hong Kong**
1982–88 **Gives music lessons, plays in the Hong Kong Philharmonic Orchestra**
1988 **First involvement with photography**
 Lives and works in Hong Kong

Solo Exhibitions

1988 Impressions of Italy, **Raffles Gallery, Hong Kong**
1991 A Feeling in Black and White, **Art & Soul Gallery, Hong Kong**
1992 **Hong Kong Arts Center and Goethe Institute, Hong Kong**
1996 Back to Egypt, **Lawrence Miller Gallery, New York**

Group Exhibitions

1994 Elemental Images, **Takashimaya Gallery, New York**
1995 DG BANK Centennial Celebration Exhibition, **Goethe Institute, Hong Kong**
1997 Galerie der Künstler, **Munich;** Hong Kong Art, **Beijing National Museum**
1998 Century of Women's Art, **Beijing National Museum**

Further Reading

DoDo Jin Ming – Photographer – Back to Egypt, **University of Hong Kong, Department of Comparative Literature, Cultural Studies, Hong Kong, 1996**
DoDo Jin Ming – Djinn Lake Series 1997, **New York, 1997**
Hanne Westkott, "Der Monitor im Heuhaufen – Zur Ausstellung junger Künstlerinnen aus Hongkong," Süddeutsche Zeitung, **August 18, 1997**

Ilya Kabakov

1933 Born in Dnepro-
petrovsk, Ukraine
1943 Attends artists' school
of the Leningrad Art
Academy
1945–51 Moscow Intermediate
School of Art
1951 Surikov Institute,
Department of Graphic
Art, Moscow
1992/93 Professor at the
Städelschule, Staat-
liche Hochschule für
Bildende Künste,
Frankfurt a. M.
1993 Joseph Beuys Prize
Lives in New York

Solo Exhibitions

1988 Ronald Feldman
Gallery, New York
1993 Museum of Contempo-
rary Art, Chicago
1995 Museum für Gegen-
wartskunst, Basel
1998 Museum van Heden-
daagse Kunst, Antwerp

Group Exhibitions

1991 Dislocations, **The
Museum of Modern Art,
New York**
1992 documenta 9, Kassel
1993 Russische Avantgarde:
Von Malewitsch bis
Kabakov, **Kunsthalle
Köln, Cologne**
1996 São Paulo Biennial
1998 Szenenwechsel XIV,
**Museum für Moderne
Kunst, Frankfurt a. M.**

Further Reading

Boris Groys, Gesamtkunstwerk
Stalin, **Munich/Vienna, 1988**
Boris Groys, Die Kunst des
Fliehens, **Munich/Vienna, 1991**
Jürgen Harten, Sowjetische
Kunst um 1990, **Cologne, 1991**
The Rope of Life and other
installations, **Schriften zur
Sammlung des Museums
für Moderne Kunst,
Frankfurt a. M., 1994**
Robert Storr, "An Interview
with Ilya Kabakov," Art in
America, **January 1995**

Peter Keetman

1916 Born in Wuppertal-
Elberfeld, Germany
1935–37 Studies photography
under Hans Schreiner
at the Bayerische
Staatslehranstalt für
Lichtbildwesen, Munich
1937–39 Assistant to Gertrud
Hesse in Duisburg
1952–87 Freelance photo-
designer in Munich
since 1994 Lives in Marquartstein,
Upper Bavaria

Solo Exhibitions

1961 Staatliche Landesbild-
stelle, Hamburg
1982 PPS-Galerie, Hamburg
1983 University of California,
Riverside
(with Toni Schneiders)
1990 Spectrum Photogalerie,
Sprengel Museum,
Hanover
1996 Museum Folkwang,
Essen

Group Exhibitions

1950 fotoform, **photokina,**
Cologne (Silver Medal)
1952 Weltausstellung der Fo-
tografie, **Kunstmuseum
Luzern, Lucerne**
1953 Subjektive Fotografie 3,
photokina, Cologne
1983 Die fotografische Samm-
lung, **Museum Folk-
wang, Essen**
1997 Positionen künstlerischer
Fotografie in Deutsch-
land seit 1945, **Martin-
Gropius-Bau, Berlin**

Further Reading

Otto Steinert, Subjektive
Fotografie, **Bonn, 1952**
Subjektive Fotografie: Images of
the 50s, **Ute Eskildsen, Manfred
Schmalriede, Dorothy Martin-
son (eds.), Essen, 1984**
Peter Keetman – Eine Woche im
Volkswagenwerk: Fotografien
aus dem April 1953, **Rolf
Sachsse (ed.) Berlin, 1985**
Peter Keetman – Bewegung und
Struktur, **Manfred Heiting (ed.),
Amsterdam, 1996**

Jürgen Klauke

1943 Born in Kliding near
Cochem on the Mosel
1964–70 Studies graphic art at
the Fachhochschule für
Design und Kunst,
Cologne
since 1993 Professor of artistic
photography at the
Kunsthochschule für
Medien, Cologne
Lives in Cologne

Solo Exhibitions

1981 Rheinisches Landes-
museum, Bonn
1986 Nationalgalerie, Berlin;
Badischer Kunstverein,
Karlsruhe;
Hamburger Kunsthalle,
Hamburg;
Museum Boymans-van
Beuningen, Rotterdam;
Museum Ludwig,
Cologne
1987 Galerie ak,
Frankfurt a. M.
1990 Galerie Stähli, Zurich
1992 Staatliche Kunsthalle,
Baden-Baden
1997 Museum of Modern Art,
Saitama, Japan et al.

Group Exhibitions

1974 Transformer, **Kunst-
museum Luzern,
Lucerne et al.**
1977 documenta 6, Kassel
1980 Venice Biennial
1987 documenta 8, Kassel
1995 Foto-Kunst, **Institut für
Auslandsbeziehungen,
Berlin**
1998 Positionen künstlerischer
Fotografie in Deutsch-
land seit 1945, **Martin-
Gropius-Bau, Berlin**

Further Reading

Ich habe einen Körper, **Claudia
Gehrke (ed.), Munich, 1981**
Kunst mit Fotografie, **Sammlung
Krauss, Berlin, 1983**
Die Maler und das Theater im
20. Jahrhundert, **Schirn Kunst-
halle, Frankfurt a. M., 1986**
Klaus Honnef, "Jürgen Klauke –
Selbstbildnis als Porträt der
Gesellschaft," Kritisches Lexikon
der Gegenwartskunst, **vol. 1,
Munich, 1988**

Astrid Klein

1951 Born in Cologne
1973–77 Fachhochschule für
Kunst und Design in
Cologne
1993 Professor at the Hoch-
schule für Graphik und
Buchkunst, Leipzig
Lives in Cologne

Solo Exhibitions

1986 Museum am Ostwall,
Dortmund
1989 Kestner Gesellschaft,
Hanover;
Institute of Contempo-
rary Arts, London;
Wiener Secession,
Vienna
1994 Kunsthalle Nürnberg,
Nuremberg
1995 Sala Parpalló, Valencia
(with Angela
Grauerholz)
1997 Käthe-Kollwitz-Preis,
Akademie der Künste,
Berlin
1998 Kunstverein Hamburg

Group Exhibitions

1981 Typisch Frau, **Galerie
Magers, Bonn**
1984 von hier aus, **Conven-
tion Center, Düsseldorf**
1986 Sydney Biennial;
Venice Biennial
(Aperto)
1987 documenta 8, Kassel
1994 Karl Schmidt-Rottluff
Stipendium, Kunsthalle
Düsseldorf
1998 Positionen künstlerischer
Fotografie in Deutsch-
land seit 1945, **Martin-
Gropius-Bau, Berlin**

Further Reading

Annelie Pohlen, "Erotik in der
Kunst heute," Kunstforum
International, **1981**
The Impossible Self, **Winnipeg
Art Gallery, 1988**
Vilém Flusser, "Astrid Klein –
Das Entsetzen," European
Photography, **vol. 9, no. 2,
April – June 1988**
Astrid Klein – Photoarbeiten
1984 – 1989, **Carl Haenlein (ed.),
Kestner Gesellschaft, Hanover
et al., 1989**

Barbara Klemm

1939 **Born in Münster,
Westphalia
Training in a portrait
studio in Karlsruhe**
since 1970 **Editorial photographer
for the** Frankfurter
Allgemeine Zeitung
Lives in Frankfurt a. M.

Solo Exhibitions

1977 **Bundeskanzleramt,
Bonn**
1982 **Museum Folkwang,
Essen**
1984 **Fotografie Forum,
Frankfurt a. M.**
1990 **Werkbundgalerie,
Berlin**
1992 **Kulturforum Alte Post,
Neuss**
1993 **Kunstverein Arolsen;
Goethe Institute,
New Delhi**
1998 **Museum Weissenfels**

Group Exhibitions

1978 Bilder und Deutschland,
**Traveling exhibition,
USSR**
1982 Bilder aus der Bundes-
republik, **Galerie
Spectrum, Hanover**
1987 Bilder des Nachbarn,
Institut Français, Paris
1988 10 Deutsche Fotografin-
nen, **Goethe Institute,
Brazil and USA**
1998 Deutsche Reportage-
Fotografie, **Galerie
Zimmer, Düsseldorf;**
Szenenwechsel XIV,
**Museum Moderner
Kunst, Frankfurt a. M.**

Further Reading

Barbara Klemm: Photographien,
**Museum für Kunst und
Gewerbe, Hamburg, 1976**
Barbara Klemm: Bilder,
Frankfurt a. M., 1986
Hugo-Erfurth-Preis 1989: Joseph
Koudelka, Graciela Iturbide,
Barbara Klemm, **Städtisches
Museum Schloss Morsbroich,
Leverkusen, 1989**
Barbara Klemm: Blick nach
Osten 1970 – 1995,
Frankfurt a. M., 1995

Imi Knoebel

1940 **Born in Dessau**
1964 – 71 **Studies at the Kunst-
akademie Düsseldorf
Lives in Düsseldorf**

Solo Exhibitions

1970 **Kabinett für aktuelle
Kunst, Bremerhaven**
1984 **Lehmbruck Museum,
Duisburg**
1987 **Dia Art Foundation
New York**
1992 **Bonnenfantenmuseum,
Maastricht**
1996 **Stedelijk Museum,
Amsterdam**
1997 **Musée de Grenoble;
Neues Museum
Weserburg, Bremen**

Group Exhibitions

1972 documenta 5, Kassel
1984 von hier aus, **Conven-
tion Center, Düsseldorf**
1987 documenta 8, Kassel
1989 **Museum für Bildende
Künste, Leipzig**
1993 Photography in Contem-
porary German Art: 1969
to the Present, **Solomon
R. Guggenheim
Museum, New York**
1997 Less is More, **Galerie
Dreher, Berlin**
1998 Deutschlandbilder,
**Martin-Gropius-Bau,
Berlin**

Further Reading

Michael Hübl, "Himmelreich
auf zwei Etagen – Galerie
Schoof, Frankfurt/Main," Kunst-
forum International, **no. 70, 1984**
Donald Kuspit, "Imi Knoebel's
Triangle," Artforum, **January
1987**
Max Wechsler, "Das Vermessen
der Empfindung – Zu Imi
Knoebel," Parkett, **no. 17, 1988**
Wolfgang Esser, "Variatio
delectat – Von der Vielgestalt
des einen Bildes," Kritisches
Lexikon der Gegenwartskunst,
vol. 23, Munich, 1993

Barbara Kruger

1945 **Born in Newark,
New Jersey
Studies at Syracuse
University, New York;
Parsons School of
Design, New York**
since 1972 **Freelance artist
Lives in New York and
Los Angeles**

Solo Exhibitions

1974 **Artists Space, New York**
1983 **Institute of Contempo-
rary Arts, London**
1984 **Kunsthalle Basel**
1992 **Centre National d'Art
Contemporain,
Grenoble**
1993 **Museo Pecci, Prato**
1994 **Mary Boone Gallery,
New York**
1997 **Jeffrey Deitch Gallery,
New York**

Group Exhibitions

1973 **Whitney Biennial,
New York**
1982 **documenta 7, Kassel;
Venice Biennial**
1987 **documenta 8, Kassel**
1989 A Forest of Signs: Art
in the Crisis of Represen-
tation, **Museum of
Contemporary Art,
Los Angeles**
1997 foto text text foto,
**Frankfurter Kunst-
verein, Frankfurt a. M.**
1998 Die Rache der Veronika:
Die Sammlung Lambert,
**Deichtorhallen,
Hamburg;**
Fast Forward, **Kunst-
verein Hamburg;**
Ciphers of Identity,
**University of Southern
Florida Contemporary
Art Museum, Tampa
et al.**

Further Reading

Barbara Kruger: Picture/
Readings, **New York, 1978**
Barbara Kruger: We Won't Play
Nature to Your Culture,
**Institute of Contemporary
Arts, London et al., 1983**
Barbara Kruger – In Other Words,
**Museum am Ostwall,
Dortmund, 1989**
Barbara Kruger – Love for Sale:
The Words and Pictures of
Barbara Kruger, **New York, 1990**

Zofia Kulik

1947 **Born in Breslau, Poland**
1970/71 **Academy of Arts,
Warsaw**
1970 – 87 **Collaborates with
Przemyslaw Kwiek
under the name
"KwieKulik"
Lives in Warsaw**

Solo Exhibitions

1971 **Galeria Wspolczesna,
Warsaw**
1975 **Malmö Konsthall**
1981 **Künstlerhaus Stuttgart**
1987 **Franklin Furnance,
New York**
1993 **Kunst und Raum,
Vienna**
1994 **Galerie Jezuitów,
Poznań**
1996 The Human Motif III,
**Watershed Media
Centre, Bristol**

Group Exhibitions

1993 Krieg, **Forum Stadtpark
Graz**
1994 Europa, Europa, **Kunst-
und Ausstellungshalle
der BRD, Bonn;**
Der Riss im Raum,
**Martin-Gropius-Bau,
Berlin**
1996 New Histories, **Institute
of Contemporary Art,
Boston**
1997 **Venice Biennial**

Further Reading

Bakunin in Dresden: Polnische
Kunst heute, **Kunstmuseum
Düsseldorf, 1990**
Wanderlieder, **Stedelijk
Museum, Amsterdam, 1991**
Dark Decor, **Independent
Curators Inc., New York, 1992**
Zofia Kulik – The Human Motif,
**Zone Gallery, Newcastle upon
Tyne, 1996**

Suzanne Lafont

1949 Born in Nîmes
 Studied literature and
 philosophy
 Lives in Paris

Solo Exhibitions

1989 Centre de la Vieille
 Charité, Marseille
1992 Galerie Nationale du
 Jeu de Paume, Paris;
 The Museum of Modern
 Art, New York
1993 Peter Kilchmann
 Galerie, Zurich
1997 Musée Départemental
 de Rochechouart

Group Exhibitions

1988 Another Objectivity,
 **Institute for Contempo-
 rary Arts, London et al.**
1990 Passage de l'image, **Cen-
 tre Georges Pompidou,
 Paris**
1992 **documenta 9, Kassel**
1996 Hall of Mirrors, **Ohio
 State University et al.;**
 Containers, **Los Angeles
 County Museum of Art**
1997 **documenta 10, Kassel**
1998 Architecture and the
 Modern Mask, **Galerie
 Wohnmaschine, Berlin**

Further Reading

Suzanne Lafont, La Mission
photographique de la D.A.T.A.R.,
traveaux en cours, 1984–1985,
Paris, 1985
Jean-François Chevrier,
**"Suzanne Lafont, l'expérience
de la nature,"** Galleries
Magazine, **no. 30, 1989**
Un autre objectivité, **Milan, 1989**
**Jacinto Lageira, "Image,
Machine Œuvre,"** Les Lettres
françaises, **October 1990**

Marie-Jo Lafontaine

1950 Born in Antwerp
1975–79 Starts studying law,
 changes to painting at
 the École Supérieure
 d'Architecture et des
 Arts Visuels,
 La Chambre, Brussels
1980 First environments
 with video sculptures
1992 Professor at the Hoch-
 schule für Kunst und
 Medien, Karlsruhe
 Lives in Brussels

Solo Exhibitions

1981 Centre Georges
 Pompidou, Paris
1985 Tate Gallery, London
1986 Sprengel Museum,
 Hanover
1994 Guggenheim Museum,
 SoHo, New York
1996 Museum van Heden-
 daagse Kunst, Antwerp
1997 Galerie Bugdahn und
 Kaimer, Düsseldorf
1998 Galerie Guth-Maas &
 Maas, Engstingen

Group Exhibitions

1986 **Chambres d'amis, Gent**
1987 **documenta 8, Kassel**
1990 Künstlerinnen des
 20. Jahrhunderts, **Kunst-
 museum Wiesbaden**
1991 Multimediale 2, **Zentrum
 für Kunst und Medien-
 technologie, Karlsruhe**
1993 Feuer – Wasser – Licht –
 Erde, **Deichtorhallen,
 Hamburg**
1996 **Sammlung Marx im
 Hamburger Bahnhof,
 Berlin**
1997 foto text text foto,
 **Frankfurter Kunst-
 verein, Frankfurt a. M.**

Further Reading

Marie-Jo Lafontaine, **Museum
für Gegenwartskunst, Basel,
1987**
Marie-Jo Lafontaine –
Immaculata, **Ostfildern, 1992**
Marie-Jo Lafontaine – Jeder
Engel ist schrecklich, **Tel Aviv
Museum of Art, 1993**

Louise Lawler

1947 Born in New York
1969 Graduates from Cornell
 University, Ithaca,
 New York
since 1972 Publishes her own writ-
 ings and photo books
 Lives in New York

Solo Exhibitions

1973 University of California,
 Davis
1982 Metro Pictures,
 New York
1987 The Museum of Modern
 Art, New York
1993 Sprengel Museum,
 Hanover
1994 Centre d'Art Contempo-
 rain, Geneva
1997 Galerie Monika Sprüth,
 Cologne

Group Exhibitions

1985 The Art of Memory – The
 Loss of History, **New
 Museum of Contempo-
 rary Art, New York**
1989 A Forest of Signs,
 **Museum of Contempo-
 rary Art, Los Angeles**
1991 Anni Novanta, **Galleria
 Communale d'Arte Con-
 temporanea, Bologna**
1993 Kontext Kunst,
 Steirischer Herbst, Graz
1994 The Camera Politic,
 **Pittsburgh Center for
 the Arts**
1997 Deep Storage, **Kunstmu-
 seum Düsseldorf et al.;**
 Collected, **Photogra-
 pher's Gallery, London**
1998 Mysterious Voyages,
 **The Contemporary
 (Museum for Contem-
 porary Arts), Baltimore**

Further Reading

**Benjamin Buchloh, "Allegorical
Procedures: Appropriation and
Montage in Contemporary Art,"**
Artforum, **September 1982**
**"Louise Lawler, Project
for Flash Art,"** Flash Art,
November/December 1988
Whitney Biennial, **Whitney
Museum of American Art,
New York, 1991**
**Johannes Meinhardt,
"Erhellung der Situation –
Louise Lawler: Situierungen
und Fotografien von Situierun-
gen,"** Kunstbulletin, **no. 2, 1992**

Jean Le Gac

1936 Born in Tamaris, France
1955–58 Training as an art
 teacher in Paris
1959 First photographic
 works
 Stages in series his
 own "disappearance"
 as an artist
 Lives in Paris

Solo Exhibitions

1970 Galerie Daniel Templon,
 Paris
1974 Israel Museum,
 Jerusalem
1977 Kunstverein Hamburg
1978 Centre Georges
 Pompidou, Paris
1984 Musée d'Art Moderne
 de la Ville de Paris
1992 Badischer Kunstverein,
 Karlsruhe
1997 Galerie Fortlaan 17,
 Gent
 (with Jacques Charlier)
1998 Galerie Sandmann +
 Haak, Hanover

Group Exhibitions

1972 **documenta 5, Kassel**
1976/80 **Venice Biennial**
1977 **documenta 6, Kassel**
1981 Autoportraits photo-
 graphiques, **Centre
 Georges Pompidou,
 Paris;**
 Westkunst, **Convention
 Center, Cologne**
1992 More Than Photography,
 **The Museum of Modern
 Art, New York**
1997 foto text text foto,
 **Frankfurter Kunst-
 verein, Frankfurt a. M.**
1998 80 Artistes autour du
 Mondial, **Galerie Enrico
 Navarra, Paris**

Further Reading

Peindre et photographier?,
**Espace Niçois d'Art et Culture,
Nice, 1983**
Jean Le Gac – Das Echo und sein
Maler, **Gerhard Fischer (ed.),
Vienna, 1988**
Jean Le Gac – Le peintre
fantôme, **Badischer Kunst-
verein, Karlsruhe et al., 1992**
Atelier de France – Kunst aus
Frankreich seit 1950, **Ludwig-
Museum im Deutschherren-
haus, Koblenz 1993**

Les Levine

1935 Born in Dublin
1953–55 Studies at the Central School of Arts and Crafts in London
1957 Emigrates to Canada
1975 Professor of video art at the William Paterson College in Wayne, New Jersey
 Lives in New York

Solo Exhibitions

1974 The Vancouver Art Gallery, Vancouver, British Columbia
1989 International Center of Photography, New York
1995 Galerie Brigitte March, Stuttgart
1996 The Alternative Museum, New York
1997 Galerie der Stadt Stuttgart

Group Exhibitions

1977 documenta 6, Kassel
1993 Kunsthalle Wien, Vienna
1994 Institute of Contemporary Art, Boston
1996 Museum Ludwig, Cologne
1997 The Museum of Modern Art, Video Gallery, New York

Further Reading

Die Sprache der Kunst: Die Beziehung von Bild und Text in der Kunst des 20. Jahrhunderts, **Eleonora Louis and Toni Stooss (eds.), Ostfildern, 1993**
Les Levine, **Galerie der Stadt Stuttgart, 1997**
Art Can See: Les Levine – Medienskulptur, **Johann-Karl Schmidt (ed.), Ostfildern, 1997**

Sherrie Levine

1947 Born in Hazleton, Pennsylvania
1965–73 University of Wisconsin, Madison (M. F. A., 1973)
 Lives in New York

Solo Exhibitions

1979 The Kitchen, New York
1987 Mary Boone Gallery, New York
1988 Galerie Nächst St. Stephan, Vienna
1991 San Francisco Museum of Modern Art; Kunsthalle Zürich, Zurich
1992 Westfälisches Landesmuseum, Münster
1998 Retrospective, Museum Schloss Morsbroich, Leverkusen

Group Exhibitions

1988 Carnegie International, Carnegie Museum of Art, Pittsburgh
1989 A Forest of Signs, Museum of Contemporary Art, Los Angeles; Prospect '89, Frankfurt a. M.
1990 Culture and Commentary, Hirshhorn Museum, Washington, D. C.
1991 Devil on the Stairs: Looking Back on the Eighties, Institute of Contemporary Art, Philadelphia

Further Reading

Benjamin Buchloh, "Allegorical Procedures: Appropriation and Montage in Contemporary Art," Artforum, **September 1982**
Sherrie Levine, **Mary Boone Gallery, New York, 1987**
Dan Cameron, "Art and its Double: A New York Perspective," Flash Art, **May 1987**
Sherrie Levine, **Hirshhorn Museum of Art, Washington, D. C., 1988**
New Work: Sherrie Levine, **San Francisco Museum of Modern Art, 1991**

Helen Levitt

1918 Born in New York
 Lives in New York

Solo Exhibitions

1943 The Museum of Modern Art, New York
1963 3 Photographers in Color (with Roman Vishniac and William Garnett), The Museum of Modern Art, New York
1980 Corcoran Gallery of Art, Washington, D. C.
1992 Retrospective, San Francisco Museum of Modern Art
1998 Frankfurter Kunstverein, Frankfurt a. M. et al.

Group Exhibitions

1955 The Family of Man, **The Museum of Modern Art, New York et al.**
1982 Lichtbildnisse: Das Porträt in der Fotografie, **Rheinisches Landesmuseum, Bonn**
1989 The New Vision: Photography Between the World Wars, **Metropolitan Museum of Art, New York**
1995 American Photography 1890–1965, **The Museum of Modern Art, New York et al.**
1997 documenta 10, Kassel

Further Reading

A Way of Seeing: Photographs of New York, **with a text by James Agee, New York, 1965**
Helen Levitt, **Corcoran Gallery, Washington, D. C., 1980**
Helen Levitt, **San Francisco Museum of Modern Art and New York, 1992**
Helen Levitt: Mexico City, **Durham, New York, and London, 1997**
Helen Levitt, **Peter Weiermair (ed.), Munich/New York, 1998**

Edgar Lissel

1965 Born in Northeim
1983–86 Trains as a lithographer
1986–91 Studies communications design at the Fachhochschule Darmstadt
1988–91 In Milan
 Lives in Hamburg

Solo Exhibitions

1989 Galleria di belle Arti, Urbino
1991 Fotogalerie, Vienna
1995 AEDES, Galerie und Architekturforum, Berlin
1996 Museum für Kunst und Gewerbe, Hamburg
1997 L. A. Galerie, Frankfurt a. M.

Group Exhibitions

1991 Coup de lune, **Musée de la Poste, Paris**
1992 Giovani Fotografi Italiani, **Milan and Modena**
1995 Vom Umgang mit Veränderung, **NGBK, Berlin**
1996 Architecture Biennial, **Venice**
1998 Konstruktionen der Bilder, **Deutsche Fotografische Akademie, Leinfelden-Echterdingen**

Further Reading

Jürgen Raap, "Città del Duce," Camera Austria, **no. 47/48, 1994**
Edgar Lissel, Illusion der Macht: Berlin 1933–1945, **Berlin, 1995**
On the Face of it, **City Art Center, Edinburgh, 1995**
Fotografie als Geste, **Staatliches Museum, Schwerin, 1997**

Ingeborg Lüscher

1936 Born in Freiberg, Saxony
1949 Moves with her family to West Berlin
1958–69 Works simultaneously as a psychologist and actress
1967 Starts work as an artist
 Lives in Tegna in Maggia, Ticino

Solo Exhibitions

1976 Musée d'Art Moderne de la Ville de Paris
1980 Steirischer Herbst, Kulturhaus Graz
1992 Museum Wiesbaden
1996 Aargauer Kunsthaus, Aarau
1997 Städtische Galerie Göppingen
1998 Graphothek, Stuttgart

Group Exhibitions

1987 Die Gleichzeitigkeit des Anderen, **Kunstmuseum Bern**
1988 Sydney Biennial; Zeitlos, **Hamburger Bahnhof, Berlin**
1989 Einleuchten, **Deichtorhallen, Hamburg**
1992 documenta 9, Kassel; World Expo Seville, **Swiss Pavilion**
1997 Engel, Engel, **Kunsthalle Wien, Vienna**

Further Reading

Ingeborg Lüscher – Der grösste Vogel kann nicht fliegen, **Cologne, 1972**
Ingeborg Lüscher – Der unerhörte Tourist Laurence Pfautz, **Aarau et al., 1985**
Markus Brüderlin, "Ingeborg Lüscher," Artforum, **January 1991**
Retrospektive Ingeborg Lüscher, **Museum Wiesbaden, Wiesbaden, 1993**
Ingeborg Lüscher – Japanische Glückszettel, **Frankfurt a. M., 1996**

Urs Lüthi

1947 Born in Lucerne
since 1970 Portrays himself in photographs, on canvas etc.
1972 First Polaroid photographs
1983 Scenic design for Kalldewey, Farce **by Botho Strauß at the Münchner Kammerspiele, Munich**
 Lives in Zurich and Munich

Solo Exhibitions

1966 Galerie Palette, Zurich
1975 Neue Galerie am Landesmuseum Johanneum, Graz
1976 Kunsthalle Basel
1978 Museum Folkwang, Essen
1983 Studio Cannaviello, Milan
1993 Bonner Kunstverein, Bonn
1997 Kasseler Kunstverein, Kassel
1998 Galerie Tanit, Munich

Group Exhibitions

1974 Transformer, **Kunstmuseum, Lucerne**
1975 São Paulo Biennial
1977 documenta 6, Kassel
1981 Westkunst, **Convention Center, Cologne;** Autoportraits, **Centre Georges Pompidou, Paris**
1996 Masculin/Feminin, **Centre Georges Pompidou, Paris**
1997 foto text text foto, **Frankfurter Kunstverein, Frankfurt a. M.**
1998 Fünf Komma Fünf, **Fotomuseum Winterthur**

Further Reading

Foto-Kunst, **Graphische Sammlung der Staatsgalerie Stuttgart and Ostfildern, 1989**
Beyond Performance, **Artii et Amitiae (ed.), Amsterdam, 1989**
Urs Lüthi: Universelle Ordnung, **Städtische Galerie im Lenbachhaus, Munich, 1990**
Urs Lüthi, **Neue Galerie Dachau, Dachau, 1992**

Robert Mapplethorpe

1946 Born on Long Island, New York
1963–70 Pratt Institute, Brooklyn
1989 Dies in New York
 Senator Jesse Helms initiates pornography and censorship debate in the USA

Solo Exhibitions

1981 Kunstverein Frankfurt, Frankfurt a. M. et al.
1983 Centre Georges Pompidou, Paris
1988 Retrospective, Whitney Museum of American Art, New York; Stedelijk Museum, Amsterdam et al.
1992 Louisiana Museum of Modern Art, Humlebaek et al.
1997 UCR/California Museum of Photography et al. (with Edward Weston)

Group Exhibitions

1977/82 documenta 6/7, Kassel
1981 Autoportaits photographiques, **Centre Georges Pompidou, Paris**
1986 The Nude in Modern Photography, **San Francisco Museum of Modern Art**
1988 Identity: Representations of the Self, **Whitney Museum of American Art**
1991 Fashion Photography since 1945, **Victoria and Albert Museum, London**
1998 Skulptur im Licht der Fotografie, **Palais Liechtenstein, Vienna et al.**

Further Reading

Robert Mapplethorpe, Certain People: A Book of Portraits, **Pasadena, 1985**
Patti Smith, Robert Mapplethorpe, **New York, 1987**
Robert Mapplethorpe, Flowers, **Munich, 1990**
Germano Celant, Mapplethorpe, **Milan, 1992**

Maix Mayer

1960 Born in Leipzig
1983–87 Studies marine biology
1993 Works in Tasmania, Australia
 Lives in Leipzig

Solo Exhibitions

1992 Landesmuseum, Mainz
1993 Künstlerhaus Mousonturm, Frankfurt a. M.
1995 Galerie Weisser Elefant, Berlin
1996 Galerie Bott, Cologne
1998 Galerie Eigen + Art, Berlin

Group Exhibitions

1990 Photography in the GDR Today, **National Museum of Photography, Film and Television, Bradford**
1992 International Photo Triennial, Esslingen; Humpty Dumpty's Kaleidoscope: A New Generation of German Artists, **Museum of Contemporary Art, Sydney**
1996 unikumok, **Ernst Múzeum, Budapest**
1997 For Lidice, **Museum of Contemporary Art, Prague;** Last und Lust: Leipziger Kunst seit 1945, **Germanisches Nationalmuseum, Nuremberg**
1998 Go East, **Wollongong City Gallery, Australia**

Further Reading

Junge Kunst in Sachsen – 7. Ausstellung der Jürgen Ponto Stiftung, **Frankfurter Kunstverein, Frankfurt a. M., 1991**
Walter Schoendorf, "Maix Mayer," Living, **no. 1, 1992**
Saar Ferngas Förderpreis Junge Kunst 1994, **Saarbrücken, 1994**
Ingeborg Ruthe, "Maix Mayer – Das dritte Auge," Berliner Zeitung, **September 14, 1995**
Friedemann Malsch, "Maix Mayer – Gullivers Reise, eine Sammlung," Neue Bildende Kunst, **no. 3, 1996**

Will McBride

1931 Born In St. Louis, Missouri
1948–50 Studies English at the University of Vermont; private study under Norman Rockwell
1950/51 National Academy of Design, New York
1953 Comes to Germany as an officer in the army; **Photos for** Twen, Quick, Life, Paris Match, **etc.** Lives in Frankfurt a. M.

Solo Exhibitions

1972 Galerie Christoph Dürr, Munich
1981 PPS Galerie, Hamburg
1983 Galerie Art and Book, Hamburg
1991 Galerie Brochier, Munich
1992/93 Retrospective, Frankfurter Kunstverein, Frankfurt a. M., and Landesmuseum, Bonn

Group Exhibitions

1957 5 Young American Artists in Berlin, **Amerika Haus, Berlin**
1979 Deutsche Fotografie nach '45, **Kasseler Kunstverein, Kassel**
1984 Die Sammlung Gruber, **Museum Ludwig, Cologne**
1985 Das Aktfoto, **Fotomuseum im Münchner Stadtmuseum, Munich**
1997 Twen 1959–71 – Revision einer Legende, **Fotografie Forum, Frankfurt a. M.**

Further Reading

Will McBride – Zeig mal! Ein Bilderbuch für Kinder und Eltern, **Wuppertal, 1974**
Will McBride – Foto-Tagebuch 1953–61, **Berlin, 1982**
Will McBride – Boys, **Munich, 1987**
Will McBride – 40 Jahre Fotografie, **Peter Weiermair (ed.), Frankfurter Kunstverein et al., 1992**
Will McBride – I, Will McBride, **Cologne, 1997**

Florian Merkel

1961 Born in Karl-Marx-Stadt (Chemnitz), East Germany
1981–86 Studies photo graphics at the Hochschule für Graphik und Buchkunst in Leipzig
since 1989 Lives in Berlin

Solo Exhibitions

1990 Fotogalerie im Rathaus, Graz
1992 Apotheke, Chemnitz
1993 Galerie eye-genart, Cologne
1995 Galerie Wohnmaschine, Berlin
1997 Sala dell'Annunziata, Imola, Italy
1998 Galerie Wohnmaschine, Berlin; Museum für Kunst und Gewerbe, Hamburg

Group Exhibitions

1987 X. Kunstausstellung der DDR, **Dresden**
1992 Jahreslabor, Fotografiestipendiaten, **Berlinische Galerie im Martin-Gropius-Bau, Berlin**
1993 Aufschwung Ost, **Sargfabrik, Vienna**
1994 Trois Photographes Berlinois, **Espace des Arts, Chalon-sur-Saône, France**
1997 Galleria La Nuova Pesa, **Rome**
1998 Collection '98, **Galerie für zeitgenössische Kunst, Leipzig**

Further Reading

Das letzte Jahrzehnt – Ostdeutsche Fotografie der achtziger Jahre, **Deutsche Fototage, Frankfurt a. M., Brandenburgische Kunstsammlungen, Cottbus, 1993**
Florian Merkel – Staircase, **Förderkreis der Leipziger Galerie für Zeitgenössische Kunst, Galerie Wohnmaschine, Berlin, 1995**
Florian Merkel – Fiction, **Sala dell'Annunziata, Imola, 1997**

John Miller

1954 Born in Cleveland, Ohio
1977 B. F. A., Rhode Island School of Design, Providence
1979 M. F. A., California Institute of Arts, Valencia
1992 DAAD Grant, Berlin Lives in New York and Berlin

Solo Exhibitions

1992 DAAD Galerie, Berlin
1993 Museum Robert Walser, Hotel Krone, Gais, Switzerland
1994 Richard Telles Fine Art, Los Angeles
1995 Metro Pictures, New York; Galerie Barbara Weiss, Berlin; Galerie Rizzo, Paris
1997 Center for Contemporary Art, Kitakyushu, Japan
1998 P.S.1, Long Island City, New York

Group Exhibitions

1991 Lost Illusions, **Vancouver Art Gallery**
1995 The Mutated Painting, **Galerie Martina Detterer, Frankfurt a. M.;** Bettenausstellung, **Hotel-Pension Nürnberger Eck, Berlin**
1997 Display, **The Charlottenburg Exhibition Hall, Copenhagen**
1998 Someone Else With My Fingerprints, **Kunstverein München, Munich**

Further Reading

John Miller, "The Mnemonic Book: Ed Ruscha's Fugitive Publications," Parkett, no. 18, 1988
John Miller – Rock Sucks, Disco Sucks, **DAAD-Galerie, Berlin, 1992**
John Miller, Christina Frey – Fotografien aus der Sammlung Allan Porter, **Kunsthalle Palazzo, Liestal, 1994**
John Miller – A Trail of Ambiguous Picture Postcards, **Center for Contemporary Art, Kitakyushu, 1997**

Tracey Moffatt

1960 Born in Brisbane, Australia
1982 Degree in visual communications, Queensland College of Art
1990 Participates in the Cannes Film Festival with Night Cries (short film, 17 min.)
1993 The Messenger (INXS music video) Lives in Sydney and New York

Solo Exhibitions

1989 Australian Center for Photography, Sydney et al.
1992 Centre for Contemporary Arts, Glasgow
1995 ArtPace, San Antonio, Texas
1997 Dia Center for the Arts, New York; Tracey Moffatt – Films, **Musée d'Art Contemporain, Lyon**
1998 L. A. Galerie, Frankfurt a. M.

Group Exhibitions

1987 Art and Aboriginality, **Aspex Gallery, Portsmouth 1991;** From the Empire's End, **Circulo de Bellas Artes, Madrid**
1995 Antipodean Currents, **Guggenheim Museum, SoHo, New York**
1996 Jurassic Technologies, **Sydney Biennial;** Prospect '96, **Frankfurt a. M.**
1997 Future, Present, Past, **Venice Biennial**
1998 Echolot, **Museum Fridericianum, Kassel**

Further Reading

Isobel Crombie, Sandra Byron, Twenty Contemporary Australian Photographers, **National Gallery of Victoria, 1990**
Lesley Stern, "When the Unexplained Happens," Photofile, **no. 40, Sydney, 1993**
"Bedevil: Tracey Moffatt," Interview with John Conomos and Raffaele Caputo, Cinema Papers, **vol. 93, 1993**
Gael Newton, Tracey Moffatt: Fever Pitch, **Annandale, 1995**

Andreas Müller-Pohle

1951 Born in Brunswick
 Lives in Göttingen

Solo Exhibitions

1992 Fotogalerie, Vienna
1993 Centre de la Photo-
 graphie, Geneva
1994 The House of Bala-
 banov, Plovdiv,
 Bulgaria
1997 Kunstverein,
 Rüsselsheim;
 Galerie Condé du
 Goethe Institut, Paris;
 Goethe Institute
 Atlanta and Houston

Group Exhibitions

1993 The Persistence of
 Memory, **Third Israeli
 Biennial of Photogra-
 phy, Museum of Art,
 Ein Harod, Israel**
1995 Fotografie nach der Fo-
 tografie, **Aktionsforum
 Praterinsel, Munich**
1997 Photography after
 Photography, **Finnish
 Museum, Helsinki et al.**

Further Reading

**Vilém Flusser, "Andreas Müller-
Pohle: Transformance,"**
Photovision, **Madrid, July –
September 1983**
Signa, **Fotogalerie Wien,
Vienna, 1992**
**Hubertus von Amelunxen,
"Perlasca Pictures," EIKON,
Vienna, 1993**
Partitions digitales I (d'après
Niepce), **Galerie Condé, Paris,
1997**
Synopsis, **Vu, Centre de la
Photographie, Quebec, 1997**

Isabel Muñoz

1951 Born in Barcelona
 Training at the Foto
 Centro de Madrid under
 Eduardo Momene and
 Ramon Mourelle
1984–87 In the USA
 Lives in Barcelona

Solo Exhibitions

1986 Institut Français,
 Madrid
1989 Galerie Spectrum,
 Saragossa
1990 Galerie Jean-Pierre
 Lambert, Mois de la
 Photographie, Paris
1991 Fondation Nationale de
 la Photographie, Lyon
1992 The Chrysler Museum,
 Norfolk, England
1993 Nouveau Théâtre
 d'Angers, Angers
1996 Galerie Scavi Scaglieri,
 Verona
1997 Danse khmère, **Rencon-
 tres Internationales de
 la Photographie, Arles;**
 Retrospective, Festival
 de Beiteddine, Beirut,
 Lebanon
1998 Galerie FNAC,
 Callao, Peru

Further Reading

Isabel Muñoz – Le Tango,
Madrid, 1990
Isabel Muñoz – Flamenco,
Paris, 1993
Isabel Muñoz – Fotografias,
Madrid, 1993
Isabel Muñoz – Tauromachies,
Paris, 1995
Isabel Muñoz – Rome Baroque,
Paris 1997

Floris M. Neusüss

1937 Born in Lennep
1955–63 Studies at the Werk-
 kunstschule Wuppertal,
 the Bayerische Staats-
 lehranstalt für Licht-
 bildwesen in Munich,
 and the Hochschule für
 Bildende Künste in
 Berlin
1964–71 Studio in Munich,
 body photograms
1971 Professor of experimen-
 tal photography at the
 Staatliche Kunst-
 akademie in Kassel
 Lives in Kassel

Solo Exhibitions

1977 Kasseler Kunstverein,
 Kassel
1982 Benteler Gallery,
 Houston;
 Stephen White Gallery,
 Los Angeles
1988 Fotoforum Bremen;
 Striped House Museum
 of Art, Tokyo
1989 Marburger Kunstverein,
 Marburg
1997 Rheinisches Landes-
 museum Bonn

Group Exhibitions

1969 Vision and Expression,
 **George Eastman House,
 Rochester, New York**
1985 Das Selbstporträt im
 Zeitalter der Fotografie,
 **Musée Cantonal des
 Beaux-Arts, Lausanne**
1989 Das Foto als autonomes
 Bild, **Kunsthalle
 Bielefeld**
1995 Moholy and Present
 Company, **The Art
 Institute of Chicago**
1998 **Gruber Collection, Mu-
 seum Ludwig, Cologne**

Further Reading

Floris M. Neusüss, Fotografie
1957 – 1977, **Kassel, 1977**
Das Fotogramm in der Kunst des
20. Jahrhunderts, **Floris M.
Neusüss (ed.), Cologne, 1990**
Floris M. Neusüss – Fotogramme
1957 – 1997, **Rheinisches
Landesmuseum, Bonn, 1997**
Positionen künstlerischer Foto-
grafie in Deutschland seit 1945,
**Ulrich Domröse (ed.), Martin-
Gropius-Bau, Berlin, 1998**

Walter Niedermayr

1952 Born in Bolzano
1995 European Photography
 Award
 Lives in Bolzano

Solo Exhibitions

1994 Museum für
 Gestaltung, Zurich
1996 Galerie Anne de
 Villepoix, Paris
1997 Galerie Norderhake,
 Stockholm;
 Kunstverein Ulm
1998 Gallery White Cube,
 London

Group Exhibitions

1989 Zeitbilder – Fotografie in
 Tirol – Südtirol – Trentino,
 **Museo d'Arte Moderna,
 Bolzano**
1995 Campo, Corderie
 dell'Arsenale, Venice;
 **European Photography
 Award 1995, Deutsche
 Leasing AG,
 Bad Homburg**
1996 Prospect '96,
 Frankfurt a. M.
1997 Venice Biennial
1998 Le Sentiment de la
 Montagne, **Musée de
 Grenoble**

Further Reading

L'insistenza dello sguardo.
Fotografie italiane 1839 – 1989,
Palazzo Fortuny, Venice, 1989
Walter Niedermayr – Die bleichen
Berge, **AR/GE Kunst, Bolzano,
1993**
Walter Niedermayr – Phantasma
und Phantome, **Offenes
Kulturhaus Linz, 1995**
EIKON – Internationale Zeitschrift
für Photographie & Medienkunst,
**no. 16/17, special edition,
Vienna, 1996**
Prospect '96, **Frankfurter
Kunstverein, Schirn Kunst-
halle, Frankfurt a. M., 1996**

Detlef Orlopp

1937	Born in Elbing, West Prussia
1955	Studies at the Staatliche Höhere Fachschule für Fotografie, Cologne
1956–59	Studies under Otto Steinert at the Staatliche Werkkunstschule, Saarbrücken
1959–60	Master at the Folkwangschule für Gestaltung, Essen
1965	Instructor at the Werkkunstschule, Krefeld
1973	Professor of design at the Fachhochschule Niederrhein, Krefeld Lives in Robertville, Belgium

Solo Exhibitions

1973	Bibliothèque Nationale, Paris
1980	Kunstverein Wolfsburg
1983	Beuteler Gallerie, Houston
1984	Galerie Lüpke, Frankfurt a. M.
1997	Galleria Karsten Greve, Milan

Group Exhibitions

1958	photokina, Cologne
1975	Photography as Art, Chalon-sur-Saône, France
1977	Künstlerische Fotografie, Saarland Museum, Saarbrücken
1979	Deutsche Fotografie nach '45, Kasseler Kunstverein, Kassel et al.
1996	50 Jahre Westdeutscher Künstlerbund, Gustav-Lübcke-Museum, Hamm, Germany
1997	Deutsche Fotografie: Macht eines Mediums 1870–1970, Bundeskunsthalle, Bonn

Further Reading

Detlef Orlopp – Photographie, **Galerie Karsten Greve, Cologne, 1990**
Spuren 28. Max Bense in Stuttgart, **Deutsche Schiller-Gesellschaft, Marbach, September 1994**
"Detlef Orlopp – Vertreter der Konkreten Fotorafie," Bulletin, **no. 14, 1998**

Gabriel Orozco

1962	Born in Veracruz, Mexico
1981–84	Attends the Escuela Nacional des Artes Plasticas, Mexico City
1986/87	Circulo de Bellas Artes, Madrid
1995	DAAD Grant, Berlin Lives in Mexico City and New York

Solo Exhibitions

1993	The Museum of Modern Art, New York; Kanaal Art Foundation, Kortrijk, Belgium
1994	Marian Goodman Gallery, New York
1996	Retrospective, Kunsthalle Zürich, Zurich; Institute of Contemporary Arts, London; DAAD, Berlin
1997	Kunsthalle Zürich, Zurich

Group Exhibitions

1993	Real Time, Institute of Contemporary Arts, London
1994	The Epic and the Everyday, Hayward Gallery, London
1995	Migrateurs, Musée d'Art Moderne de la Ville de Paris
1997	Lyon Biennial
1998	Die Rache der Veronika: Die Sammlung Lambert, Deichtorhallen, Hamburg; Fotografie als Handlung, International Photo Triennial, Esslingen

Further Reading

Gabriel Orozco, **Catherine de Zegher (ed.), Kanaal Art Foundation, Kortrijk, 1993**
Francesco Bonami, "Back in five minutes"; Catherine de Zegher, "The Os of Orozco," Parkett, **no. 48, 1996**
Gabriel Orozco, **Kunsthalle Zürich, Zurich, 1997**

Anne and Patrick Poirier

1942	Born in Nantes and Marseille
1967	Grand Prize of Rome for painting and sculpture
1977/78	DAAD Grant, Berlin Live and work in Paris and Trevi

Solo Exhibitions

1977	Neuer Berliner Kunstverein, Berlin
1978	Centre Georges Pompidou, Paris
1981	Villa Romana, Florence
1985	Newport Museum of Art, Los Angeles
1994	Museum Moderner Kunst, Stiftung Ludwig, Vienna
1996	Musée de Picardie, Amiens

Group Exhibitions

1974	Spurensicherung, Kunstverein Hamburg et al.
1977/ 80/84	Venice Biennial
1977	documenta 6, Kassel
1987	Zauber der Medusa, Künstlerhaus Wien, Vienna
1989	Wiener Diwan, Museum des 20. Jahrhunderts, Vienna
1998	Cloth Bound, Laure Genillard, London

Further Reading

Anne et Patrick Poirier – Les Paysages Revolus, **Galerie Sonnabend, Paris, 1975**
Anne und Patrick Poirier, **Bonner Kunstverein, Bonn, 1978**
Anne and Patrick Poirier – The Falling Tower, **Philadelphia College of Art, Philadelphia, 1979**
Anne und Patrick Poirier – Memoria Artificiosa, **Galerie Ropac, Salzburg, 1990**

Sigmar Polke

1941	Born in Oels, Silesia
1953	Emigrates to Düsseldorf via West Berlin
1961–67	Studies under Gerhard Hoehme and Karl Otto Goetz at the Staatliche Kunstakademie in Düsseldorf
1977–91	Professor at the Hochschule für Bildende Künste in Hamburg Lives in Cologne

Solo Exhibitions

1966	Galerie Block, Berlin
1976	Kunsthalle Tübingen et al.
1984	Kunsthaus Zürich, Zurich
1996	Museum of Contemporary Art, Los Angeles
1997	Kunst- und Ausstellungshalle der BRD, Bonn
1998	Hamburger Bahnhof, Berlin

Group Exhibitions

1977	documenta 6, Kassel
1981	A New Spirit in Painting, Royal Academy of Arts, London
1984	von hier aus, Convention Center, Düsseldorf
1986	Venice Biennial

Further Reading

Sigmar Polke, **San Francisco Museum of Modern Art, 1990**
Sigmar Polke – Fotografien, **Staatliche Kunsthalle Baden-Baden, 1990**
Sigmar Polke – Photoworks: When Pictures Vanish, **Museum of Contemporary Art, Los Angeles et al., 1995**
Sigmar Polke – Join the Dots, **Tate Gallery Liverpool, 1995**
Sigmar Polke – Die drei Lügen der Malerei, **Kunst- und Ausstellungshalle der Bundesrepublik Deutschland, Bonn, Ostfildern, 1997**

Richard Prince

1949 Born in the Panama Canal Zone
Lives in New York

Solo Exhibitions

1988 Le Case d'Arte, Milan
1990 Jablonka Galerie and Galerie Gisela Capitain, Cologne
1992 Whitney Museum of American Art, New York
1993 San Francisco Museum of Modern Art
1994 Kestner Gesellschaft, Hanover
1997 Museum Haus Lange and Haus Esters, Krefeld
1998 Barbara Gladstone Gallery, New York

Group Exhibitions

1988 Venice Biennial; BiNationale, Institute of Contemporary Art and Museum of Fine Arts, Boston; Kunsthalle Düsseldorf
1992 documenta 9, Kassel
1993 The Language of Art, Kunsthalle Wien, Vienna
1994 Pictures of the Real World, Paula Cooper Gallery, New York
1998 Die Rache der Veronika: Die Sammlung Lambert, Deichtorhallen, Hamburg; Fast Forward, Kunstverein Hamburg

Further Reading

Hal Foster, "The Expressive Fallacy," Art in America, **January 1983**
Richard Prince, "The Perfect Tense," Blasted Allegories: An Anthology of Writings by Contemporary Artists, **Brian Wallis (ed.), New Museum of Contemporary Art, New York, Cambridge, Massachusetts, 1987**
Susan Tallman, "To Know, Know, Know Him," Parkett, **no. 34, 1992**
Richard Prince – Photographien 1977 – 1993, **Carl Haenlein (ed.), Kestner Gesellschaft, Hanover, 1994**
Richard Prince, Why I Go to the Movies Alone, **Barbara Gladstone Gallery, New York, 1994**

Bernhard Prinz

1953 Born in Fürth
1976 – 81 Akademie der Bildenden Künste, Nuremberg
Lives in Hamburg

Solo Exhibitions

1988/89 Kunstraum München, Munich
1989 Kunsthalle Nürnberg, Nuremberg
1990 Wiener Secession, Vienna
1992 Kunstverein Hannover, Hanover
1996 Hamburger Kunsthalle, Hamburg
1998 Produzentengalerie, Hamburg

Group Exhibitions

1982 Künstler arbeiten mit Fotos, **Kunsthalle Kiel**
1984 Der versiegelte Brunnen, **Kunststichting, Rotterdam**
1987 documenta 8, Kassel
1989 Das konstruierte Bild, **Kunstverein München, Munich et al.**
1992 Photography in Contemporary German Art, **Walker Art Center, Minneapolis et al.**
1997 Portraits, **Galerie Eugen Lendl, Graz**

Further Reading

Bernhard Prinz, **Serpentine Gallery, London, 1988**
Bernhard Prinz – Stilleben, **Kunstraum München, Munich, 1989**
Bernhard Prinz – Idee Ideal Ideologie, **Kunsthalle Nürnberg, Nuremberg, 1989**
"Insert: Bernhard Prinz," Noëma, **1991**
Words Don't Come Easy, **Kunsthaus Hamburg, 1992**

Arnulf Rainer

1929 Born in Baden near Vienna
1954 First "paint-overs"
1968 First grimace photos
1981 – 95 Professor of painting at the Akademie der Bildenden Künste in Vienna
1989 Prize from the International Center of Photography, New York
Lives in Vienna and Tenerife

Solo Exhibitions

1972 Galerie van de Loo, Munich
1980/81 Retrospective, Nationalgalerie, Berlin et al.
1984 Centre Georges Pompidou, Paris
1997 Kunstmuseum, Bonn
1998 Rupertinum, Salzburg

Group Exhibitions

1959 documenta 2, Kassel
1972 – 82 documenta 5 – 7, Kassel
1978 Venice Biennial
1989 Bilderstreit, **Convention Center, Cologne**
1996 Austria im Rosennetz, **MAK, Vienna**

Further Reading

Otto Breicha, Arnulf Rainer – Überdeckungen, **Vienna, 1972**
Arnulf Rainer – Hirndrang, Selbstkommentare und andere Texte zu Werk und Person mit 118 Bildbeigaben, **Otto Breicha (ed.), Salzburg, 1980**
Arnulf Rainer: abgrundtiefe, perspektiefe, Retrospektive 1947 – 1997, **Carl Aigner, Johannes Gachnang, and Helmut Zambo (eds.), Vienna, 1997**
Arnulf Rainer – Die Radierungen, **Kunstmuseum Bonn, Cologne, 1997**

Inge Rambow

1940 Born in Marienburg
since 1979 Works as a photographer for theaters
1998 Travel grant from the Hessische Kulturstiftung
Lives in Frankfurt a. M.

Solo Exhibitions

1980 Bücherbogen, Berlin
1993 Deutsches Historisches Museum, Berlin
1994 Amerika Haus, Frankfurt a. M.
1998 Goethe Institute, New Delhi and Bombay

Group Exhibitions

1975 Experimenta 5, **Frankfurter Kunstverein, Frankfurt a. M.**
1992 Wasteland, **Photography Biennial, Rotterdam**
1993 European Exercises: Twentieth Century Storm, **Galerie DB-S, Antwerp**
1994 Screen Towers, **Museum für Moderne Kunst and Amerika Haus, Frankfurt a. M.**
1996 Prospect '96, **Frankfurt a. M.**
1997/98 Szenenwechsel XII, **Museum für Moderne Kunst, Frankfurt a. M.**

Further Reading

Theaterbuch 1, **Munich, 1978**
Bilder der Strasse, **Frankfurt a. M., 1979**
Inge Rambow – Deutsche Szenen, **Frankfurt a. M., 1990**
Wasteland, Landscape From Now On, **Photography Biennial, Rotterdam, 1992**
Positionen aktueller Kunst der 80er und 90er Jahre. **Museum für Moderne Kunst, Frankfurt a. M., 1994**
Kunst aus Frankfurt 1945 bis heute, **Frankfurt a. M., 1995**

Robert Rauschenberg

1925 Born in Port Arthur, Texas
1946/47 Studies at the Kansas City Art Institute
1947 Académie Julian, Paris
1948–50 Black Mountain College, North Carolina
1964 First American artist to be awarded the Grand Prize at the Venice Biennial
Lives in New York and on Captiva Island, Florida

Solo Exhibitions

1960 Leo Castelli Gallery, New York
1963 Galerie Ileana Sonnabend, Paris
1968 Stedelijk Museum, Amsterdam
1980 Staatliche Kunsthalle, Berlin et al.
1998 Solomon R. Guggenheim Museum, New York et al.

Group Exhibitions

1953 The Stable Gallery, New York
1959 documenta 2, Kassel
1962 Moderna Museet, Stockholm
1982 Beuys, Rauschenberg, Twombly, Warhol, Nationalgalerie, Berlin; Städtisches Museum Abteiberg, Mönchengladbach
1990 High and Low, The Museum of Modern Art, New York

Further Reading

Robert Rauschenberg – Werke 1950 – 1980, **Staatliche Kunsthalle, Berlin, 1980**
C. Tomkins, Off the Wall: Robert Rauschenberg and the Art World of Our Time, **New York, 1980**
M. L. Kotz, Robert Rauschenberg: Art and Life, **New York, 1990**
Robert Rauschenberg – A Retrospective, **Walter Hopps and Susan Davidson (eds.), Guggenheim Museum, New York, 1998**

Bettina Rheims

1952 Born in Paris
1977 First photo reportage; in New York
1981 Founds the Galerie des Contemporains (with Jean Charles de Castelbajac)
1984 Contract with Sygma photo agency
1992 – 94 Photography for Gianfranco Ferré's campaign
1994 Grand Prix de la Photographie de la Ville de Paris
Lives in Paris

Solo Exhibitions

1981 Centre Georges Pompidou, Paris
1989 Münchner Stadtmuseum, Munich; Musée de l'Elysée, Lausanne
1990 Maison Européenne de la Photographie, Paris
1997 Retrospective, Galerie Odykyu, Tokyo

Group Exhibitions

1984 La Photographie de Mode, **Galerie Texbraun, Paris**
1988 L'Arche de Noé, **Palais de Tokyo, Paris; Photography Biennial, Nancy**
1993 Das Bild des Körpers, **Frankfurter Kunstverein, Frankfurt a. M.**
1997 Antlitz, **Galerie Ropac, Salzburg**
1998 **Photography Biennial, Moscow**

Further Reading

Les Femmes de Vogue Hommes, **Paris, 1988**
Bettina Rheims – Female Trouble, **Munich, 1989**
Bettina Rheims – Chambre Close, **Paris, 1992**
The Color of Fashion, **Eastman Kodak, New York, 1993**
Bettina Rheims – I.N.R.I., **Paris, 1998**

Olivier Richon

1956 Born in Lausanne
1980 B. A. in film and photography, School of Communications, Polytechnic of Central London
1988 M. A. in philosophy, London
Teaches at the University of Westminster, London
Lives in London

Solo Exhibitions

1984 Institute of Contemporary Arts, London
1987 Galerie Samia Saouma, Paris
1991 Espace d'Art Contemporain, Lausanne
1993 Jack Shainman Gallery, New York

Group Exhibitions

1987 The Analytical Theater, **Akron Art Museum, Ohio et al.**; Mysterious Coincidences, **Photographer's Gallery, London et al.**
1990 Wichtige Bilder, **Museum für Gestaltung, Zurich;** Images in Transition, **National Museum of Modern Art, Kyoto and Tokyo**
1993 Diskurse der Bilder, **Kunsthistorisches Museum, Vienna**
1998 Dinge, **Neue Gesellschaft für Bildende Kunst, Berlin**

Further Reading

Olivier Richon (ed., with John X. Berger), Other Than Itself. Writing Photography, **London, 1989**
Laura Mulvey, "Magnificent Obsession," Visual and other Pleasures, **Basingstoke, 1989**
Michael Newman, "Mimesis and Abjection in Recent Photowork," Thinking Art, Beyond Traditional Aesthetics, **London, 1991**
Olivier Richon, **Galerie des Beaux-Arts, Nantes, 1992**

Evelyn Richter

1930 Born in Bautzen, Germany
1948–52 Photographic training under Pan Walther and Franz Fiedler in Dresden
1953–56 Studies photography at the Hochschule für Graphik und Buchkunst (HGB), Leipzig
1980–90 Instructor of photography at the HGB, Leipzig
Lives in Neukirch (Lausitz), Dresden, and Leipzig

Solo Exhibitions

1983 Galerie P, Leipzig
1984 Fotomuseum im Münchner Stadtmuseum, Munich
1992 Hochschule für Bildende Künste, Dresden; Staatliche Galerie Moritzburg, Halle
1997 Historisches Museum, Zeughaus unter den Linden, Berlin

Group Exhibitions

1958 action fotografie, **Hansahaus, Leipzig**
1986 Fotografie in der Kunst der DDR, **Staatliche Kunstsammlungen Cottbus**
1994 Fotografien der Leipziger Schule 1955 – 93, **Kölner Kunstverein, Cologne et al.**
1997 Deutsche Fotografie: Macht eines Mediums 1870 – 1970, **Bundeskunsthalle, Bonn**
1998 Deutsche Reportage-Fotografie, **Galerie Zimmer, Düsseldorf**

Further Reading

Alltag und Epoche: Werke bildender Kunst der DDR aus fünfunddreissig Jahren, **Altes Museum, Berlin, 1984**
DDR Frauen fotografieren – Lexikon und Anthologie, **Gabriele Muschter (ed.), Berlin, 1989**
Kunst in der DDR, **Eckhard Gillen and Rainer Haarmann (ed.), Cologne, 1990**
Nichts ist so einfach wie es scheint: Ostdeutsche Fotografie 1945 – 1989, **Ulrich Domröse (ed.), Berlinische Galerie, Berlin, 1992**

Gerhard Richter

1932 Born in Dresden
1952–57 Studies at the Hochschule für Bildende Künste in Dresden
1961–63 Studies at the Staatliche Kunstakademie in Düsseldorf
1971–94 Professor of painting at the Staatliche Kunstakademie in Düsseldorf

Solo Exhibitions

1971 Retrospective, Kunstverein für die Rheinlande und Westfalen, Düsseldorf
1973 Modern Art Agency, Naples
1981 Tate Gallery, London
1986 Retrospective, Kunsthalle Düsseldorf et al.
1993/94 Retrospektive, Musée d'Art Moderne de la Ville de Paris; Centro de Arte Reina Sofia, Madrid et al.
1997 Hamburger Kunsthalle, Hamburg
1998 Lenbachhaus, Munich

Group Exhibitions

1964 Kapitalistischer Realismus, **Galerie René Block, Berlin**
1972 Venice Biennial; **documenta 5, Kassel**
1990 Passage de l'image, **Centre Georges Pompidou, Paris**
1992 Allegories of Modernism, **The Museum of Modern Art, New York**
1997 **documenta 10, Kassel**

Further Reading

Gerhard Richter – 18. Oktober 1977, **Museum Haus Esters, Krefeld, Portikus, Frankfurt a. M., Cologne, 1989**
Gerhard Richter – Editionen 1965 – 1993, **Munich, 1993**
Gerhard Richter, **3 vols., Ostfildern, 1993**
Gerhard Richter – Text, Schriften und Interviews, **Hans-Ulrich Obrist (ed.), Frankfurt a. M. and Leipzig, 1993**
Gerhard Richter – Atlas der Fotos, Collagen und Skizzen, **Helmut Friedel and Ulrich Wilmes (eds.), Lenbachhaus München, Cologne, 1997**

Klaus Rinke

1939 Born in Wattenscheid, Germany
1954–57 Training as a poster painter in Gelsenkirchen
1957–60 Studies free and applied painting at the Folkwangschule, Essen
1974 Starts teaching at the Staatliche Kunstakademie Düsseldorf
Lives in Haan near Düsseldorf and in Los Angeles

Solo Exhibitions

1985 Centre Georges Pompidou, Paris
1986 Palais du Tau, Reims
1990 Galerie Meyer-Ellinger, Frankfurt a. M.
1991 Galerie Karsten Greve, Cologne
1992 Kunsthalle Düsseldorf

Group Exhibitions

1970 Tokyo Biennial
1971 Paris Biennial
1972 documenta 5, Kassel
1973 São Paulo Biennial
1993 Photographie in der deutschen Gegenwartskunst, **Museum Ludwig, Cologne**
1997 Deutsche Fotografie: Macht eines Mediums 1870 – 1970, **Bundeskunsthalle, Bonn**

Further Reading

Klaus Rinke: Zeit Raum Körper Handlungen, **Götz Adriani (ed.), Kunsthalle Tübingen, 1972**
Klaus Rinke: Objekte, Photoserien, Zeichnungen 1969 – 1975, **Kunstverein für die Rheinlande und Westfalen, Düsseldorf, 1975**
Klaus Rinke: Retroaktiv (1954 – 1991), **Städtische Kunsthalle, Düsseldorf, 1992**
Photographie in der deutschen Gegenwartskunst, **Reinhold Mißelbeck (ed.), Museum Ludwig, Cologne, 1993**

Miguel Rio Branco

1946 Born in Las Palmas, Grand Canary
1966 Studies at the New York Institute of Photography
1968 Studies at the Escola Superior de Desenho Industrial in Rio de Janeiro
1982 Member of Magnum photo agency
Lives in Rio de Janeiro

Solo Exhibitions

1986 Burden Gallery, Aperture Foundation, New York
1991 ifa-Galerie, Bonn; Fotografie Forum, Frankfurt a. M.
1993 Espace Archide, Paris
1995 Galeria Luisa Strina, São Paulo; ifa-Galerie, Stuttgart
1996 Throckmorton Fine Art, New York
1997 D'Amelio Terras, New York

Group Exhibitions

1982 Photographie contemporaine latino-américaine, **Centre Georges Pompidou, Paris**
1985 Auto-Retrato do Brasileiro, **Museu de Arte Moderna de São Paulo**
1987 Masters of Street Photography III, **Museum of Photographic Arts, San Diego**
1994 Havana Biennial, Cuba; **Ludwig Forum für Internationale Kunst, Aachen**
1998 Der brasilianische Blick, **Haus der Kulturen der Welt, Berlin**

Further Reading

"Rio Branco en Amazonie," PhotoMagazine, **1984**
Miguel Rio Branco – Salvador de Bahia, **Paris, 1985**
Miguel Rio Branco – Das Herz ist ein Spiegel des Fleisches, **Fotografie Forum, Frankfurt a. M. et al., 1991**
Miguel Rio Branco – Von nirgendwoher, **Institut für Auslandsbeziehungen, ifa-Galerie, Stuttgart, 1995**

Peter Roehr

1944 Born in Lauenburg, Pomerania
1959–62 Training as a neon-sign maker in Frankfurt a. M.
1962–65 Studies applied painting at the Werkkunstschule Wiesbaden
1968 Dies in Frankfurt a. M.

Solo Exhibitions

1967 Galerie Loehr, Frankfurt a. M.
1971 Städtisches Museum, Schloss Morsbroich, Leverkusen; Videogalerie Schum, Düsseldorf
1977 Stedelijk van Abbe Museum, Eindhoven
1988 Galerie Paul Maenz, Cologne; Galerie Meyer-Ellinger, Frankfurt a. M.
1994 Museum für Moderne Kunst im Fotografie Forum, Frankfurt a. M.

Group Exhibitions

1966 Galerie Patio, Frankfurt a. M.
1967 Serielle Formationen, **Studiogalerie, Universität Frankfurt a. M.**
1972 **documenta 5, Kassel**
1973 Kunst aus Fotografie, **Kunstverein Hannover, Hanover**
1991 **Museum für Moderne Kunst, Frankfurt a. M.**
1996 Die Sammlung Speck, **Museum Ludwig, Cologne**

Further Reading

Burkhard Brunn, Rudi H. Fuchs, Werner Lippert, Paul Maenz, Charlotte Posenenske, Peter Roehr, **Cologne, 1977**
Peter Roehr, **Kunstmuseum Luzern, Lucerne, 1978**
Peter Roehr zum 20. Todestag 1968 – 1988, **Galerie Paul Maenz, Cologne; Galerie Meyer-Ellinger, Frankfurt a. M., 1988**
Hommage an Peter Roehr – Foto-Montagen der Jahre 1964 – 1966, **Rolf Lauter (ed.), Frankfurt a. M., 1994**

Ulrike Rosenbach

1949 Born in Salzdetfurth, Germany
1964–69 Studies sculpture at the Hochschule für Bildende Kunst in Düsseldorf, master student under Joseph Beuys
1973 First performance, Kunsthalle Düsseldorf
1976 Founds the Schule für kreativer Feminismus in Cologne
1989 Professor of new artistic media at the Hochschule der Bildenden Künste in Saar
 Lives near Cologne

Solo Exhibitions

1978 Kunstmuseum Düsseldorf
1983 Institute of Contemporary Art, Boston
1985 Museum van Hedendaagse Kunst, Gent
1990 Stadtgalerie Saarbrücken
1997 Museum Bad Arolsen

Group Exhibitions

1977 documenta 6, Kassel
1980 Venice Biennial
1983 The Video History Show, The Museum of Modern Art, New York
1986 Ars Electronica, Linz; Eva und die Zukunft, Hamburger Kunsthalle, Hamburg
1987 documenta 8, Kassel
1998 Performance-History, Museum of Contemporary Art, Los Angeles; Die Unruhe und die Zufriedenheit, Kunstverein, Karlsruhe

Further Reading

Ulrike Rosenbach: Videokunst, Aktion/Performance, feministische Kunst, Foto, Cologne, 1982
Ulrike Rosenbach-Arbeiten der 80er Jahre, Stadtgalerie Saarbrücken, 1990
Ulrike Rosenbach – Last call für Engel, Kunstmuseum Heidenheim, 1996
Made for Arolsen: Ulrike Rosenbach, Museum Bad Arolsen, 1997

Georges Rousse

1947 Born in Paris
1985–87 In Rome
1993 Grand Prix Nationale de la Photographie
 Lives in Paris

Solo Exhibitions

1985 Musée des Beaux-Arts, Orléans
1993 Musée National d'Art Moderne, Paris
1994 Galerie Springer und Winckler, Frankfurt a. M.
1995 Bibliothèque Louis Aragon, Choisy
1997 Musée de l'Elysée, Lausanne
1998 Heidi Reckermann Photographie, Cologne

Group Exhibitions

1989 Nos années 80, Fondation Cartier, Paris
1990 National Museum of Modern Art, Tokyo
1993 De Brancusi a Boltanski, Castello di Rivoli, Turin
1996 Ich Phoenix, Oberhausen Triennial
1997 Kunsthalle Wien, Vienna

Further Reading

Georges Rousse, Third Eye Center, Glasgow, Arnolfni, Bristol, 1987
Georges Rousse, Galerie Michael Haas, Berlin, 1988
Georges Rousse, Tel Aviv Museum of Art, 1990
Georges Rousse 1982 – 1994, Centre Photographique d'Île-de-France, Musée de la Cour d'Or, Metz, 1994

Thomas Ruff

1958 Born in Zell am Hamersbach, Black Forest
1977–85 Studies under Bernd Becher at the Kunstakademie Düsseldorf
1990 Dorothea von Stetten Art Prize, Bonn
 Lives in Düsseldorf

Solo Exhibitions

1988 Portikus, Frankfurt a. M.
1989 Stichting de Appel Amsterdam; Kunsthalle Zürich, Zurich
1991 Bonner Kunstverein, Bonn et al.
1996 Rooseum Center for Contemporary Art, Malmö, Sweden
1998 303 Gallery, New York

Group Exhibitions

1988 BiNationale, Kunsthalle Düsseldorf et al.
1991 Aus der Distanz, Kunstsammlung Nordrhein-Westfalen, Düsseldorf
1992 Photography in Contemporary German Art 1960 to the Present, Walker Art Center, Minneapolis et al.; documenta 9, Kassel
1995 Venice Biennial
1998 Wounds: Between Democracy and Redemption in Contemporary Art, Moderna Museet, Stockholm

Further Reading

Thomas Ruff – Porträts Häuser Sterne, Stedelijk Museum Amsterdam et al., 1989 – 90
Thomas Ruff, Schriften zur Sammlung des Museums für Moderne Kunst, Frankfurt a. M., 1992
Thomas Ruff – Andere Porträts + 3D, Venice Biennial, 1995
Thomas Ruff, Rooseum Center for Contemporary Art, Malmö, Sweden, 1996

Sebastião Salgado

1944 Born in Aimores, Brazil
1968 Masters degree in economics at the University of São Paulo
1971 Doctorate in agriculture at the Sorbonne, Paris
1973 First work as a photojournalist (reports on famine in Nigeria)
1974 Works for Sygma agency; travels to Portugal, Angola, and Mozambique
1975 Member of Gamma agency; travels through Europe, Africa, and Central America
since 1979 Member of Magnum photo agency
1984 Prize from the city of Paris for the photo series Otras Americas
1986 Starts work on his six-year project Workers – An Archaeology of the Industrial Age with trips to 26 countries
1985 World Press Photo Award
1987 Photographer of the Year
1998 Prince of Asturias Prize
 Lives in Paris

Further Reading

Sebastião Salgado – Sahel: L'Homme en Détresse, Paris, 1986
Sebastião Salgado – Other Americas, New York, 1986
E. Galeano and F. Ritchin, An Uncertain Grace: Photographs by Sebastião Salgado, New York, 1994
Sebastião Salgado – Die Würde des Menschen – 100 Fotos für die Pressefreiheit, Reporter ohne Grenzen e.V. (ed.), Berlin, 1996

Jörg Sasse

1962 Born in Bad Salzuflen, Germany
1982–88 Studies at the Kunstakademie Düsseldorf
1987 Master student under Bernd Becher
Lives in Düsseldorf

Solo Exhibitions

1995 DG BANK art project, Frankfurt a. M.; Oldenburger Kunstverein, Oldenburg
1996 Kölnischer Kunstverein, Cologne; Städtische Galerie Wolfsburg
1997 Kunsthalle Zürich, Zurich; Lehman Maupin, New York; Musée d'Art Moderne de la Ville de Paris
1998 Portikus, Frankfurt a. M. (with Udo Koch)

Group Exhibitions

1994 Kunst mit Fotografie – Die neunziger Jahre, **Rheinisches Landesmuseum, Bonn**
1995 Scharfer Blick, **Bundeskunsthalle, Bonn;** ... wie gemalt, **Neuer Aachener Kunstverein, Aachen**
1996 Der soziale Blick, **special photography exhibit at the Art Frankfurt exhibition, Frankfurt a. M.;** Fotografia nell'arte tedesca contemporanea, **Gian Ferrari Arte Contemporanea, Milan; Foro Boario, Modena**

Further Reading

Jörg Sasse, **Institut Mathildenhöhe, Darmstadt, 1992**
Christoph Blase, "Die Gesamtretusche – Zu den Bildern von Jörg Sasse," Kunst Bulletin, **September 1996**
Jörg Sasse, **Kölnischer Kunstverein, Cologne, 1996**
Jörg Sasse, **Musée d'Art Moderne de la Ville de Paris, Paris, 1997**

Michael Schmidt

1945 Born in Berlin
1965 First photographic works
1976/77 Founds and heads the photography workshop at the Volkshochschule Kreuzberg in Berlin; instructor at the Pädagogische Hochschule Berlin
since 1980 Instructor at various colleges
Lives in Berlin

Solo Exhibitions

1975 Galerie Springer, Berlin
1981 Museum Folkwang, Essen
1987 Berlinische Galerie, Berlin
1995 The Museum of Modern Art, New York
1997 Sprengel Museum, Hanover

Group Exhibitions

1980 Absage an das Einzelbild, **Museum Folkwang, Essen**
1985 Das fotografische Selbstporträt, **Kunstverein Stuttgart**
1986 **Enschede Photography Biennial, Netherlands**
1987 Poignant Sources, **Artspace San Francisco**
1998 Positionen künstlerischer Fotografie in Deutschland seit 1945, **Martin-Gropius-Bau, Berlin**

Further Reading

Michael Schmidt – Berlin Kreuzberg, **Berlin, 1978**
Michael Schmidt – Waffenruhe, **with a text by Einar Schleef, Berlin, 1987**
Michael Schmidt – Bilder 1979 – 1986, **Sprengel Museum, Hanover, 1987**
Ein-Heit, **Sprengel Museum, Hanover, Zurich, 1997**

Sean Scully

1945 Born in Dublin
1965–73 Croydon College of Art, London and Harvard University, Cambridge, Massachusetts
1977–83 Teaches at Princeton University, New Jersey
Lives in New York and Barcelona

Solo Exhibitions

1973 Rowan Gallery, London
1985 Boston Museum of Fine Arts
1989 Lenbachhaus, Munich; Whitechapel Art Gallery, London; Palacio Velázquez, Madrid
1993 Mary Boone Gallery, New York
1996 Kunsthalle Schirn, Frankfurt a. M.; Galerie Nationale du Jeu de Paume, Paris
1996–99 Museum Folkwang, Essen, Metropolitan Museum, New York et al.
1998 Galerie Bernd Klüser, Munich; Bawag Foundation, Vienna

Group Exhibitions

1984 An International Survey of Recent Painting and Sculpture, **The Museum of Modern Art, New York**
1992 Geteilte Bilder, **Museum Folkwang, Essen**
1993 Drawing in Black and White, **The Museum of Modern Art, New York**
1996 Nuevas Abstraciones, **Centro de Arte Reina Sofia, Madrid**
1998 On a Clear Day, **Staatsgalerie Stuttgart**

Further Reading

Sean Scully – Paintings 1971 – 1981, **Icon Gallery, Birmingham, 1981**
Sean Scully, **The Art Institute of Chicago, 1987**
Mairice Poirier, Sean Scully, **New York, 1990**
Sean Scully: Twenty Years 1976 – 1995, **High Museum of Art, Atlanta, 1995**

Cindy Sherman

1954 Born in Glen Ridge, New Jersey
1976 B. A., State University, Buffalo, New York
since 1977 Lives in New York

Solo Exhibitions

1980 Metro Pictures, New York
1991 Kunsthalle Basel et al.
1993 Tel Aviv Museum of Art
1995 Deichtorhallen, Hamburg et al.
1996 Museum Boymans-van Beuningen, Rotterdam
1998 Museum Ludwig, Cologne

Group Exhibitions

1981 Autoportraits, **Centre Georges Pompidou, Paris**
1982 documenta 7, Kassel
1983 Whitney Biennial, **New York**
1990 Figuring the Body, **Museum of Fine Arts, Boston**
1991 Metropolis, **Martin-Gropius-Bau, Berlin**
1992 More Than Photography, **The Museum of Modern Art, New York**
1996 Masculin/Feminin, **Centre Georges Pompidou, Paris**

Further Reading

Untitled Film Stills: Cindy Sherman, **Munich, 1990**
Cindy Sherman – History Portraits, **Munich, 1991**
Cindy Sherman 1975 – 1993, **Munich, 1993**
Jürgen Klauke – Cindy Sherman, Sammlung Goetz, **Ostfildern, 1994**
Cindy Sherman, **Museum Boymans-van Beuningen, Rotterdam, 1996**

Stephen Shore

1947 Born in New York
1961 Edward Steichen acquires three of his photos for The Museum of Modern Art, New York
1965–68 Frequent visits to Andy Warhol's Factory
since 1982 Teaches and Head of the Department of Photography at Bard College, Annandale
Lives in New York

Solo Exhibitions

1971 Metropolitan Museum of Art, New York
1976 The Museum of Modern Art, New York
1977 Kunsthalle Düsseldorf
1992 The J. Paul Getty Museum at the Getty Center, Malibu
1995 Westfälischer Kunstverein, Münster
1997 Nederlands Foto Instituut, Rotterdam

Group Exhibitions

1973 Landscape/Cityscape, Metropolitan Museum of Art, New York
1975 New Topographics, George Eastman House, Rochester
1980 Mirrors and Windows, The Museum of Modern Art, New York et al.
1989 On the Art of Fixing a Shadow, The Art Institute of Chicago et al.
1994 Maison de la Photo, Reims
1996 Breuer's Whitney, Whitney Museum of American Art, New York

Further Reading

Stephen Shore – Fotografien 1973 – 1993, **Munich, 1995**
Stephen Shore – The Velvet Years: Andy Warhol's Factory, 1965–67, **London/New York, 1995**
Stephen Shore – The Nature of Photographs, **Johns Hopkins University Press, 1998**

Katharina Sieverding

1944 Born in Prague
1962/63 Hochschule für Bildende Kunst, Hamburg
1967–72 Studies under Teo Otto and Joseph Beuys at the Staatliche Kunstakademie Düsseldorf
since 1992 Professor at the Hochschule der Künste, Berlin
Lives in Düsseldorf

Solo Exhibitions

1972 Galerie L'Attico, Rome
1980 Kunsthalle Düsseldorf
1984 Museum Abteiberg, Mönchengladbach
1992 Neue Nationalgalerie, Berlin
1998 Stedelijk Museum, Amsterdam; Neues Museum Weserburg, Bremen

Group Exhibitions

1965 Paris Biennial
1972 documenta 5, Kassel
1976/80 Venice Biennial
1982 documenta 7, Kassel
1985 1945 – 1985: Kunst in der Bundesrepublik Deutschland, Neue Nationalgalerie, Berlin
1997 Venice Biennial

Further Reading

Brennpunkt Düsseldorf, **Kunstmuseum Düsseldorf, 1987**
Katharina Sieverding: Die Sonne um Mitternacht schauen, **Galerie Barbara Gross, Munich, 1990**
Photographie in der deutschen Gegenwartskunst, **Reinhold Mißelbeck (ed.), Museum Ludwig, Cologne, 1993**
Deutschsein?, **Kunsthalle Düsseldorf, 1993**
Foto-Kunst, **Institut für Auslandsbeziehungen, Stuttgart and Ostfildern, 1995**
Katharina Sieverding 1967 – 1997, **Kunstsammlung Nordrhein-Westfalen, Düsseldorf, 1998**

Lorna Simpson

1960 Born in Brooklyn, New York
Lives in Brooklyn

Solo Exhibitions

1990 Projects: Lorna Simpson, The Museum of Modern Art, New York
1992 Museum of Contemporary Art, Chicago
1995 Wiener Secession, Vienna
1997 Wexner Center for the Arts, Columbus, Ohio

Group Exhibitions

1993 Biennial Exhibition, Whitney Museum of American Art, New York
1994 Standing in the Water, Whitney Museum of American Art, New York, and The Fabric Workshop, Philadelphia
1995 Outburst of Signs, Künstlerwerkstatt, Munich
1998 Hugo Boss Prize, Solomon R. Guggenheim Museum, New York

Further Reading

Michael Brensen, "New Visions," New York Times, **January 1987**
Julia Koether, "Lorna Simpson: Psychosoziale Forschungen," Artis, **December 1990/January 1991**
Lorna Simpson: Untitled 54, **Friends of Photography, San Francisco, 1992**
Beryl J. Wright, Lorna Simpson: For the Sake of the Viewer, **New York and Chicago, 1992**
Bell Hooks, "Lorna Simpson: Waterbearer," Artforum, **September 1993**
Kim Levin, Lorna Simpson, Village Voice, **October 1993**

Annelies Štrba

1947 Born in Zug, Switzerland
Lives in Richterswil and Melide, Switzerland

Solo Exhibitions

1990 Aschewiese, Kunsthalle Zürich, Zurich
1993 Galerie Bob von Orsow, Zurich
1995 Museum Moritzburg, Halle
1996 Kunstverein Düsseldorf; Kunstverein Weimar
1997 Aargauer Kunsthaus, Aarau
1998 Galerie Eigen + Art, Leipzig

Group Exhibitions

1994 Another Continent, Metropolitan Museum of Photography, Tokyo
1995 Surroundings, Museum Fridericianum, Kassel
1996 The Eye of the Beholder, The Swiss Institute, New York
1997 Antechamber, Whitechapel Art Gallery, London; Vertrauenssache, Bonner Kunstverein, Bonn

Further Reading

Aschewiese, **Kunsthalle Zürich, Zurich, 1990**
Annelies Štrba, **Galerie Eigen + Art, Berlin, 1992**
WARE IRI WARE NI IRU, **Galerie Meile, Lucerne, 1994**
The Epic & The Everyday, **Hayward Gallery, London, 1994**

Beat Streuli

1957 Born in Altdorf, Switzerland
since 1990 Lives in Düsseldorf and New York

Solo Exhibitions

1990 Helmhaus, Zurich
1993 Raum für aktuelle Kunst, Lucerne
1994 Gesellschaft für aktuelle Kunst, Bremen
1995 Kunstverein Stuttgart
1996 Musée d'Art Moderne de la Ville de Paris
1998 Museo de Arte Contemporáneo, Barcelona

Group Exhibitions

1991 Kunst mit Fotografie, **Galerie Conrads, Düsseldorf**
1993 In Their Own Image, **P. S. 1, Long Island City, New York**
1994 The Act of Seeing (Urban Space), **Fondation pour l'Architecture, Brussels**
1995 Szenenwechsel VII, **Museum für Moderne Kunst, Frankfurt a. M.**
1996 **The Whitney Museum of American Art, New York**
1997 Distanz und Domizil, **Kunsthaus Dresden**
1998 Images, **Galerie Bernhard Schindler, Bern**

Further Reading

Jean-François Chevrier, Beat Streuli – Projektionen und Fotografien NYC 91/93, **Kunstmuseum Luzern, Lucerne, 1993**
European Photography Award, **Deutsche Leasing AG (ed.), Bad Homburg, 1993**
Jean-Charles Masséra, "Beat Streuli – Manière d'être/Ways of Being," Art Press, **no. 197, 1994**
Martin Hentschel and Adrian Dannatt, USA 95, **Württembergischer Kunstverein, Stuttgart, 1995**
Internationale Foto-Triennale: Dicht am Leben/Close to Life, **Galerie der Stadt Esslingen, 1995**

Thomas Struth

1954 Born in Geldern
1973–78 Studies under Peter Kleemann, Gerhard Richter, and Bernd Becher at the Kunstakademie Düsseldorf
1978 Fellowship for New York from the Kunstakademie Düsseldorf
Lives in Düsseldorf

Solo Exhibitions

1987 Kunsthalle Bern et al.
1990 Marian Goodman Gallery, New York
1991 Shimada Gallery, Yamaguchi, Japan
1994 Institute of Contemporary Arts, London et al.
1996 Kunstmuseum Bonn
1998 Stedelijk Museum, Amsterdam

Group Exhibitions

1990 **Venice Biennial (Aperto)**
1991 A Dialogue about Recent American and European Photography, **Museum of Contemporary Art, Los Angeles;**
Sguarda di Medusa, **Castello di Rivoli, Turin**
1992 **documenta 9, Kassel**
1997 Absolute Landscape: Between Illusion and Reality, **Yokohama Museum of Art**
1998 Art of the Eighties, **Culturgest, Lisbon**

Further Reading

Thomas Struth – Porträts, **Museum Haus Lange, Krefeld, 1992**
Thomas Struth – Museum Photographs, **Hans Belting (ed.), Munich, 1993**
Thomas Struth – Strangers and Friends: Photographs 1986–1992, **Institute of Contemporary Arts, London et al., 1994**
Thomas Struth – Landschaften: Photographien 1991–1993, **Düsseldorf, 1994**
Thomas Struth – Strassen: Fotografie 1976–1995, **Kunstmuseum Bonn, 1995**

Hiroshi Sugimoto

1948 Born in Tokyo
1966–70 B. A., Saint Paul's University, Tokyo
1972 B. F. A., Art Center College of Design, Los Angeles
since 1974 Lives in New York

Solo Exhibitions

1989 The National Museum of Contemporary Art, Osaka
1994 The Museum of Contemporary Art, Los Angeles
1995 Kunsthalle Basel
1996 Moderna Museet, Stockholm
1997 Berkeley Art Museum
1998 Galerie Claudia Delank, Bremen

Group Exhibitions

1993 Multiple Images: Photographs from the Collection, **The Museum of Modern Art, New York**
1994 Space, Time, and Memory: Photography and Beyond in Japan, **Hara Museum of Contemporary Art, Tokyo**
1995 Private/Public, **Museum of Contemporary Art, Helsinki**
1996 Prospect '96, **Frankfurt a. M.**
1997 In Visible Light, **Museum of Modern Art, Oxford**
1998 Terra Incognita – Five Visionary Worlds, **Neues Museum Weserburg, Bremen**

Further Reading

Francesco Bonami, "Hiroshi Sugimoto: Zen Marxism," Flash Art International, **no. 180, January/February 1995**
Jean-Christian Fleury, "Hiroshi Sugimoto: Théâtres du vide," Camera International, **Summer 1995**
Thomas Kellein, Hiroshi Sugimoto: Time Exposed, **London, 1995**
Norman Bryson, "Sugimoto's Metabolic Photography," Parkett, **no. 46, 1996**

Wolfgang Tillmans

1968 Born in Remscheid, Germany
1990–92 Studies at Bournemouth & Poole College of Art and Design, England
1994/95 In New York
since 1996 Lives in London

Solo Exhibitions

1992 PPS Galerie F. C. Gundlach, Hamburg
1993 L. A. Galerie, Frankfurt a. M.
1994 Andrea Rosen Gallery, New York
1995 Portikus, Frankfurt a. M.
1996 Kunstmuseum Wolfsburg
1997 Chisenhale Gallery, London

Group Exhibitions

1994 L'Hiver de l'Amour, **Musée d'Art Moderne de la Ville de Paris;**
Sogetto Sogetto, **Castello di Rivoli, Turin**
1995 Human Nature, **New Museum of Contemporary Art, New York;**
Kunstpreis der Böttcherstrasse in Bremen, **Kunsthalle Bremen**
1996 New Photographers # 12, **The Museum of Modern Art, New York**
1998 Die Sammlung Gruber, **Museum Ludwig, Cologne;**
Die Rache der Veronika: Die Sammlung Lambert, **Deichtorhallen, Hamburg;**
Fast Forward, **Kunstverein Hamburg**

Further Reading

Wolfgang Tillmans, **Burkard Riemenschneider (ed.), Cologne, 1995**
Wolfgang Tillmans, **Kunsthalle Zürich, Zurich, 1995**
Wolfgang Tillmans, **Portikus, Frankfurt a. M., 1995**
Wolfgang Tillmans – Wer Liebe wagt lebt morgen, **Kunstmuseum Wolfsburg, Ostfildern, 1996**

James Turrell

1943 Born in Los Angeles
1965 B. A. in psychology and mathematics, Pomona College, Claremont, California
1973 M. F. A. in art, Claremont Graduate School
Lives in Flagstaff, Arizona

Solo Exhibitions

1967 Pasadena Art Museum
1976 Stedelijk Museum, Amsterdam
1983 Israel Museum, Jerusalem
1987 Kunsthalle Basel
1993 South Bank Centre, London
1998 Hue-Williams Fine Art, London

Group Exhibitions

1986 Directions 1986, Hirshorn Museum and Sculpture Garden, Washington, D. C.
1986/87 Individuals: A Selected History of Contemporary Art 1945 – 1986, Museum of Contemporary Art, Los Angeles
1991 Museum für Moderne Kunst, Frankfurt a. M.
1994 Starlight, Kunstmuseum, Aarhus
1997 Lux Lumen, Fundació Joan Miró, Barcelona
1998 Sunshine & Noir: Art in L. A. 1960 – 1997, Kunstmuseum Wolfsburg

Further Reading

James Turrell, Suzanne Pagé (ed.), Musée d'Art Moderne de la Ville de Paris, 1983
Occluded Front: James Turrell, Julia Brown (ed.), Museum of Contemporary Art, Los Angeles, 1985
James Turrell: First Light, Josef Helfenstein and Christoph Schenker (eds.), Kunstmuseum Bern, Berne, 1991
Axel Müller, Die ikonische Differenz: das Kunstwerk als Augenblick, Munich, 1997

Uecker/Schroeter

Günther Uecker

1930 Born in Wendorf, Mecklenburg
1949 – 53 Studies painting in Wismar and at the Kunstakademie Berlin-Weissensee
1955 – 58 Studies at the Kunstakademie Düsseldorf
Lives and teaches in Düsseldorf

Rolf Schroeter

1932 Born in Zurich
1954 – 57 Studies visual communications in Ulm
1957/58 Works with Max Bill
Lives in Zurich

Exhibitions of Joint Projects

1983 Galerie Erker, St. Gallen; Kunsthalle Düsseldorf; Galerie Lörl, Mönchengladbach
1984 Galerie der Stadt Esslingen
1991 Espace de L'Art Concret, Château de Mouans-Sartoux
1992 Galerie K, Leukstadt
1992 Alte Fabrik, Rapperswil, Switzerland
1993 Galerie Spielvogel, Munich

Further Reading

Rolf Schroeter/Günther Uecker – Bildrituale, Glarus, 1981
Rolf Schroeter/Günther Uecker – Vision Rapperswil aus dem Quadrat, Zurich, 1982
Schroeter/Uecker, Entwicklung eines Werkes, Fotoumwandlungen, St. Gallen, 1983
Rolf Schroeter/Günther Uecker – Baum, Glarus, 1986
Rolf Schroeter/Günther Uecker/Hubert Neuerburg – Muttermord in der Diamantenwüste, Zurich, 1986
Rolf Schroeter/Günther Uecker – Vorfeldzeichen Vatnajökull Island, Munich, 1987

Wolf Vostell

1932 Born in Leverkusen
1971 Founds the Happening Archive Berlin
1976 Founds the Museo Vostell Malpartida, Extremadura, Spain
1977 Visiting lecturer at the Universität Essen
1998 Dies in Berlin

Solo Exhibitions

1961 Galerie Le Soleil dans la Tête, Paris
1966 Kölnischer Kunstverein, Cologne
1974 Musée d'Art Moderne de la Ville de Paris
1978 Museo Español de Arte Contemporáneo, Madrid
1980 Bilder 1954 – 79, Kunstverein Braunschweig, Brunswick
1982 Bibliothèque Nationale, Paris
1988 Kouros Gallery, New York
1997 Hannah-Höch-Preis, Berlinische Galerie, Berlin
1998 Fine Art Rafael Vostell, Berlin

Group Exhibitions

1962 Festus Fluxorum, Museum Wiesbaden
1977 documenta 6, Kassel
1983 São Paulo Biennial
1990 Fluxus Retrospective, Venice Biennial
1994 Murmures des Rues, Centre d'Histoire de l'Art Contemporain, Rennes
1997 Video Sculptures in Germany, Museum van Hedendaagse Kunst, Gent
1998 Europa, Auf den Stier?, Kunstverein Bad Salzdetfurth

Further Reading

René Block, 1962 – Wiesbaden – Fluxus – 1982, Wiesbaden et al., 1983
Wieland Schmied, Die fünf Hämmer des Wolf Vostell, Berlin, 1992
Rolf Wedewer (ed.), Vostell, Bonn et al., 1992
Vostell, Leben = Kunst = Leben, Kunstgalerie Gera, 1994

Andy Warhol

1928 Born in Pittsburgh
1945 – 49 Studies at the Carnegie Institute of Technology, B. F. A. in graphic design
1949 Moves to New York, works as a graphic designer for ad agencies
1962 First solo exhibitions in New York and Los Angeles
1987 Dies in New York

Solo Exhibitions

1964 Galerie Ileana Sonnabend, Paris
1968 Moderna Museet, Stockholm
1979 Whitney Museum of American Art, New York
1982 Leo Castelli Gallery, New York
1985 Invisible Sculpture, Area (nightclub), New York
1989 Andy Warhol: A Retrospective, The Museum of Modern Art, New York, and Museum Ludwig, Cologne
1998 Kunstmuseum Basel

Group Exhibitions

1962 The New Realists, Sidney Janis Gallery, New York
1968 documenta 4, Kassel
1980 Westkunst, Museums of the city of Cologne
1982 Zeitgeist, Martin-Gropius-Bau, Berlin; documenta 7, Kassel
1985 Warhol, Basquiat Paintings, Tony Shafrazi Gallery, New York
1998 Ideal und Wirklichkeit, Rupertinum, Salzburg

Further Reading

Andy Warhol, a, New York, 1968
The Work of Andy Warhol, Gary Garrels (ed.), Dia Art Foundation, Discussions in Contemporary Culture no. 3, Seattle, 1989
Andy Warhol Retrospektive, Museum Ludwig, Cologne, Munich, 1989
Bob Colacello, Holy Terror – Andy Warhol Close Up, New York, 1991
The Andy Warhol Museum, Andy Warhol Museum, Pittsburgh, New York, Ostfildern, 1994

John Waters

1945	Born in Baltimore
1964	First Super-8 film
1965	University of Baltimore
1966	New York University
1969	Starts working with Divine
1980s	Teaches at a prison in Baltimore
	Lives in Baltimore

Films

1969	First full-length feature film: Mondo Trasho
1981	Polyester
1988	Hairspray
1994	Serial Mom

Exhibitions

1995	My Little Movies, **American Fine Arts, New York;** Director's Cut, **American Fine Arts, New York**
1996	My Little Movies, **Galerie Christian Nagel, Cologne**
1997	Director's Cut, **PaceWildensteinMacGill, Los Angeles; Lyon Biennial**
1998	Sunshine & Noir: Art in L. A. 1960–1997, **Kunstmuseum Wolfsburg; Gavin Brown's Enterprise, New York**

Further Reading

John Waters – Schock, **Munich, 1982**
John Waters – Abartig: Meine Obsessionen, **Berlin, 1991**
John McCarthy, The Sleaze Merchants: Adventures in Exploitation Filmmaking, **New York, 1995**
Colin De Land, "Ein Gespräch mit John Waters," Parkett, **no. 49, 1997**
Director's Cut, **Zurich, Berlin, and New York, 1997**

William Wegman

1943	Born in Holyoke, Massachusetts
1961–65	Studies painting, Massachusetts College of Art, Boston
1965–67	University of Illinois, Urbana
1986	Guggenheim Fellowship
	Lives in New York

Solo Exhibitions

1973	Los Angeles County Museum of Art
1986	Cleveland Museum of Art, Ohio
1991	Frankfurter Kunstverein, Frankfurt a. M.; Centre Georges Pompidou, Paris
1992	Ringling Museum, Sarasota, Florida
1998	Holly Solomon Gallery, New York

Group Exhibitions

1984	Venice Biennial
1986	Prospect '86, Frankfurt a. M.
1987	Animal Art, Steirischer Herbst, Neue Galerie Graz
1989	Whitney Biennial, New York
1990	Photography Until Now, The Museum of Modern Art, New York
1998	Conceptual Photography, David Zwirner, New York

Further Reading

Les Levine, "Camera Art," Artes Visuales, **August 1980**
Craig Owens, "William Wegmans Psychoanalytic Vaudeville," Art in America, **March 1983**
William Wegman, "Insert," Parkett, **no. 21, 1989**
William Wegman – Malerei, Zeichnung, Fotografie, Video, **Martin Kurz (ed.), Cologne, 1990**
William Wegman – Cinderella, **Munich, 1993**

Rainer Wittenborn

1941	Born in Berlin
1960–66	Studies at the Akademie der Bildenden Künste in Munich
1971/72	Villa Massimo, Rome
	Lives in Munich

Solo Exhibitions

1966	Galerie Patio, Frankfurt a. M.
1981	San Francisco Museum of Modern Art
1983	Übersee Museum, Bremen
1985	Villa Stuck, Munich
1991	Silpakorn University Art Gallery, Bangkok
1997	Galerie Brigitte March, Stuttgart

Group Exhibitions

1983	Das Prinzip Hoffnung, **Museum Bochum; São Paulo Biennial**
1987	Exotische Welten, **Kunstverein Stuttgart**
1988	Zurück zur Natur, aber wie?, **Städtische Galerie im Prinz-Max-Palais, Karlsruhe**
1990	Ressource Kunst, **Müsamok Museum, Budapest;** Gesichter, **Villa Stuck, Munich**
1993	Bright Light, **Schloss Prestenek, Stein am Kocher**

Further Reading

Rainer Wittenborn: De Finibus Terrae, **Fondazione Mudima, Milan et al., 1991**

Photo Credits

Jürgen Baumann: p. 333

Michael Frank: pp. 52 – 53, 77, 87, 97, 109, 119, 151, 169, 187, 203, 243, 247, 303, 329, 342 – 343, 344

Peter Ganditz: p. 137

Mario Gastinger: p. 305

Werner J. Hannappel: p. 191

Rolf Lenz: pp. 50, 57, 73, 99, 141, 159, 171, 207, 215, 225, 231, 237, 241, 253, 255, 259, 277, 281 – 283, 291, 299, 307 – 309, 317, 319, 325

Klaus Mettig: pp. 314 – 315

Norbert Miguletz: pp. 16, 42

Peter Sander: p. 79

Axel Schneider: pp. 45 – 47, 163 – 165, 341

Nic Tenwiggenhorn: p. 313

Jens Ziehe: p. 145

This book was first published
on the occasion of
the exhibition
The Promise of Photography –
The DG BANK Collection
held at the following venues:
Hara Museum of Contemporary Art, Tokyo October 1998 – January 1999
Kestner-Gesellschaft, Hanover March – May 1999
Centre National de la Photographie, Paris June – August 1999
Akademie der Künste, Berlin January – March 2000
Schirn Kunsthalle Frankfurt, Frankfurt am Main January – March 2001

Library of Congress
Cataloging-in-Publication Data is available

Cover illustration
John Hilliard, Distorted Vision (A) 1991

Manuscript edited by
Judith Gilbert

The publisher would like to thank
Jenny Marsh and **Michael Ashdown**
for their work on the translations

Artists' biographies by
Hubert Beck and **Martina Weinhart**
translated by
Judith Gilbert

List of Works
Christina Leber

Prestel-Verlag
Mandlstrasse 26
D – 80802 Munich
Phone 0049 89/381 709 0
Fax 0049 89/381 709 35
and
16 West 22nd Street, New York, NY 10010, USA
Phone (212) 627-8199; Fax (212) 627-9866

Prestel books are available worldwide.
Please contact your nearest bookseller or write to
either of the above addresses for information
concerning your local distributor.

Design and Layout by
Nicolaus Ott + Bernard Stein, Berlin
Typesetting and Lithography by
CitySatz & Nagel, Berlin
Printed by
Druckhaus EA Quensen GmbH,
Lamspringe
Bound by
Kunst- und Verlagsbuchbinderei,
Leipzig

Printed in Germany

ISBN 3-7913-1995-7